Delta Work ⚬ Lili Whiteass ⚬ Millie Shayntwright
arrie Oakey ⚬ Ida Slapter ⚬ Brooke Lynn Hytes
awhip ⚬ Portia Control ⚬ Dee ⚬ Anabelle
tlife ⚬ Ruby Wednesday ⚬ International Chrysis
Kay Sedia ⚬ Sissy Spastik ⚬ Sandy Beach ⚬ Jessyc
odthyme ⚬ Barbra Seville ⚬ Nina Levin ⚬ Portia
O'Manda Tension ⚬ Sandy Devastation ⚬ Blackic
en ⚬ Honey Mahogany ⚬ Cherra Secret ⚬ Shirley
erkill ⚬ Hellin Bedd ⚬ Sutton Lee Seymour ⚬ Fay
blend ⚬ Phatti LuPone ⚬ Wanda DeCountryside
al Mess ⚬ Christy Annity ⚬ Anita Waistline ⚬ Coco
⚬ Damanda Fortune ⚬ Clare Boothe Luce Chango
Ida Nevasayneva ⚬ Madam Ovary ⚬ Astala Vista
Bessie Mae Mucho ⚬ Plenty Moore ⚬ Jasmine Rice
na Davenport ⚬ Shelita Buffet ⚬ Rhuma Hazzet
Fanculo ⚬ Marsha Dimes ⚬ Delighted Tobehere ⚬
Di'n't ⚬ Tia Wanna ⚬ MoMo Shade ⚬ Heidi Haux ⚬
ril Showers ⚬ Maci Sumcox ⚬ Nova China ⚬ Annec
DeLear ⚬ Mah Jong ⚬ Sham Payne ⚬ Wilma Balls
Cotton Kan Dee ⚬ Crystal DeCanter ⚬ Waxie Moon
il Tefish ⚬ Ivana Diamond-Nicholas ⚬ Maxi Shield
elen Back ⚬ Anita Mandalay ⚬ Dusty Flaps ⚬ Mary
anter ⚬ Mimi Imfurst ⚬ Shasta Cola ⚬ Hapi Phacc
Cake Moss ⚬ Miss Ann Thrope ⚬ Ophelia Love

P9-AOH-906

Date: 9/25/19

792.028 DEC
DeCaro, Frank,
Drag : combing through the
big wigs of show business /

PALM BEACH COUNTY
LIBRARY SYSTEM
3650 SUMMIT BLVD.
WEST PALM BEACH, FL 33406

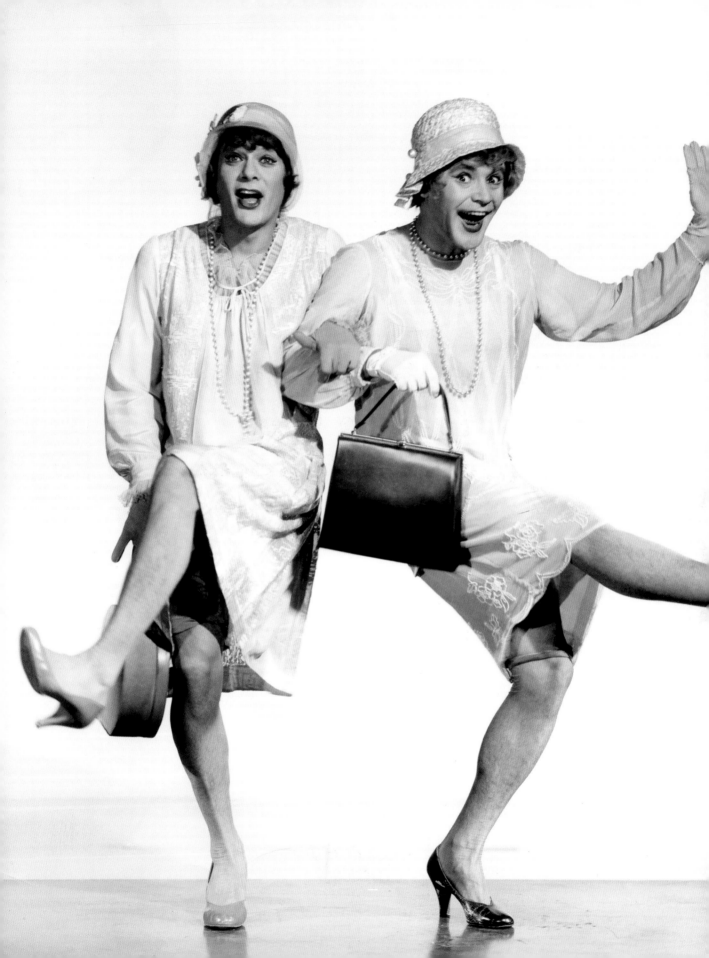

DRAG

★★★★★★★★★★★★★★★★★★★★★★★★★★★★★★★★★★★

Combing Through the Big Wigs of Show Business

By
FRANK DeCARO

Foreword by
BRUCE VILANCH

RIZZOLI
NEW YORK

New York · Paris · London · Milan

First published in the United States of America in 2019
By Rizzoli International Publications, Inc.
300 Park Avenue South
New York, NY 10010
www.rizzoliusa.com

Copyright © Frank DeCaro
Foreword © Bruce Vilanch

Designed by Lynne Yeamans

All rights reserved. No part of this publication may be reproduced, stored in a
retrieval system, or transmitted in any form or by any means, electronic, mechanical,
photocopying, recording or otherwise, without prior consent of the publisher.

Distributed to the U.S. Trade by Random House, New York

Printed in Italy

2019 2020 2021 2022 / 10 9 8 7 6 5 4 3 2 1

ISBN-13: 978-0-8478-6235-1

Library of Congress Control Number: 2018967337

Front cover photograph by Scotty Kirby
Back cover photograph by Steven Menendez

★ ★

**To Mimi,
my first drag queen.
May she always be
*Where the Boys Are...***

★ ★

"What's that on your head? A wig."

— The B-52's

Contents

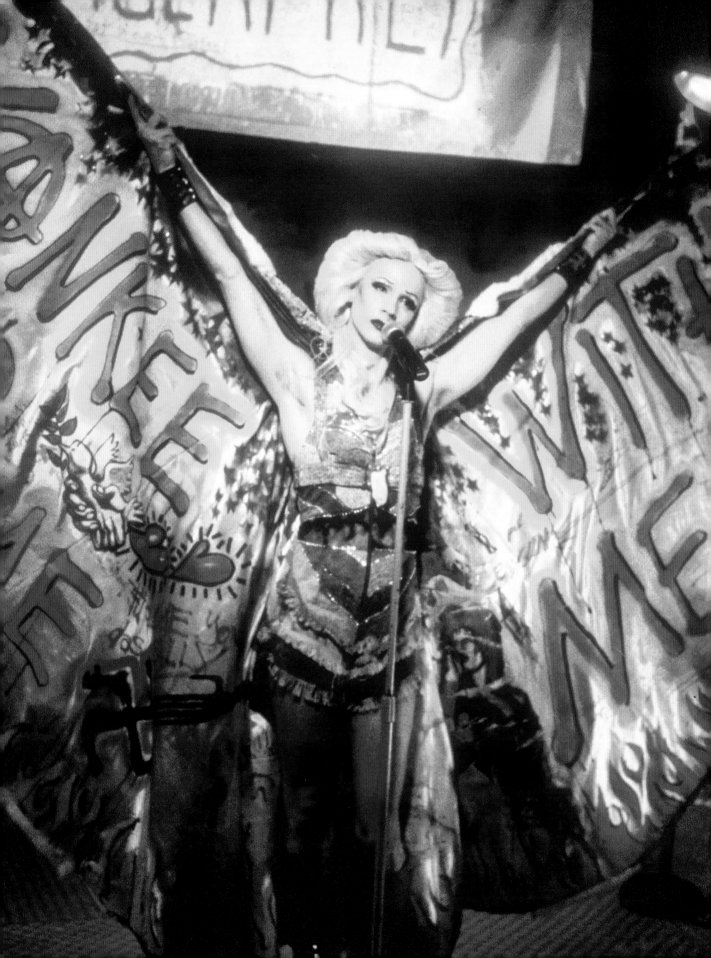

Foreword

BY BRUCE VILANCH

When was the last time you held an encyclopedia in your hands? Well, you're holding one now. This volume will tell you everything you have wondered and, no doubt, argued about during the commercials on *RuPaul's Drag Race*. Like encyclopedias used to do, before Google.

And it's so much more entertaining.

Encyclopedias, as a rule, didn't squander too much academic space on outlier art forms like drag. The history of drag was handed down from one practitioner to another, like ancient Navajo rituals, in deep, spiritual conversations around campfires—accent on "camp." If you wanted to know about your forebears—and some of them were bears, of the ursine-fluid variety—you had to find a likely suspect and ask. That's all over now, as Frank DeCaro has done the heavy lifting for all of us.

You are about to encounter a living, pulsing documentation of some of the most brilliant artists in America's subcultural history. If you are a refined old sodomite like a guy I know who writes forewords, most of these names will be familiar to you. Most – but not all. There are surprises on every page.

If you are a casual observer of, or a younger convert to, drag, the RuPaul crew may be the only names you recognize. By the time you finish the book, you will be so wide-eyed you will be competing in Rudolph Giuliani look-alike contests. Spoiler alert: He's a drag queen.

I wrote for a number of people in this book. In fact, at one point in the early 1970s, I was creating material for, in alphabetical order, Jim Bailey, Lynne Carter, Charles Pierce, and Craig Russell . . . not to mention the Bette Midler material I was recycling, with the Divine's blessing, for Kenny Sacha, her preeminent impersonator. They're all gone now. And that is also part of the drag story. Along with the fact that I sometimes gave each of them the same stuff, but that's for my memoirs, if I live as long as Scotty Bowers.

Drag in America—as opposed to drag in the UK, where a performer like Danny La Rue could be a mainstream proposition for decades, even starring in a West End revival of *Hello, Dolly!*—was always a subversive, outlaw, "other" kind of entertainment, maybe because by the time theater started here, we already had women playing women's parts.

The people who made up the drag world were themselves the Stella Dallases of show business, standing outside the main room, watching through the glass. Their depictions of women were not really women; they were women in quotes, larger-than-life versions of women. Even when doing impressions of famous flamboyant women, like Bette, Carol Channing, and Liza, they were commenting on the techniques those real women employed to be super-personalities.

Putting out these dry, academic views of them isn't doing them any favors. It's more important that they look fantastic and are really funny. But if you're going to put them in an encyclopedia, you have to give them as much dignity as their heels can support. You'll see what I mean once you turn the page. Frank gives them all their props. But this is not a book about Madame Curie. It's Madame Queerie, and she is a fabulous dame. There is nothing like her.

OPPOSITE: John Cameron Mitchell as Hedwig in Hedwig and the Angry Inch.

Six Inches Forward

*"I look back on where I'm from, look at the woman I've become,
and the strangest things seem suddenly routine..."*

—Hedwig and the Angry Inch

It was a night when drag queens were shining from sea to sickening sea.

At the Belasco Theatre in Los Angeles, a renovated 1926 burlesque house in the perpetually gentrifying downtown of the glittering showbiz mecca, the place was packed and the screaming was positively Beatle-esque.

A dozen stars of *RuPaul's Drag Race*, the wildly popular reality competition show that has been crowning "America's Next Drag Superstar" since 2009, were engaged in what was billed as the "Battle of the Seasons."

Cast members from the TV series' various seasons were girded together for a months-long, multi-city tour that would take them—lashes, falls, duct tape, and all—from Tucson to Barcelona, with stops in destinations as far-flung as Calgary, Austin, and Reykjavik.

The lineup would change from city to city, but that was no problem. After all these years, there were enough "girls" to go around, and plenty of worshipful fans who'd pay good money to see them perform anything, anywhere. It didn't matter that RuPaul wasn't there in person; she was there in spirit.

That evening, the champion of season six, New York–based insult comic Bianca Del Rio, was hosting, her tongue as sharp as her stiletto heels as she introduced one drag queen after another to thunderous applause. Though only two of the performers had taken home the crown on TV, everyone was a winner.

Adore Delano, a season six finalist, sang "Purple Rain" in a see-through raincoat, while her mother cheered from the balcony. Ivy Winters, a quick-change artist awarded season five's Miss Congeniality sash, performed "Prisoner," the theme to the 1978 fashion-world thriller *The Eyes of Laura Mars*, and then juggled knives.

Season three's runner-up Manila Luzon—only half Filipino—joked, "I like cats, but I've never eaten a whole one," and then, from the stage, sold two hundred dollars' worth of T-shirts emblazoned with her face.

Sharon Needles, whose Goth-meets-Gaga look won her the top prize in the fourth season, sang "I Wish I Were Amanda Lepore," a disco homage to the jet-set darling of the LGBTQ community.

Then there was Alaska Thunderfuck 5000, a season five standout from Pittsburgh who went on to win season two of *Drag Race All-Stars*. She channeled Whitney Houston but sounded more like Louis Armstrong gargling. A signature "*Hieee*" from her, though, was all the crowd needed to lose their sequins.

Except for the contestants' off-color language, this variety extravaganza was like *The Ed Sullivan Show* transported from the 1950s to the twenty-first century. With brows plucked and members tucked, these performers would do anything to give the crowd a night it wouldn't forget. Although cutting edge, they proved themselves to be the heirs apparent to such old-school entertainers as Don Rickles, Vicki Carr, and Gypsy Rose Lee, given a pastie or two. So what if their plumbing is hidden in a back closet—they come to shine. That's entertainment, all right.

Meanwhile, that very same night, three thousand miles away at another Belasco Theatre, this one built in 1907 on 44th Street in New York City's Times

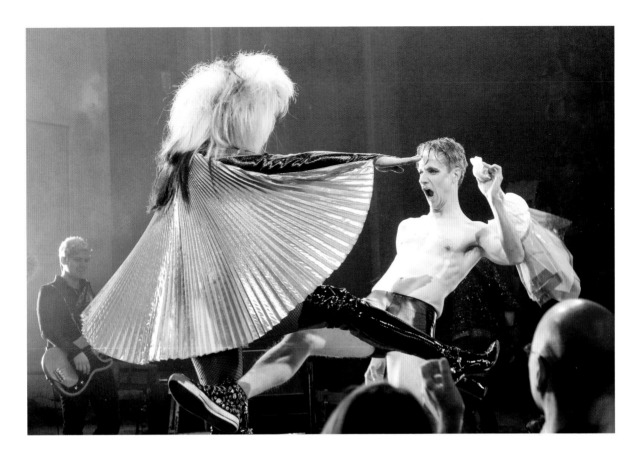

Square, the scene was no less splendiferous. John Cameron Mitchell was back on Broadway after sixteen years and starring in *Hedwig and the Angry Inch*, the glorious drag rock musical he cocreated with musician Stephen Trask.

Two weeks earlier, Mitchell—the man who first began developing his "internationally ignored" transsexual chanteuse character at underground clubs in downtown Manhattan in the mid-1990s—became the fourth man to play Hedwig on Broadway. He succeeded TV icon Neil Patrick Harris, who won the Tony Award for his performance; *Book of Mormon* star Andrew Rannells, who played her with more than an inch of anger; and *Dexter* himself, Michael C. Hall, who brought a darkness to the role that made his portrayal, well, killer.

Between Mitchell's early SqueezeBox! gigs and the big-time success of the Tony-winning Best Musi-

cal Revival at the Belasco, *Hedwig* had a long Off-Broadway run beginning in 1998, was made into a cult hit movie, which Mitchell directed and in which he starred in 2001, and has been staged around the world. Wherever it has played, adoring fans have fallen hard for the East German "slip of a girly boy" who'd gotten the short end of the dick in a sex-change operation gone awry, then took her wig down off the shelf and dreamed of becoming a Midwest beauty queen.

It was a story of survival in any language.

Mitchell's return to the role was a story of survival, too. He was over fifty—the oldest of the Broadway Hedwigs—when he took on the role. But he looked great in and out of drag and the part fit him like an opera glove. As one diehard "Hed head," as the musical's super fans are called, said, "Those other guys were playing Hedwig—John *is* Hedwig." No one, not *Glee* star Darren Criss, the youngest actor to play the

ABOVE: John Cameron Mitchell.

11

role, nor Taye Diggs, who became the first African-American to play the role before it closed on Broadway in 2015, could match him.

Even when Mitchell tore up his leg early in his Broadway run and had to adapt the show to his now-limited mobility, he was amazing, whether he was throwing shade at Broadway colleagues, taking the piss out of Grindr while grinding up against a lucky audience member, or, with impish delight, explaining how a close relative died in a Nazi prison camp—he fell from a guard tower.

Two decades after Mitchell first slipped into sausage curls, his cheeky downtown diva in cheap Dynel had taken the Great White Way by storm in this lavish version of a funny little punk-rock drag show, delighting audience members who'd plunked down more than 150 bucks a pop and kept coming back for more. This *Hedwig* wasn't amateur lip-synch night at a local gay bar, this was subversive drag hitting the big time.

In the second decade of the twenty-first century, such entertainment has become more easily accessible to its fans and more digestible for everyone else. Men in dresses may not quite be ubiquitous—not in the *Wicked*, *N.C.I.S.*, or *Harry Potter* sense of the word—but cross-dressing has crossed over. Drag as divertissement has climbed to a higher ground than ever before. Paris was always burning but now everyone is watching . . . and toasting marshmallows.

The category is . . . mainstream!

Here's the thing, though: once the runners-up from *RuPaul's Drag Race* have sashayed away on a gay cruise to Puerto Vallarta, and once Hedwig's collection of *Hurt Locker: The Musical* playbills all have been recycled, how much does anyone really know about the history of cross-dressing in show business?

Not enough. Hence, this book. Herein you'll find glimpses of the past, present, and future of show biz drag in all its *Kinky Boot*-ed glory. On a journey worthy of *Priscilla, Queen of the Desert*—without all that Outback dust—you'll discover that the drag superstars you know are part of a storied history of gender illusion, female impersonation, and dear old drag.

In the pages that follow, you'll meet the drag divas of Broadway, a harem of Hollywood actors who found themselves in hosiery for the cameras, and the larger-than-life Baltimore legend Divine and her sister-in-sequins Sylvester. You'll get to know the cross-dressing TV clown who had a python in his panties, the wiggy—and sometimes stocky—women of Wigstock, the luscious Lypsinka, the vivacious cheese-food-guzzling coloratura Varla Jean Merman, and an army of men who've been dressing up as famous women since Dorothy first went over the rainbow.

You'll get to wrap your mind, too, around more outré drag stars like Seattle sensation Dina Martina, whose absurdist characterization makes her an otherworldly comic delight, and Darcelle XV, the world's oldest working drag queen, whose Portland showplace is a Pacific Northwest must-visit. And let's not forget drag king Murray Hill. No story on professional cross-dressing would be complete without a groaner from that old salt, the hardest-working middle-aged "man" in show biz.

Drag has become big business in the twenty-first century, but really, it has long been a vital part of American entertainment. Whether on the West Coast or the East, or in clubs and theaters in cities in between, audiences have always been drawn to the delicious diversion that drag can provide. These folks—the crowd they used to call the "Smart Set"—have always been looking for the Next Drag Superstar to sashay and shantay into the spotlight, dressed to the mother-scratching nines, and ready to do a death drop on a moment's notice.

Here are the Big Wigs of show business.

As RuPaul would say, "Gentlemen, start your engines . . ."

OPPOSITE: *Just a few of the notable queens from* Rupaul's Drag Race.

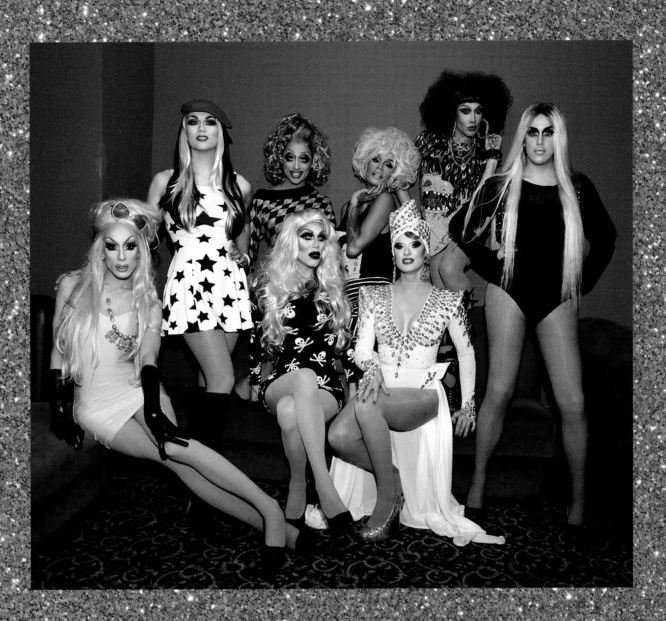

SEQUINS OLDER THAN DIRT

"It depends on where you put the paint, not how much you splash on."
—Julian Elfinge

A drag queen, one more clever than most, was once asked her age. Without missing a beat, she flicked the ash from the cigarette in her Bakelite holder, and replied, "There were two of me on the ark. I was the one with the beads."

Okay, that story might not be 100 percent true. It was told by Charles Pierce and both he and Noah are dead, so who can really say? But this much is known for sure: drag in show business—a line of work in which Pierce excelled in the twentieth century—goes back a lot further than the first season of *Drag Race*.

With all due respect, when it comes to cross-dressing for success, RuPaul is standing on some pretty broad shoulders. Without Flip Wilson—the pioneering African-American comedian whose 1970 NBC variety show owed much of its popularity to his feminism-powered, Pucci-clad drag character, Geraldine Jones—for instance, there might be no Ru.

Wilson, in turn, owed a debt to vaudevillian Milton Berle, who first did drag on television in the medium's earliest days. Known as much for stealing jokes as telling them, Berle was only bringing to the airwaves what Mickey Rooney had done in the movies before he turned twenty-one. With his midriff bared and a basket of fruit on his head, that diminutive song-and-dance man had out-Carmen Miranda-ed Carmen Miranda in the 1941 Hollywood musical *Babes on Broadway*.

And Rooney, to be perfectly honest, had merely taken the kind of drag performance that Julian Eltinge had done on Broadway and played it strictly for big-screen laughs. The early twentieth century's most famous female impersonator, Eltinge was so celebrated that he had a Broadway theater named after him in 1912! And even that wasn't the beginning of drag in show business. As long as there has been popular entertainment, drag has played a featured part.

Male actors had a lock on female roles in ancient Greece, for instance, wearing masks to play the opposite sex—who were banned from the stage. As it turns out, *Medea* was more Tyler Perry's *Madea* than they taught us in school.

Women were forbidden from performing in the Middle Ages, so in Bible pageants, men played all the parts, even when they didn't have the usual biological ones.

Gentlemen played ladies in Shakespearean times as well. In the sixteenth century, it wasn't exactly glamorous work, though. Juliet was not the Jujubee of the 1500s, and the House of the Capulets certainly wasn't the Renaissance's answer to the House of Evangelista. But in early productions of *Romeo and Juliet*, men were dressing as women onstage, and that's drag. Really, what is *As You Like It* but *Victor/Victoria* without the flapper number? I ask you.

In the seventeenth century, Kabuki theater in Japan went through periods where casts were made up entirely of women, then times when they were made up solely of men. Males playing female roles were called *onnagata*—Anna Gata, now *there's* a drag name!—and all kabuki actors were expected to have the facility to plays roles of any gender. Themes of these works were often erotic in nature and, periodically, that led to crackdowns and all sorts of *sturm und* drag.

In England, the 1800s saw the establishment of high-camp drag characters in the broad family-oriented variety shows called pantomimes. This theatrical tradition continues right up to today at Christmastime in Britain and beyond, with such popular actors as Barry Humphries, Danny La Rue, and Shaun Pendergast performing as "pantomime dames." Meanwhile in America, minstrel shows of the nineteenth century featured men not only in drag

OPPOSITE: *Julian Eltinge, the RuPaul of the early 20th Century, was so popular that he had a Broadway theater named after him in 1912. He made his movie debut in 1914.*

but in blackface singing "wench" songs. You can be sure these numbers were not celebrations of female or African-American empowerment. But audiences of the day approved.

As vaudeville became the dominant form of popular entertainment in the States early in the twentieth century, female impersonators became a viable part of the variety show, with drag artists mixing with jugglers, baggy-pants comedians, strongmen, and singers.

It's here that drag as we know it began.

In those days, there were a number of noteworthy cross-dressers in American theater, but none reached as high a level of fame as Julian Eltinge. Today, his is the name that contemporary queens, at least those with any sense of history, cite as the progenitor of modern drag.

There are many reasons why Eltinge is the mother of them all.

First, he was beautiful in women's clothes—not Courtney Act beautiful, but, for the turn of the twentieth century, pretty darn cute. And, he could really sing. The guy went from vaudeville to Broadway to touring to playing a command performance for King Edward VII in London. Eltinge even made a movie in drag, wearing both male and female garb in 1917's *The Countess Charming*, his first screen smash. And, although he was a man who staunchly (and sometimes violently) defended his masculinity, Eltinge even published a lifestyle magazine offering women tips on makeup, fashion, and decorating. He did it all.

He was the RuPaul, Charles Busch, and Brini Maxwell of his day: a famous drag queen, a celebrated

★ ★

As vaudeville became the dominant form of popular entertainment in the States early in the twentieth century, female impersonators became a viable part of the variety show, with drag artists mixing with jugglers, baggy-pants comedians, strongmen, and singers. It's here that drag as we know it began.

male actress, and a cross-dressing domestic goddess, all in one! "Eltinge was a huge star," says Busch, the playwright and actor known for his 1984 Off-Broadway hit, *Vampire Lesbians of Sodom*.

Among Eltinge's best-known contemporaries were Bert Savoy, Karyl Norman, Bothwell Browne, and Arthur Blake.

Known for wearing big jewelry and colorful garters, Bert Savoy performed on Broadway in the *Ziegfeld Follies* of 1918 and was a star attraction at the *Greenwich Village Follies* shortly thereafter. Mae West, Busch notes, credited Savoy with helping to create her outsized persona. Savoy's abrupt end came in 1923, according to newspaper reports, on Long Beach in New York's Nassau County.

"He had a very strange demise," Busch says, explaining that Savoy was walking on the beach when the weather turned bad. "As the story goes, he made a joke. He said, 'Enough out of you, Miss God,' and was hit by a bolt of lightning."

That'll teach you to throw shade in an electrical storm!

Karyl Norman reportedly was hit by something almost as bad as a lightning bolt—a morals charge—when he was caught doing gay stuff in public. But Eleanor Roosevelt reportedly intervened on his behalf because she was a fan of the man the press called the "Creole Fashion Plate," a performer whose mother made his clothes and traveled with him, by the way. Norman, whose birth name was George Francis Peduzzi, scaled the showbiz heights as part of what

OPPOSITE: Sheet music for "I'm Through (Shedding Tears Over You)" from 1922 featuring the "Creole Fashion Plate," Karyl Norman, whose real name was George Francis Peduzzi.

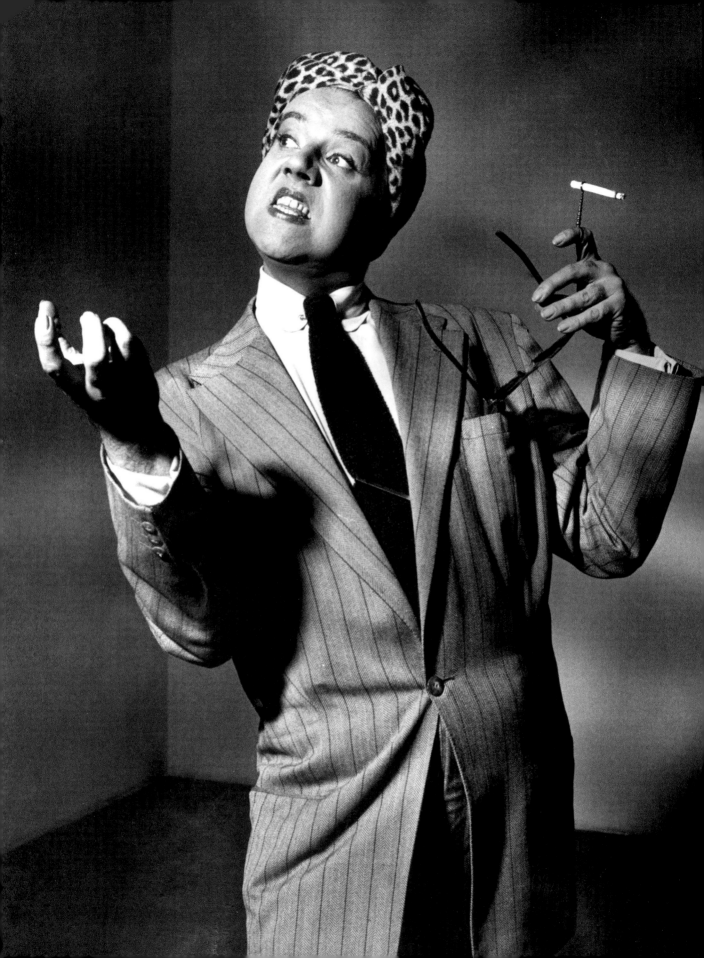

was called "the pansy craze" of the early 1930s, a brief fad in Prohibition-era America when drag and other forms of gay entertainment were showcased in mainstream urban venues, before he died in 1947 at age fifty.

Bothwell Browne was originally from Copenhagen but immigrated to San Francisco. He performed in drag—sometimes with a female costar in male attire—and at the height of his popularity played the Palace, a New York City headlining gig that was as big an honor as it sounds. His film career amounted only to a 1919 Mack Sennett picture called *Yankee Doodle in Berlin* in which he played an airman who goes undercover dressed as a woman. A film critic for the *New York Times* noted that Browne performed "an Oriental dance," provocative for the time. He died in 1947.

A Pennsylvania native, Arthur Blake studied industrial design at the Pratt Institute in New York, and, after graduation, worked for several textile firms and took other fashion-related employment. On the job, he was infamous for mimicking the clients.

Blake embarked on a career as an impressionist in the 1930s. Among his celebrity repertoire were Bette Davis, Carmen Miranda, Edna Mae Oliver, Katherine Hepburn, Beatrice Lillie, Jayne Mansfield, Gloria Swanson, and even Eleanor Roosevelt, a talent that led to an invitation to perform at the White House. Blake impersonated famous men, too, but his fabulous females took the cake. Lana Turner once told Blake, "I wish I were important enough that you could do me," the Associated Press reported in 1948.

★ ★

"All you need is your own imagination... your dreams will open the door..."

—Madonna

At the height of his fame, Blake played the London Palladium five times. Later, he was a fixture in Provincetown for two decades. He also appeared in a number of films, most notably as Montfleury in *Cyrano de Bergerac* in 1950. He had a career renaissance in the 1970s, touring the country with his classic impersonations. "Arthur Blake may not be the funniest man on earth. He is, however, the funniest woman," Bruce Vilanch, then a columnist for the *Chicago Tribune*, declared in 1974. Dubbed the "King of Caricaturists," Blake died in 1985.

To this day the best known of them all, Eltinge met his end in 1941 after having a cerebral hemorrhage during a performance in New York. He was fifty-seven. According to the *Times*, three hundred "stars of stage and screen" attended Eltinge's memorial. The funeral was held at the Church of the Transfiguration, which seems only appropriate. Where better to say good-bye to a cross-dresser? He was cremated and his ashes were sent to Hollywood.

He maintained that he was heterosexual until the end. "I'm not gay, I just like pearls," he once said. Still, in the 1967 *Female Impersonator's Handbook*, a performer named "Pudgy" Roberts wrote, "Of the impersonators who have achieved greatness, he alone excels as the top, only to be imitated by hundreds of others." The façade of the Eltinge 42nd Street Theatre, a showplace designed by renowned architect Thomas W. Lamb, is now a multiplex movie theater.

In New York City, Eltinge continues to give good face.

OPPOSITE: *Acclaimed mimic Arthur Blake, ready for his close-up in 1951, impersonates Gloria Swanson, one of the many famous women in his repertoire.*

BOYS WILL BE GIRLS

"I much prefer being a man. Women have to spend so much time pulling themselves together, and their shoes kill your feet. I know."
—Lynne Carter

Before America was comfortable with the words "drag queen," before there were Yelp reviews for restaurants serving up men in bugle beads along with bottomless—you should pardon the expression—mimosas at brunch, drag shows were an activity usually reserved for the "in crowd."

Generally, these drag hags were gays and their liberal friends—and more than a few heterosexual thrill-seekers looking for a walk on the mildly wild side. They were quite happy to fork over their hard-earned greenbacks to see a good "female impersonator" sing like a diva and then kibitz like a stand-up comedian.

These entertainments were a hit across the country, whether at the Top Hat Night Club in Dennison, Ohio, where, in 1954, Dick Barrett's *Turnabout Revue*, a drag variety extravaganza, was billed as "the most unusual show of the season" and held over by popular demand, or thirty years later at the *La Cage aux Folles* show in Los Angeles, where host James "Gypsy" Haake welcomed the famous likes of Lucille Ball, Paul Lynde, and Charles Nelson Reilly to ringside seats for nights of cross-dressing tomfoolery.

Sometimes, although not always, "gender illusionists," to use the favorite term of the *ne plus ultra* impersonator Jim Bailey, transformed themselves into the spitting image of celebrated actresses or recording artists of their day. But frequently, they came up with female alter egos all their own, and audiences took to them as fervently as they did the genuine articles.

Although in many towns a man could be arrested for impersonating a woman, most every city had at least one club that featured cross-dressers and managed to get away with it. "People would go because it was something naughty to do," says John Epperson, the New York performance artist better known as Lypsinka. And depending on just how late it got, things could get pretty dicey. Deliriously so.

Beginning in 1936, San Francisco had what was probably the best-known female impersonator club in America. It was Finocchio's, a North Beach hotspot that attracted a stellar clientele that included Phyl-lis Diller, Lana Turner, Tallulah Bankhead, and Sal Mineo. The place, open for more than sixty years, was publicized as "the most unique and unusual nightclub in the West."

There, Ray—or sometimes Rae—Bourbon became known for hilariously risqué monologues. One of his drag revues was titled *Don't Call Me Madam*. Lee Shaw did a Marilyn Monroe impression so breathtaking they say the iconic actress felt compelled to see it for herself. Lori Shannon, who went on to play the female impersonator Beverly LaSalle on several episodes of TV's *All in the Family* in the 1970s, was a star at Finocchio's too.

New York City had the Ubangi Club in Harlem and the Pansy Club in midtown in the 1930s. From 1950 until the 1970s, there was the 82 Club, "where the waiters were girls who looked like boys and the performers were boys who looked like girls," according to a magazine of that vintage. The notorious nightspot at 82 East Fourth Street was called the "East Side's newest rendezvous" when it opened, and later the "East Side's gayest rendezvous."

It was home to the *82 Club Revue*, which, at one point, featured a queen named Titanic and what that magazine article called "a continual parade of the great and the near-great in drag." Columnist Walter Winchell covered the goings-on there and was partial to the performer Kitt Russell, whom he dubbed "America's top femme mimic." Ty Bennett, a zaftig Sophie Tucker–esque impersonator who "began his rib-tickling at the 82 Club in 1958," to quote a souvenir program, was known as "The Sensation of the Nation." He released an adults-only album called *Queen for a Day!* in 1961. The title was considered quite provocative at the time. Today, it's collectible.

At its height, the 82 Club could become so raucous that Errol Flynn once allegedly took out his penis and played the piano with it! Judy Garland, Elizabeth Taylor, and Montgomery Clift were seen enjoying themselves there too, although they kept their goodies under wraps. Photographer Diane Arbus began shoot-

ing the festivities there in 1958. The club later became a glam rock joint, and a hangout for the New York Dolls. Same address, different drag.

Chicago, in the early 1970s, was home to Sparrow's, a bar where a queen named Wanda Lust became a local "drag sensation" as a featured player in *Roby Landers' Hot Pants Revue*. It's gone but the Windy City still has the Baton Show Lounge, which was opened in 1969 by Jim Flint, a Chicagoan by way of Peoria, Illinois, whose girl name was Felicia. Now popular mostly with hetero bachelorettes, the Baton has made local legends of Ginger Grant, Sheri Payne, and Chilli Pepper.

Although these venues became magnets for amuse-ment-seeking visitors from across the country, drag fans who didn't live in San Francisco or New York or Chicago weren't starved for sequins in the early- to mid-twentieth century.

For decades, beginning in 1939, the Jewel Box Revue toured the States with twenty-five men and, later, one woman, too—Stonewall activist and early drag king Stormé DeLarverie. The impersonator show, created by Danny Brown and Doc Benner, played theaters across the country including twelve-week stretches in such conservative locales as Fort Worth and Dallas, and in such famed venues as New York's Apollo Theatre, attracting famous fans like Sammy Davis Jr.

"During a time when gay people were viewed as abhorrent subversives and a threat to society," *Huffington Post* blogger Wayne Anderson wrote in 2012, the Jewel Box was "America's first racially inclusive traveling revue of female impersonators" and "in many ways, it was America's first gay community."

Drag shows of the 1940s and '50s, he contends, cit-ing an influential paper by the Yale-educated researcher Mara Dauphin, were "highly instrumental in creating queer communities and carving out queer niches of urban landscape in post-War America that would flour-ish into the sexual revolution of the Sixties."

DeLarverie's participation in both the Revue and the Stonewall uprising, which in 1969 marked the beginning of the gay rights movement, may make her the most culturally significant player to emerge from the Jewel Box. Her 2014 *New York Times* obituary called her a "gay superhero."

But the biggest star of the Revue—based strictly on entertainment—was a former dancer named Lynne Carter, who skillfully impersonated the divas of his day. His drag career began when he dressed as "The Incomparable Hildegarde," the so-called First Lady of the Supper Clubs, at a Cleveland Halloween party after a tour of duty in the U.S. Navy during World War II, and he continued to perform for four decades.

According to his 1985 *New York Times* obituary, Carter became, in 1971, the first female impersonator to star in a concert at Carnegie Hall. His roster of impres-sions included Marlene Dietrich, Bette Davis, Mae West, Hermione Gingold, and Eartha Kitt. Josephine Baker once gave him three taxicabs full of Balenciaga and Dior gowns to wear. His earliest celebrity champion, Pearl Bailey, also happily donated her designer hand-me-downs, because she said listening to Carter was "like listening to a playback of my own voice."

Although Carter sang live, not all female imper-sonators did or do, but fans don't mind if a "playback" is *exactly* what they're listening to at a drag show. If a female impersonator can transform himself visually into the woman he is "doing," no one cares if the sing-ing voice is Memorex.

For decades, Frank Marino was chief among those keeping the term "female impersonator", and the flame, alive. As the Joan Rivers–esque ringmaster of *Divas Las Vegas*, a long-running celebrity imperson-ation show, he and his cast made thousands of "Sin City" tourists happy each week.

Today, there are as many flavors to celebrity impersonation as there are stars to mimic. No one would dare confuse Chuck Sweeney's lovingly cracked take on Miss Peggy Lee with the performance artist John Kelly's earnest—and often moving—tribute to Joni Mitchell any more than they'd mistake "He's a Tramp" for "Both Sides, Now." But these artists are all female impersonators when the wigs go on, and they keep alive the long show-business tradition of boys being girls.

Carol Channing

"I thought, if she doesn't like what I'm doing, I will never do it again."

—Richard Skipper

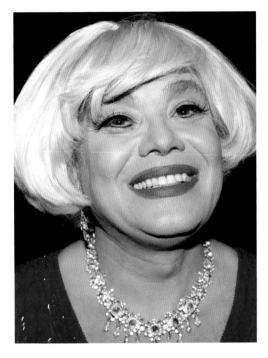

Every gay man of a certain age does a Carol Channing impression. But for Richard Skipper, embodying the *Hello, Dolly!* star was a true calling. "This guy is no zircon. His is a Carol Channing worthy of Tiffany and Cartier," the *Hartford Courant* gushed in 2002.

Skipper started polishing his diamonds when, as a kid growing up in Conway, South Carolina, he saw Channing on the 1969 television special *Carol Channing and Pearl Bailey: On Broadway.* "I became an instant fan," Skipper says.

At eighteen, he moved to New York City and began singing at a weekly Broadway night at an Upper West Side piano bar. When he did his Channing impersonation, he killed. "As I began to sing *a la* Carol, the room immediately burst into applause. I finished to a standing ovation."

He had no intention of doing drag, but his reputation for mimicry grew so strong that he was cast in an Off-Off-Broadway musical as a female impersonator. His run in that show was short, but every Halloween, Skipper would dig out that costume and make the rounds of Manhattan's piano bars.

In 1995, as Channing headed back to Broadway as Dolly, Skipper staged a revival of his own. He built a show for himself called *Carol Channing's Broadway* and opened at the Don't Tell Mama cabaret in midtown. It was a hit.

Two years later, he did something gutsy. The New York City Gay Men's Chorus was saluting *Hello, Dolly!* composer Jerry Herman with a concert at Carnegie Hall and Skipper decided to crash the after-party dressed as Channing.

"As I walked in, I truly felt like Dolly arriving at the Harmonia Gardens," he remembers. "Flashbulbs were going off and people were parting as I was brought to the back of the club where Carol was holding court. My friend said, 'Miss Channing, meet Miss Channing.'"

Skipper struck up a conversation with the icon herself in Channing's voice and never broke character. "She asked, 'How long have you been imitating me?' and I responded, 'Who's to say you're not imitating *me*?'" That brought an invitation to join Channing at her table.

Feeling emboldened, Skipper told Channing that he'd like to sing for her and then did. After his performance, she told him, "Most people who imitate me are mean and vicious, but this is a true valentine."

ABOVE: *Skipper up close and personal.*

FRANK MARINO AS

Joan Rivers

"I get excited when a man tells me his wife dragged him to the show and he ended up having a better time than she did!"

—Frank Marino

On the cover of his autobiography, *His Majesty, the Queen*, Frank Marino called himself "The World's Most Famous Female Impersonator!" and that, he says, was only because his editor wouldn't let him really gush.

The hyperbole may well be true. Marino began impersonating Joan Rivers on the Las Vegas strip in 1985, and—can we talk?—became one of the highest-paid drag performers in the world.

After appearing for more than twenty years in the standard-setting drag revue *An Evening at La Cage* at the Riviera, Marino launched *Divas Las Vegas*, a glitzy variety show that put Celine Dion, Cher, Tina Turner, Dolly Parton, Lady Gaga, Britney Spears, and, yes, a Brooklyn-born boy dressed as Joan Rivers, gloriously on the same stage.

Before becoming the ultimate Joan Rivers impersonator, Marino attempted to do various other celebrities. "When I started doing drag, I tried everybody," he says. "I even did Diana Ross, but I wasn't very supreme."

He settled on Rivers, who became a fan and, as a friend, introduced Marino to the producers of *La Cage*, where he made his name. Rivers later sued the female impersonator because she didn't want Marino performing her actual material. "It became a little too

close for comfort," he explains. "She ended up suing me for five million dollars, which at nineteen years old was a very scary thing, especially because I was, like, eighty bucks short."

The spat with Rivers ended amicably, and the legal troubles forced Marino to become a real stand-up comic rather than just re-create one. Besides his Rivers impersonation, he has his own funny female persona.

Well-dressed and well-respected, Marino was named "Entertainer of the Century" by *Las Vegas Today* magazine in 2009.

"Las Vegas to me is like a game, and the rules of the game change every day," he says. "You can never rest on your laurels. You've got to keep changing with the times." That means new queens impersonating new divas. But Marino has one rule of thumb for all of them. "I always tell everyone, you're not Lady Gaga. You're not Shania Twain. But when you put your own personality into it, it makes the audience love you as much as the stars themselves."

Certainly that has been true in his case. Las Vegas' most famous female impersonator quotes his idol, "Joan used to say, 'Frank Marino does me better than I do!'"

And that was when she was still alive.

OPPOSITE: Can We Talk? Frank Marino as a Versace-clad Joan Rivers in his long-running show, Divas Las Vegas.

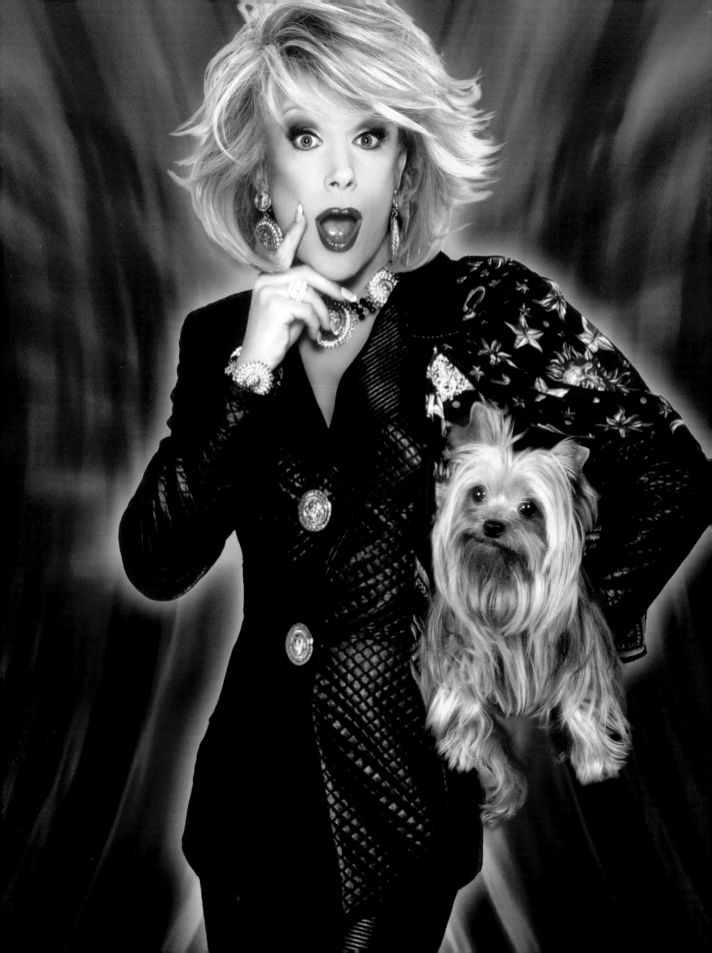

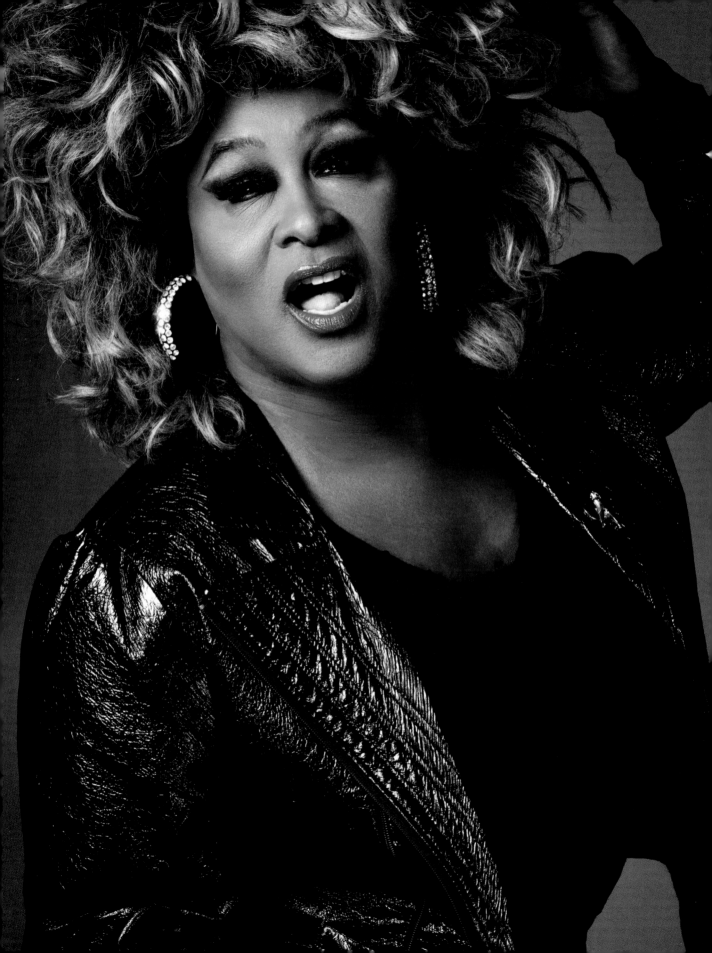

LARRY EDWARDS AS

Tina Turner

"When your mother gives you a standing ovation, you have really accomplished something."

—Larry Edwards

Growing up in Fort Myers, Florida, *Divas Las Vegas* star Larry Edwards heard the music of Tina Turner and did what so many other boys have done—he put on his mother's heels and danced his heart out. When he saw Turner sing on the *Cher* show on TV in 1975, he became her number-one fan. "Tina's energy and stage presence just won me over," he says

In the years since, no one has come to embody the iconic singer of "Proud Mary," "Acid Queen," and "We Don't Need Another Hero" better than he does. He is, in Turner parlance, simply the best.

Since he first took to the stage as Turner at Sweet Gum Head, a fondly remembered Atlanta nightclub that billed itself as "The Original Showplace of the South," Edwards has impersonated the high-octane diva from Nutbush, Tennessee, on stage, on television, and in several big-budget movies.

His first show as Turner, Edwards remembers, wasn't an easy one, even though he had competed in drag pageants—with his mother in the audience, no less. "I was so nervous trying to portray such an energetic, stunning woman with such gorgeous legs," he says. "What a surprise, the crowd really loved my performance." This early triumph was well before the soul singer's comeback in 1984 with *Private Dancer*. As her solo career grew, so did his.

Known in drag circles as "Hot Chocolate"—a name given to him by his drag mother, the female impersonator Roxanne Russell (Logan Carter), whom he'd first seen performing in Tampa—Edwards auditioned and found work impersonating Turner in Los Angeles in the *La Cage* show.

When he was tapped to perform in Las Vegas, Edwards was off and running in high heels, and there was no river deep or mountain high enough to stop him. He performed for more than a dozen years as a star of *An Evening at La Cage* at the Riviera, and appeared on such television shows as *Sally Jesse Raphael*, *Entertainment Tonight*, and *Donahue*. After the long-running *La Cage* show closed, Edwards resurfaced in *Divas Las Vegas*.

"If you can make it in Vegas, you can make it anywhere," he says. Even on the big screen. Edwards appeared as a Turner impersonator in an uncredited role in the 1993 biopic *What's Love Got to Do with It* and, again, in the 2005 comedy *Miss Congeniality 2: Armed and Fabulous*.

The highlight of Edwards's career, though, he says, was meeting the actual Tina Turner after appearing as her on *The Oprah Winfrey Show*. During a layover at Chicago's O'Hare airport, he showed her photographs of his tribute performances. "She thanked me for portraying her with class," he says.

Edwards was truly one proud Mary.

OPPOSITE: *Simply the best Tina Turner impersonator, Larry "Hot Chocolate" Edwards.*

Liza Minnelli

"By hiding myself behind her fabulous makeup and wardrobe, I am free to be my most dynamic showbiz self."

—Rick Skye

Rick Skye's fascination with Liza Minnelli began much the same way Liza Minnelli herself began—with Judy Garland.

He grew up watching *The Wizard of Oz* every year on television, then discovered Garland's other movies. "There was something about the depth of her emotions that I related to," he says. "Her feeling not quite as beautiful as she might, but trying to get by with hard work, good will, and a special talent." He was hooked on Garland . . . and then he saw *Cabaret*. "The star had the same nervous energy, sense of humor, and same basic magical thing that my idol had."

Skye went from being smitten with Judy to being obsessed with Liza.

"I followed her every moment," he says, monitoring Minnelli's moves from film to Broadway to concert stage. And then there was that fateful day when he first laid eyes on Liza up close in 1974, outside the Winter Garden Theatre before a performance to which a young Skye had begged his parents to buy tickets.

"A blue Lincoln Continental pulled up and a chauffeur got out with two Pomeranians," Skye recalls. "He opened the passenger door and out came Liza in a rust-colored fur coat over black pants and a turtleneck. I approached her with a photo of her to sign and I dropped it. As she bent over to pick it up, she said, 'My god, who *is* this woman? She's gorgeous!'"

That's the Liza that Skye has mimicked ever since.

If Skye is not exactly Minnelli's physical double— "As her look has changed, fortunately, she looks more like me," he says—he is able to conjure up her essence onstage. "It has gotten so deeply ingrained that I can take the character anywhere onstage. The audience fills in the details that I cannot control and believes everything I say and do are things that Liza might say or do."

Skye does other vocal impressions—Garland, Tallulah Bankhead, Elaine Stritch, Patricia Neal, and others—a talent he has featured on a web series called *Celebritease*. As a ventriloquist, he performed for a while as Madame, the bejeweled puppet comedienne of "Wayland Flowers and Madame" fame. But it is his Liza impersonation that remains his most-requested gig.

He played a Liza-esque character named Slice O'Minnelli in the 2009 film *The Big Gay Musical*, and continues to perform to sold-out crowds, sometimes in concert with Judy Garland impersonator Tommy Femia. "Bring a safety harness: you'll fall out of your seat with laughter at the hijinks," one critic noted.

Skye's greatest stage moment as Liza Minnelli came while he was appearing in London. "They kept telling me that the British audience would be cool and polite. When I finished 'New York, New York,' I went back to my dressing room. There was a frantic knock at the door and the stage manager said, 'Can you come back to the stage please, no one will leave.' The audience was standing and cheering. That would never have happened if I had been just singing as myself."

OPPOSITE: *Rick Skye rings them bells as Liza Minnelli.*

Britney Spears

"I like messing with people's minds. To me, that's drag."

—Derrick Barry

He has impersonated Amy Winehouse and Lady Gaga and played five-octave diva Mariah Carey on *Watch What Happens Live*. But it is as Britney Spears—and a contestant on both *America's Got Talent* and *RuPaul's Drag Race*—that Derrick Barry has made his mark.

Originally from Modesto, California, Barry was only fifteen when he first saw the singer's "Hit Me Baby One More Time" video. "I was eating my breakfast and I was completely hooked. I had never seen a pop star like that."

Then he looked in the mirror . . . and realized maybe he had. "My best friend in high school told me I looked like her. I thought I did too, but no one else saw it, so we thought we were just crazy Britney fans," he says.

But after testing the waters in West Hollywood in 2003, and then meeting Spears herself at a TV taping, Barry landed jobs impersonating the singer and worked his way to Las Vegas. He impersonated Spears in the now-defunct *La Cage* show and then, oops, he did it again in *Divas Las Vegas*.

What was it like that first time dressing as Britney?

We walked to Santa Monica Boulevard for the Halloween parade. I went into a restaurant to use the restroom. I was in a little khaki skirt and a green "I'm a Slave 4 U" bra. My whole midriff was out. I had no business being in a fancy restaurant, but I just started singing Britney's "(You Drive Me) Crazy." I don't know what I was thinking, but I felt like a superhero so it didn't matter. Everyone got up and applauded. I was like, oh my god, I could do this for a living!

It didn't take too long for you to meet the actual Britney . . .

It was only two and a half weeks later. Britney was the musical guest on *The Tonight Show*. She was being interviewed and someone onstage pointed at me and her mouth dropped. She did the famous Britney smile. That's when I knew I didn't want to do anything else.

What's the key to doing Britney right?

The most important thing is to just believe in the sexuality that she represents. When she's onstage, she doesn't care what anyone thinks. You really need to have that to pull it off.

How do you deal with Drag Race fans who dismiss celebrity impersonators?

There are people who didn't think I belonged there, but I'll never feed into that negativity. I wasn't competing with anyone but Britney and that's a pretty good person to compete with. Besides, there aren't a lot of Britney impersonators. It's not like Cher or Madonna or Liza or Barbra Streisand. It's kind of either me or Britney, and if you can't get her, I'm available for a fraction of the price.

OPPOSITE: Derrick Barry as Britney Spears.

Barbra Streisand

"The nails go on last…"

—Steven Brinberg

When Barbra Streisand could not attend the birthday party of her friend, the fashion designer Donna Karan, she sent the next best thing, Steven Brinberg.

"She even offered me direction over the phone!" says the acclaimed New York–based Barbra impersonator. Not that Brinberg needed much. He has been performing as Streisand in his cabaret show *Simply Barbra* for more than two decades, and no one does her better.

As the *Times* of London once wrote, Brinberg "inhabits the role with eerie authority" and he "catches all the tics and mannerisms."

Maybe not enough to fool Donna Karan, but close enough.

Brinberg has toured the world as Streisand, won MAC and Bistro awards, played Carnegie Hall and the Library of Congress, and appeared on Broadway in a concert version of *Funny Girl*, which originally starred you-know-who.

When you can't have Barbra, you call Brinberg.

How did Streisand enter your life?
I was about fourteen when I started collecting all her old albums. I would buy one each week at Alexander's department store on Fordham Road in the Bronx. Prior to that, I have a memory of watching her on TV with my aunt and her mother-in-law, who commented that Barbra had big bosoms.

Other than her big bosoms, what fascinated you about Barbra?
The voice is always what makes her stand apart from all the other great entertainers. I adore Liza and Judy and Bette and Lena Horne, Eydie Gorme and all the greats, but just hearing Barbra hum a few notes is pretty magical.

How did you get started doing her?
In high school I put my voice down on tape, and my dad found it and thought it was Barbra. When I realized I could fool people, I figured it was worth pursuing, though it was still a while before I ever got dressed up and did it.

What was it like when you finally did get dressed up and do it?
It was scary at first. I had never done drag and I knew little about makeup. This was the early 1990s. I started my first run of shows just weeks before Barbra's comeback tour. I knew, even with someone doing my hair and makeup, I'd never be a big look-alike. But I also knew the sound and the gestures would compensate. To me, it has to be as understated as possible. No crossed eyes.

What was your finest hour onstage as Barbra?
Getting to tour the United States for a decade with Marvin Hamlisch was pretty exciting . . . singing with Audra McDonald and Jonathan Groff . . . and performing at events for Joan Rivers, Catherine Zeta-Jones, and Stephen Sondheim. The original Sally Bowles, Jill Haworth, came to my show as did the movie Sally, Liza Minnelli.

What's your ultimate dream for playing Barbra?
To sing for her and to sing with her! When I first met Marvin, his idea was to have her say something like, "You know, I'm so busy, sometimes I wish there were two of me."

OPPOSITE: *The ultimate Barbra impersonator, Steven Brinberg, just humming along.*

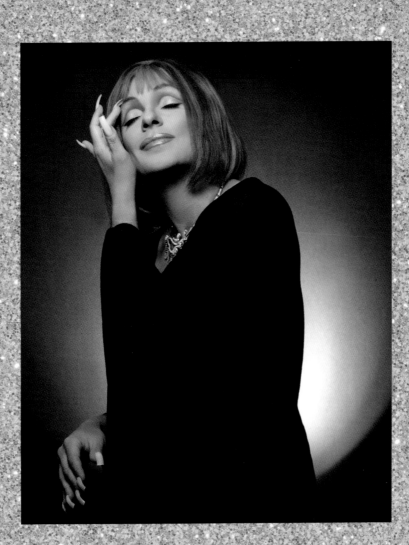

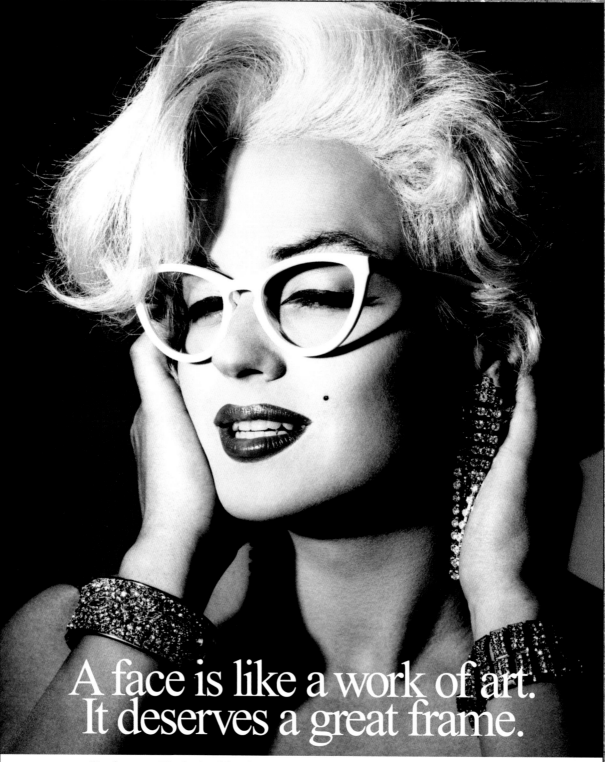

A face is like a work of art.
It deserves a great frame.

Designers of limited edition frames for sunglasses and prescription eyewear

l.a.Eyeworks®

Face: Jimmy James. Frame: Cornu.
Photographer: Greg Gorman. ©1991, l.a.Eyeworks. www.laeyeworks.com

Marilyn Monroe

♛

"All good queens are born on Halloween."

—Jimmy James

His repertoire of celebrity voices is as expansive as his impressions are uncanny. Award-winning singer-actor-impersonator Jimmy James can channel everyone from Cher to Adele, Eartha Kitt to Lana Del Rey. And no Christmas is complete without listening to his Bette Davis perform "Feliz Navidad."

"Oh god, is there no end to this song?" she breathlessly asks.

It's his spot-on impersonation of Marilyn Monroe, though, that takes the birthday cake, Mr. President. At the height of his "Marilyn period," James performed as the legendary actress on talk shows—Phil Donahue practically needed saltpeter to calm himself—and modeled as Monroe in national ads, most notably for l.a. Eyeworks.

These days, James is better known perhaps as the singer of the international club hit "Fashionista," an irresistible dance track from 2006 with a rallying cry of "No one ugly allowed!" The original song spawned a walk-in closetful of fan-made videos that continue to rack up millions of YouTube views.

While he rarely dresses as Marilyn anymore, James still knows how to "show a look, have a look, or give a look" with the best of them.

When and how did Marilyn enter your life?

I was living in San Antonio, Texas. In high school and college, I studied theatrical makeup. One day around 1980, I was in the mall and walked into a bookstore and cracked open *Life Goes to the Movies*. There was a photo of Marilyn Monroe in a white, draped, off-the-shoulder dress. I knew immediately that her face had a similar structure to mine. Something came over me. I had a premonition. I spent several years doing many, many makeup tests, locked in the bathroom while the rest of my family was asleep.

What led you to become an impersonator?

I was teased for looking like a girl and sounding like a girl. I was called a sissy. On top of that, I was chubby. Oh, and did I mention I was living in Texas? I wanted to escape. Being an impersonator was perfect for me. I could leave that fat sissy behind and become somebody else!

When did you first impersonate Marilyn?

It was Halloween 1981 at the Sunset Boulevard dance club in San Antonio. I entered a costume contest hosted by the legendary trans entertainer Jahna Steele. The contest was judged by audience applause. I was competing against a Divine impersonator and it was very hard to call. I had only waved like Marilyn and blew kisses. So I asked Jahna for the microphone and I started to sing "Happy Halloween" in that "Happy Birthday" way. The crowd went ballistic!

Would you call your Marilyn your greatest achievement?

She's probably my *Mona Lisa*. I've done a lot of character acting but nothing compares to the visual power of Marilyn Monroe.

Is there anyone you've ever tried to impersonate but couldn't?

Joni Mitchell. I'm a big fan but I can't capture her tone. And if I could impersonate Aretha Franklin, I wouldn't even be talking to you!

OPPOSITE: Jimmy James as Marilyn Monroe.

Joni Mitchell

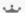

*"My work isn't parody, or about tricks or sleight of hand.
But for the purpose of clarity, I'm happy to use the term 'drag.'"*

—John Kelly

The moment John Kelly opened his mouth and something eerily evocative of Joni Mitchell's voice came out, he became a downtown New York legend.

Since that day in the early 1980s, he has shown audiences how drag and performance art can be fused into something beautiful. One critic called it "transformation through spiritual osmosis" and if that sounds too highbrow for drag, too bad. "I've been able to shape my love of Joni's music into a show that bounces between being a bit absurd and a moving tribute," he says.

New Yorker writer Ariel Levy once wrote, "Though his physical and vocal likeness to Mitchell is hardly uncanny, the intensity of his portrayal achieves a spooky depth." In that 2009 profile, she noted that when the Canadian singer-songwriter first came to see Kelly perform as her, she expected a "lampooning" but instead ended up feeling like "Huck Finn attending his own funeral."

Talk about "Both Sides Now"!

A painter, opera singer, ballet dancer, and about five other things from tightrope walker to fashion illustrator, Kelly calls himself an "aesthetic octopus." He has toured with Natalie Merchant, and played Carnegie Hall as his character Dagmar Onassis, the imaginary love child of Maria Callas and Aristotle Onassis.

"When I first started doing drag, it was the most fucked-up thing I could think of," Kelly said in that *New Yorker* piece. "It was punk." Yet it's when he is channeling the anything-but-punk Joni Mitchell that Kelly soars.

How did you discover Joni Mitchell's music?

Joni Mitchell's music first entered my life through LPs that my two older sisters brought into our home in New Jersey. It was my first exposure to that kind of poetry, lyricism, bizarre and lush guitar sounds, and her singular voice displaying an interior life full of longing, wanderlust, and melancholy.

What led you to do a drag version of her?

I performed at the Pyramid Club the night it opened. That was my family and my home. A few years later, when Lady Bunny and the others told me they wanted to organize a Wigstock Festival in Tompkins Square Park, I knew right away that I had to sing Joni's song "Woodstock" as "Wigstock."

How did that lead you to do full shows as Joni Mitchell?

After the success of the initial Wigstock appearance, we kept adding songs and eventually played hour-long versions of the show at the Pyramid Club, the Cat Club, Siberia, the Brooklyn Bridge Anchorage, and in galleries.

What was your finest moment on stage as Joni?

My finest moment may also have been my most frightening. It was the first time I performed the show for Joni herself. Just getting through those two hours was an accomplishment. She was sitting in a banquette in the dark, and it felt like a tribunal, or like I was sculpting for Michelangelo. After the show, I was backstage and she walked up to me and gave me a really long hug. It was a wild night.

OPPOSITE: John Kelly as Joni Mitchell.

Cher, Bette Midler, and . . . Randy

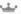

"I wanted to be the next Jerry Orbach, but I looked better as Cyd Charisse!"

—Randy Roberts

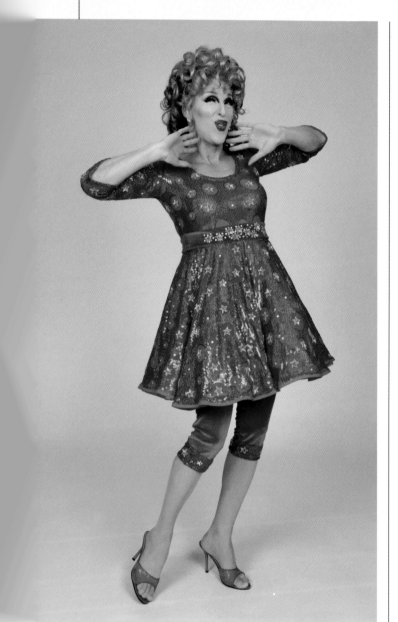

His roster of impersonations runs the *glam*-ut from Judy Garland to Lady Gaga. He has can-we-talked like Joan Rivers, tapped his tush off as Ann Miller, and even gone nose-to-nose-job with the real Phyllis Diller on daytime TV. He has channeled Carol Channing, raised a wire hanger as Joan Crawford, and bettered his Bette Midler until he could fool anyone but Bruce Vilanch.

But with all these fabulous women in his repertoire—not to mention his own female alter ego—Randy Roberts is best known for his Cher. Although there are plenty of other "Gypsies, Tramps and Thieves" in the business—*RuPaul's Drag Race: All-Stars* winner Chad Michaels chief among them—Roberts may well be the most appealing "Dark Lady" this side of the "Half Breed" singer herself. Yet she has never seen him live . . . and neither has Bette.

Can you "Believe"?

What led you to become a female impersonator?

The first time I did drag was in high school. We had planned to go see *The Rocky Horror Picture Show*. We all brought costumes. I raided the wardrobe department and went in drag. A few years later, I entered a pageant at a gay bar. I decided to sing live, for the talent competition. I looked like Roseanne Roseannadanna and sang "Stormy Weather"—in the wrong key. It wasn't pretty, but luckily things got better.

ABOVE: Roberts as the Divine Miss M, Bette Midler. OPPOSITE: Randy Roberts as Cher.

When did you become good enough to go pro?

I was in Florida working on a cruise ship as a singing waiter. I went to see a production called *The Foam Rubber Follies* at the Newport Beachside Hotel. It was a lip-synch look-alike show. I watched and thought, "I can do that!" I asked if I could audition and they hired me. That was the beginning of my professional drag career and it's been my main career since 1985!

Who has been the hardest to perfect?

Bette! The humor and the mannerisms were easy, but her voice was a bitch to get right! I've only been doing her for ten years or so. I put her in my show in Key West. It worked, so I kept it. I've loved the Divine Miss M since my sister gave me her first album on vinyl. I wore that record out. Once I saw her live, I was even more hooked. There really is no one else like her in concert.

When did you first start doing Cher?

The first time I did Cher was in *Boy-lesque* with Kenny Kerr in Las Vegas. We had moved from the Sahara to the Stardust. Kenny did two looks as Cher. While he went offstage to change looks, I appeared behind a scrim as Cher. No one could see my face, which was a good thing. I still had full Ann Miller makeup on! Blue eye shadow for days! One day I was bored in my dressing room and started playing with the makeup. All of sudden, there was Cher. When I left *Boy-lesque*, I was hired for a show in Madrid. That's where my Cher came together. I performed in an old castle. There were over three thousand people focused on "La Cher." I was really big in Spain!

What was your finest hour on stage portraying Cher?

My favorite Cher moment was on *America's Got Talent* and it never aired! They edited the whole thing out. But to have Howard Stern tell me I was like Jim Bailey with my Cher—that was great. I've also gotten to perform as Cher with symphonies. There's nothing like singing "The Way of Love" with a full orchestra!

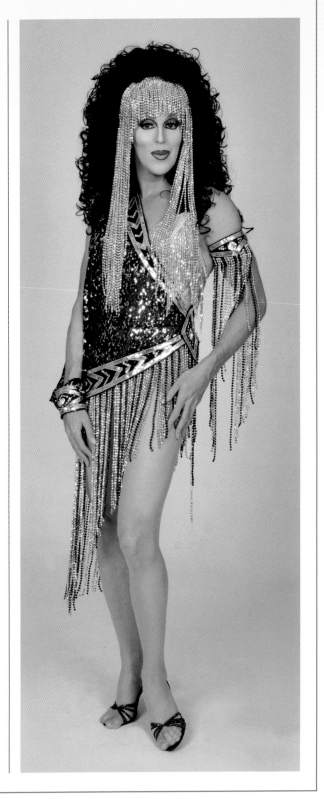

Judy Garland

"When people hear how long I've been doing Judy, they say you've been singing 'Over the Rainbow' longer than she did."

—Tommy Femia

There are other Judy Garland impersonators—Peter Mac, for instance, is so good that Mickey Rooney called him "phenomenal"—but few nail the iconic singer's exquisite pain and wicked humor quite like New York's Tommy Femia.

"There is no one in this town, and perhaps on the planet, who can re-create the energy, the charisma, the wildness, the spontaneity of the Garland persona as well as Mr. Femia," a New York critic once wrote, and Femia has the MAC awards to prove it.

Since the early 1990s, the Brooklyn native has performed as the Grand Rapids, Minnesota, native in nightspots from Don't Tell Mama in Manhattan to the old Cinegrill in Hollywood, on television, and even Off-Broadway in the revue *Howard Crabtree's Whoop-De-Doo!*

New York's *Daily News* summed it up best: "If you think all Judy Garland impersonators are a drag, you haven't seen Tommy Femia. He'll mesmerize you whether you're Garland's most ardent admirer or the fan that got away."

What led you to become a Judy Garland impersonator?

I've loved her all my life, but I never wanted to be an impersonator. At parties in the 1970s, friends would say, "Oh Tommy, do Judy!" I'd be so afraid to sing in the middle of someone's living room, I would go into the kitchen and sing through the doorway with nobody looking at me. I never thought of doing Judy on a stage. You would have had to put a gun to my head. To me, it was faggy, clichéd. But let me tell you, it's not. She's hard work.

What finally made you decide to do it?

I did it on a dare back in '91. Hal Simons, a friend of mine from high school had been nagging me. He did Ann Miller. So after ten years, I said, "Let's write something. We'll do two Tuesdays at eight. Who's going to come?" But the goddamned thing took off. I couldn't get arrested as a boy singer. I do Judy and all of a sudden every critic in town doesn't have a conflict.

Did you ever meet Garland?

I wanted to go see her when she opened up the Felt Forum at Madison Square Garden, but my parents said, "Next time she's in New York." The next time she was in New York, she was in a pine box! I remember I wanted to go to her wake. I was the only kid in grade school with a black armband. But I never did get to see Judy, dead or alive.

Those who've seen you feel like they've seen her alive . . .

There was an elderly woman one time who was visiting from Hong Kong with her daughter. When the show was over, she said, "Judy Garland looks so good. I thought she'd be so old." My accompanist said, "Don't you know she's dead?" She screamed, "Nooooooooo!" And then he told her, "By the way, that's a guy doing Judy." She was like, "No, no!"

Will you always be a Judy Garland impersonator?

When I get sick of her, I'll stop. But it's still rewarding. You can't do a person more over the top than Garland. Well, next to Minnelli. Besides, somebody has got to keep her alive the right way. There aren't many of us left!

OPPOSITE: Tommy Femia as Judy Garland.

Miss Peggy Lee

"For years I've wanted to lose the gowns and just perform as me, but this old lady keeps turning up like a bad penny."

—Chuck Sweeney

Flight attendant by day, chanteuse by night. Is that all there is to Chuck Sweeney? Not by a frequent-flyer mile!

A much lauded cabaret performer with two MAC awards and a Bistro Award for Outstanding Impersonation in his carry-on luggage, Sweeney is the best Peggy Lee impersonator in the business, even if his take on the iconic singer is, well, deranged.

Audiences from New York City to Provincetown to the Montreal Just for Laughs comedy festival have adored him. "Tantalizing," one critic called his show. "Oh-so-fabulous," said another. A third landed it perfectly: "His channeling of Peggy Lee is one of the most brilliant acts of female impersonation you're likely to see," he wrote.

"She was funny, she was camp, and she knew it. She was in on the joke," Sweeney says. Those who knew Lee have told him that she would have loved his act.

His singing would have given her fever, baby.

When did you first see Peggy Lee perform live?

I first saw Peggy Lee in person at the Ballroom in New York City in 1988. At the top of the show when she was introduced and one of her musicians walked her out onstage, I remember thinking, "That's not Peggy Lee, that's Jim Bailey." I still had visions in my head of Peggy on TV with long blonde hair, and flowing gowns. This version of Peggy with the white Cleopatra wig and rhinestone glasses seemed so far removed from that memory, it was jarring. But when she started singing there was no denying who she was.

What fascinated you most about her that night?

The fact that she just sat there and did her thing. No dancing, no big movements—it was all happening in her eyes and vocal delivery. She did the entire show in a chair, but you got so caught up in the music, the magic, the camp, you forgot about that. She had a devilish smirk and side-eye thing too. She was so loopy, at one point in the show she was introducing the band and couldn't remember the name of her percussionist.

Did you know right then that you wanted to become a Peggy Lee impersonator?

That night I consciously made the decision that she was going in my show. I was doing my first solo show in Provincetown at the Pilgrim House that summer. Prior to that I was working with Frank Massey—he was a veteran of the *Jewel Box Revue*—and appearing as Judy Garland, Tina Turner, Phyllis Diller, Dr. Ruth, and other characters. But Peggy was so funny and out-there that night that there was no way I could not put her in my show.

What is the key to doing an outstanding Peggy Lee impersonation?

I only know that I have to infuse her with my own silliness and comedy so it's fun for me. That's why, as Peggy, I do songs she never sang and physical comedy she would never do. My version is layers of absurdity and patter that take her to a different level. When I first did her in shows at Don't Tell Mama, I would say to Ron Poole, "Are you sure your audiences will like this?" His response was, "You're like a giant crazy Muppet with those feathers and glasses! They'll love you!"

OPPOSITE: Chuck Sweeney as Miss Peggy Lee.

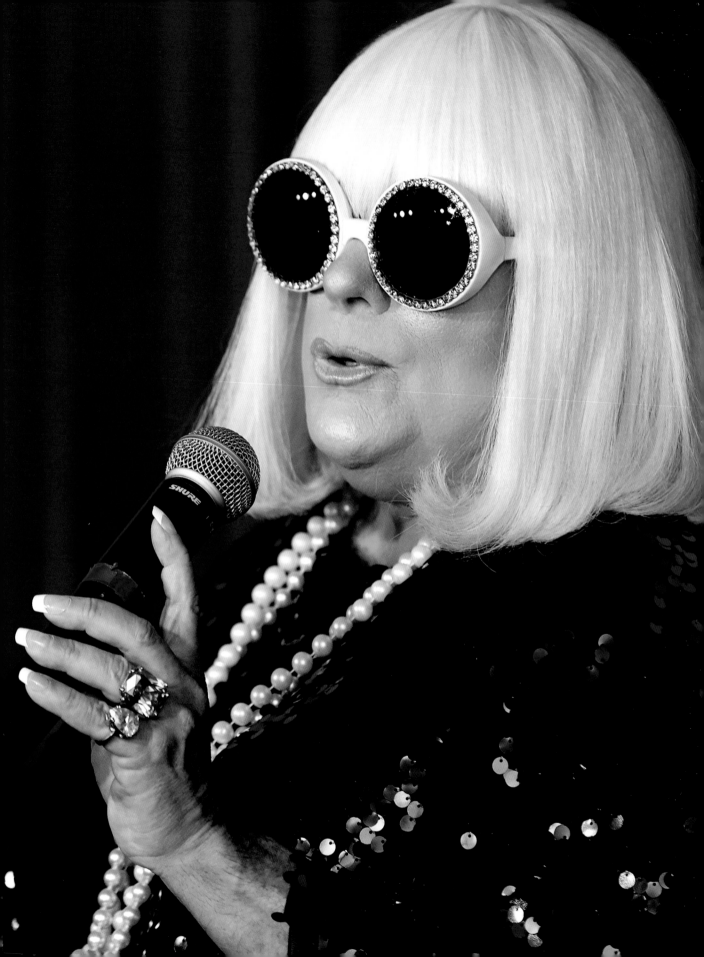

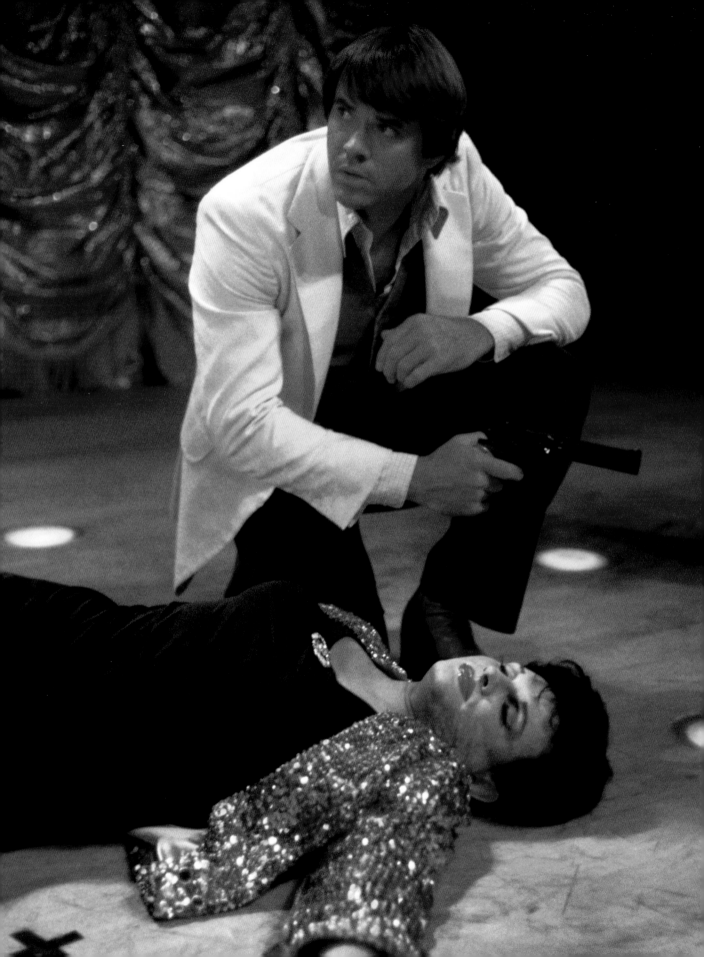

Jim Bailey

"The reason I was accepted by average everyday people is the fact that I did it with artistry. I did it without making fun of whom I was doing."

—Jim Bailey

★ ★

He was a man in a dress—Phyllis Diller's, Barbra Streisand's, Judy Garland's—but no one ever called Jim Bailey a drag queen and got away with it. He was, by his own description, a "gender illusionist" or more simply a "character actor" whose characters just happened to be female.

Conjuring up amazing women on the world's greatest stages, Bailey played Carnegie Hall, the Dorothy Chandler Pavilion, and the London Palladium time and again. He performed before American presidents and members of the British royal family.

He was so convincing that the *Boston Globe* once wrote, "If he were to appear at Madison Square Garden instead of Barbra, who could possibly tell the difference?" The man sang *for* Barbra Streisand as Barbra Streisand, and, in 1973, did duets with Liza Minnelli while dressed as her mother at the Flamingo Hotel in Las Vegas. Bailey once was misidentified as Phyllis Diller in a *New York Times* photo caption!

If that doesn't make him the truest person ever to wear falsies, what does?

Growing up near Philadelphia, Bailey, at age eleven, won a school talent contest singing a Garland-esque rendition of "You Made Me Love You." After studying classical piano and operatic voice, he did summer stock and put together a nightclub act. "I wasn't doing badly, but I needed that gimmick, something to make me different, unique," he told the *Philadelphia Inquirer* in 1995.

The plan worked better than he could have imagined.

In women's clothes, Bailey became a frequent presence on variety, talk, and comedy programs on television, from *The Ed Sullivan Show* to *The Carol Burnett Show* to *Here's Lucy*. He even appeared *en travestie* on TV celebrations of the Olympics and the Super Bowl, and even took a stab at crime drama. Bailey brought his Peggy Lee to a two-part 1976 episode of the light-hearted detective series *Switch* opposite Eddie Albert and Robert Wagner, and his Judy Garland to an installment of the Robert Urich crime drama *VEGA$* in 1980. In that role, he had a split personality.

OPPOSITE: Jim Bailey as Judy Garland on the TV crime drama, VEGA$, in 1980.

More sympathetic was Bailey's turn as a college buddy of prosecutor Dan Fielding (John Larroquette) on the sitcom *Night Court* in 1985. It was one of the first sensitive portrayals of a transgender character on a sitcom.

Bailey wasn't shy about what he managed to accomplish.

"From the first minute on stage when I am Barbra Streisand, I look like her, talk like her, I have her mannerisms and sing like her. I am Barbra, not an imitation," he once said. "When I made my Las Vegas debut in 1970, I opened doors for all the guys who came to town in dresses." Critics agreed. As one British columnist wrote in 2009, "It's a supreme illusion, a sort of perfect madness."

Bailey liked to think that Minnelli put it best. "I mentioned to Liza once that maybe it was time for me to do something else with my life. Maybe I should forget about the ladies and start appearing as Jim Bailey.

Liza said to me, 'If you do that, how would I ever see my mother again?'"

When Bailey died at age seventy-seven in 2015, Qweerty.com said that Bailey had "helped introduce American television audiences to drag." He would have hated that phrase, even though it's true. "I've been explaining for 27 years that I don't do drag," Bailey told *The Advocate* in 1997. "I don't want to be remembered as one of those guys who wore a dress and pretended to be female. I want to be remembered for the uniqueness of the art form I created."

When he died, Lucie Arnaz, who had dated Bailey in her early twenties, tweeted: "He was a uniquely talented, hilariously funny, tortured man who played an important role in my growing up. May his soul finally be at peace."

Bailey's own website imagined a more active time for him in the Great Beyond. "Heaven is getting a fabulous show tonight with standing room only!" it read. Garland, Diller, and Lee surely had ringside seats.

ABOVE: *Jim Bailey as Barbra Streisand on the 1980* VEGA$ *episode "The Man Who Was Twice."*

Randy Allen

{ 1957–1995 }

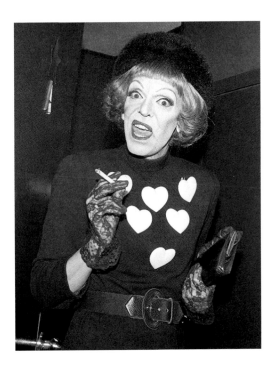

Performance artist Randy Allen could impersonate Judy Garland, Liza Minnelli, and Marilyn Monroe, but it was his Bette Davis—particularly his post-stroke version of the actress—for which he'll always be remembered.

An Indiana native who'd studied at the London Academy of Music and Dramatic Arts and earned a master's degree in directing at the University of Southern California, Allen toured the United States conjuring up the indomitable actress in his acclaimed one-person show *P.S. Bette Davis* in the early 1990s.

Critics hailed him—"a remarkably adept and talented female impersonator," one wrote—as a performer who could not only have audiences in stitches but bring them to tears. Joan Rivers was clearly impressed when she featured Allen on her afternoon talk show in 1991. "A part in a movie?" he told a delighted Rivers, "Joan Crawford would sleep with somebody to get a part in her *hair*!"

In November 1994, days before opening Off-Broadway in Elizabeth Fuller's two-person Davis-centric comedy *Me and Jezebel*, Allen collapsed. By the following spring, he was dead at age thirty-eight, another casualty of the AIDS crisis.

Upon his passing, Sally Jesse Raphael paid tribute to him on her show, and *Theater Week* magazine wrote, "If there's a legend heaven, Randy's up there with the rest of them." Allen as Davis would, no doubt, have said, "What a dump!"

ABOVE: Pre-stroke or post-, few have done a better Bette Davis than Randy Allen.

BIG WIG

Craig Russell

★ ★

As a teenager in Canada, Craig Russell founded an international Mae West fan club. Before he was twenty, he had taken a bus to Hollywood, met his oversexed idol, and gotten a job as her secretary. Then he left to impersonate her in drag clubs from Toronto to Las Vegas. Hey, that's one way to do your boss!

West was only the beginning for Russell. He went on to adroitly mimic a roster of iconic women including Tallulah Bankhead, Carol Channing, Sophie Tucker, Barbra Streisand, Bette Midler, and Judy Garland. He even squeezed a few oranges for comedy's sake as the anti-gay beauty pageant queen Anita Bryant.

Wherever he went—and Russell traveled the world impersonating these women—he managed to convince audiences they'd been in their presence, even if a bitter *New York Times* critic, Richard Eder, did once complain in 1977 that his Peggy Lee looked like "a bar of pink soap left too long in the bath water."

By the time of his death in 1990, Russell was ranked, as the *Los Angeles Times* put it, "with a select group of female impersonators who were considered illusionists rather than just men in drag." His short, glitter-dusted life ended at age forty-two of AIDS-related causes in a Toronto hospital. Although he identified as gay, Russell was survived by a wife and daughter.

Today, he is best remembered as the star of *Outrageous!*, a loosely autobiographical 1977 film comedy directed by Richard Benner that was one of the first gay-themed movies to get wide release in North America.

Playing a female-impersonating Toronto hairdresser, which Russell had been in real life, he charmed the critics. "The humor comes mostly from Russell, who throws in one-liners, asides, and exit lines, and is funny (and sometimes uncannily accurate) onstage in his impressions," Roger Ebert wrote upon the film's release in America.

The performance earned Russell the Silver Bear for Best Actor at the 28th Berlin International Film Festival in 1978. He also has the distinction of winning both Best Actor and Best Actress at the Virgin Island Film Festival for the role.

A sequel, starring Russell and featuring Jimmy James doing his Marilyn Monroe, was released in 1987. But *Too Outrageous!* never found its way into audiences' hearts the way the first film did.

There are stories of Russell becoming unhinged after he hit the big time. The Associated Press reported that a 1981 tour of western Canada was canceled after Russell, to use their words, "undressed onstage and threw wigs and jewelry at the audience." In hindsight, that sounds more compelling than offensive, but whatever. He reportedly was barred from a Vancouver talk show, as well.

Some may have thought of Craig Russell in his heyday as the Canadian Jim Bailey. Truly, he was the most famous female impersonator from north of the border. But there are fans who would argue that Jim Bailey was actually the American Craig Russell. It's a claim that really isn't too outrageous at all.

OPPOSITE: Canada's most Outrageous *female impersonator Craig Russell as Carol Channing.*

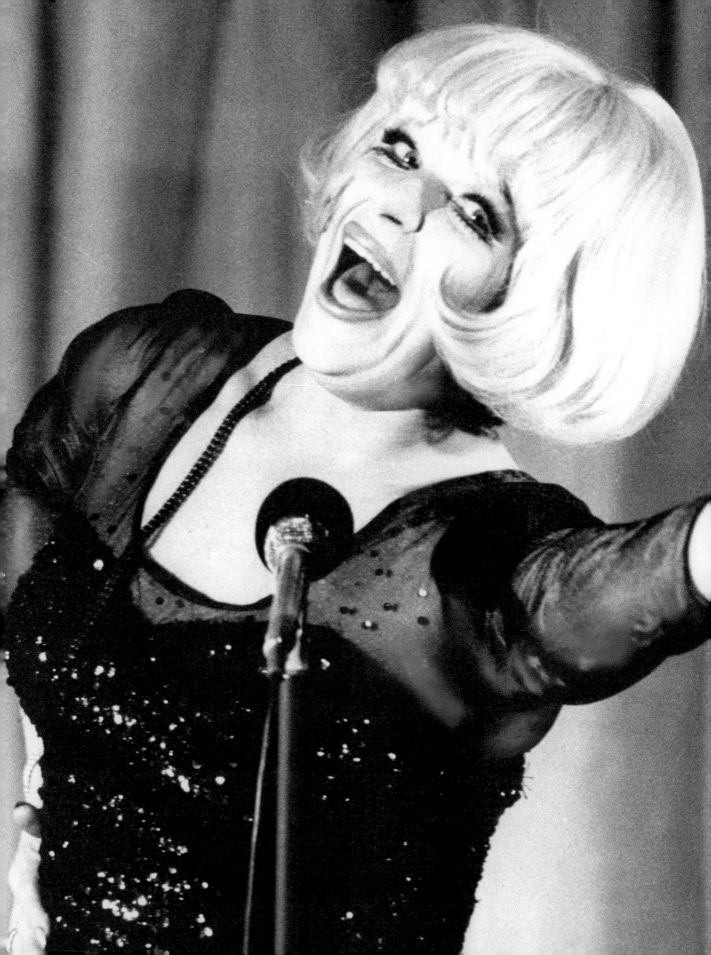

BROADS ON THE BOARDS

"So when my spirit starts to sag, I hustle out my highest drag, and put a little more mascara on..."
—La Cage Aux Folles

Hugh Jackman—an actor versatile enough to play both the Adamantium-clawed superhero Wolverine in the *X-Men* on-screen and the well-manicured showman Peter Allen in *The Boy from Oz* onstage—nailed it when, as the host of the 2014 Tony Awards, he said: "What a great season it has been on Broadway. It has just been incredibly diverse. Whether you like men dressed as women or drag queens, there's something for everyone, ladies and gentlemen."

He wasn't exaggerating. That watershed year, you couldn't twirl a feather boa without hitting an actor in a dress. Drag featured prominently in some of the season's most noteworthy and award-winning productions.

The deadly funny *A Gentleman's Guide to Love & Murder*, a musical version of the film *Kind Hearts and Coronets*, starring Jefferson Mays in roles both male and female, took home the Tony for Best Musical. Ten years earlier, Mays had won the Tony for blurring gender lines as the cross-dressing star of *I Am My Own Wife*, a performance that the critic Jonathan Mandell called "paradigm-shifting."

The puckish punk-rock musical *Hedwig and the Angry Inch* won Best Musical Revival and the 2014 Tony for Best Leading Actor in a Musical for star Neil Patrick Harris. His costar, Lena Hall, was named Best Featured Actress in a Musical for the drag king role of Hedwig's husband, Yitzhak.

Harvey Fierstein's *Casa Valentina*, a well-reviewed "straight" play about a vacation colony of cross-dressing heterosexual men, was nominated for four Tony Awards. Reed Birney, who was up for Best Featured Actor in a Play for the role of Charlotte, lost out to *another* cross-dressing actor, Mark Rylance, who played Olivia in an all-male production of *Twelfth Night*. Samuel Barnett, as Viola, and Paul Chahidi, as Maria, in that boys-only production, were nominated for Tonys, too.

Those celebrated shows joined the Tony Award–winning drag holdover from the year before, the glittering musical *Kinky Boots*, which won the Tony for Best Musical in 2013. The high-heeled heart-warmer, with music and lyrics by Cyndi Lauper and a book by Fierstein, starred Billy Porter as Lola, a drag queen with father issues and an amazing voice. He took home the 2013 Tony for Best Leading Actor in a Musical, beating Bertie Carvel, who cross-dressed to play the evil headmistress Miss Trunchbull in *Matilda*.

Even the most seen-it-all critics noticed that something was up.

"When Jackman made that joke, there were at least six shows on Broadway that involved drag, and three others that had closed a few months earlier, which is really quite a lot," says *Time Out New York* theater critic Adam Feldman.

In jest, Jackman was actually speaking the truth. Broadway was experiencing a new diversity, at least where drag was concerned. Yes, we'd seen a modern attitude toward drag in everything from *Angels in America* to *Rent*, but this was cross-dressing hitting critical mass in the legitimate theater.

"What's intriguing about all the current cross-dressing on Broadway is how various it is," Mandell wrote at the time. Even the witches of *Macbeth* in Jack O'Brien's 2013 production at the Vivian Beaumont were men: the actors Malcolm Gets, John Glover, and Byron Jennings.

What a radical change that was from the days when Mae West's infamous 1927 play *The Drag*—which she described as "a great evening's entertainment: dramatic, tragic, comic," in a 1970 *Look* magazine profile—was deemed too controversial for New York, and had to play New Jersey and Connecticut instead.

"Drag may have come out in the twenty-first century," says Feldman, "but it's not coming out of nowhere. There's a very long timeline."

Along that timeline, these shows are chief among the drag milestones:

OPPOSITE: A sign of the times. Harvey Fierstein as the lovable drag queen Arnold Beckoff in Torch Song Trilogy.

The Importance of Being Earnest

When Oscar Wilde's *The Importance of Being Earnest* premiered on Valentine's Day 1895 at London's St. James's Theatre, the role of Lady Augusta Bracknell was played by a woman, Rose Leclercq.

Over the years, some of the finest English-speaking actresses have played the Victorian dowager to end all Victorian dowagers, among them Edith Evans, Judi Dench, Hermione Gingold, and Maggie Smith. But some of the best English-speaking male actors have played the role as well. Geoffrey Rush and David Suchet have played Bracknell, as did the British eccentric, author, and gay rights pioneer Quentin Crisp. Few have done so to more acclaim, however, than Brian Bedford, who won a Drama Desk Award for his 2011 Broadway turn.

"In no sense of the word is his performance a drag," Kevin Sessums wrote for the *Daily Beast*. When Bedford's production opened on Broadway, *New York Times* theater critic Charles Isherwood gushed, "This magnificent gorgon . . . has perhaps never been more imperious, more indomitable—or more delectably entertaining—than in Mr. Bedford's brilliant portrayal."

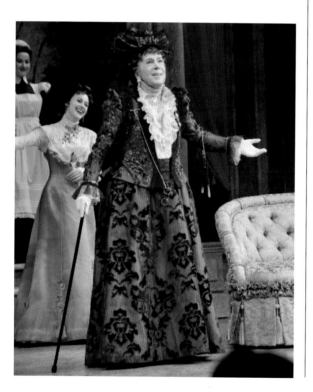

Charley's Aunt / Where's Charley?

The original production of *Charley's Aunt*—the Brandon Thomas farce in which a pair of undergrads, Jack and Charley, persuade their friend, Lord Fancourt Babberley, to impersonate a female relative visiting from Brazil—opened at the Theatre Royal in Bury St. Edmunds, Suffolk, England in 1892.

It soon transferred to London with actor W.S. Penley still in the dress he wore in Suffolk, and settled in for a run of nearly fifteen hundred performances. In 1893, a Broadway production began a long run as well. Its star, Etienne Girardot, stayed with it for three years. Audiences, then as now, couldn't get enough of the cross-dressing college clowning.

Over the years, the title role—so coveted by actors for its showy scenery-chewing physicality—has gone to actors as disparate as the comedian Frankie Howerd, the three-time Tony nominee Tom Courtenay, and movie star Roddy McDowall, not to mention Raul Julia, José Ferrer, and many a high school student.

Both Charlie Ruggles and Jack Benny—perhaps the actor most associated with the part—played Babbs in movie versions. Art Carney, in the 1950s, and Charles Grodin, in the 1980s, starred in TV special adaptations.

Charley's Aunt became the musical *Where's Charley?*—in which Charley does the cross-dressing—in 1948. With music and lyrics by Frank Loesser and a book by George Abbott, the hit Broadway show gave the world the song "Once in Love with Amy" and was a triumph for its star Ray Bolger, who'd played Judy Garland's brainless buddy, the scarecrow, in *The Wizard of Oz*.

"Mr. Bolger skips impishly through it like a rustic caricature with winged feet," the theater critic Brooks Atkinson wrote upon the show's Broadway opening. Bolger won the Tony and then, in a rarity for Hollywood, re-created the role in the 1952 film.

ABOVE: Brian Bedford as Lady Bracknell in the 2011 Broadway production of The Importance of Being Earnest.

Sugar

When *Sugar*—the Jule Styne / Bob Merrill / Peter Stone musical version of the Billy Wilder film *Some Like It Hot*—opened on Broadway in 1972, *New York Times* theater critic Clive Barnes liked everything about the production except the show itself. He called *Sugar* "largely lamentable" and said, "Rarely in show-business history has so much been done by so many for so little."

Yet he raved about the cast, especially Robert Morse, who played Jerry/Daphne. "If it had closed out of town," Barnes wrote, "New York would have been the poorer for not having the very positive treat of seeing Robert Morse playing Robert Morse in drag. While never offering a female impersonation—he is always clearly a man—his acting shows a sharp insight into feminine psychology, and his girlish delight at becoming betrothed is funny and also moving."

The show ran 505 performances at the Majestic Theatre before the producer, legendary impresario David Merrick, pulled the plug. Martin Gottfried, in his 1979 book *Broadway Musicals*, noted, "*Sugar* was that bewildering Seventies breed of failure, the one that runs a year on Broadway and is still not considered a success." Morse was nominated for a Tony Award and won the Drama Desk for his performance. He still considers it the most fun he ever had on Broadway.

A Chorus Line

No one dresses in drag in the classic backstage musical *A Chorus Line*—the dancers all wear their rehearsal clothes—but Paul's heart-wrenching monologue about his parents discovering him performing in the *Jewel Box Revue* at the Apollo in the early 1960s—dressed as an Anna May Wong–type character—is a seminal moment in the history of drag on Broadway.

Most of his fellow queens, the character remembers, "were ashamed of themselves and considered themselves freaks." But Paul, played originally on Broadway by Sammy Williams, had the dignity they may have lacked, and so did the writing of this 1975 musical. Its treatment of gay characters was frank and humane at a time when most portrayals were anything but.

Few could hear Paul's tearful confession of running into his mother and father at the drag show— "And just before my parents left, my father turned to the producer and said: 'Take care of my son.' That was the first time he ever called me that"—without becoming a puddle themselves. It was, as the *New York Times* critic Ben Brantley wrote upon the show's 2006 Broadway revival, "a monologue that brought shattered audiences to tears."

Williams, who died in 2018, won the Tony for Best Featured Actor in a Musical in 1976. James Kirkwood and Nicholas Dante, who cowrote the book, won a Tony and shared the Pulitzer Prize for Drama with director-choreographer Michael Bennett, composer Marvin Hamlisch, and lyricist Edward Kleban. All told, the show won nine Tonys. It was turned into a lamentable film that tried but just couldn't capture the singular sensation of the theatrical experience.

ABOVE: An 1895 souvenir calendar for Charley's Aunt *starring W.S. Penley at the Globe Theatre.*

Torch Song Trilogy

When *Torch Song Trilogy* opened at the Richard Allen Center on the Upper West Side in 1981, the *New York Times* critic Mel Gussow raved that it was a "double tour de force" for Harvey Fierstein, who not only wrote the hilarious, poignant play but also starred in it as the sentimental drag queen Arnold Beckoff.

The production also featured Matthew Broderick, five years before *Ferris Bueller's Day Off*, and a pre–*Golden Girls* Estelle Getty as Arnold's mother. Anyone who saw them in it—and a few who didn't—are still bragging that they did.

The most interesting thing in Gussow's glowing review, at least as far as drag is concerned, is that Arnold is described as a "professional 'drag queen,'" and those words are in quotes in the *Times*. In the early 1980s, being a drag queen wasn't considered a legitimate pursuit. Neither was being openly gay, on- or offstage, for a lot of people.

Audiences could handle the cross-dressing undergrad of *Where's Charley?* because he was always in love with Amy. The leads of *Sugar* wore women's clothes to hide from the mob. Who could fault them for that? The unseen drag queens of *A Chorus Line* hated themselves, so they were pitiable. But a drag queen who wanted to live and love and work just like anybody else? That was unheard of, crazy talk, a pipe dream in a girdle.

Then, thank heaven, came Fierstein, who has spent his entire life removing critics' quote marks and letting the world see that drag queens can be functional human beings capable of a full range of emotions. Buoyed by glorious reviews, *Torch Song* moved to Broadway's Little Theater in 1982 and earned Fierstein his first two Tony Awards, one for Best Actor and one for Best Play.

In 2017, when it was announced that Michael Urie—so good in *Ugly Betty* on television and in *Buyer & Cellar* onstage—would be starring in a revival of *Torch Song Trilogy* (shortened and renamed simply *Torch Song* by director Moisés Kaufman), the *Times* described the show matter-of-factly as a "Tony-winning play about love, family and drag performance."

There were no quotes around those last two words.

When it opened Off-Broadway, the paper called the production "stirring" and "vibrant." Reviews, in fact, were so good that the production transferred to Broadway in 2018.

ABOVE: Robert LuPone as the choreographer Zach and Sammy Williams as dancer and sometime drag queen Paul San Marco in the original Broadway production of A Chorus Line.

La Cage aux Folles

It came as no surprise that Fierstein, who was Broadway's most stirring and vibrant drag performer in 1982, was tapped to write the book for the musical version of *La Cage aux Folles*. Based on the top-grossing 1978 Franco-Italian comedy about a drag queen and her family, and the 1973 play of the same name, *La Cage* became the toast of New York in 1983. It nabbed Fierstein his third Tony.

With the legendarily flamboyant producer Allan Carr behind it and music and lyrics by Jerry Herman—the hit-maker who gave the world *Hello, Dolly!* and *Mame*—*La Cage Aux Folles* was groundbreaking because it was a drag-queen-in-love story rendered as deliciously sentimental as either of Herman's earlier, more mainstream hits.

In 1983, as hard as it may be to believe today, few in the audience had ever imagined a man could sing a love song to another man, let alone see him do it on a Broadway stage. But eight times a week, at the beginning of Act II, Gene Barry as Renato sang "Song on the Sand" to George Hearn, as his beloved drag queen "wife," Albin.

"It wasn't easy making a gay-themed show palatable to the bridge-and-tunnel crowd without turning them into caricatures," Ken Bloom and Frank Vlastnik wrote in their 2004 book *Broadway Musicals: The 101 Greatest Shows of All Time*. But, for as broad as it was, *La Cage* didn't diminish its leads.

Before intermission, Hearn had the crowd on its feet with "I Am What I Am," the ultimate drag empowerment anthem that invites audience members to "try to see things from a different angle." Bloom and Vlastnik say, "the reason the song truly brought the house down was the fully realized character behind all the bravado, a person driven to take a stand for himself—a notion that all people could relate to." Even people from Staten Island.

★ ★

"There are easier things in this life than being a drag queen. But I ain't got no choice. Try as I may, I just can't walk in flats."

—**Harvey Fierstein**, *Torch Song Trilogy*

Feldman of *Time Out New York* considers *La Cage* to be "the moment when the genre stepped out of its closet in the big sequined and spangled drag costume that many people had long suspected it of wearing in secret all along."

He adds that the show's "aesthetic conservatism may have been essential to its success." In other words, *La Cage* pushed the envelope but not too much. Anyone who liked Herman's other musicals could enjoy this one without becoming nauseated by the sight of two middle-aged men kissing as if they were—oh, God, no!—actual lovers.

In his review of *La Cage* in 1983, *New York Times* theater critic Frank Rich wrote, "*La Cage aux Folles* is the first Broadway musical ever to give center stage to a homosexual love affair, but don't go expecting an earthquake. The show at the Palace is the schmaltziest, most old-fashioned musical Broadway has seen since *Annie*, and it's likely to be just as popular with children of all ages."

Longtime theater critic Peter Filichia remembers how tame it was. "The original production had George Hearn's Albin and Gene Barry's Georges walk off arm in arm at the end of the show," he says. That the lovers *didn't* kiss at a moment when any straight couple would have felt like a cheat, at least to those gay men in the crowd. Rich had noted that *La Cage* sometimes felt "as synthetic and padded as the transvestites' cleavage." But perhaps the lack of a man-on-man kiss was a necessary omission. As Filichia notes, "The audiences of 1983 needed to be eased into a gay relationship."

The wait for that kiss ended when *La Cage* was revived in 2004. That production, directed by Broadway veteran Jerry Zaks and starring Daniel Davis and Gary Beach, won the Tony for Best Revival of a Musical in 2005. In 2010, the show returned to Broadway with Kelsey Grammer and Douglas Hodge in the leads, and, again, won the Best Revival statuette.

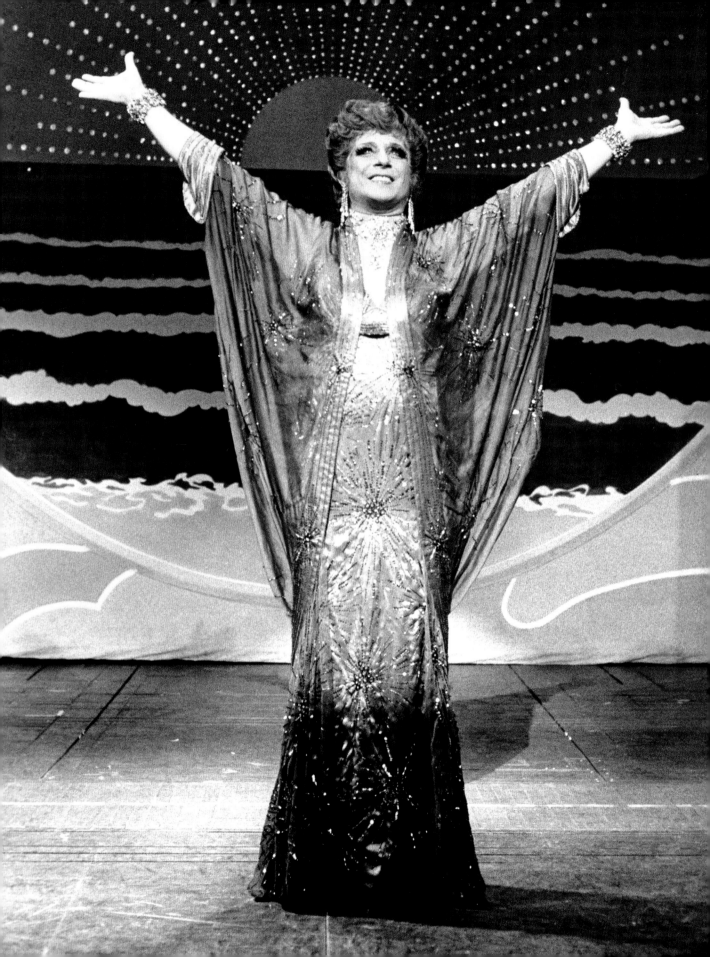

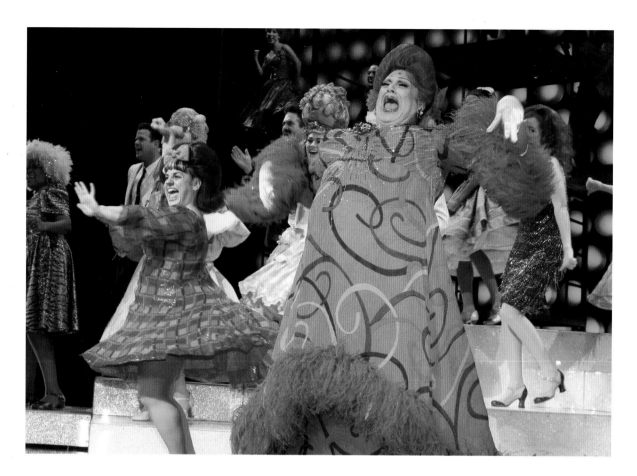

"In both Broadway revivals, more than two decades later, they kissed. The audiences applauded and roared in approval," Filichia remembers.

Late in its run, *La Cage* cast a pair of openly gay men, Christopher Sieber and Fierstein, as a pair of openly gay men, Georges and Albin. Sieber revealed that, at every performance, the two actors would play "What flavor is Harvey?"—a guessing game in which he would try to discern what type of candy the actor had sucked before making his final entrance.

Bad breath would have been a real drag.

Hairspray

Between his turn as a New York drag queen in *Torch Song Trilogy* in 1982, and his turn as a Saint-Tropez drag queen in the revival of *La Cage aux Folles* in 2010,

Harvey Fierstein did something very different on Broadway:

He played an actual woman . . . and won his fourth Tony for a performance that Ben Brantley of the *New York Times* called "captivatingly humane."

As Edna Turnblad, a Baltimore housewife with a curvaceous anti-segregation activist for a daughter, Fierstein stepped into the oversized pumps filled by Divine in the 1988 John Waters movie upon which *Hairspray* is based. One drag actor doing a part made famous by another drag actor made the whole undertaking completely meta. And, for once, the fat girl got the cutest guy.

The 2002 musical, with music by Marc Shaiman and lyrics by Scott Wittman and Shaiman, took home eight Tony Awards. Five years later, a film version cast

OPPOSITE: Albin (George Hearn), dressed as his glamorous alter ego Zaza, the star attraction at La Cage Aux Folles *in the original 1983 Broadway production.*
ABOVE: Harvey Fierstein as a post-makeover Edna Turnblad with daughter Tracey (Marissa Jaret Winokur) in Hairspray.

John Travolta in prosthetic drag as Edna. In 2016, *Hairspray Live!* was broadcast on NBC with Fierstein reprising his Tony-winning role. In his review, the *Hollywood Reporter* critic David Rooney wrote, "After John Travolta's muffled take on the role in the 2007 movie, it was a commendable idea to return queer-culture flag-bearer Harvey Fierstein to the muumuus he first wore onstage."

Kinky Boots

"Sometimes a man doesn't dress up like a woman because he wants to be a woman. He dresses like a woman to make him feel more like a man," Cyndi Lauper told the *Los Angeles Times* in 2013. She was speaking of Lola, the shoe-designing drag queen at the heart—and sole—of *Kinky Boots*, the musical she wrote with (surprise!) Harvey Fierstein. The role was played to perfection by Billy Porter.

Based on the 2005 British film of the same name, which had starred a pre–*12 Years a Slave* Chiwetel Ejiofor as Lola, *Kinky Boots* let audiences know that "Sex Is in the Heel," but love is in the heart . . . of every drag queen (and every straight boy who needs just such a "girl" to save the family shoe business).

Lola may not be her father's son—to paraphrase a particularly moving song from the 2013 show—but she is a role model nonetheless. "It's very much an heir to *La Cage*, but with the emphasis shifted from gay love to personal expression," notes *Time Out* critic Feldman. "As in *La Cage*, drag queens save the day, in this case, old-fashioned working-class factory jobs."

By the end, everyone—not just the drag lead—is wearing over-the-knee kinky boots and the audience is on its feet for the finale of "Raise You Up" and "Just Be." The show won six Tony Awards, including one for Porter.

Hedwig and the Angry Inch

If *Kinky Boots* let everyone get in touch with his or her inner drag queen, the Broadway version of *Hedwig and the Angry Inch* in 2014 went even further.

Although not the enduring mainstream hit that *Kinky Boots* has become, *Hedwig* proved that a truly defiant rock musical, with a score written by Stephen Trask and an aesthetic borne out of the downtown New York drag scene, could triumph on a big mid-town stage.

The playfully rude, sometimes moving story of an East German transsexual with a "Wig in a Box" and a wicked sense of humor, *Hedwig* was as associated with its creator John Cameron Mitchell, who wrote the book and starred in the original 1998 Off-Broadway production, as Dolly Levi was to Carol Channing.

But the 2014 Broadway version proved to be a triumph for its Tony-winning star, Neil Patrick Harris, who took on the role after years of playing the womanizing Barney Stinson on the hit TV show *How I Met Your Mother*. To say *Hedwig* was a departure for a man who first found fame as the teenaged doctor *Doogie Howser, M.D.* on TV in 1989 is an understatement.

But Hedwig was no *Sugar*-y cross-dressing role.

"The real power of the show comes from its combination of caustic humor and brave vulnerability. It speaks to the metaphorical power of drag performance as a form of armor," says Feldman. Although he felt that the Broadway version was "more showy and less personal" than the Off-Broadway original had been, Feldman calls *Hedwig* truly an important development in the history of drag on Broadway and "one of the great musicals of the past fifty years."

Over those decades, audiences have changed as much as the shows have.

Peter Filichia notes, for instance, that when *Chicago*, the John Kander and Fred Ebb musical about "merry murderesses" in the Windy City of the 1920s, opened in 1975, the revelation that the busybody reporter Mary Sunshine is played by a man came as a shock to all but the most seasoned theatergoers.

"With his stratospheric falsetto and his dowdy female clothing, Michael O'Haughey"—billed as M. O'Haughey in the program—"had totally fooled the crowd into thinking that this was a genuine actress portraying a female character," Filichia says. "When the revival opened in 1996, the moment that 'D. Sabella' came onstage, many a patron quickly turned to his or her seatmate and said, 'That's a man!'"

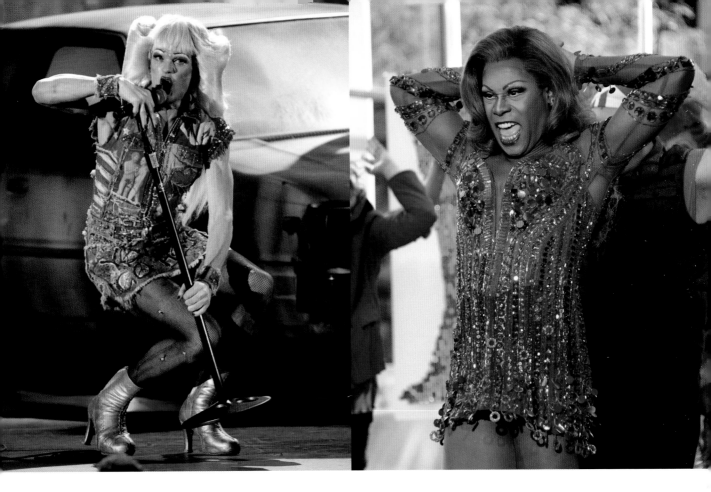

It's not that Sabella was any less an actor than O'Haughey had been.

"The difference," Filichia says, "was that in 1975, drag was a comparative rarity in musical theater, so audiences weren't even inclined to think about it. But in the ensuing years, it has become so mainstream that theatergoers' drag antennae are far more sharply attuned and they need only a second to see through the ruse."

Wise to the charade or not, audiences—and Tony voters—continue to love men in dresses onstage.

In the more than three decades since George Hearn won the Tony for *La Cage aux Folles* in 1984, five guys have won Tony Awards as Best Actor in a Musical for playing drag-related roles: Brent Carver in 1993 for *Kiss of the Spider Woman*, Fierstein in 2003 for *Hairspray*, Hodge in 2010 for *La Cage aux Folles*, Porter for *Kinky Boots* in 2013, and Harris for *Hedwig* in 2014.

Four more—Tom Hewitt as Dr. Frank-N-Furter in the 2001 production of *The Rocky Horror Show*, Euan Morton as Boy George in *Taboo* in 2004, Gary Beach as Albin in *La Cage* in 2005, and Tony Sheldon as the transsexual Bernadette in *Priscilla, Queen of the Desert* in 2011—were also nominated.

Add in Wilson Jermaine Hereda, who won the Best Featured Actor in a Musical category as Angel in *Rent* in 1996, and Beach, who won as Roger De Bris, a hilariously swishy queen who, in drag, really did look like the Chrysler Building, in *The Producers* in 2001, and you've really got a tidal wave of pailletted pageantry on Broadway.

"Drag definitely has become far more mainstream in musical theater," Filichia says, adding, "Broadway may not be in a Golden Age, but it's certainly in a Golden Age of Drag." As Lola sings in *Kinky Boots*, "Everybody Say Yeah."

ABOVE, LEFT: Neil Patrick Harris as the appropriately miffed title character in the Broadway production of Hedwig and the Angry Inch.
ABOVE, RIGHT: Billy Porter as Lola, the glittering star of Kinky Boots, during a 2013 Today show appearance.

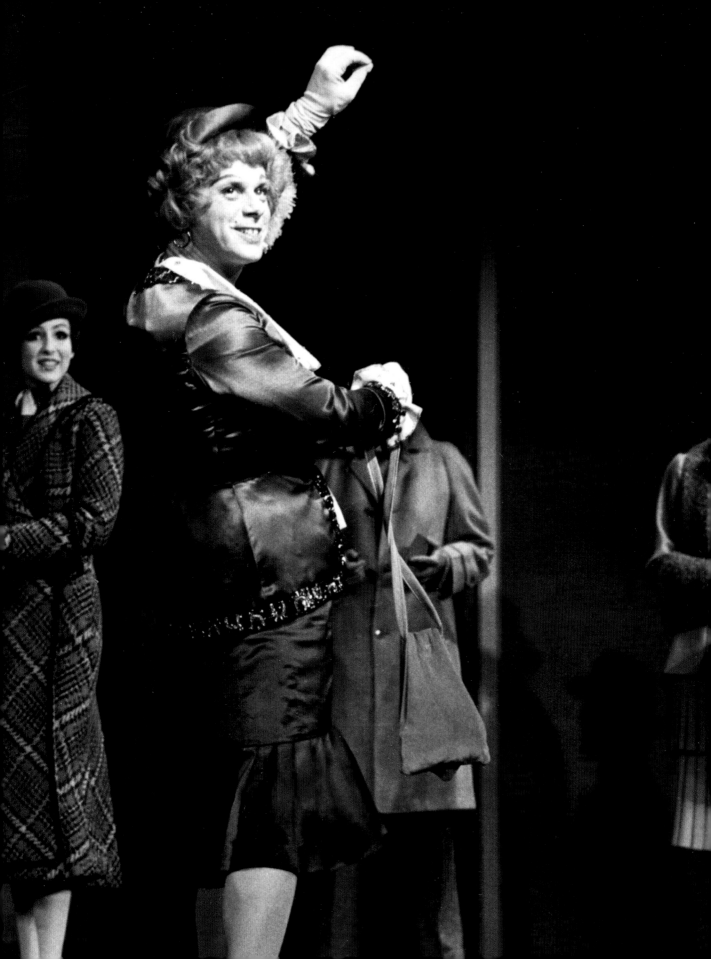

HOW TO SUCCEED IN DRAG WITHOUT REALLY TRYING
A Conversation with Robert Morse

Before he played advertising Brahmin Bertram Cooper on *Mad Men*—and was Emmy nominated five times for the role—and before he uncannily portrayed Truman Capote in *Tru* on Broadway in 1989 and later on PBS—and won the Tony and Emmy awards for that—Robert Morse was synonymous with the role of J. Pierrepont Finch, the hapless climber in the 1961 musical *How to Succeed in Business Without Really Trying*. He played the part in the 1967 movie version, too.

It turns out, though, that a flamboyant role in another Broadway show, *Sugar*, the 1972 musical based on the greatest drag movie of all time, *Some Like It Hot*, is the apple of Morse's eye. And, why shouldn't it be? A *New York Times* profile from that year said "When all the reviews were in, Morse had gotten nearly unanimous raves for what critics agreed was the most exuberant clowning-in-skirts since Ray Bolger's stint as Charley's mythical aunt."

How did playing Daphne in Sugar **compare with playing Finch in** How to Succeed in Business Without Really Trying**?**
I loved *How to Succeed*. It was very important in my life, working with Frank Loesser, Abe Burrows, and Bob Fosse. But I had more fun being a leading lady in *Sugar*. What a show! It was hilarious.

Why was that experience more fun?
They treat you better! Much better than a leading man! If you're a leading man on Broadway, they say, "Go over to Bloomingdale's and get yourself a shirt." But when you're a leading lady, they make the whole costume for you. I felt like Ethel Merman. They'd come up to me and say, "What earrings do you want to wear, Mr. Morse?" I'd say, "How the hell do I know what earrings?"

The role of Daphne, which Jack Lemmon played in the movie, seemed made for you.
It was sort of a burlesque show and it was right up my alley. As a kid, for some reason, growing up in Newton, Massachusetts, I had this feeling that if I had been born twenty years earlier, I'd have been terrific in burlesque as a comedian. The style, the movement, the way I think . . . I just felt that way.

Why do you think Sugar **didn't last?**
I'm of the opinion, and other people have told me, that if it came out at the time *The Producers* came out in 2001, it would have been a big hit. It was way before its time. The audience loved it, but it wasn't a success. Broadway wasn't ready for that kind of show, and it didn't catch on. But, oh, how I loved *Sugar*!

OPPOSITE: *Robert Morse as Daphne in* Sugar, *the Broadway musical based on the classic film* Some Like It Hot.

A Conversation with Michael Gross

He is best known for his seven seasons as the father of Alex P. Keaton (Michael J. Fox) on the middle-American 1980s sitcom *Family Ties*.

But before settling into network-sanitized legend, Michael Gross originated the down-and-dirty role of Greta, a cross-dressing German nightclub owner with ties to the Third Reich, in the original 1979 production of *Bent*, Martin Sherman's landmark play about the persecution of homosexuals in Nazi Germany.

A Chicago-born actor, Gross was thirty-two when he first set his high-heeled foot on a Broadway stage, opposite Richard Gere at the New Apollo Theatre. The part brought him a 1980 Drama Desk nomination as Best Featured Actor in a Play.

How did your parents feel about you playing Greta?

I remember telling my family about the gig, and it sounded like one of those classic jokes. First the good news: "Mom, Dad, I'm doing a show on Broadway." The bad news: "I'll be wearing a red wig, a bustier, garter belt, and fishnet hose." My parents were hardly shocked or surprised, though, as they knew my penchant for the unusual. *Bent* marked my Broadway debut. I had largely worked Off-Broadway and in regional theater, so the fact that I was playing anything on Broadway was a big deal to me, particularly as it was a straight play, so to speak, not a musical.

So you had no reluctance about playing a drag queen?

On the contrary, I was almost foaming at the mouth! I have always thought one of the great pleasures of acting was to play characters as different from myself as possible: different in their beliefs, their upbringing, their geography, their social status, and their place in time. So the opportunity to play a drag queen in 1930s Berlin was a godsend.

Did your agent agree with you?

My agent had no objections, and there were few, if any, discussions that I recall about the downside of taking this role. The consensus seemed to be that this would be a great opportunity for a heterosexual actor to display his range.

When audiences first see Greta in Bent, it's quite an amazing moment . . .

I had a grand entrance—I was lowered from the fly loft on a trapeze. It was a trifle scary, as mine was the second scene in the play so, prior to the curtain's rise, I had to be hoisted up thirty or forty feet out of sight from the audience and hang there, like a spider, during the entire first scene. The altitude was a bit daunting, but I got used to it. It was a pretty impressive entrance, and the audience always loved the surprise.

How did you feel onstage in drag?

To be entirely honest, I felt no different than I ever did playing a costumed character. This is what I did. This is what I loved doing. My greatest reaction to seeing myself in drag was to think, "Jesus, you are one unattractive woman!"

OPPOSITE: *Michael Gross making his Broadway debut as Greta in* Bent, *opposite David Marshall Grant and a young Richard Gere.*

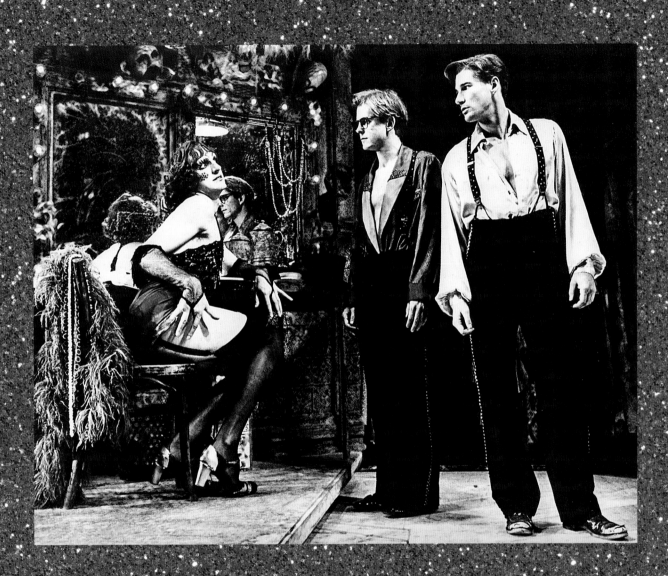

Dame Edna Everage

''If Edna were doing a drag act, she'd have to dress up as a man, wouldn't she?"

—Barry Humphries

★ ★

In a sixty-year climb to international "giga-stardom," Edna Everage has gone from a frumpy suburban Australian housewife to a wisteria-haired international glamourpuss surrounded by a cadre of famous friends. With her penchant for outrageous dresses and bejeweled "face furniture" to match, she has conquered Broadway, starred on television, written best sellers, and even had her face emblazoned on postage stamps in her homeland.

That she is a man in drag has never mattered a lick to a world of fans, among them, that old stuffed shirt Prince Charles, who has been an avowed "Ednabopper" for decades. Few cross-dressing creations have ever been as complete as Dame Edna. Her realness is unparalleled. Her 1989 "autobiography" *My Gorgeous Life* was published as nonfiction!

"Dame Edna seems amazingly actual," theater critic John Lahr wrote in his *New Yorker* profile of Humphries that was expanded into the exemplary 1992 biography *Dame Edna Everage and the Rise of Western Civilization: Backstage with Barry Humphries.* "Whether watching her on TV or face-to-face, a person soon loses the sense that this is a man-as-woman and accepts her as real. This sense of actuality is due in part to the rich coherence of her story."

Part insult comic, part social commentator, this dame is, as Lahr puts it, "an Amazon of outrageousness." But only a handful of "possums," as Edna calls her audience, ever walk out of her show offended. "The ones who get away are few, but they do distress me," Edna's alter ego, Barry Humphries, once told me. "I don't know how Edna does it. But she is sure that people hear the caring in her voice." Humphries himself hasn't always gotten that pass: transphobic comments he made in 2018 landed him in enough hot water to fill the Tasman Sea.

An actor, an author, and a, by most accounts, heterosexual dandy in real life, Humphries created Edna when, in December of 1955, as a member of an Australian comedy troupe, he wrote a housewife sketch for a revue that was only supposed to last a couple of nights.

"Edna was conceived as a character to remind Australians of their bigotry and all the things that I found offensive," he has said. She was not intended to have legs, especially not men's ones. Initially, Humphries's castmate Zoe Caldwell, who'd go on to win four Tony Awards, was to play the role, but Humphries's reading was funny and the director suggested he go on in drag.

There was no turning back after that night, although Humphries tried, eventually playing Fagan on stage in *Oliver!* and appearing as other characters of his own creation, most notably Les Patterson, a "prodigiously endowed" Australian cultural attaché known to shower front-row patrons in spittle.

While Dame Edna insists she is not Barry Humphries, Humphries has always asserted that he is she. Edna, he told me for a 1999 profile I wrote for the *New York Times*, "regards crass assertions that she's a cross-dressing weirdo from Australia as scurrilous and actionable.''

Edna almost didn't become a star in America, at least not on her first stateside tour of duty. Although she was famous in Australia and Britain, her 1977 New York solo debut in a show called *Housewife! Superstar!!* at Theatre Four was savagely panned by the *New York Times*. The review's headline seethed "1-Man Show is One Too Many," and critic Richard Eder said Edna "gave new depths to the phrase 'Down Under.'" The show, he wrote, "is abysmal." (No fan of drag, Eder also wrote a caustic review of Craig Russell's show, just a few weeks later.)

Humphries was humbled by the experience. "It was like starting in England again," he said. A rave from critic Rex Reed, whose camp sensibility was a good match for Humphries's own, came too late. The show had already closed by the time it was published. "It was off-off-off-off-off-Broadway," Edna had told me, noting that "there was a time when I was a bit too complex for America."

Even when she did make it bigger in America, she remained a cult hit.

"I'm a luxury item. I'm caviar. A special interest for the discerning few," she said of her stateside status when I spoke to her for the *New York Times*. "Not everyone gets the point of me, or I would have to be playing Madison Square Garden." Instead, she played the Booth Theatre and became the toast of New York. Her not-quite-one-woman Broadway show *Dame Edna: The Royal Tour* opened to raves and Edna won a special Tony Award for it.

The *New York Times*, which had been so cold twenty-some years earlier, now sang her praises. Critic Ben Brantley called her "as unexpurgated an insult wielder as Joan Rivers and Jackie Mason." Humphries, Brantley added, "is not only a loopy social satirist but also a great instinctive physical comic."

The success of that show led to another hit Broadway engagement, *Dame Edna: Back with a Vengeance* in 2004—"tirelessly funny," Brantley again raved—and, in between, a recurring role on the cult TV favorite *Ally McBeal* in 2001–2. Edna—not Humphries—played Claire Otoms, a client of and then a secretary employed by the show's fictional law firm. The character name is an anagram of "a sitcom role"—just the kind of mischievous touch that Humphries so enjoys.

Edna's American TV success never matched her televised triumphs in Britain, but audiences around the world have found her shows on DVD. *The Dame Edna Experience*, a talk show she described as "a monologue interrupted by total strangers" that ran from 1987 to 1989 on the BBC, is Everage at her best. *Dame Edna's Neighborhood Watch*, a 1992–93 exercise in audience humiliation that was billed as a "game show that's also a Dame show," is a scream, too.

A few years after his 2010 Broadway show *All About Me*, costarring the singer and pianist Michael Feinstein, failed to catch fire, Humphries announced he was hanging up his frocks. Audiences couldn't believe their ears. Although Humphries was pushing eighty at the time, Edna was eternal. When he did put touring behind him, he made sure Edna left in a blaze of glory.

In 2015, the old bird embarked on her "final farewell" world tour with a show called *Dame Edna's Glorious Goodbye*. The evening, a spin on *Eat, Pray, Love* that was as funny as any show she'd ever done, was a bittersweet parting. At the end of each performance, Humphries did something he'd never done before. He stepped out of the shadows at the curtain call, having made a quick change, and took a bow as himself. Edna, it turned out after sixty years, may really have been a man in drag all along.

ABOVE: Dame Edna portrait by Ken Fallin.

THE THREE CHARLES-ES

"You've seen Women's Wear Daily?
This is what men wear nightly."
—Charles Pierce

What's in a name?

In the annals of drag—if you'll pardon the expression—three of the greatest stage actors that audiences have ever seen have all been named Charles:

Charles Pierce, Charles Ludlam, and Charles Busch.

Two are as well-known as playwrights as they are as performers. Two are legendary on the cabaret circuit. All three have unexpected TV credits—*Laverne & Shirley* (Pierce), *Starsky & Hutch* (Ludlam), and *Oz* (Busch)—and although two are dead, that hasn't stopped the surviving Charles (that would be Mr. Busch) from being mistaken for each of the other two, even though he's much younger than both of them.

John Davidson, who in 1974 played a psychotic drag queen on TV's *The Streets of San Francisco*, once swore to Busch that they'd done an episode of *The Love Boat* together. It was Pierce with whom Davidson costarred, and the show was *Love, American Style*, but who's counting?

Here are the Three Great Charles-es of Drag . . . and one John.

The Charles Pierce Show

"Ladies and Gentlemen, Mr. Charles Pierce"

. . . "And all those blondes"
. . . "And all those turbans"

The Victorian Virgin
(or *How she lost it on the sofa*)

Katie

The Living Dolls

INTERVAL

Eleanor Roosevelt, revisited

By a waterfall

Miss Davis; Joan and Tallu

Beautiful Girls

Golden Gate Memories with Jeanette

The Musicians
Ted and Peter Beament

OPPOSITE: *Charles Busch.*

ABOVE: *A peek inside the souvenir program from a London engagement of* The Charles Pierce Show *at the Fortune Theatre.*

67

Charles Pierce

"I'm really very masculine. I dress this way to counteract it."

—Charles Pierce

Others may have more faithfully re-created the women they were playing—Jim Bailey dressed as Judy Garland could fool even Liza Minnelli—but no one has ever gotten closer to the very essence of the legendary women he was impersonating than Charles Pierce.

Pierce was a 3-D caricaturist who ran wild with the quirks that made the Great Ladies of Hollywood's Golden Age so distinctive. Bette Davis's eye-rolling. Joan Crawford's puss-pursing. Katharine Hepburn's signature shake. As the theater critic Clive Barnes wrote in the *New York Times*, upon Pierce's first big New York engagement, in 1975, he was "the living equivalent of an Al Hirschfeld cartoon," an entertainer possessing "slashing histrionic flashes of insight."

When Pierce sashayed onto a stage in a billowing skirt, his own baby blue eyes bulging, he made a better Bette than Davis herself, although she apparently didn't agree. Nevertheless, he got huge laughs simply by saying, "*Thaaaaaaank* you." Pierce was so adept at doing Davis, in fact, that he could perform her in tandem with Tallulah Bankhead, a two-character feat of verbal sparring that Pierce accomplished simply by turning his head and adjusting his wig. "People who never saw him as Tallulah and Bette Davis—at the same time—don't know what they missed," says John "Lypsinka" Epperson, who counted Pierce as a friend and inspiration.

As Davis, Pierce often set his comedic sights on those superstars whom he so adored. "Liz Taylor is pretty now. A year ago she was pretty fat," he would say, adding, "I caught her shopping at Woolworth's the other day for stretch jewelry!"

Pierce also did a killer Katharine Hepburn, quavering through *Lion in Winter* jokes; a cooing Marilyn Monroe, who bragged that she was "ate before she was seven"; and a bluer-than-blue Mae West. Early in his career, Pierce did Jeanette MacDonald, too, swaying out over the audience on a flower-covered swing to the tune of "San Francisco." Later, he added a *Mommie Dearest*–era Joan Crawford, who always made her entrance to the theme from *Jaws*.

Erudite talk show host Dick Cavett, introducing Pierce on his television program, said Pierce was a favorite of "people in the know" and added, "He has filled late-hour clubs on both coasts year after year with his deft and hilarious impersonations. He has a great following." That following included celebrities as far-flung as Lucille Ball and Truman Capote, Henny Youngman and Stephen Sondheim, Tina Turner and Rip Taylor.

Rubbing elbows with such stars was what Pierce always wanted. Growing up in Watertown, New York, in the 1930s, he spent afternoons playing dress-up with vintage vaudeville costumes—his aunt had been in show business—that he found in his grandmother's attic. "On rainy days, I would play up there and create my own fantasy world," he told an interviewer, author Ronald L. Davis, a retired professor in Southern Methodist University's oral history program, in 1989.

At age nine, Pierce made his first public appearance in drag when he attended a Halloween party dressed as Mae West. As a teenager, he worked as a radio announcer at his hometown radio station, WWNY, and it fueled his desire to perform. Pierce liked to say that his line of work chose him, rather than the other way around. "I didn't go to my vocational guidance counselor in high school and say, 'Hi, I'd like to be a female impersonator.' She came to me and said,

OPPOSITE: Patti LuPone copping a feel from Charles Pierce in full Mae West mode in 1980.

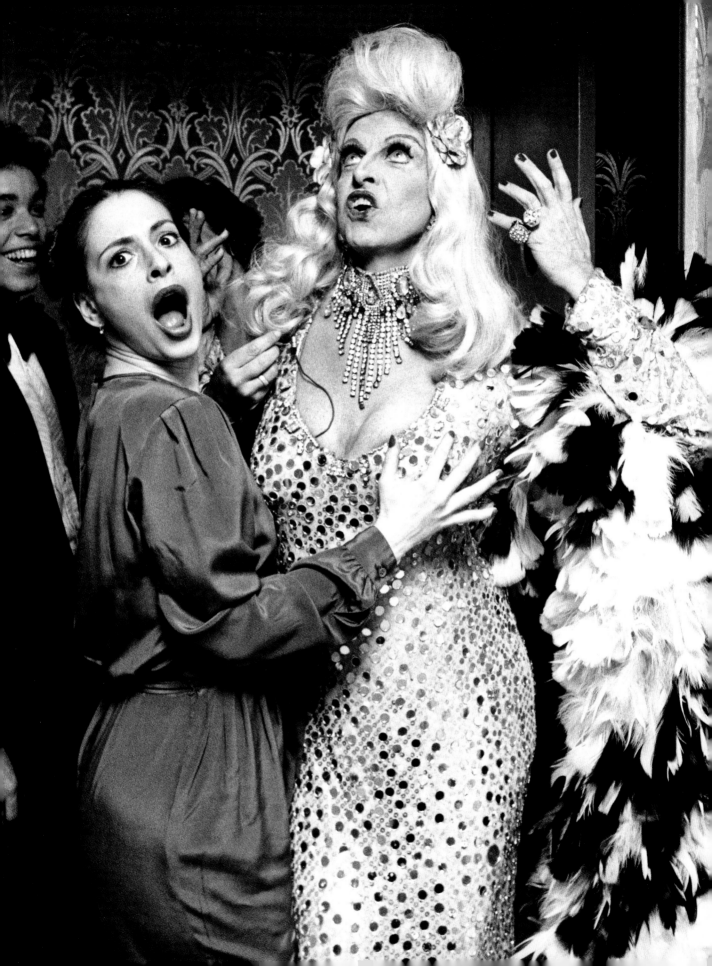

'Charles, I've seen you in the hall. You're a female impersonator,'" he once said.

In the late 1940s, Pierce ventured west and joined the school of the Pasadena Playhouse. After he finished his training there, he began, in 1954, performing an act of his own design at Club La Vie in Altadena, California. "I'd use a leopard stole, a boa, a hat, but I wasn't in drag," he once said. His first onstage impersonation was as First Lady Eleanor Roosevelt, who quipped that if the president could have a mistress, so could she.

In the years that followed, Pierce made his name at such gay and gay-friendly establishments as the Gilded Cage in San Francisco and Club Echo in Miami Beach. Pierce always wanted it known that he was not simply a drag queen. "I'm really just an actor who puts on certain costumes, generally gowns, to create female characters familiar to millions of people. I'm not doing it to be a woman. I'm doing it to be a star."

Eventually, Pierce did become a star, packing such swank venues as the Ballroom in New York City, and the Venetian Room at the Fairmont Hotel in San Francisco. Such was Pierce's popularity that he played Margo Channing in a 1974 San Francisco production of the musical *Applause*, did a run of shows in 1975 at the Fortune Theatre in London, and opened for Ann-Margret in 1978 in Las Vegas. A Bay Area critic called him "one of the funniest men to ever wear a girdle."

Pierce went on to find mainstream (albeit sporadic) television work in the 1970s and '80s. He memorably appeared on such sitcoms as *Laverne & Shirley*—he played a cross-dressing villain in a two-part 1980 episode called "Murder on the Moosejaw Express"—and *Designing Women* in 1987 in which he played a male ship's steward who, when dinnertime rolled around on a cruise the ladies were taking, impersonated Joan Collins and Bette Davis. Pierce also appeared on *Chico and the Man*, *Wonder Woman*, *Madame's Place*, *Fame*, and even *Good Sex! with Dr. Ruth Westheimer*.

His movie career included the underrated lowbrow comedy *Rabbit Test* from 1978 in which director Joan Rivers cast Pierce as the Queen of England, and the 1988 big-screen version of the play *Torch Song Trilogy*, in which Pierce played drag queen Bertha Venation (a role written especially for him by Harvey Fierstein) opposite Broadway star Ken Page as Marsha Dimes. In the late 1980s, Pierce was a model for a line of campy (and now collectible) greeting cards, too.

Pierce retired from performing—"abdicated," he called it—after starring in a string of shows at his alma mater, the Pasadena Playhouse, in 1990. He'd come full circle. A few years later, he was coaxed back into a dress one last time to appear at one of the greatest nights in the history of modern drag, a show called *Charles Busch's Dressing Up! The Ultimate Dragfest*, held in June 1994 at Town Hall in New York City as part of the twenty-fifth anniversary of Stonewall.

That night, in addition to entertaining, Pierce was tasked with getting Milton Berle—also in drag that evening at age eighty-five—off the stage, when he clearly didn't want to leave. It was no small feat, but Pierce managed with aplomb.

Although not technically a drag queen, Bea Arthur was there that night, too. Over the years, she was one of Pierce's biggest champions, calling him "one of my very, very, very, very dearest friends." She remained Pierce's bosom buddy until his death of prostate cancer in 1999. He died at his home in North Hollywood, California, at age seventy-two, having donated his papers, scrapbooks, and archives to the Performing Arts Library of Lincoln Center in New York City.

It seems only fitting that Pierce's grave, marked by a golden plaque bearing a likeness of him out of drag, is not far from Bette Davis's final resting place at Forest Lawn in the Hollywood Hills. A *Los Angeles Times* obituary written by Michael Kearns explained Pierce's special abilities perfectly: "Even though he was clearly a man's version of a woman, it was never a condescending lampoon."

Some considered him to be too dirty, too camp, but that suited Pierce just fine. "Of course I'm too much," he'd say onstage. "If I were too little, I wouldn't be up here."

Lypsinka Talks!

"I was too young to be a rebellious hippie, so instead, I became a rebellious gay guy dressing in drag…"

—John Epperson

He has been dubbed the heir-apparent to the great Charles Pierce, and a kindred spirit to the glittering Charles Ludlam, and, offstage, he's a pal of Charles Busch. But John Epperson and his one-name creation, Lypsinka, are truly unlike any other.

To say that Lypsinka lip-synchs is to say that Picasso painted. Onstage in spectaculars like *Lypsinka! The Boxed Set*, and *The Passion of the Crawford*, La Lyp doesn't miss a beat, every twitch and every quiver matching the carefully curated recordings to which she performs.

What Epperson, an actor and playwright originally from Hazlehurst, Mississippi, does is put into a creative Cuisinart a century of pop culture—obscure movie clips, snippets of songs, snatches taken off spoken-word albums, and more—and then slip those words into Lypsinka's mouth.

Whether answering the phone at the Hollywood Hotel or pointing to a little boy named Mikey on a cereal box while singing "This Is My Life," no one lip-synchs like Lypsinka, or looks as gorgeous doing it.

Charles Isherwood, writing in the *New York Times*, said Epperson "has proved to be a savvy scavenger in the archives of camp, stitching together snippets of heavy-breathing movie dialogue with the rigor of a gene-splicing scientist, and lip-synching to the chaotic results with the histrionic abandon of a dozen assorted screen goddesses."

But somehow, she remains completely her own woman.

When did you first do drag?

The earliest memory I have of being in drag was when I was a kid. There's an 8mm home movie of me racing my sister who's older and bigger, and she wins. You see me crying and then going into this playhouse that we had, and I come out of the playhouse and I've put on an old dress. The attention was back to me, and everyone forgot about the humiliation of my losing the race. I used drag to make myself feel better.

How did your parents feel about your proclivities?

There was a movie house in New Orleans called the Carrollton that started showing revival films. This was around 1974. My mother and I went there for a weekend. I'd memorized the soundtrack recording to *That's Entertainment*, so I said to my mother in the car, "You know, I can do a June Allyson impression," and I did it for her and she said, "Maybe you'll have a career as a female impersonator." It was like she was saying, "It's okay."

Who was your greatest influence? Not June Allyson . . .

I'm not sure who the biggest one would be . . . Dolores Gray, Kay Thompson, Carol Burnett, Lucille Ball. Really, though, it was Charles Ludlam. When I read about him doing *Camille*, I was still in college. It sounded so original. That was a big moment when I realized you could do something in drag and end up in *Time* magazine. But not in Mississippi. You have to get to New York and do that.

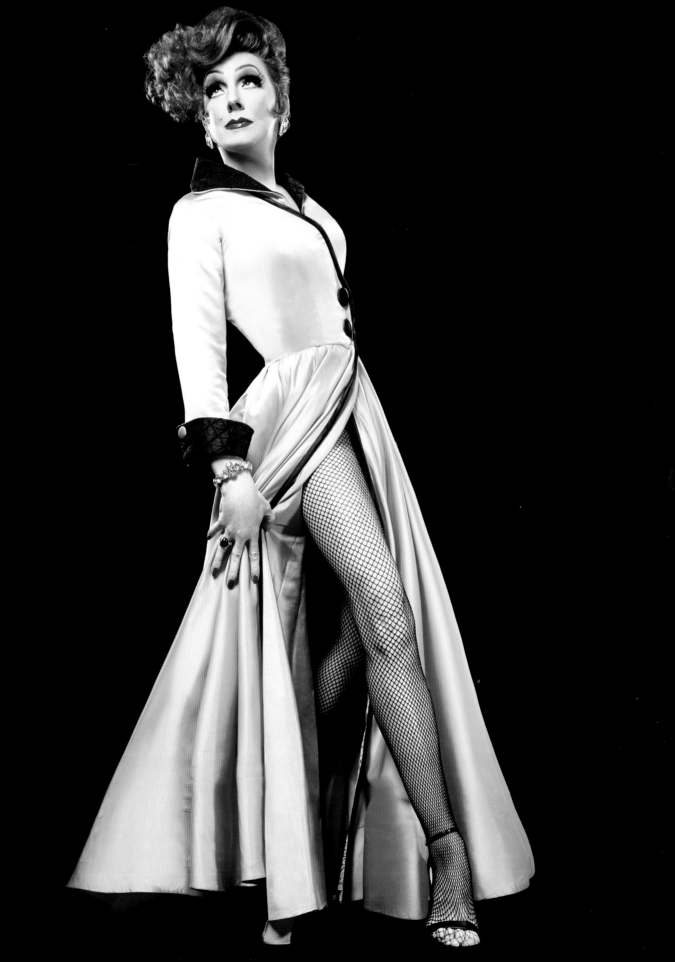

And you did get there. What was the city like when you arrived?

When I moved to New York in 1978, there were lots of revival houses. Cable hardly existed and home video didn't exist at all. So you had to go out to see movies. There was a listing in the *Village Voice* for *Beyond the Valley of the Dolls* at a place called Club 57 on St. Marks Place. I convinced some friends that we should go. It was packed, and when the credits started to unreel, they were all screaming and going insane. I thought, oh yeah, this is where I belong.

How did that lead to you performing?

I started getting the newsletter every month about what was happening at Club 57. One month, it said John Sex is having his *Acts of Live Art* show, and if you want to be in it, here's his phone number. So I called and left a message. The day before the show he called and asked, "Well, are you going to be in the show?" I said okay, and quickly pulled some drag together. That was my first public lip-synching. It was the summer of 1980.

You were doing drag, but I know you're not a fan of the words "drag queen."

I despise that term. I think "drag queen" connotes an amateur, dressing up for Halloween, dressing up just for fun. I'm a professional. It also connotes a man in a dress. I see Lypsinka as a woman the way Barry Humphries sees Dame Edna. Honestly, I see myself as a surrealist more than anything.

Was playing the evil stepmother in Cinderella **at the New York City Opera in 2004 a defining moment for you?**

I was thrilled to be cast as the stepmother in *Cinderella*. I spoke with my own voice, I sang with my own voice, I actually said lines onstage to other people, and they said lines back to me the way actors do! The audience dug me. At the same time, I was in the movie *Kinsey* with Liam Neeson, and I had a ten-page fashion spread in French *Vogue* that Bruce Weber did. All of that at one time. I've done a lot of things that the people who stayed behind didn't get to do. When I feel discouraged, I remember what Roddy McDowall said to me, and I can drop that name because we were friends. He said, "Don't ever give up," and he meant it. For a little kid from Hazlehurst, Mississippi, it's been a pretty incredible life.

OPPOSITE: Lypsinka (John Epperson) at her leggiest. ABOVE: Portrait by Ken Fallin of Lypsinka performing her signature telephone number.

Charles Ludlam

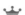

"The theater has always been to me a place where beautiful lies are told."

—Charles Ludlam

He was a prolific playwright of some twenty-nine works, a promising arthouse filmmaker, and an actor who never let the fact that he was a bald, hairy-chested man in a dress stop him from getting genuine laughs or eliciting more than a few tears. Even frockless—he performed naked sometimes, too—Charles Ludlam was a legend of underground theater, a drag artist whose influence is still felt decades after his death of AIDS-related pneumonia at age forty-four in 1987.

The founder in 1967 of the Ridiculous Theatrical Company—a troupe the *New York Times* called "one of the most prolific, influential, and dependably outrageous bastions of the Off-Broadway avant-garde"—Ludlam was a master of the mashup. A "grand recycler of popular culture," as one critic called him, he was a provocateur who bridged high art and low comedy in such works as *Bluebeard* (1970), *Camille* (1973), *Der Ring Gott Farblonjet* (1977), *Galas* (1983), and his most enduring comedy, the 1984 "penny dreadful," *The Mystery of Irma Vep.*

Few had seen anything like Ludlam's ambitious genre-defying plays, which, in his earliest days, were often staged after midnight in downtown New York movie houses. "Compared with the great ages of the theatre, my plays are really mediocre," he famously said, "But they're better than anything my contemporaries are doing."

Ludlam's plays, as the theater critic Mel Gussow, one of Ludlam's most zealous supporters, wrote in the *New York Times* in 1976, were known for "spontaneity, soaring high spirits and yeasty buffoonery." The jokes were both silly and sophisticated. In 1971's *Eunuchs of the Forbidden City*, for instance, one of the title characters says, "I don't think of myself as castrated. I think of myself as extremely well circumcised."

Even as a student at Hofstra University, Ludlam demanded that his work be taken seriously, and critics and audiences obliged. The Ridiculous troupe won an Obie for the 1969–70 season for distinguished achievement in Off-Broadway theater. In 1973, Ludlam won one for acting, too. In 1983, both *Time* magazine and the *New York Times* named Ludlam's play *Galas*, in which he played opera diva Maria Callas, one of the best plays of the year. Among his fans were such showbiz legends as Bette Midler, Lotte Lenya, and Rudolf Nureyev.

Ludlam never intended to do drag when he was growing up on Long Island. It just sort of happened. In 1966, he was persuaded by the underground film star Mario Montez, a mainstay of the Andy Warhol crowd, to appear onstage as Norma Desmond, the delusional silent film star in *Sunset Boulevard*, in a loosely constructed play called *Screen Test*.

"I'd been in drag once before, in a little film, but I'd never done it onstage and I was nervous," Ludlam said in a 1976 interview. "Other actors warned me I'd be ruining my career. [But] the disguise, the costume, freed me, made me do things I never could have done myself."

Ludlam's performance in the title role of *Camille* was considered his greatest triumph. "I didn't want to engage in the kind of trickery that would make people think I

OPPOSITE: Charles Ludlam and Bill Vehr in the 1974 Off-Off Broadway production of Camille.

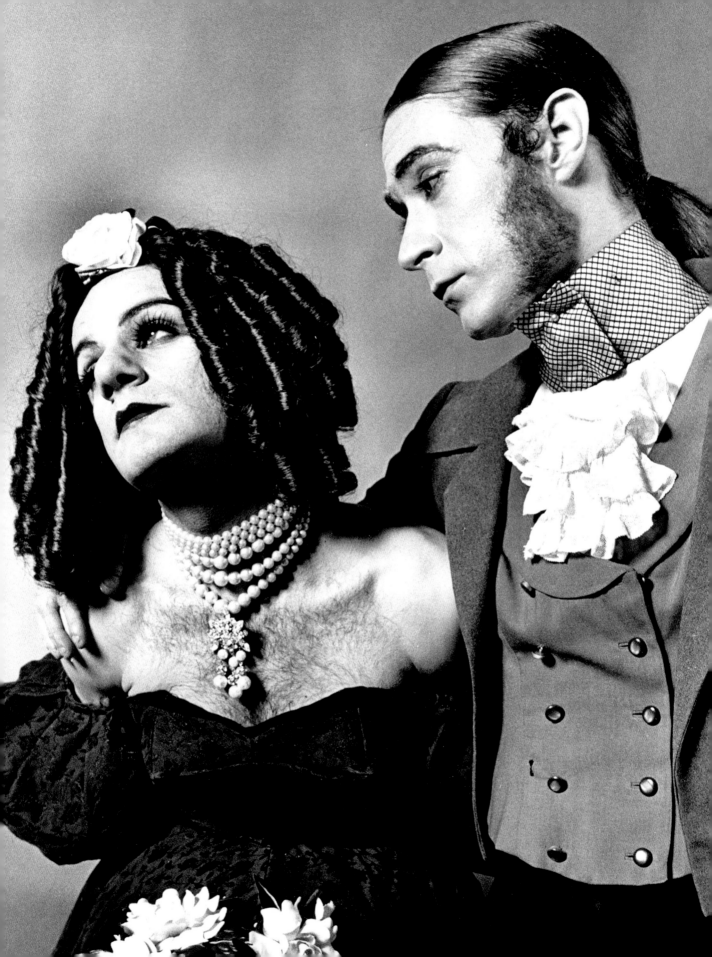

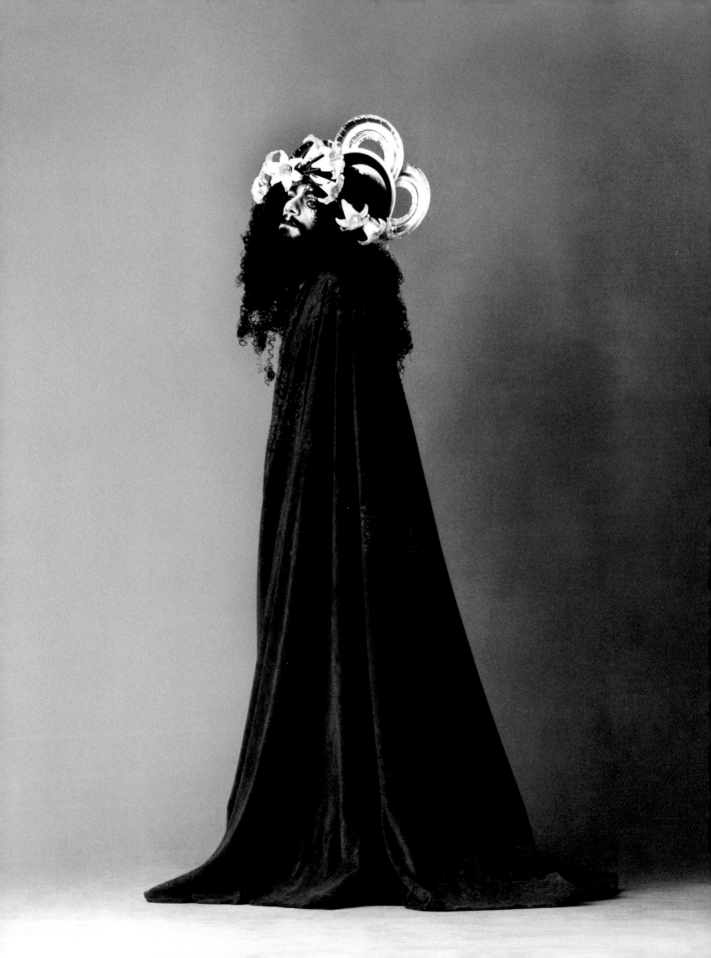

was a real woman, and then suddenly unmask at the end. I wanted to lure them gradually into forgetting, to make it more amazing later on," Ludlam explained in 1976. His acting "was no facile female impersonation, but a real performance," as one critic said.

"Charles always talked about how in the last act of *Camille*, you could hear the pocketbooks opening and the women getting their tissues out because Camille was dying," says Everett Quinton, Ludlam's partner of twelve years in life and forever in art. "Two things were happening: There was the over-the-top outlandishness and then there's the internal journey that was quite serious. It was pretty amazing to see him live."

In the last years of his life, Ludlam began finding mainstream acting work. He appeared on a 1985 episode of *Miami Vice*, played a bowtie-wearing New Orleans lawyer in the 1986 crime drama *The Big Easy*, and scored a lead role as the wart-covered "Bubba" in a 1987 episode of *Tales from the Darkside* called "The Swap." His most memorable screen role was his first television appearance, in 1984, when he played a cross-dressing romance novelist named Tiffany Knight on the ABC sitcom *Oh Madeline*, starring his former Hofstra University classmate Madeline Kahn, in an episode entitled "Play Crystal for Me."

When Ludlam died on May 28, 1987, his obituary appeared on the front page of the *New York Times*. It made mention of the many projects on which he was working that year: a Broadway version of his Wagner's *Ring* epic, a production of *Titus Andronicus* for the New York Shakespeare Festival, and a play about Houdini, in which he planned to star.

"There was regret for the loss of all he promised, but respect for all he had achieved," as Steven Samuels wrote in the introduction to *Ridiculous Theatre: Scourge of Human Folly*, a 1992 compendium of Ludlam's essays.

At Ludlam's memorial service, held in July 1987 at the Second Avenue Theater, a thousand people gathered including Public Theatre producer Joseph Papp, who said that Ludlam had "a kind of imagination no one has touched, and a remarkable sense of theater. I don't think he's replaceable."

★ ★

"I didn't want to engage in the kind of trickery that would make people think I was a real woman."

—Charles Ludlam

Decades later, new generations of admirers have found Ludlam's irreplaceable oeuvre. His experimental film work was rediscovered in 2009 when two of his short films, *The Sorrows of Dolores* and *Museum of Wax*, were screened at the Anthology Film Archives in New York City.

Quinton, a supremely talented actor himself, continues to preserve Ludlam's legacy while burnishing his own reputation as a drag artist to be reckoned with. "Charles played Camille and then, after he went to heaven, I played it," he once told me. "When I did *Camille* in London, I heard the pocketbooks open from the stage, too, and it was breathtaking. What Charles Ludlam did was legitimize us, and let us really get to play these characters."

Quinton says he and every other male actress owe Ludlam a debt. Thanks to him, he says, "we get to just play the roles and play them for real and have some fun and hope that the audience does like it. It's not for everybody. But we get to chew the scenery with our own teeth."

OPPOSITE: Charles Ludlam, in a 1971 Vogue *spread, dressed as the Holy Fool of the Last Judgement in his play* The Grand Tarot.

Charles Busch

"For me, drag is less a political statement than an aesthetic one. I look kind of pretty in a dress."

—Charles Busch

Onstage, he has played a Sapphic succubus, a beach babe with multiple personality disorder, a Beekman Place social darling, a lady in question, a Mother Superior, and every flavor of dame in between.

He has written, directed and starred in movies, appeared on HBO's lurid prison drama *Oz* in a role that one critic described as a "double-crossing cross-dresser," been the subject of the acclaimed 2005 feature documentary *The Lady in Question is Charles Busch*, and toured the world with a cabaret act that audiences called boffo.

Above all, he has been a much-lauded playwright—the man responsible for one of the longest running Off-Broadway shows in history, *Vampire Lesbians of Sodom*, and the Broadway hit *The Tale of the Allergist's Wife*, which not only ran for 777 performances but also was nominated for a 2001 Best Play Tony.

Such is Charles Busch's stellar list of accomplishments, and it's an especially noteworthy one for a guy who, after graduating from college, feared he'd never find much success in show business.

For more than thirty years, he has been, as *New York Times* writer Alex Witchel wrote in 1994, "New York's preeminent drag performer." The third Great Charles of Drag, Busch has carved out a mega-niche that encompasses so many facets of entertainment that it could make any other queen's wig spin.

Growing up in Westchester County, New York, Busch was only seven when his mother died and his father sent him to live with his aunt in Manhattan. This Auntie Mame–like figure and other strong female relatives fostered Busch's interest in theater, a passion that took him first to the High School of Music and Art in Manhattan, and then to Northwestern University in the Chicago suburbs.

"I wanted to be onstage my whole life [but] I was too gay and too eccentric and too androgynous and too thin" to be cast in conventional parts, even in college, Busch says. But when he began seeing avant-garde productions, like those written and staged by Charles Ludlam, he realized where his place in show business might be.

ABOVE: *Charles Busch drawing by Ken Fallin.* **OPPOSITE:** *Charles Busch as the title character of his 2012 play* Judith of Bethulia.

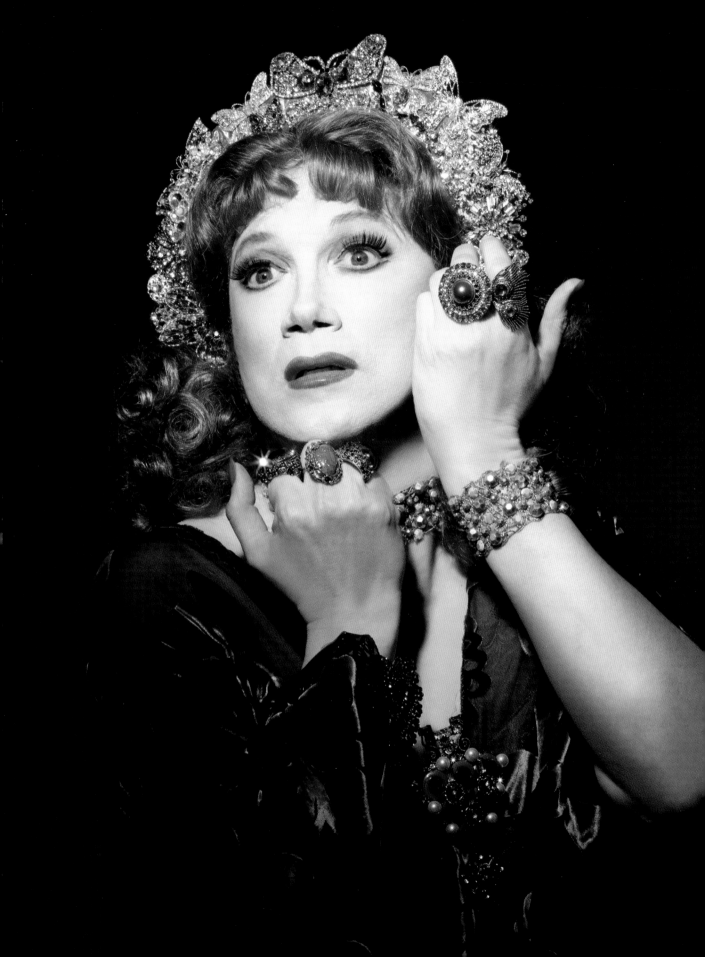

"Theater could be whatever I chose it to be," Busch decided, and the universe he chose to create used classic Hollywood film and vintage Broadway conventions as a jumping-off point for comedies that had something to say. Once he began casting himself as his own leading lady, there was no stopping him.

With Kenneth Elliott, a college chum, Busch founded in 1985 Theatre-in-Limbo, a theatrical company performing original plays, written by Busch and directed by Elliott, at an East Village watering hole called the Limbo Lounge.

"It was a magical period for our troupe," Busch says of that time. "We never knew what to expect. We adored each other and, for a group of young people who had been made to feel unemployable in the theater, we were suddenly special and people thought we were fascinating."

Drag quickly became Busch's greatest tool as an actor. "I never defined myself theatrically until I put on the lashes and heels," he told The *New York Times* in 1989. "It liberated within me a whole vocabulary of expression."

It was as if this glamorous creature always had been waiting to emerge.

24 PERFORMANCES ONLY! BEGINS MARCH 25, 2016

PHOTO: DAVID RODGERS · DESIGN: B.T.WHITEHILL

CHARLES BUSCH'S
CLEOPATRA
Starring CHARLES BUSCH
Directed by CARL ANDRESS

SmartTix.com Theater for the New City 155 First Avenue, NYC

"I've never wanted to be a woman. I wanted to be an actress," Busch says. "Theatrically, my great dream was never to play Biff in *Death of a Salesman*. I wanted to play Blanche DuBois. I wanted to play Auntie Mame. I wanted to be Bette Davis in *Dark Victory*."

Busch has been able to channel those women in his various stage turns.

Vampire Lesbians of Sodom, which opened at the Limbo Lounge in 1984 and transferred to Off-Broadway and sold-out crowds in 1985, was a seminal moment in Busch's early career. That play was "a hip, downtown novelty," as *New York Times* writer Patrick Pacheco wrote in 1989, that quickly "began to attract a wide cross-section of theatergoers, their curiosity piqued by good reviews and a Theda-Bara-meets-Jackie-Susann title."

Busch had no idea the show would run as long as it did. "As silly and frivolous as it was, the play gave people a sense of escape and joy during the bleakest years of the AIDS crisis," he reckons. "Many young gay people, new to New York, came to see the play as a kind of wacky pilgrimage. It sounds bizarre, but it makes crazy sense."

When other comedies—*Times Square Angel* (1984), *Psycho Beach Party* (1987), *The Lady in Ques-*

ABOVE: 2016 postcard advertising Charles Busch's Cleopatra *at Theater for the New City.*

tion (1988)—followed, critics realized that Busch was more than just a drag queen with a typewriter. D.J.R. Bruckner, a critic who raved about *Vampire Lesbians* in the *New York Times*, noted that "'impersonator' is too feeble a word for Mr. Busch."

What is most appealing about Busch's brand of drag is that, *en travestie*, he remains himself. "There's no reason why I should be in drag. I don't have a drag persona. I don't have a name like Bianca Del Rio or Lypsinka. I'm just Charles Busch," he says. In drag, in fact, he is even *more* himself. When Busch does his cabaret act, he says, "I come out looking like Greer Garson mixed with Tina Louise and then proceed to pretty much be myself and tell true stories and sing songs from the American songbook in a very honest way. I'm like an old Philco TV set; I turn up the brightness and turn up the contrast, but it's still basically me."

Audiences expect no less. As Busch's friend, the performer and playwright Ryan Landry, one of Boston's preeminent drag talents, once told him, "If I came to see you and you weren't in drag, it would be like going to Disneyland and finding out that Space Mountain was closed."

Critics, Busch admits, "prefer when I just do my trip. Except for *The Tale of the Allergist's Wife*,"—which opened on Broadway in 2000—"every time I've done the great, brave experiment, they've never really liked it."

But other projects further endeared Busch to his acolytes. He wrote the book for the 2003 Broadway musical *Taboo*, about Boy George, Leigh Bowery, and the drag-heavy London club scene, and penned the

screenplay for and starred in drag in the movie version of his play *Die, Mommie, Die!* that year as well. Three years later, he wrote, directed, and starred in a male role in the indie feature *A Very Serious Person*, which won a special mention at the Tribeca Film Festival.

In more recent years, Busch has returned to his theatrical roots. His naughty take on nun movies, *The Divine Sister*, was a smash when it opened in 2010. Ben Brantley of the *New York Times* called it "Mr. Busch's freshest, funniest work in years, perhaps decades." Busch revived it in 2016. Also that year, he wrote and starred in *Charles Busch's Cleopatra* at Theater for the New City in the East Village, not far from the site of the old Limbo Lounge.

"My entire creative life, for the most part, has been filtered through a female persona," he says. "It's very deep in me. Fortunately, I've been intelligent enough to develop it in a way that's been creatively satisfying to me and other people. Ben Brantley in the *Times*, in one of his later reviews of me, said that the roles I've done over the course of thirty-five years have run the same course as the old stars," Busch says. "I started off as Chicklet in *Psycho Beach Party* as a young girl, then came into maturity with *The Lady in Question* set in the Forties, then *Red Scare on Sunset* set in the Fifties, then, in *Die, Mommie, Die*, I'm the mother of grown-up children in the kind of Sixties horror movie that Bette Davis or Joan Crawford did late in their careers, and then I've become the Mother Superior in *The Divine Sister*. There's nothing left for me now but *Dynasty* or *Falcon Crest*."

Again, Charles Busch underestimates himself.

ABOVE: Promotional pill bottle, filled with candy, for Busch's 2003 film Die, Mommie, Die!

BIG SCREEN DRAG

"Honey, I am more man than you'll ever be and more woman than you'll ever get!"

—Antonio Fargas in *Car Wash*

When the American Film Institute, in 2000, assembled a blue-ribbon panel to put together a list of the hundred greatest movie comedies of all time, the judges—more than eighteen hundred men and women from all walks of the movie business—ranked 1959's *Some Like It Hot* and 1982's *Tootsie* number one and two.

Is it any surprise that a pair of drag comedies took the top spots?

Not on your lip liner!

Since the earliest days of cinema, actors and actresses have dressed as the so-called opposite sex, and audiences have embraced them—first curiously, then tentatively, and finally passionately. As early as 1914, when the actress Edith Storey swallowed a gender-altering seed in *A Florida Enchantment* and became cinema's first drag king, cross-dressing has been big at the box office.

From Charlie Chaplin, who was the title character in 1915's *A Woman*—talk about a Little Tramp!—to Stan Laurel and Oliver Hardy, who played each other's wives, Jack Sprat style, in 1933's *Twice Two*,

drag has been part of the filmic landscape. Wallace Beery, Roscoe "Fatty" Arbuckle, and John Bunny all played women with gay abandon. As *Paper* magazine film critic Dennis Dermody puts it, "In all those pre-code movies, you think, oh my god, they're really *nelling* it up!"

Whenever a screen actor, the more macho the better, has "nelled" it up, he has been able to get laughs. "Something big trying to be something small is always funny," says the screenwriter Douglas Carter Beane, who convinced the uber-masculine Wesley Snipes and Patrick Swayze to slip into sequins for his 1995 comedy *To Wong Foo, Thanks for Everything! Julie Newmar.*

Truly, among the most adored movies of all time are such "drag classics" as *Charley's Aunt* (1941), *La Cage aux Folles* (1978), *Victor Victoria* (1982), and *The Birdcage* (1996)—all comedies involving a cross-dressing ruse.

But drag on-screen can do more than just get laughs.

As John Lithgow—no stranger to women's clothing in his work—notes in the introduction to Jean-Louis

OPPOSITE: *Michael Dorsey (Dustin Hoffman) is in for a close shave when he transforms himself into soap opera actress Dorothy Michaels in Sydney Pollack's 1982 comedy* Tootsie. ABOVE LEFT: *Charlie Chaplin finds himself* A Woman *named Nora Nettlerash in a 1915 short.* ABOVE RIGHT: *Michel Serrault as Albin, a drag queen in disguise as a real woman, in the 1978 international megahit,* La Cage Aux Folles.

Ginibre's 2005 ode, *Ladies or Gentlemen: A Pictorial History of Male Cross-Dressing in the Movies*, drag roles over the years have not only split sides, but also have run the gamut from the "horrific"—think of the murderous mama's boy Norman Bates (Anthony Perkins) in Alfred Hitchcock's 1960 thriller *Psycho*—to the "deeply moving."

The latter would include Lithgow's touching, Oscar-nominated performance as Roberta Muldoon in 1983's *The World According to Garp*. Gender transmutation, he contends, remains "the most potent tool an actor has to startle an audience, whether his intent is to amuse, to frighten, or to move them."

Beyond mainstream drag hits, which, generally speaking, were birthed from a white, heterosexual male point of view—not that there's anything wrong with that!—there is a wealth of authentic big-screen drag worth exploring.

For every *Some Like It Hot*—Billy Wilder's timeless 1959 musicians-on-the-run farce starring Jack Lemmon and Tony Curtis—and every *Tootsie*—the 1982 Sydney Pollack film in which an actor (Dustin Hoffman) becomes a better man by pretending to be a woman—there are fabulous drag movies, from *The Adventures of Priscilla, Queen of the Desert* (1994) to the underappreciated *Connie and Carla* (2004), that deserve to be more than glitter-dusted cult hits.

These alternative classics often are films with real gay sensibility and actual drag queens in the cast, titles like Paul Morrissey's 1970 comedy *Trash* starring Holly Woodlawn, and such midnight favor-

★ ★

"Gender transmutation remains the most potent tool an actor has to startle an audience."

—John Lithgow

ABOVE: Felicia (Guy Pearce), Bernadette (Terence Stamp), and Mitzi (Hugo Weaving) are a trio of gender-fluid lounge lizards in director Stephan Elliott's 1994 Australian drag classic, The Adventures of Priscilla, Queen of the Desert. *OPPOSITE, TOP: Real-life drag performer Ricky Renee is Elke in Bob Fosse's divinely decadent 1972 musical* Cabaret. *OPPOSITE, BOTTOM LEFT: Tyler Perry as Madea in the 2017 comedy* Tyler Perry's Boo 2! A Madea Halloween. *OPPOSITE, BOTTOM RIGHT: Eddie Murphy is Rasputia—and she is wearing bottoms—in 2007's* Norbit.

ites as 1972's *Pink Flamingos*, starring Divine; 1977's Canadian comedy *Outrageous!*, starring Craig Russell; the Doris Fish sci-fi spoof *Vegas in Space* (1991); the scandalous *Girls Will Be Girls* (2003), featuring Varla Jean Merman, Miss Coco Peru, and Evie Harris; and *Hurricane Bianca* (2016), starring Bianca Del Rio—not to mention the seminal 1968 documentary *The Queen*, featuring drag mother Flawless Sabrina (Jack Doroshow).

The folks at the American Film Institute may not have placed *Female Trouble*, John Waters's brilliant 1974 satire of fashion and crime alongside *Tootsie*, but it's as funny and subversive a comedy as you'll ever see.

It's not just gay oversight, though. Critics have left out, too, what is arguably the best screen work that African-American artists like Tyler Perry, Eddie Murphy, and Martin Lawrence have ever done, in or out of drag. The 2007 comedy *Norbit* wasn't on anyone's ten-best lists. In fact, it won three Golden Raspberry awards and some observers say cost Murphy an Oscar for *Dreamgirls!* But the *Saturday Night Live* alum was hilarious as the big-mouthed, bigger-bellied, bathing suit-clad harridan Rasputia screaming, "I'm slidin', bitches!" as she wreaks havoc on a water park. It's lowbrow drag to be sure, but it's really a hoot.

Film's relationship with drag has always been problematic, and rife with double standards. "It's funny when a man wears a dress, but it's never funny when a woman wears pants," says Alonso Duralde, a Los Angeles–based film critic and the senior programmer of OutFest, the Los Angeles LGBTQ Film Festival. And it's never shameful. "Women in drag are entitled to a certain mystique and power because they're assuming the masculine mantle," he explains. "When you have Marlene Dietrich in a tuxedo, there's something very sexual happening."

Cross-dressing women like Dietrich came into their own in the Hollywood of the 1930s. The Ger-

man bombshell wore a top hat and tailored clothing to great effect in 1930's *Morocco*. Greta Garbo was crowned with androgyny in the title role of 1933's *Queen Christina*. And Katherine Hepburn almost passed for a man in George Cukor's 1935 romantic comedy *Sylvia Scarlett* opposite Cary Grant.

But, Duralde he says, "With men in dresses, there is often a lot of mincing silliness. It's often used to denigrate femininity and vilify male homosexuality."

Certainly, every epoch has its own attitude toward cross-dressing on film, and that's inarguably tied to society's take on homosexuality at the moment the movie was made. "Some macho directors *did* hate gay people," says Dermody. "So any time they put drag in a movie, it was to be contemptuous."

In the 1940s and '50s, drag was basically a big heckle in Hollywood. Think of Alec Guinness in 1949's *Kind Hearts and Coronets* or Bob Hope in 1954's *Casanova's Big Night*. Beginning in the 1960s and lasting for decades, drag, even in good films, often symbolized societal decline. Men in frocks were part of what Sally Bowles (Liza Minnelli) in 1972's *Cabaret* called "divine decadence." Who can forget the shock of real-life drag queen Ricky Renee standing next to Michael York at the Kit Kat Club urinals in that award-winning Bob Fosse musical?

Worse yet, drag was often used to signal a deranged personality.

From the murderous transvestite played by Ray Walston in 1967's lurid thriller *Caprice*—America's sweetheart Doris Day pushes him to his death—to the drag queen–dispatching serial killer Christopher Gill (Rod Steiger) in Jack Smight's gritty 1968 crime drama *No Way to Treat a Lady*, right up to sicko psychiatrist Dr. Robert Elliott (Michael Caine) in Brian De Palma's 1980 *Dressed to Kill*, a film whose poster promised "the latest fashion in murder," which—spoiler alert!—turned out to be women's clothes in

> **"With men in dresses, there is often a lot of mincing silliness. It's often used to denigrate feminity and vilify male homosexuality."**
>
> —Alonso Duralde

men's sizes, one thing was clear:

A man in a dress could tuck his balls, but he was still nuts.

But films like *The Gay Deceivers*—a 1969 draft-dodging comedy that presaged *I Now Pronounce You Chuck & Larry* by forty years, and featured the flamboyant drag-savvy actor Michael Greer—

"came from a place that wasn't hateful, and that's the big difference," Dermody says.

It took until the 1970s for Hollywood to catch up to the "sexual revolution" and acknowledge the march toward gay equality begun at Stonewall in 1969. Film-makers began to come up with better drag characters, even if they did feel obligated to kill them off in the last reel. The "sweet transvestite from Transsexual, Transylvania" Dr. Frank-N-Furter (Tim Curry) meets an unhappy ending in 1975's *The Rocky Horror Picture Show*, but the film, up until then, celebrates pansexuality and drag with the rallying cry, "Don't dream it, be it!" And, even dead, Curry looked fabulous in fishnets.

Just as rousing to one's inner drag queen was 1976's

★ ★ ★ ★ ★ ★ ★ ★ ★ ★ ★ ★ ★ ★ ★ ★ ★ ★ ★

"Don't dream it, be it!"

— The Rocky Horror Picture Show

Car Wash. Written by Joel Schumacher, who went on to direct the 1999 Philip Seymour Hoffman drag comedy *Flawless*, the film gave us the swish-tacular, gender-fluid Lindy, played by Antonio Fargas in a hairnet and SEXY BITCH necklace.

"Audiences loved Lindy," remembers Dermody. "They embraced him because he was so defiant. He was doing his own thing and that was good."

Since then, drag on film has become increasingly more diverse.

The 1980s gave us films about drag queens with full lives, chief among them the big-screen version of Harvey Fierstein's *Torch Song Trilogy*. The 1990s brought such beloved titles as *Mrs. Doubtfire*; *Priscilla, Queen of the Desert*; and *To Wong Foo*—not to mention the landmark documentary *Paris Is Burning*, which shed light on the drag balls of Harlem, where the art form of "voguing" and the RuPaul-approved tenet that every outfit is drag were born.

The early 2000s saw a return to the traditional trope of men going undercover in drag in a glut of

ABOVE LEFT: *Michael Caine is* Dressed to Kill *as Nancy Allen in Brian DePalma's 1980 thriller.* ABOVE RIGHT: *Antonio Fargas, best known as Huggy Bear on the Seventies TV series* Baretta, *is the fierce and fabulous Lindy in the 1976 comedy* Car Wash.

films that included *Big Momma's House* starring Martin Lawrence, *All the Queen's Men* with Matt LeBlanc and real-life heterosexual transvestite Eddie Izzard, and *White Chicks* starring Shawn and Marlon Wayans, which featured not only cross-dressing but whiteface. These movies harked back to the earliest days of drag on film, but they really were a last gasp before something new arrived in the pantheon of drag on film.

More recently, the most intriguing big-screen drag hasn't technically been drag at all. Instead, the most interesting cross-dressing roles—if you define that as male actors wearing women's clothes—have been transsexual characters in such films as 2013's *Dallas Buyers Club*, for which Jared Leto won an Oscar, and 2015's *The Danish Girl*, for which Eddie Redmayne was nominated.

Although such films have been criticized for casting cisgender men in transgender roles, they've not only resulted in some terrific performances, but also fostered dialogue about gender issues.

"*The Danish Girl* is a safe movie and it's a stodgy movie," says Duralde. But because of it, he says, "the Sunday matinee crowd seeing a nice art-house movie began having conversations they were not ready to have before. Even though it's not the most up-to-speed movie about trans issues, it's a start."

Dermody says a film like Sean Baker's *Tangerine*, which features transgender actresses Kitana Kiki Rodriguez and Mya Taylor, points even more clearly to the future of "drag" on film. The 2015 festival favorite, shot on three iPhones, is important, he says, "because it's completely realistic and not pandering. There's nobody copping an attitude about these people. This is just a day in their lives."

Seeing such a progressive movie, Dermody says, is moving.

"You just want to cry because it's so refreshing," he says. "From having to suffer through Jack Benny in drag in *Charley's Aunt* to having people who really live *in* drag, so to speak, you think we've come a long way, baby."

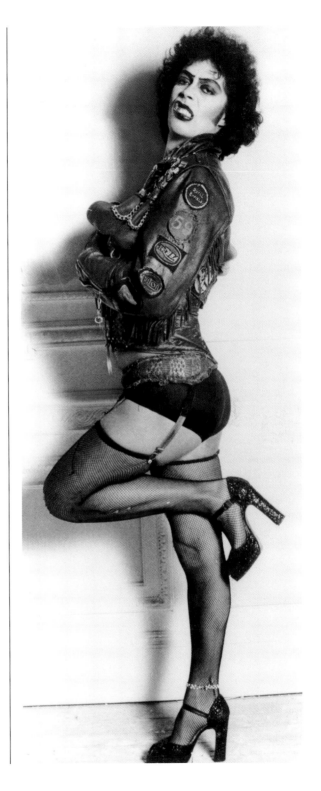

OPPOSITE: *Robin Williams serving nanny realness as* Mrs. Doubtfire *in the 1993 Chris Columbus comedy.* **ABOVE:** *The sweet transvestite scientist Dr. Frank-N-Furter, played by the inimitable Tim Curry, in 1975's midnight movie classic* The Rocky Horror Picture Show.

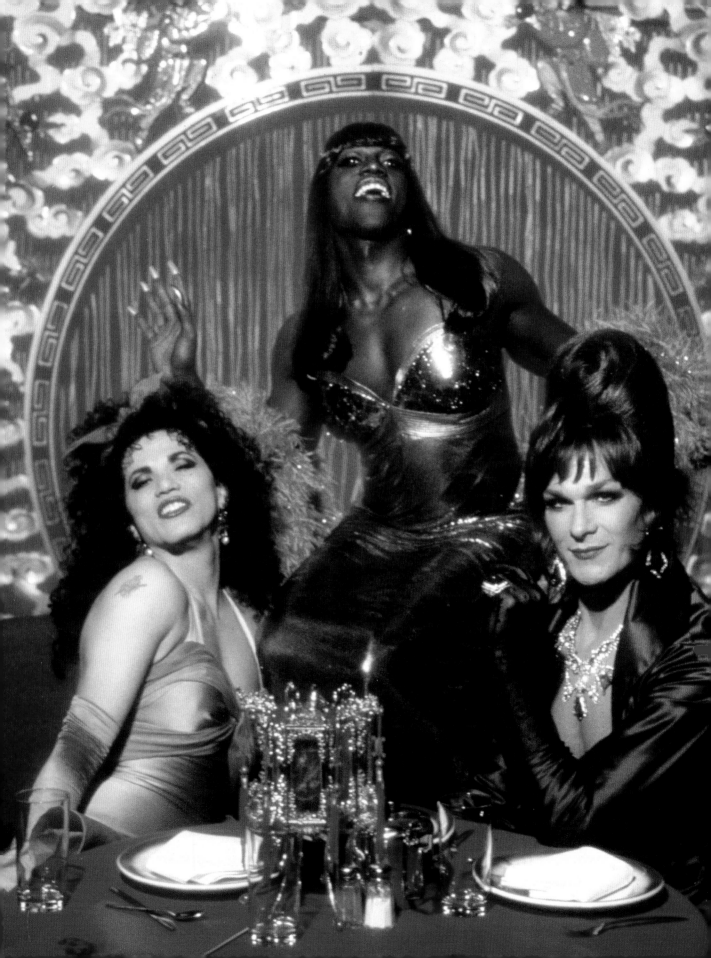

TAKE IT ALL OFF WITH NOXEEMA

A Brief Tête-à-tête with

Wesley Snipes

"When a gay man has way too much fashion sense for one gender, he is a drag queen."

—Wesley Snipes in *To Wong Foo, Thanks for Everything! Julie Newmar*

Wesley Snipes played a murderous drug king-pin in *New Jack City*, a double-crossing bas-ketball player in *White Men Can't Jump*, and the title role in the *Blade* film trilogy. But in 1995, he put macho roles aside to play a drag queen named Noxeema Jackson in the improbably titled big-screen comedy *To Wong Foo, Thanks for Everything! Julie Newmar*.

What was it like making To Wong Foo?

It was probably the funniest film that I've ever worked on. Working every day with John Leguizamo and the late, great Patrick Swayze, there were so many laughs. If they put together just a reel of the off-camera stuff, it would leave you in stitches.

You three really committed to your roles.

That was the only way to do it, the only way to make it believable. That was the fun of it, to see if you can really go there and enjoy that experience.

What did you learn doing drag?

I now understand some of the difficulties women go through in getting ready. When we started out, it took two hours to get me dressed, then we got it down to fifty-some minutes for the wig, makeup, and every-thing. When we wrapped, I buried the stockings, I buried the shoes, and I buried the Johnson holder.

What did you think when you first saw yourself as Noxeema?

She had a great personality, but Noxeema wasn't win-ning any beauty contests. She was the kind of chick your mama would love. She did have a great body, though. I had a whole badonkadonk, before they even had badonkadonks.

Had you ever done drag before?

I previously did Sister Boom Boom on Broadway in 1986 in a play called *Execution of Justice* based on the whole Harvey Milk experience, that whole San Francisco story. I remember one of the New York critics said, "There was this other thing that came out onstage, probably the most hideous creature I've ever seen."

Why do you think audiences like seeing macho men in drag?

Because it's breaking the mold. Especially when you see tough guys do something so identified with being a woman and femininity. Most of the time, we enjoy look-ing at men in drag because they look crazy. Dragging well is *not* easy. Not everyone can do it. Ask RuPaul.

Patrick Swayze looked pretty darn good . . .

He had a lot of help.

OPPOSITE: *Chi-Chi (John Leguizamo), Noxeema (Wesley Snipes), and Vida (Patrick Swayze) hit the road in Beeban Kidron's 1995 comedy,* To Wong Foo, Thanks for Everything! Julie Newmar.

BIG
WIG

Divine

"When I'm in costume, I can get away with almost anything."

—Divine

★ ★

When Harris Glenn Milstead died at age forty-two in 1988, *People* magazine called him "the Drag Queen of the Century," and, to generations of midnight moviegoers, he was Number One even if he did eat Number Two in *Pink Flamingos*.

In his short life, the man the world knew as Divine made only a handful of feature films, but, thanks to him, cross-dressing—not to mention canine coprophagy—would never be the same, on-screen or off.

Born in 1945 in the staid Baltimore suburb of Towson, Maryland, the effeminate only child of upper-middle-class parents, Milstead blossomed into a full-fledged—and full-figured—big-screen diva when, in his early twenties, he fell under the creative spell of outlaw filmmaker John Waters in the 1960s.

"John was not interested in drag, per se. He was interested in scaring people," says film critic Dennis Dermody, whose offbeat blog appears on originalcine-maniac.com and who has been a close friend of Waters for more than forty years. "He had a nightmare drag vision that was the opposite of what drag queens found pretty." That vision was Divine, a criminally outrageous queen who was to drag what punk rock would become to music.

"Drag queens were squares then. They wanted to be Miss America," Waters said in a 2015 interview with *Baltimore* magazine. "Divine frightened them because he would show up with a chainsaw. He broke every rule."

Painted to within an inch of his life by Van Smith, Divine became a cartoon version of Hollywood sexi-ness. At more than three hundred pounds, he was an even-more-outsized Jayne Mansfield. Waters drew his inspiration for Divine's character from Argentine sex bomb Isabel Sarli of the 1969 nymphomaniac pot-boiler *Fuego*, and Clarabell the Clown from *The Howdy*

OPPOSITE: Divine is Babs Johnson, the filthiest woman alive, in John Waters's classic 1972 comedy Pink Flamingos.

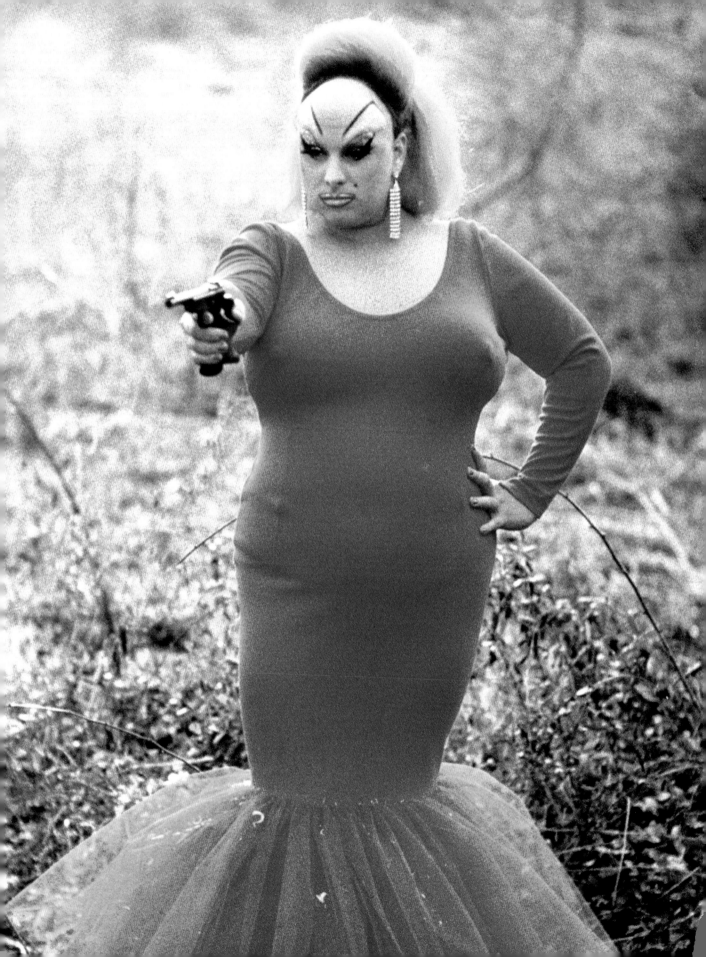

Doody Show in the late 1940s. "You look at Divine in *Pink Flamingos* and that all starts to make sense," says Dermody. Burlesque icon Blaze Starr was an influence, too, Waters has said.

Divine's greatest screen triumph was playing the juvenile delinquent–turned–fashion model Dawn Davenport in what fans consider Waters's best film, 1974's *Female Trouble*. But she was dogged by her on-screen antics in *Pink Flamingos*. "Having to be the actor who ate dog shit was something that was always going to be over his head when he was trying to get other roles," says Dermody. But Divine did get them, and, with each passing year, garnered more acceptance from the mainstream.

When Waters paid homage to the great melodrama director Douglas Sirk with the 1981 comedy *Polyester*, Divine played *hausfrau* Francine Fishpaw opposite 1950s heartthrob Tab Hunter. Dermody, who spent time on the *Polyester* set, says, "Tab loved Divine. But Divine was so nervous. This was the guy from *Damn Yankees* and they were going to do a love scene."

Hunter teamed up again with Divine in Paul Bartel's 1985 western spoof, *Lust in the Dust*. In it, Divine played Lainie Kazan's twin sister. That same year, in Alan Rudolph's neo-noir picture *Trouble in Mind*,

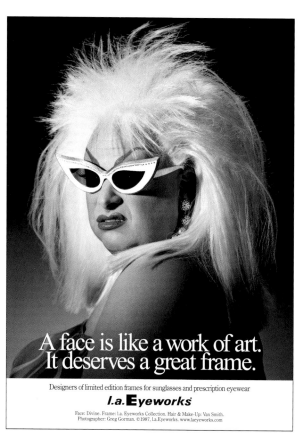

A face is like a work of art.
It deserves a great frame.

Designers of limited edition frames for sunglasses and prescription eyewear
l.a.Eyeworks

Face: Divine. Frame: l.a. Eyeworks Collection. Hair & Make-Up: Van Smith.
Photographer: Greg Gorman. ©1987, l.a.Eyeworks. www.laeyeworks.com

Divine appeared out of drag as a corpulent gangster named Hilly Blue, a character that *Time Out London* described as "a local Sydney Greenstreet, unexpectedly incarnated by a poised Divine."

Divine's work was not limited to the screen, of course. In 1972, he appeared onstage with the infamous Cockettes in San Francisco. Stephen Holden in the *New York Times* noted that "when Divine flew to San Francisco to perform with the drag troupe the Cockettes, he was greeted like a visiting dignitary."

A few years later, Divine took to the stage in New York, appearing in such underground productions as *Women Behind Bars* in 1976 and *The Neon Woman* in 1978. In the early 1980s, he toured in a cabaret show that was filthy fun.

Although told he couldn't sing, Divine launched a recording career that proved the naysayers wrong. Beginning with his character's personal anthem, 1980's "Born to Be Cheap"—a 45-rpm single backed with a naughty version of the novelty song "The Name Game"—he went on to score several international dancefloor hits with songs like "Native Love" and "Jungle Jezebel."

The greatest challenge for Divine—short of losing weight—was moving beyond a gay cult following. His transcendent moment came when he reteamed with Waters in 1988 to play Edna Turnblad, the doting

ABOVE: *Divine.*

mother to Ricki Lake's segregation-busting schoolgirl Tracy, in *Hairspray*. The most mainstream of John Waters's films, *Hairspray* opened to the most glorious reviews of Divine's career.

Janet Maslin in the *New York Times* wrote, "Divine barges through the film in a housedress and pin-curls, looking something like a wildly dressed refrigerator but sounding a lot more amusing."

After *Hairspray* opened, Divine was riding on a high that, for once, wasn't induced by his beloved marijuana. He was cast in a male guest-starring role as Uncle Otto on the popular Fox sitcom *Married… With Children*.

It was the gig he'd dreamed of, one that would allow him to distance himself from the dresses and the heels. "My favorite part of drag is getting out of it," Divine once said. In a 1976 interview, he added, "I don't do Judy Garland or Mae West, and I'm not a female impersonator. I'm an actor." While in Los Angeles preparing for the sitcom role, however, Divine died. The world found out he'd passed when he didn't show up on the *Married… With Children* set for rehearsal.

Divine's autopsy blamed his death on hypertrophic cardiomyopathy, essentially an enlarged heart, brought on by obesity. United Press International reported that about four hundred people attended Divine's funeral back in Baltimore. Other reports noted that floral tributes came from Elton John, Tab Hunter, and Whoopi Goldberg, whose note read, "See what a good review will do." The cast and crew of *Married… With Children* reportedly sent flowers with the message, "If you didn't want the job, all you had to do was say so."

"He was my Elizabeth Taylor," Waters said in the 2000 documentary *Divine Trash*. "He was an actor who started his career as a homicidal maniac and ended it playing a loving mother, which is a pretty

★ ★

"He was an actor who started his career as a homicidal manic and ended it playing a loving mother."

—John Waters

good stretch, especially when you're a three-hundred-pound man."

Divine achieved immortality of a sort the year after he died when, in 1989, Disney released *The Little Mermaid*. Ursula the Sea Witch, the movie's voice-stealing villain, is clearly based on Divine's curvaceous badness. Other posthumous tributes have followed. Melissa McCarthy was photographed in *Pink Flamingos* drag for an *Entertainment Weekly* cover story in 2011. Divine was the subject of Jeffrey Schwarz's 2013 documentary *I Am Divine*. Fashion designer Adam Selman, best known for creating costumes for Rihanna, based his Fall 2015 collection on Divine and her bad-girl cohorts in *Female Trouble*. Meanwhile, Annaleigh Vytlacil, a biologically female drag queen (or "bio-queen") from Milwaukee, discovered *Hairspray* at age 12 and has since become a leading Divine impersonator, named Divine Trash.

Fans like her frequently visit Divine's grave in Towson, Maryland—leaving messages and occasionally doughnuts on his tombstone—and new audiences continue to discover his work. One of Divine's earliest collaborations with Waters, *Multiple Maniacs*, was released on Blu-ray by the Criterion Collection in 2016, and *Female Trouble* got the same deluxe treatment in 2018.

"Divine was one in a million," says Dermody.

The late actor's mother, Frances, who wrote the 2001 memoir *My Son, Divine*, didn't quite grasp how beloved Divine was until long after he was gone. "It makes you feel good that people remember," she told the Baltimore Sun in 2000. "I guess they'll never let him die."

Never.

Factory Girls

AN APPRECIATION

"You must always be yourself, no matter what the price."

—Candy Darling

Jackie Curtis, Candy Darling, and Holly Woodlawn. Andy Warhol "discovered" them. Lou Reed immortalized them. But it was director Paul Morrissey who captured them in all their glory in a series of underground films that, for a while, set the standard for drag on film.

These three transgender actresses—all name-checked in Reed's classic song "Walk on the Wild Side"—were Warhol "superstars" who tripped the light glam-tastic in the 1970s. New York City scene-makers, they starred in the underground movies *Trash*, *Flesh*, and *Women in Revolt*, which even today remain strangely funny, oddly moving, must-see art films.

Jackie Curtis was born John Holder Jr. in 1947 in New York City and worked as both a man and a woman throughout her career. Warhol called Curtis "a pioneer without frontier." An Actors Studio–trained performer, poet, and playwright, she appeared in both 1968's *Flesh*—a low-rent *Midnight Cowboy* starring Joe Dallesandro—and the 1972 women's-lib satire *Women in Revolt*.

She wrote such plays as *Lucky Wonderful* and *Vain Victory* and a retelling of the Frances Farmer story called *I Died Yesterday* that were produced in hip venues like La Mama and Theater for the New City. Interestingly for a habitué of downtown Manhattan, Curtis in 1973 had a role on an episode of *The Corner Bar*, a TV sitcom remembered solely for having the first recurring gay character on American television. She died, at age thirty-eight, of a drug overdose in 1985; her short life is chronicled in Craig Highberger's 2004 documentary *Superstar in a Housedress*.

Candy Darling, who starred along with Curtis in *Flesh* and *Women in Revolt*, was born James Slattery,

but escaped his Long Island childhood, moved to Manhattan, and spun himself into Candy.

"Beautiful as a boy, Jimmy was spectacular as a woman," Hilton Als of the *New Yorker* wrote in 2011. That was the year the feature-length documentary *Beautiful Darling*, directed by James Rasin, was released. Reviewing the film, Als said that Candy mixed "Kim Novak's champagne-blond realism and the sarcasm it took to protect Darling's dreams, which included movie stardom of her own."

She achieved that, on an underground scale, in the Morrissey films—and in Mervyn Nelson's infamous 1971 gay film *Some of My Best Friends Are*—playing both Karen and Harry. She had a role in the 1972 horror film *Silent Night, Bloody Night* and a cameo in *Klute*, too. Darling's most mainstream stage role was in Tennessee Williams's *Small Craft Warnings* in the early 1970s.

More widespread notoriety came long after her death of lymphoma at age twenty-nine in 1974. Stephen Dorff played Candy in the 1996 film *I Shot Andy Warhol* and, fifteen years later, real-life drag queen and actor Willam Belli was Darling in the 2011 HBO drama *Cinema Verite* (based on the reality series *An American Family)*.

Holly Woodlawn really did come from "Miami, F-L-A" to New York City, as "Walk on the Wild Side" says, but she was born in Puerto Rico in 1946 as Haroldo Santiago Franceschi Rodriguez Danhakl. Her childhood was a hand-to-mouth existence and in her teens, she turned tricks to survive, according to her 1991 memoir *A Low Life in High Heels*.

After moving to Manhattan and insinuating herself with the Warhol crowd in the late 1960s, Woodlawn

appeared in Curtis's plays, acted alongside her in *Women in Revolt*, and gave what is undoubtedly her greatest performance in Morrissey's *Trash*. Her 1970 portrayal of the garbage-scavenging lover of a heroin addict, played by Joe Dallesandro, was so good that the legendary director George Cukor reportedly petitioned the Academy to nominate Woodlawn for an Oscar.

The *New York Times* critic Vincent Canby wrote of *Trash*, "Holly Woodlawn, especially, is something to behold—a comic book Mother Courage who fancies herself as Marlene Dietrich but sounds more often like Phil Silvers."

Although she continued to face tough times throughout her career—moving from place to place, doing menial work outside of show business—Woodlawn triumphantly returned to the stage in her senior years, performing to sold-out cabaret audiences on the (high) heels of her memoir.

She also was seen on-screen in Madonna's "Deeper and Deeper" video in 1992, the gay comedy *Billy's Hollywood Screen Kiss* in 1998, and, shortly before her death, on two episodes of *Transparent* in 2014.

When Woodlawn died at age sixty-nine in 2015 in Los Angeles, the *L.A. Times* quoted a 2007 interview she had given to *The Guardian*. Regarding her time in the spotlight, Woodlawn said, "I felt like Elizabeth Taylor. Little did I realize that not only would there be no money, but that your star would flicker for two seconds and that was it. But it was worth it, the drugs, the parties. It was fabulous."

The flames of their fame flickered for a lot longer than two seconds. Warhol would have clocked it at no less than fifteen minutes.

ABOVE: Warhol superstar Holly Woodlawn and her pussycat.

Big Screen Realness

THE QUEENS OF PARIS IS BURNING

Pepper LaBeija's 2003 *New York Times* obituary called her "the last of the four great queens of the modern Harlem balls."

She was one of the stars of *Paris Is Burning*, Jennie Livingston's award-winning 1990 film documentary that, along with Madonna's 1990 hit "Vogue" and Malcolm McLaren's 1989 song "Deep in Vogue," introduced mainstream audiences to the culture of upper Manhattan drag competitions.

The Mother of the House of LaBeija—known for her "glamorous bravado," in Livingston's words—was only fifty-three when she died of a heart attack. She followed Dorian Corey, Angie Xtravaganza, and Avis Pendavis, all featured in the film, to premature spots on the Great Dance Floor in the Sky. Corey died of AIDS at fifty-six in 1993. Xtravaganza passed at twenty-eight that year, too. Pendavis left us in 1995.

Paying tribute to LaBeija and her cohorts, the *Times* wrote, "These four exuded a sort of wild expressionism that might make Las Vegas showgirls seem tame." Certainly, this quartet of ball walkers were among the biggest stars to emerge from the Harlem scene, a largely African-American and Latino phenomenon that dates back to the early twentieth century.

The film, Livingston always said, was not about the dance, but something far greater. At its core, *Paris Is Burning* was about learning to thrive in a culture of oppression. "It's about people who have a lot of prejudices against them," she said, "and who have learned to survive with wit, dignity, and energy."

Coverage of Angie Xtravaganza's memorial noted how tough the lives of those depicted in *Paris* continued to be even after the film's success. Walking the balls had been their salvation and would continue to be. "For Dorian and for many of Angie's other mourners, drag is not a means of destruction but of rescue— a little beauty, however perverse and rococo," Jesse Green wrote in a 1993 *Times* story headlined "Paris Has Burned." At that service, Green noted, a prayer circle was formed and one mourner said, "Remember, we are all legends."

That was, and now more than ever is, true.

Corey, however, was not fazed by the notoriety that came her way after her star turn in *Paris Is Burning*. She had tasted fame in the 1960s while touring in the Pearl Box Revue, a black drag cabaret, and was featured on the album *Call Me MISSter*, produced by Billy Guy, one of The Coasters. "I was in show business for years," she said, "so when my fifteen minutes finally came, it was gravy."

Her story didn't end without one final, shocking twist. After Corey passed, a partially mummified corpse was found in a suitcase in her apartment among her belongings. The discovery prompted a 1994 *New York* magazine cover story, "The Drag Queen Had a Mummy in Her Closet." It was her greatest moment of fame.

As for *Paris Is Burning*, the forever-fascinating documentary was added to the National Film Registry in 2016 alongside such mainstream hits as *The Lion King*, *The Princess Bride*, and *The Breakfast Club*. And, in 2018, the film served as inspiration for the hit FX TV series *Pose* starring Tony Award–winner Billy Porter (*Kinky Boots*) and a bevy of transsexual actresses.

Ladies with an attitude, indeed.

OPPOSITE: Dorian Corey and Pepper LaBeija, two of the stars of Jennie Livingston's 1990 documentary Paris is Burning.

TV ON TV

"You don't have to be a thing of beauty to be a joy forever."
—Geraldine Jones

As had been the case in much of twentieth-century cinema, men who were the least likely candidates for male-to-female transformation—the manliest, hairiest actors in Hollywood—were usually cast when it came time to cross-dress on TV. Bugs Bunny in a headdress of tropical fruit made a more convincing woman than most of them! But under pounds of pancake and teetering on too-high heels, these unlikely drag performers found their calling in TV comedy.

Whether it was the strapping Max Baer Jr. playing a backwoods she-beast named Jethrine Bodine on *The Beverly Hillbillies* in the 1960s, the hirsute Jamie Farr as Corporal Maxwell Q. Klinger, a picture-hat-happy soldier forever seeking a discharge from the army, on *M*A*S*H* in the 1970s, or, in the 1980s, Tom Hanks and Peter Scolari in wigs to snag the cheapest apartment in New York City on the most famous cross-dressing sitcom in American TV history, *Bosom Buddies*, these guys were little more than sight gags in garter belts. But that 1980–82 series, with its tagline "Friendship can be a real drag," was TV's answer to *Some Like It Hot*, and it's fondly remembered as the pinnacle of small-screen drag.

Doing drag has been popular on television for as long as the medium has existed because it "was never a diminishment of one's masculine self to do drag, it was just a way to be as outrageous as possible," says senior critic for *TV Guide* magazine Matt Roush. These guys looked nothing like a dame, but that didn't matter. In fact, their untarnished masculinity was the very point of their drag.

No one did more to popularize cross-dressing on early television than Milton Berle. A rabbit-faced vaudevillian, Berle was renowned for two things: stealing other comics' jokes and possessing a *schwanse* of legendary proportions. He was dubbed "Mr. Television" when his variety show *Texaco Star Theatre* became the toast of the nation in 1948, and, as for his member, it was a hell of a lot bigger than the seven-inch screens that America watched him on.

"Tuesday night was Berle Night," wrote Arthur Shulman and Roger Youman in their exhaustive 1966 assessment of TV's first Golden Age, *How Sweet It Was*. The program was such a must-see in those days that less-fortunate neighbors filled the living rooms of early TV owners, and crowds gathered outside appliance stores to watch "Uncle Miltie" through plate-glass windows.

"Berle was a major factor in establishing the popularity of the new medium," the authors noted, "and he was undoubtedly responsible for the purchase of the first television set in many households."

Berle also happened to be TV's first drag superstar.

The comedian—heterosexual by almost all accounts—got his biggest laughs whenever he donned a dress. "For me, drag is another way to get laughs," Berle wrote in his eponymous autobiography. Over the years, he zestfully played Cleopatra and countless other camp cuties. In May 1949, he appeared dressed as Carmen Miranda on the cover of *Newsweek*, which called him "television's whirling dervish."

Berle revealed that he learned the power of cross-dressing when, as a young performer, he snuck into the drag balls of Harlem—the same kinds of underground events that many decades later were immortalized in the documentary *Paris Is Burning*. The ferocity Berle observed on the floors of those hallowed uptown halls inspired him to become a clown in a gown.

"My drag is too gay to be gay," he once said. His cross-dressing was pure comedy. Ladies and germs, the guy wasn't pretty, but, man, was he a riot in a dress. In drag, he famously complained to his audience, "What you have to go through for a lousy $15,000 a week!"

Drag became the signature of Berle's career, whether playing a matronly aunt on *The Lucy-Desi Comedy Hour* in 1959 or a less-than-dreamy genie on *Donny and Marie* in 1976. Even in his seventies, he rocked a frock in the video for Ratt's 1984 heavy metal hit, "Round and Round." Eleven years later, he dressed up as a frightful Jane Fonda in a hot-pink unitard and leg warmers for a 1995 "low-impact / high-comedy" exercise tape aimed at seniors. In drag, also that year, on Roseanne, Berle caught the bouquet at one of the first gay weddings ever on TV on *Roseanne*.

OPPOSITE: Berle making an asp of himself as Cleopatra on The Milton Berle Spectacular *in 1962.*

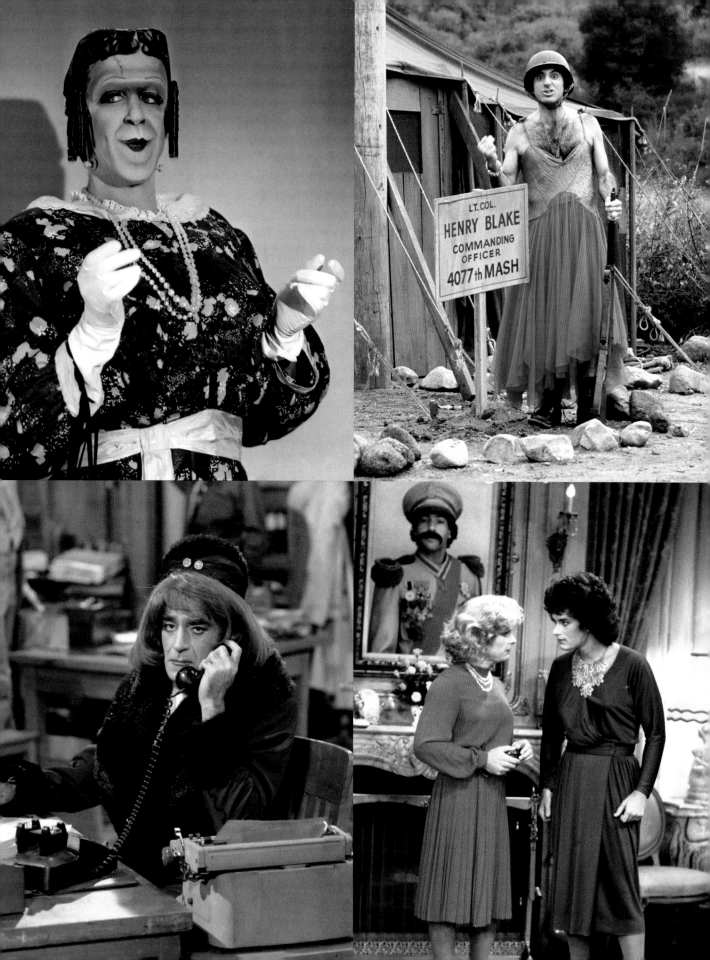

Show-business historian Anthony Slide writes in his 1998 book *Eccentrics of Comedy* that Berle "helped keep alive the comic art of female impersonation, providing a direct link with the impersonators from the 'golden age' of the teens and twenties to the present. By the very grotesque and eccentric qualities of his female characterizations, he made the art form—and it is an art form—respectable for an often bigoted and oversensitive America."

The fact that it was Milton Berle—the man with the "meatiest tuck" in show business—wearing all those dresses wasn't ironic; it was the point of drag on television in the twentieth century. Generations before RuPaul brought gag-worthy glamour to primetime, drag on television usually involved a man in a dress looking ugly but still being mistaken for an actual woman by everyone around him.

On a 1952 episode of *I Love Lucy* called "Ricky Asks for a Raise," curmudgeonly landlord Fred Mertz (William Frawley) was transformed from a portly codger in ultra-high-waisted pants into a blonde-tressed dowager, and no one notices she's a he when she shows up at the Tropicana nightclub.

In 1966, on *The Munsters*, the fantasy sitcom about a middle-class family of ghouls, Frankenstein monster–look-alike Herman Munster (Fred Gwynne) was zapped by thousands of volts of electric current and turned into a woman. He may well have been television's first trans character. In the episode, titled "Just Another Pretty Face," "Aunt Herman" was no Candis Cayne, but that didn't stop her from finding a job as a cocktail waitress. "Don't let the customers get fresh," his wife, Lily (Yvonne De Carlo), counseled as she left for work. Drag Herman looked like Boris Karloff in barrel curls, but she still got wolf whistles as she walked out the door, from her father-in-law (Al Lewis) no less!

In 1968, a drag sitcom called *The Ugliest Girl in Town* told the story of Hollywood talent agent Timothy Blair (Peter Kastner), who pulled the wool over Carnaby

Street's eyes as "Timmie," a female model in swinging London. He did this, of course, so he could spend time with the British woman he loved. The show lasted only four months on ABC, but made quite an impression. In 2002, *TV Guide* ranked it number eighteen on a list of the fifty worst TV shows of all time. "I'm not really sure what the point of that show was," says Roush.

Almost a decade later, *Godfather* character actor Abe Vigoda made for the ugliest girl in Manhattan on a 1977 episode of *Barney Miller* called "Group Home," when his character, Sergeant Phil Fish, drew mugging detail. In drag, Vigoda looked like a Great Neck widow, but the cop still got hit on in a city park by a lonely heterosexual man (Phil Leeds) who offered him twenty dollars for sex. In old-lady drag, Fish was fishy enough to get a straight man to jump ship.

In 1979, *Laverne & Shirley*'s brewery buddies Lenny (Michael McKean) and Squiggy (David L. Lander) "put the 'gore' in angora" when they masqueraded as members of a girl gang in an episode called "Bad Girls." Renamed "Lenore" and "Squendelyn," they got picked up by sailors. "We was gonna tell them the truth immediately, but they were big spenders," Squendelyn explains. The last we hear of these "Angora Debs" is Lenore, offscreen, screaming, "I'm not that kind of girl!"

Even in commercials, such haggy drag ruled the twentieth-century airwaves. In a series of commercials for Dunkin' Donuts in the 1980s, plus-size pastry pitchman Fred the Baker (Michael Vale) wedged himself into a housedress to check out the freshness of his competitors' baked goods. Hiding his mustache with his index finger, he was enough to make you toss your Munchkins. But audiences ate it up.

Only one man ever really managed to get away with looking sexy in drag on a regular basis on television in the twentieth century and that was comedian Flip Wilson on his groundbreaking variety show *Flip*, beginning in 1970. "He really sold that character," says Roush.

OPPOSITE, CLOCKWISE FROM TOP LEFT: Herman Munster (Fred Gwynne) transformed by a bolt of lightning into Aunt Herman on The Munsters; *Corporal Klinger (Jamie Farr), forever looking for a discharge from the army, on* M*A*S*H; *Henry Desmond (Peter Scolari) and Kip Wilson (Tom Hanks) as their alter egos, Hildegarde and Buffy, on the ultimate drag sitcom, 1980–1982's* Bosom Buddies; *Abe Vigoda ready to go on a stakeout on* Barney Miller.

With the exception of Wilson, a man who actually looked *good* in drag was often too creepy for prime-time audiences in those days. "Men dressed as women on television never lost their man-selves within the masquerade because that would have been too unsettling," says Roush.

To be accepted by the viewing public in those days, a man in a dress had to look like a man in a dress—Harvey Korman with ginormous bosoms as the super-duper Jewish Mother Marcus on *The Carol Burnett Show* in the 1960s and '70s, for instance. Everyone around him remained somehow blind to five o'clock shadow, oblivious to the Adam's apple, unmindful of man-hands, no matter how obvious.

That has often been the TV drag trope.

Archie Bunker (Carroll O'Connor), for instance, had no idea in a 1975 episode of *All in the Family* called "Archie the Hero" that the fainting woman he'd picked up while moonlighting as a cabdriver and then performed mouth-to-mouth resuscitation upon was no lady, but rather a female impersonator. The character, Beverly LaSalle, was played by real-life drag queen Lori Shannon. "She was great," says series creator Norman Lear. "She was a performer in San Francisco. I saw her up there and I loved her and brought her down to do the show."

Beverly was such a hit with TV audiences that Lear brought her back twice more. During her third appearance, "Edith's Crisis of Faith, Part 1," though, Beverly was murdered. Even on shows with the best of intentions, that was the typical fate of drag characters on television in those days. Another notorious death occurred when the legendary drag performer Charles Pierce, playing a "bald lady spy," was thrown off a speeding train on a two-part 1980 episode of *Laverne & Shirley* called "Murder on the Moosejaw Express."

To its credit, *All in the Family* treated the death of its recurring drag queen character as tragedy, not comeuppance. "Society was changing and we all had to deal with it, even someone as closed-minded as Archie Bunker," says Roush. But the underlying message that remained, he says, was, "If you were living that life, you weren't going to live a long one."

It wasn't completely unheard of to see cheerful, almost celebratory cross-dressing on sitcoms, talk and variety shows, and even children's programs. *Bewitched* favorite Paul Lynde, who did drag in the 1966 Doris Day movie *The Glass Bottom Boat*, for instance, appeared as a wicked witch on a 1969 children's game show called *Storybook Squares*, famously cracking, "I love kids but I can't bear 'em." On the sitcom *Soap*, controversial when premiered in 1977, Billy Crystal's

ABOVE LEFT: Beverly La Salle, played by real-life female impersonator Lori Shannon, reveals her true self to her date Pinky Peterson (Eugene Roche) on a 1976 episode of All in the Family. *ABOVE RIGHT: Harvey Korman as Mother Marcus in a 1973 sketch on* The Carol Burnett Show.

proto-gay character Jodie Dallas had a penchant for dresses—"You wear that belted!" his mother said, catching him in her closet—and got laughs.

Most notably, the consummate "gender illusionist" Jim Bailey appeared on numerous shows from the milquetoast afternoon staple *The Mike Douglas Show* to the mainstream sitcom *Here's Lucy* dressed as everyone from Barbra Streisand to Phyllis Diller, and made no apologies for dressing in women's clothing.

A drag queen on a cop show was doomed, however.

"You were basically seen as tragic and deluded, somebody to be either pitied or killed, or you were psychotic or damaged enough that you would be killing people," says Roush.

One of the most notorious examples was a 1974 episode of *The Streets of San Francisco*, the crime drama starring Karl Malden and Michael Douglas. In the installment called "Mask of Death," Disney song-and-dance-man John Davidson played a schizophrenic female impersonator named Ken Scott. He does a mean Carol Channing impression—Craig Russell supplied the singing voice—but the female half of his personality, Carol Marlowe, is a murderess.

When Jim Bailey guest-starred on *Vega$* oppo-

site Robert Urich in 1980, he played a Judy Garland impersonator who was getting death threats. In the episode called "The Man Who Was Twice," he is nearly stabbed to death while singing "The Man That Got Away." It turns out, he is his own stalker. Like Ken Scott on *Streets*, he has a dual personality, a bloodthirsty alter ego out of control.

By 1984, on an episode of *Murder, She Wrote* entitled "Birds of a Feather," things got better in the portrayal of drag queens on television drama, but only slightly. Author-turned-sleuth Jessica Fletcher (Angela Lansbury) flies to San Francisco for the wedding of a niece who fears her fiancé, a struggling actor played by Jeff Conaway, is cheating on her. They attempt to catch him in the act, but instead catch him in his *drag* act at a nightclub. "I'm not particularly proud of what I had to do to earn that money, but I did it," Conaway says, explaining away his momentary lapse into onstage transvestism.

At least he didn't die.

A drag queen who made it to act four was rare on a television drama, but rarer still were male actors cast in actual female roles. In 1966, Boris Karloff played an elderly female assassin out for April Dancer (Stefanie

ABOVE: Wanda Wayne (Jamie Foxx) and her magic fingers will "rock your world" on In Living Color.

Powers) in an infamous episode of *The Girl from U.N.C.L.E.* called "The Mother Muffin Affair." The master of movie horror played she. Period.

It took nearly forty years for a man to again play a female role of any note in primetime. That came in 2002 when Dame Edna Everage was cast as client–turned–law office secretary Claire Otoms on the David E. Kelley series *Ally McBeal*. She was revealed to be Barry Humphries only in the end credits.

In the decades between April and *Ally*, something wonderful *did* happen that changed the state of drag on television forever—the rise of the countercultural sketch comedy show.

Beginning with *Monty Python's Flying Circus*, which arrived in America from Britain via PBS in 1974, sketch comedy shows generally brought a more sophisticated approach to TV drag. *Python* and late-night comedy shows like *Saturday Night Live*, which followed in the fall of 1975, and *SCTV* (*Second City TV*), which swooped down from Canada in 1976, gave audiences men actually playing female characters, albeit outsized, hilarious ones.

Some sketch shows like *In Living Color* still relied on ugly drag for comedy. On that popular series, which ran on Fox from 1990 to 1994, Jim Carrey played a double-jointed female body builder named Vera de Milo who whinnied when she got worked up, and Jamie Foxx famously played Wanda Wayne, who promised to rock every man's world with one sloppy kiss.

On the *SNL* knockoff *Fridays*, a pre-*Seinfeld* Michael Richards proved how shrill he could be in drag as a blonde named Beverly Hills, who screamed, "Oh, shut up!" But on shows like *Saturday Night Live*—and later on such shows as *Kids in the Hall*, *Little Britain*, and *Key and Peele*—there was room for drag that had more in mind than just how heinous a man could look in hosiery.

The members of *Monty Python* cross-dressed to satirize British middleclass mores, playing hen-party harridans with names like Mrs. Scum and Mrs. Non-Gorilla. *SCTV* took an absurdist tack when it gave us John Candy impersonating real-life drag star Divine flying over crowds at the Melonville War Memorial Auditorium in

a production of *Peter Pan*, or ice-skating on a Christmas special surrounded by chorus boys and singing "Santa Bring My Baby Back to Me."

On *Saturday Night Live* in a classic 1978 spoof of *The French Chef*, the doughy Dan Aykroyd played Julia Child, looking and sounding as much like her as Meryl Streep did in the 2009 movie *Julie & Julia*. The audience shrieked with laughter, but not when they first laid eyes on Aykroyd dressed as the famous TV chef—this wasn't Milton Berle batting cat eyes. Instead they waited to howl until she cut herself with a very sharp knife while deboning a chicken. Aykroyd hemorrhaged all over the set like a plasma fountain in a kitchen apron. Audiences had never seen that much blood—or such subversive drag—on television before.

In forty-plus seasons of *SNL*, other male cast members memorably have played real women, from John Belushi's voracious version of Elizabeth Taylor, who almost choked to death on a chicken leg, to Terry Sweeney's brilliantly biting impersonation of brittle First Lady Nancy Reagan, to Fred Armisen's quirky takes on Penny Marshall and Joy Behar.

With little diversity in the *SNL* cast over the years, African-American men have had to play women on the show. Garrett Morris took diva turns as Tina Turner and Diana Ross in the 1970s; Tracy Morgan impersonated Sherri Shepherd, Missy Elliott, and LaWanda Page in the 1990s; and Kenan Thompson, who joined *SNL* in 2003, became known more for his versions of Maya Angelou, Oprah Winfrey, Raven Symone, Chaka Kahn, and Whoopi Goldberg than for most of his male characters.

Some of *Saturday Night Live*'s most popular characters over the years have been men in drag, too. Among the most memorable are Dana Carvey's always-superior "Church Lady," whose "Isn't that special?" became a national catchphrase; Mike Myers's Streisand-worshipping "Coffee Talk" show host Linda Richman; and Adam Sandler, David Spade, and Chris Farley's trio of "Gap Girls," who gave a deep voice to low blood sugar when Farley warned, "Lay off me, I'm starving!"

When it works, it works.

"Drag is like anything else in sketch comedy. If it's funny and people are laughing, it's got a wonderful place," says Andy Samberg, who appeared on *SNL* from 2005 to 2013 and who famously put on heels and a bodysuit in 2008 to parody Beyoncé's "Single Ladies" video. Audiences, he says, will laugh at a cross-dressing sketch that "is attached to a solid premise and that has a point, and is funny." But the comedy has to be character-based to fly in an era when real drag queens are getting laughs on their own terms on shows like *RuPaul's Drag Race*.

Samberg says his former castmate Fred Armisen always knows how to get drag right. "When he does it, it's very much done with care. It's not, 'Can you imagine a guy dressed in women's clothes?' It's more, 'Here's this tic that this girl I know has and I want to do a character based around it.'"

After more than a decade on *Saturday Night Live*, Armisen went on to play various female characters on *Portlandia* beginning in 2011. On *Documentary Now!*, which premiered in 2015, Armisen played a Big Edie–like crackpot in a crumbling mansion in a spoof of *Grey Gardens* on one episode.

To prove just how much drag has changed on television since the days when the mere sight of a man in a dress was enough to evoke screams of laughter, one needs only look at a 2012 show called *Work It*. With a tagline of "And you thought your job was a drag," the short-lived series about two unemployed car salesmen (Benjamin Koldyke and Amaury Nolasco) who cross-dress to find work as pharmaceutical reps was so out of step with modern attitudes toward drag that it made *Bosom Buddies* seem like *Paris Is Burning*.

"What made people hate it so much was just how retro and stale it felt because our image of drag had moved beyond all that thanks to the fabulousness we see on *RuPaul's Drag Race*. It just seemed so incredibly stupid," says Roush.

Drag Race, which premiered in 2009, has shed light on what it's like to do drag and introduced audiences to the men behind the face paint and falsies. The reality competition show has allowed audiences to see drag queens not only looking fabulous, but as people

with lives and loves, families and friends. Arriving at a time when the LGBTQ equality movement was making historic strides, the series forced television to up its game when it comes to drag.

The hairy-lug-in-high-heels TV stereotype just won't fly with modern audiences who are used to seeing a glamazon like RuPaul—or Alex Newell as the gender-fluid Unique on *Glee*—doing their fierce thing, or comedian Louie Anderson bringing a bushelful of pathos to the role of a rodeo clown's passive-aggressive mother on *Baskets*, for which he won an Emmy in 2016.

The exponential growth of TV outlets—from niche cable channels like Logo to such streaming services as Netflix, Hulu, and Amazon—have let drag become something more than a joke on television. Gender roles can now be seriously examined, even in the funniest comedies, and characters can explore their identities in ways that TV never has let them before.

Certainly, Jeffrey Tambor's portrayal of a late-in-life transsexual on *Transparent*, which premiered on Amazon in 2014, was a more sensitive a portrayal of a woman being liberated from the masculine vessel in which she was born than TV ever saw in the twentieth century. Maura Pfefferman was no stereotypical drag role, no mere man in a dress. As one of the show's most high-profile fans, Norman Lear, the man who boldly cast a real-life drag queen on *All in the Family* in 1975, told me, "That character rides the line between heartbreak and hilarity perfectly."

It has been a long trip from Milton Berle on *Texaco Star Theatre* to shows like *Transparent* and *Pose* featuring transsexual characters in a multifaceted light, but it's been fun to watch. As *TV Guide*'s Roush says, "We've gone from grotesque to fabulous to real, and that, I think, is an interesting arc right there."

ABOVE LEFT: John Candy as Divine on SCTV

ABOVE RIGHT: Dan Ackroyd as Julia Child in 1978 on Saturday Night Live.

OPPOSITE: Flip Wilson as his Pucci-clad alter ego Geraldine Jones on his pioneering variety show FLIP.

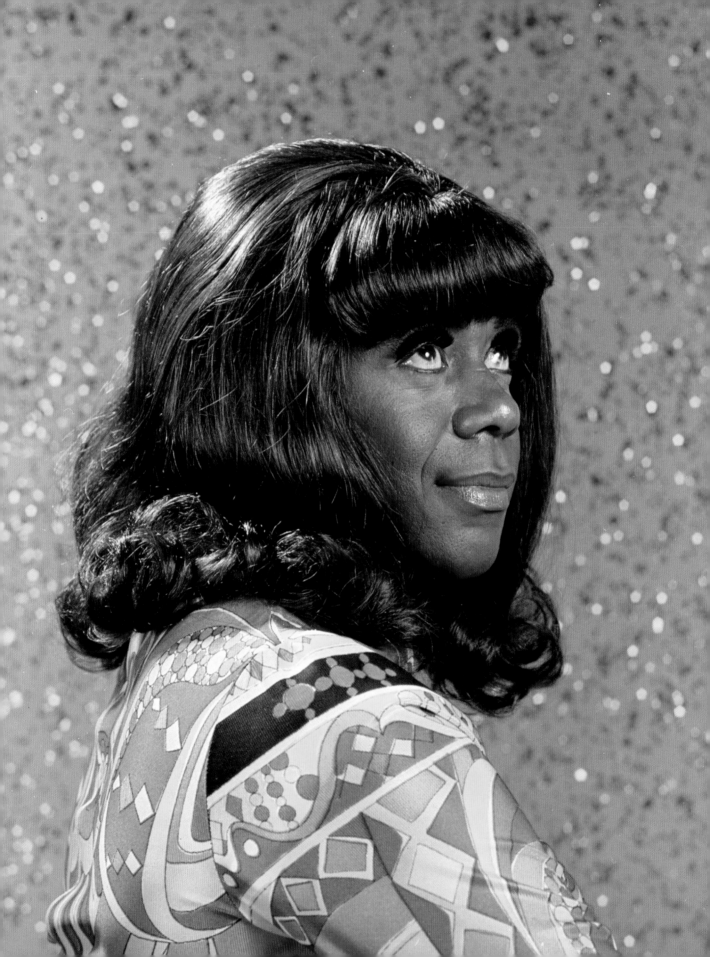

Flip Wilson

★ ★

The January 31, 1972, cover of *Time* magazine heralded Flip Wilson as "TV's First Black Superstar" and the Nielsen ratings for his groundbreaking 1970–74 variety series proved the headline wasn't just hype. At the height of its popularity, more than forty million people tuned in on Thursday nights to watch *Flip*.

Performed in the round, the NBC show was a crossover hit in an era of racial unrest, a very funny once-a-week pacifier during the Vietnam War years. Each installment of the hour-long show paired mainstream white guest stars like Perry Como and Phyllis Diller with hip African-American entertainers like Stevie Wonder and Richard Pryor. Joan Rivers and Mahalia Jackson on *one* show? The formula was irresistible to audiences of every stripe.

Without drag, though, the kind of Emmy-winning mega-success that *Flip* found on television would never have happened. When Wilson put on a flip wig and a Pucci minidress and created his most famous character, a fashionable feminist named Geraldine Jones, it was star time.

He had other characters—the wily Reverend Leroy, for instance—but they paled next to Geraldine. From the moment she arrived in 1969 on *The Flip Wilson Special* playing an airline stewardess who finds the feisty Maude Frickert (comedy legend Jonathan Winters in

old-lady drag) in one of her rows, she was a hit.

Geraldine quickly became the hottest "woman" on television, and landed on more magazine covers—*Ebony, Jet, TV Guide*—than Wilson did. In fact, she proved such a draw that she released her own Grammy-winning comedy albums, sold her own talking cloth doll, and spawned such culture-permeating catchphrases as "Don't fight the feeling!," "The devil made me do it," and "What you see is what you get!" Yes, Geraldine Jones was the original WYSIWYG girl.

In drag, Wilson delighted not only in cracking up his macho costars—including O.J. Simpson, whom Ger almost married in one skit—but also in making them uncomfortable with just how flirtatious she could be. Wilson had legs and Geraldine knew how to use them.

TV had never mined this kind of aggressively sexy drag comedy before. The joke had always been how ugly men looked in dresses and how men could never master heels. But Geraldine looked fabulous and, not only could Wilson walk in her shoes, he could also shuffle and glide, sway and sashay in them.

Dressed as a Playboy bunny for a 1972 episode, Geraldine confronts an inebriated conventioneer in a fez (played by crooner Bing Crosby) who sees her in rabbit ears and cracks, "Well, you've got to see it to believe it." Geraldine barks back, "Well, you better believe it, 'cause you ain't gonna get to see it."

Hilarious. But not everyone was comfortable with her popularity.

James A. Hudson, writing in a 1971 biography, *Flip Wilson: Close-Up*, said, "What seems to annoy Flip's black critics consistently, more than anything else, is his character Geraldine Jones." Hudson quotes a letter written to *Ebony*, "This Geraldine character is especially repulsive and degrading. The black woman has, for too long, been stripped of her femininity and beauty by a racist society."

Others complained that a black man doing drag on television tarnished the reputation of all African-American men. At the 1971 Emmy Awards, where Wilson's show picked up statuettes for Outstanding Variety Series and Outstanding Writing, host Johnny Carson quipped, "Flip's done a lot for the black man. He put him in a dress."

Geraldine wasn't Wilson's first time wearing one. As a grade-school kid in the poorest part of Jersey City, New Jersey—where Flip was born Clerow Wilson Jr. in 1933—he went on as Clara Barton for a classmate when she was struck with stage fright.

The character's high-pitched voice, which *Time* called "a sassafras falsetto," first sprang from an imitation that Flip did of a little girl welcoming her soldier brother back home. It was the same voice that Wilson, who'd come up through the so-called Chitlin' Circuit of African-American clubs in the 1950s and '60s, used for all his female characters: the reverend's wife who couldn't resist buying a new frock and explained, "The devil made me buy this dress," and "Queen Isabelle Johnson" who gave Christopher Columbus money to sail to the New World because he "gonna find Ray Charles" there.

For four seasons, *Flip* burned brightly—holding its own against *All in the Family* and other landmark shows of the 1970s—but, in 1974, it was canceled after nearly one hundred episodes.

★ ★

When Wilson put on a flip wig and a Pucci mini-dress and created his most famous character, a fashionable feminist named Geraldine Jones. it was star time.

For a time, Wilson put Geraldine in mothballs. But she reappeared in 1977 as a guest on a short-lived TV variety series called *3 Girls 3*, and, more memorably, in 1980 in a Diet 7-Up commercial set in a roller disco. A few years later, Geraldine performed at a 1983 tribute to Bob Hope at the Kennedy Center, flirting with then-president Ronald Reagan, and then resurfaced when Wilson hosted an episode of *Saturday Night Live* in its ninth season. Geraldine played the long-lost mother of Eddie Murphy's flamboyant hairdresser character, Dion.

Audiences never grew tired of Geraldine—even Bette Davis was a fan—but Wilson did. In his 2013 biography *Flip*, Kevin Cook quotes Gladys Knight, a costar in Wilson's short-lived 1985 sitcom *Charlie & Co.*, saying, "Flip hated Geraldine. He felt he'd created a monster." Flip made his peace with Geraldine before dying of liver cancer at age sixty-four in 1998. His *New York Times* obituary quoted the comedian, late in his career, saying, "She carried me longer than my mother did."

Flip was rebroadcast on TV Land from 1997 to 2005 and then on Magic Johnson's fledgling network Aspire. *Los Angeles Times TV* critic Robert Lloyd noted in 2013 that the Aspire website described Wilson as a "famed comedienne." The gender reassignment, he wrote, was "probably just a spelling error—but an appropriate one, given the character he's best remembered for: the sassy, sexual, self-possessed, fully inhabited, completely real Geraldine Jones."

Then again, maybe the devil made them do it.

A Moment with John Davidson

"They shaved off my eyebrows!"

—John Davidson

In 1974, actor John Davidson took on the role of a female impersonator named Ken Scott, whose alter ego, Carol Marlowe, murders men with a hat pin to the heart on *The Streets of San Francisco*, the gritty TV crime drama starring Michael Douglas and Karl Malden that ran for five seasons beginning in 1972.

To say it was a departure for a man best known, at that point, as the squeaky-clean star of such Disney musicals as *The Happiest Millionaire* and *The One and Only, Genuine, Original Family Band*, is an understatement.

But Davidson did it, and his performance has been called one of the best of his career. He looks back on it saying, "I could have been better in some places," but he doesn't regret his drag turn for a minute.

What led you to *The Streets of San Francisco*?

I'd done Disney films, and *The Girl with Something Extra* opposite Sally Field. I'd always done romantic parts. My manager and I were looking for something that was offbeat because I was trying to show some acting range. I was trying to do things that were a little bit more controversial or that had a little bit more depth.

How did you feel about playing a cross-dressing character?

I was nervous because I hadn't done it before. I rehearsed for several weeks with a professional drag artist, Craig Russell. We had long sessions about playing a woman and then exaggerating it to be a drag artist. We did a lot of rehearsal. The director would come in and make notes. We even did a little bit of video shooting to see how it looked.

What was the greatest challenge of shooting a drag role?

I was drinking water like crazy, and Tab, the diet drink. So at about noon, I had to go to the restroom. Now when you're in full drag, which restroom do you go to? So I thought, well, we're shooting in San Francisco, it's no problem here, I'll just run into the ladies' room. So I'm in there, taking care of business, and a lady walked in. She said, "What are you doing in here? This isn't right!" I said, "How'd you recognize me?" She said, "You were the only one standing."

OPPOSITE: John Davidson as Ken Scott/Carol Marlowe, a murderous female impersonator with a split personality, on the 1974 "Mask of Death" episode of The Streets of San Francisco.

WORKING THE RUNWAY
Chris March

"Drag can set your spirit free!"
—Chris March

No one creates oversized style quite like *Project Runway* season four alumnus Chris March. Whether done up as the world's most famous superheroine, a cheese-food-clad glamour goddess, a plus-size Christina Crawford, or the most buxom Elvira impersonator in the business, March can pull together a big look.

Over the years, he has dressed everyone from movie queen Meryl Streep to Prince, made outfits out of lettuce for a Wishbone salad dressing fashion show, created costumes for the long-running San Francisco revue *Beach Blanket Babylon*, and even did a line of Halloween wigs for Target.

With the mantra "Get in touch with your wild side through hairspray and sequins," March makes the world a more sparkly place.

How does drag fit into all you do?
I suppose I am technically a drag queen, but I don't make a living performing in drag. Drag lets me tap into the psyche of female power and I can translate that into fashion to make a woman feel fabulous and invincible.

What did your time on Project Runway **mean to your career?**
Project Runway gave me validity as a designer on a national level, and turned me into a "TV personality." It's so much fun to be recognized and hear stories about how you truly affected people's lives. I've gotten to meet and work with huge celebrities, and, let's face it, I made that white dress for Meryl Streep at the Oscars, so I can die happy.

Your drag creations tend to be enormous. Is your giant version of Wonder Woman your greatest hit?
Wonder Woman is definitely the most popular. It's funny because I knew nothing about her. I only made the costume because I had sixteen dark brown wigs. My favorite, though, was a nasty B-movie delinquent girl in leopard who smoked, spit, and gave everyone the finger. I carried a vintage radio and had my own stripper-music soundtrack to grind to. That, or Mrs. Potato Head.

How many different drag characters have you created?
It has to be hundreds. I've been doing this professionally for over thirty years. The strangest one was Velveeta. It was a gown made of cheese-colored velvet with a headpiece like Carmen Miranda only made of Velveeta boxes.

You once made an outfit completely out of vegetables. Did you wear that yourself?
No! If I made an edible outfit for myself, it would be made out of Kentucky Fried Chicken.

Whom do you admire most?
My idol is Bob Mackie. I grew up worshipping him and now we're friends. He always tells me to keep doing what I'm doing because it makes the world happy. As for drag performers, my favorite has to be Lady Bunny, even though I used to often find her passed out on my stoop. I also love Willam Belli—he's so funny, I pee my pants—and that Jinkx Monsoon bitch has got a voice on her. But my Shirley Temple wipes the floor with all of them.

OPPOSITE: *Vintage NobleWorks greeting cards featuring* Project Runway *standout Chris March in various guises, each with great big hair, of course.*

A Chat with Denis O'Hare

"It's ironic that women have been so unfairly treated for so long and yet audiences delight in seeing them impersonated."

—Denis O'Hare

Tony Award–winning actor Denis O'Hare had already played a burn victim with a secret, a mute butler with a very creepy doll collection, and a con artist with a giant member when he was cast as the Cleopatra-eyed, bald-headed barkeep named Liz Taylor on the 2015 season of the gory Ryan Murphy TV thriller *American Horror Story.*

Although O'Hare cross-dressed to play her, the character was not the drag queen he originally expected. Liz, it turned out, was a transgender woman and, to him as an actor, that was a very big distinction.

Here, the much-lauded "actor's actor" who has appeared in such films as *Dallas Buyers Club* and *Milk*, and who memorably played the vampire king of Mississippi on the HBO series *True Blood*, discusses the challenges of making Liz Taylor come alive in the deadly surroundings of *American Horror Story: Hotel.*

What was the most daunting thing about playing Liz Taylor?
Oddly enough, it was the emotional intensity of some of the scenes. For the first episode, I was still thinking of Liz as a drag persona, which meant that there was a male counterpart whom I assumed we'd see at some point. When it became clear to me that Liz was transgender, I had to really change my approach. Here's the interesting thing: when you play a woman, you end up crying a lot. Whether that is engaging in gender stereotypes or not I don't know, but the script continually said, "tearing up," "choking back tears," "devastated," "dabbing at her eyes . . ."

That must have been hell for the makeup department! How did you come up with Liz's look?
Eryn Krueger Mekash and her husband Mike Mekash were responsible for Liz's look under the watchful direction of Ryan Murphy. As we found Liz, I asked for some variation on her eye look and I also had them make me many, many colors for my nails. To go with my dresses, of course!

In terms of costumes, that was a fun but exhausting process. Lou Eyrich was our costumer. The first thing she did was to put me in a pair of leopard-patterned Louboutin platforms. That kind of sealed the deal. Then we found this very tall, long black lace pantsuit that fit me like a glove and I walked around the room a little bit and Lou said, "Well, hello, Liz," and that was that.

Is it true that Liz's look was based on Robert Sherman's drag persona Constance Cooper? He's the Mapplethorpe model who works at the Chateau Marmont in Los Angeles.
We actually had his picture on a mood board so he was very much an early inspiration. But as we discovered Liz, we moved away from him. His look was key though.

Did you have a favorite Liz look?
The black pantsuit with my favorite platforms, although I also had this above-the-knee, chartreuse cocktail number from the late '60s that was amazing. One of the issues with dressing Liz was that I have a very masculine frame. That, combined with my bald head, could push me into what we called the "Yul Brynner" problem. I was delighted, though, to find out that I was a size 2.

OPPOSITE: *Behind-the-scenes shots of Denis O'Hare as Liz Taylor on the 2015 season of* American Horror Story.

Sort of.

"Thank you, America. You've got taste, style, and you know a good drag queen when you see one."

—Boy George, accepting Culture Club's Best New Artist Grammy Award, 1984

Before Bob the Drag Queen walked "Purse First" into every room, and Alaska Thunderfuck 5000 told everyone just how terrible their makeup really is, music videos featuring drag queens were a fairly rare commodity on television.

When MTV was new and showed video clips—rather than the wave of reality shows about sandy-creviced shore-house mates audiences now associated with the channel—it was easier to find rock superstars in drag than it was to find drag superstars in rock videos.

There was plenty of androgyny—Boy George in corn rows and capri pants asking "Do You Really Want to Hurt Me?" in 1982, Pete Burns of Dead or Alive in over-the-elbow gloves spinning right 'round, baby, right 'round like a record in 1984, and Annie Lennox performing that year at the Grammys sporting sideburns and a men's suit.

They were all "Sweet Dreams" to be sure. But to see the transgressive transvestites of Frankie Goes to Hollywood's "Relax" video, which was banned from MTV in 1984, or Divine's dragtastic clip for "You Think You're a Man" that same year, you had to go to a windowless gay bar in a bad part of town.

Only rock superstars could appear in drag in rock videos and actually get them shown on MTV. David Bowie's 1979 video for the song "Boys Keep Swinging," which featured Ziggy gone wiggy, was one of the first clips shown on the fledgling music channel. In the video, the Thin White Duke turned out in three different drag getups, first looking like a full-skirted refugee from *Grease*, then a walking Hurrell glamour shot, and finally, a late-in-life Bette Davis.

Queen front man Freddie Mercury did drag in the 1984 video for the hit "I Want to Break Free." The flamboyant singer vacuums his flat in a bouffant wig, a patent leather miniskirt, a sleeveless shell with one bra strap showing, and a mustache. That same year, Milton Berle appeared in both a tuxedo and a sequined evening dress in Ratt's "Round and Round" video.

Things began to change for drag queens in music videos in 1989 when MTV viewers got an early glimpse of RuPaul in the raucous video for the B-52's party-hearty hit "Love Shack." Four years later, Ru had her own smash hit video with "Supermodel (You Better Work)" and a follow-up called "Back to My Roots."

Around that time, Erasure's Andy Bell and Vince Clarke stepped into Swedish drag. Prancing in gauchos and boots and working faux-fur boas into a frenzy, they turned up as Agnetha Fältskog and Anni-Frid Lyngstad impersonators in the video for their cover of "Take a Chance on Me" from their *ABBA-esque* EP.

The high point of drag queen exposure in music videos back in the day came in 1994 when Cyndi Lauper, a tireless LGBTQ advocate, remade her biggest hit "Girls Just Want to Have Fun" into the reggae-flavored "Hey Now (Girls Just Want to Have Fun)." The video for that clip cast practically every drag queen in New York, including such part-time cross-dressers as *Village Voice* columnist Michael Musto and the glitter-loving painter Chris Tanner. That year, boys just wanted to have fun, and Cyndi, who always dressed like a thrift-store drag queen herself, was only too happy to let them show their true colors.

OPPOSITE: *Mamma Mia! It's Andy Bell and Vince Clarke in ABBA drag.*

Dean Johnson

{ 1952–2007 }

Dean Johnson was too much for MTV. Too bad. Lady Bunny called him a "big, bald freakazoid," nightlife columnist Michael Musto pegged him as "the last of the red-hot rebels," and filmmaker Lola Rocknrolla dubbed him "the happiest hooker I ever met." That those comments were made in a lurid *New York Times* story about his mysterious death in a Washington, D.C., apartment in 2007 only added to his legend.

As the front man of the punk band Dean and the Weenies, he was a performer quite capable, as the *Times* noted, of "charming audiences with his size-14 stilettos and acerbic rhymes." Truly Johnson cut a striking figure as a shaved-headed, six-foot-six, gender-defying glamour-puss in a cocktail dress.

Featured in the 1988 film *Mondo New York*, his best-known song was "Fuck You," an underground anthem that contains the most genre-defining couplet in all of punk rock: "Fuck thermonuclear war, fuck Mary Tyler Moore."

A product of the Boston suburbs who moved to New York in 1979 to go to film school, Dean was, at various points in his life, a gay escort famous for the size of his Johnson, a New York club promoter whose weekly Rock and Roll Fag Bar parties were the coolest place to be in the rough-and-tumble East Village of the late 1980s, and, as lead singer of the Velvet Mafia, an architect of the queercore movement. With that band, he created the 2004 album *Cheap But Not Free* featuring such hilariously titled songs as "The Girl from Planet Muff," "This Stud's for You," and "The Big Johnson."

Late in his life—still making the scene—the real Big Johnson became a blogger. While his sexually charged tales garnered him a rabid cult audience on the internet, it's as a singer that Johnson is remembered.

His final performance, at the East Village arts festival called Howl! a few weeks before his untimely death, he took the stage dressed not in his signature baldheaded drag, but in an English bobby's uniform. When Johnson sang, "You've got more going on than any supermodel," he could just as easily have been talking about himself. Any doubts about Dean's fabulousness? Fuck you.

OPPOSITE: *Dean Johnson, the biggest Weenie.*

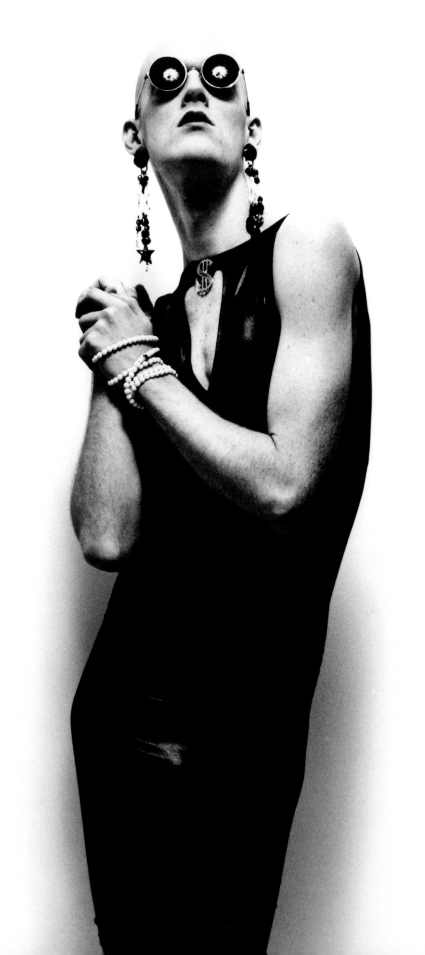

RABBITS IN LIPSTICK
Cartoon Cross-dressing

"Don't waugh. I'll bet pwenty of you men wear one of these."

—Elmer Fudd

From Alvin the Chipmunk to Yogi Bear, the most famous figures in the history of animation have at least one thing in common: they've all done drag.

Whether Heckle and Jeckle, those talking magpies so popular in post–World War II America, who put lipstick on their beaks to swindle a millionaire in the 1953 short *Blind Date*, or the squeaky-clean Disney icons Mickey Mouse and Donald Duck who, nearly fifty years later, dressed as their girlfriends Minnie and Daisy in *Mickey's Big Break* in 2000, cartoon characters can't resist cross-dressing.

Even Fred and Barney, two cavemen with permanent five o'clock shadows, impersonated their wives to enter a ten-thousand-dollar "Tasty Pastry" baking contest in a 1961 episode of *The Flintstones*.

But no one—not Bart and Milhouse on *The Simpsons*, not Peter and Stewie on *Family Guy*—has ever done cartoon drag with more conviction than Bugs Bunny. The star of Looney Tunes and Merry Melodies cartoons for more than seventy-five years, Bugs has made drag as much a part of his repertoire as anyone in show biz.

Since hopping on the scene in *A Wild Hare*, a 1940 short generally regarded as Bugs's official debut, he has played girl parts Little—Bo Peep and Red Riding Hood—and big—a hoop-skirt-wearing Scarlett O'Hara and a curvaceous lady Eskimo who swings a mean fish.

"Bugs loved nothing more than to mess with his foils, and if that meant wearing a tight sweater and cleavage, so be it," says animation aficionado and actor Bob Bergen, who, among his many roles, has voiced Porky Pig since 1990.

Over the years, the hilarious hare has proven to have a costume closet bigger than Lady Bunny's, playing roles as varied as Napoleon's "petite cabbage" Josephine, an opera-singing Brunhilde, a Roaring '20s flapper, or, with ears braided, a square-dancing Daisy Mae. These animated shorts are, to quote a popular 2013 meme, "where kids used to learn about classical music and drag queens."

The fascination with cartoon drag has never abated. A 2007 installment of *Robot Chicken*, for instance, featured a "Big Bad Cross-dressing Wolf" who gussied himself up like Little Red's grandma long after he'd digested her. "You ate that chick three weeks ago. How long are you going to keep dressing like that?" his wife asks. "As long as it makes me happy," he says.

Only one contemporary animated program, though, has truly captured both the rebellious and innocent qualities of the old Bugs Bunny cartoons and that's SpongeBob SquarePants. In a 2011 episode entitled "Love That Squid," the titular sea sponge pops on an Annette Funicello bubble wig and goes on a practice date with his awkward neighbor, Squidward.

Not since a tuxedo-clad Bugs Bunny married Elmer Fudd, looking positively lovestruck in a wedding gown in 1950's *The Rabbit of Seville*, has a cartoon couple been so completely camp. But no one minds because, as Bergen says, "Kids today find it as innocently funny as we always did."

In the 2003 feature film *Looney Tunes: Back in Action*, a studio head played by Jenna Elfman, hoping to improve Bugs Bunny's image, suggests to the rabbit that he leave drag behind. "About the cross-dressing thing—in the past, funny; today, disturbing," she says. Bugs doesn't buy it. "Lady, if you don't find a rabbit with lipstick amusing," he says, "you and I have nothing to say to each other."

OPPOSITE: *This is My Hare: Bugs Bunny as Carmen Miranda.*

PYRAMID SCHEME

"New York City was creating the underground culture that the whole world was vibing to."

—Lady Bunny

In the late 1970s and early '80s, the seeds of modern drag—the cross-dressing that would lead to so much of what we think of as show-biz drag in the twenty-first century—were being sown in the run-down theater spaces and dive bars of New York City's Lower East Side. Drag performance was happening all over the country but something very special was going on in Manhattan below 14th Street.

The crime rate in the East Village was as high as the junkie passed out on every corner, but the rent was so low that the fabulous flocked to live there. The area, sometimes referred to as Alphabet City, was irresistible to young artists and scene makers who felt a newfound sense of gay empowerment and a need to express themselves in the most colorful way possible.

For drag and its fans, the 'hood was a hotbed in hot-rollers.

Harvey Fierstein paved the way when he began starring as the drag queen Arnold Beckoff in *International Stud*, the first play in his *Torch Song Trilogy*, in 1978 at La MaMa, Ellen Stewart's experimental Off-Off-Broadway theater on East Fourth Street.

Marc Shaiman and Scott Wittman, who'd go on to write the musical *Hairspray*, were making names for themselves at Club 57 in the basement of a Polish church on St. Marks Place. One of their earliest, campiest productions—"part Andy Warhol, part Andy Hardy," as *New York* magazine writer Mary Kaye Schilling once put it—turned *The Sound of Music* into *Keep Your Von Trapp Shut*. Warhol drag superstar Holly Woodlawn played Maria in that one.

A few years later, the influential playwright and beloved grand dame Charles Busch got his start at the Limbo Lounge, first staging *Vampire Lesbians of Sodom*, a landmark of drag theater, there in 1984.

"It really was the Emerald City—like magic," Wittman told *New York* in 2011. "So much creativity with so little money. The whole Lower East Side was like that then, the way Paris must have been in the Twenties."

Add to this flamboyant theater community an influx of drag queens from places like Atlanta, New Orleans, and Los Angeles and you've got a scene to be reckoned with.

The performers who'd redefine drag—Lypsinka, Lady Bunny, and RuPaul among them—all found their way to a joint called the Pyramid Club. In the 1980s, the East Village dive bar, on Avenue A near Tompkins Square Park, was the epicenter of subversive cross-dressing entertainment. The cheerfully rebellious sensibility that, decades later, would flavor *RuPaul's Drag Race*—and inspire new generations of drag queens—was, if not born there, then incubated.

"Bobby Bradley, who was the brains behind the Pyramid, said he wanted it to be a cross between Club 57 and the Anvil, and that's what it was," remembers John "Lypsinka" Epperson. "It was a gas, and one of the reasons was because the drag fools who were there called themselves performance artists. They had a point of view about drag."

That point of view was both funny and daring. It was a smarter kind of drag.

These Pyramid queens had as deep an affection for the glamour of old Hollywood as any of the more traditional female impersonators had had. But their collective consciousness was colored by years of seeing Flip Wilson as Geraldine on *Flip*, listening to punk rock records by the Plasmatics and The B-52's, shopping thrift stores for kitschy castoffs, and watching the gay underground films of artists like John Waters, Kenneth Anger, James Bidgood, Paul Morrissey, and the Cockettes.

These flaming creatures had actually seen Jack Smith's *Flaming Creatures*.

They were walking amalgams of all the pop culture drag that had come before, as much in love with Judy Jetson as Judy Garland, Carol Brady as Carol Channing, and Ethel Mertz as Ethel Merman.

To them, Divine really was divine.

In some other quarters—even in Manhattan—drag had become "very square, stuck in a time warp of female impersonation," remembers Linda Simpson, a drag queen / drag historian and the force behind the

fondly remembered zine *My Comrade*. "But in the East Village, drag was being wildly reinvented as an exciting and eccentric art form. In many ways, it was a rejection of mainstream drag, which seemed to take itself so seriously. Instead, the East Village sensibility was campy, ironic, and very silly. It was sort of a parody of drag."

As Epperson says, "At the Boy Bar"—a popular club on St. Marks Place in those days—"someone would get in drag and lip-synch a whole Barbra Streisand song with no irony, not mixing it up, not doing any editing. But at the Pyramid, they'd have 'Night of a Thousand Barbras' instead."

If there *were* celebrity impersonations to be seen at the Pyramid, they'd always be performed with a twist. Instead of one Tallulah Bankhead impersonator, for instance, there'd be *twin* Tallulahs—a pair of *Dueling Bankheads* as David Ilku and Clark Render became known. When they weren't rocking out to a Steppenwolf song, they'd snipe at each other in throaty growls, shrouded in a cloak of cigarette smoke.

This was *not* Judy at the Palace.

The Pyramid Club became, as Simpson says, "the world headquarters for an entirely newfangled way of drag," a place where "kooky and punky, postmodernist" drag could thrive, where "gender bending was an underground art form." John Kelly would channel Joni Mitchell there, Ethyl Eichelberger would be Nefertiti, and Lypsinka would perform *Dial M for Model*, and never phone it in. Amidst such mischief, a queen named Frieda could have a vintage doll head instead of her own, and no one would bat a false eyelash.

"The Pyramid in its heyday was a sight to behold," RuPaul wrote in his 1995 memoir *Lettin It All Hang Out*. "A bunch of twisted queens pumping this sick look all crammed up on this tiny bar working a room that was no bigger than your average living room and no taller than one either. Most of us bigger girls had to duck the entire time, or get a sprinkler stuck in our wig."

It was a small price to pay for big stardom.

"The great thing about the Pyramid was that it was mostly about the queens," remembers Stephen Tashjian, a painter who is known in drag as Tabboo! "Instead of drag being maligned, it was worshipped. There was no shame."

Although AIDS was ravaging the gay community in the late 1980s, drag queens not only kept everyone's

ABOVE: *Original Polaroids by David Yarritu of Wigstock stalwarts. From left: Lypsinka, Linda Simpson, John Kelly as Joni Mitchell, Tabboo! and Edwige.*

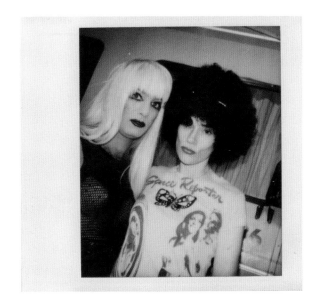

spirits up, but also rallied to the cause as they had done at Stonewall twenty years earlier. Hedda Lettuce (Steven Polito), for one, got her start raising money for the activist group Queer Nation by dragging it up in the streets alongside Miss Understood (Alex Heimberg). "We'd stand there and lip-synch and change costumes behind a sheet," Polito remembers.

"The new wave of queer activism had the same sort of radical energy that was happening in the East Village drag scene," says Simpson. The righteous anger of these queens was always infused with humor. "I'm not a faggot, I'm a *drag-got!*" Tabboo! once told a crowd. She didn't take a back seat to anyone, and her message to other outsiders was, neither should you.

Onstage and off, "the Pyramid queens expanded the parameters of what you could do in drag," Lady Bunny, the alter ego of writer/performer/DJ Jon Ingle, told the *Huffington Post* in 2014. "There was a feeling that we were all part of a happening—a magic moment, perhaps, like a very [low] budget Studio 54."

★ ★

"The Pyramid Club became the world headquarters for an entirely newfangled way of drag . . . where gender bending was an underground art form."

—Linda Simpson

The most monumental shift came in 1985 when Bunny, along with friends like Hattie Hathaway (Brian Butterick), staged a Labor Day festival of "hair peace" called Wigstock in Tompkins Square Park. The day-long variety show featured the queens of the Pyramid and their friends doing comedy, lip-synching, singing, and carrying on in a manner that was as much *Laugh-In* as Woodstock.

Drag hasn't been the same since.

"With Wigstock, we took it outside into the daylight and broke the glass ceiling," Tashjian says. As the late drag queen Sweetie (Daniel Booth) wrote in photographer Bobby Miller's 2008 book *Wigstock in Black and White*, "Wigstock was a magical day when the queens truly ruled a kingdom called Gotham and our loyal subjects humbly worshipped at our stilettoed feet."

Drag would no longer have to live in the shadows or pretend to be "gender illusion" with a queen whipping off her wig at the end of every performance to reveal the dude beneath the 'do and return titillated—and perhaps uncomfortable—viewers to their regular

programming. Wigstock was drag on its own gleefully gay terms, not watered down for straight consumption.

But even full-strength—and few things have ever been more unabashedly queer than Wigstock—drag ultimately proved irresistible to mainstream audiences. Without really trying, these queens built bridges to the bridge-and-tunnel crowd, seducing the very suburban and rural folks they'd run to New York City to escape.

As the actor-singer Joey Arias remembers, "You would see policemen in wigs and old Polish grannies in wigs. It was East Village madness, but, at the end of the day, everyone felt liberated. *This* was freedom."

With each passing year, Wigstock grew, and so did the crowds who attended it. In 1994, the festival relocated, for a time, to the piers near Christopher Street, a development captured in Barry Shils's 1995 documentary *Wigstock: The Movie.* (A 1987 documentary short of the same name by filmmaker Tom Rubnitz, focused on Wigstock's earliest days; its footage is used in the opening sequence of Shils's feature.)

The move to larger quarters brought more mascaraed eyes not only to the event, but to this new kind of drag. The *New York Times*, in a 1994 story headlined "If There Was Ever a Place for Big Hair, It's Wigstock," reported, "Many tourists on their Sunday tours of the West Village stumbled onto the festival, and many New Yorkers showed up for the first time, determined finally to get a glimpse of what they had been curious about for years."

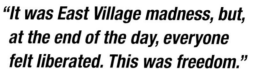

★ ★

"It was East Village madness, but, at the end of the day, everyone felt liberated. This was freedom."

—Joey Arias

ABOVE, LEFT AND RIGHT: *Drag queens—young and old, famous and infamous—gathered for 2018's rebooted Wigstock festival in Lower Manhattan.*

For the nellies of New York and those who followed their goings-on from afar, Wigstock became, in the words of the artist Billy Erb, the real "gay Christmas," even if it was held around Labor Day each year. Everyone who was anyone made a stop at Perfidia's Wig World at Patricia Field and got himself some hair—and perhaps a makeover from trans performer Codie Ravioli—and that was just to be a member of the Wigstock *audience*. Even in the heat, it was the place to be. As Sweetie once noted, "It was the day when Ban Roll-On went on your face before your foundation." It was hot, baby.

Homegrown acts like Deee-lite and RuPaul went from Wigstock favorites to mainstream stars. Famous Brits like Boy George, Graham Norton, and Leigh Bowery flew over from London to join the Wigstock party, rubbing over-the-elbow gloves with such local favorites as Flotilla DeBarge, Sherry Vine, Hapi Phace, Ragu Mountain Woman, Lahoma Van Zandt, Mona Foot, Flloyd, Jimmy Paulette, Brenda A Go-Go, Ming Vauze, Barbara Patterson Lloyd, and even cisgender punk princess Debbie Harry, the drop-dead chic leader of Blondie.

★ ★

"People of all colors and sexual persuasions and musical tastes... all felt connection somehow."

—Lady Bunny

"People of all colors and sexual persuasions and musical tastes . . . all felt connected somehow," Lady Bunny once noted. "Wigstock was not only a reflection of the vibrant, inventive drag community, but of the more bohemian, less expensive New York City of the time. It was a hipper version of Gay Pride Day for the freakier set."

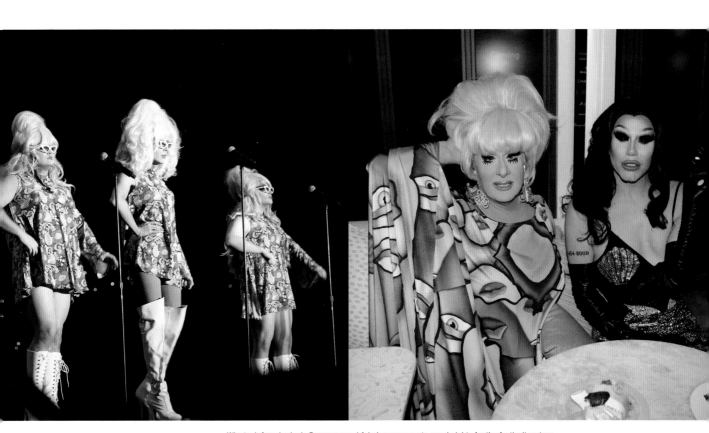

ABOVE, LEFT AND RIGHT: Wigstock founder Lady Bunny coaxed fabulous queens to new heights for the festival's return.

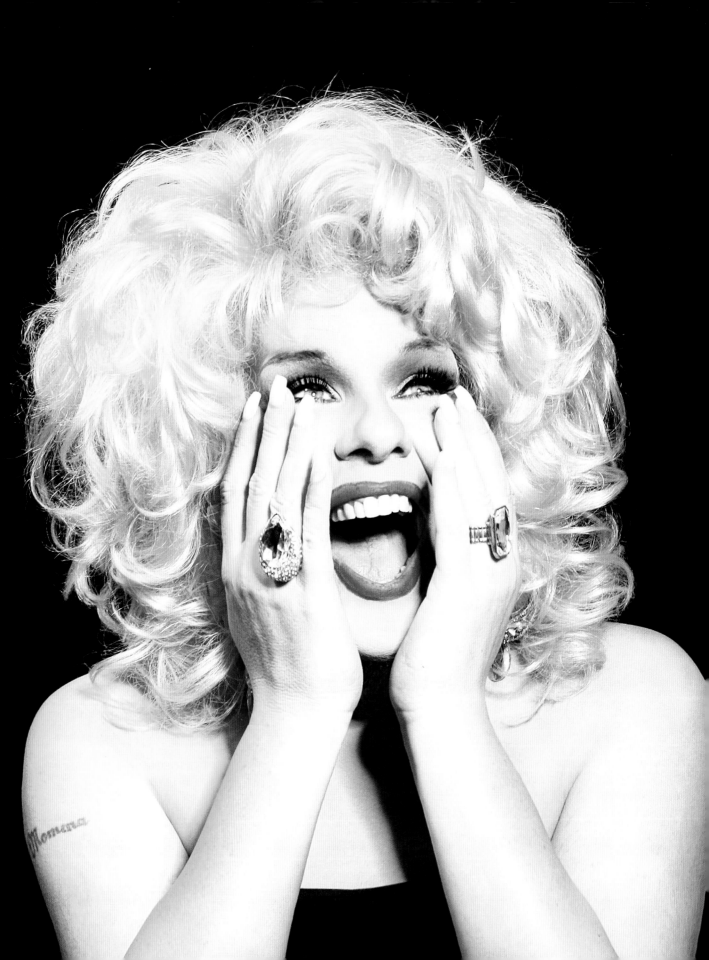

Sweetie

{ 1965–2017 }

Daniel Booth hailed from the suburbs of Detroit, Michigan. But between 1990 and 2017, he loomed large on the New York drag scene as Sweetie—plump, delicious, and, yes, a real sweetie.

"I had always considered myself a serious actor in a lot of ways, and drag was kind of lowbrow to me," he told *Paper* magazine in 2016. But after dressing up for a Halloween party thrown by Manhattan scenemaker Susanne Bartsch, Booth was bitten. Along with his then roommate, a performer who went by the name Faux Pas, he experimented with various drag incarnations.

Booth's original alter ego was Cousin Gert Munson, Lesbian Authoress, with a look he called "a cross between Fran Lebowitz and Oscar Wilde." After that, he became Tootsie McTavish, then, simply Shirley. "Before I finally became Sweetie," he said, "I'd gone through a ton of names . . . awful names, just to make people say them." He ended up borrowing the name of one of his favorite movies, Jane Campion's *Sweetie*, and it fit the living bouquet-of-flowers he would become.

"I was this fat girl who used to do cartwheels in heels, and that always made people happy," Sweetie said.

Known for her darkly funny stage patter and her expert way with a prerecorded song—"I'm probably the best lip-syncher out there," she once said—

Sweetie could wring every bit of emotion out of Bette Midler's version of "I Shall Be Released," or sink her teeth into Natalie Cole's unexpected rendition of "Lucy in the Sky with Diamonds."

In the heyday of East Village drag in the early 1990s, Sweetie became a staple at such clubs as the Pyramid, Boy Bar, and Jackie 60, and later reigned over such parties as Cheez Whiz and High Life Low Life, where she was fond of bringing underappreciated drag performers to the stage.

Sweetie took her career seriously. "I consider myself in drag to be kind of a method actress," she once said. On the big screen, she had roles in the drag favorites *To Wong Foo, Thanks for Everything! Julie Newmar* and *Starrbooty*, the RuPaul comedy in which she played a character named Ol' Lestra. She also appeared as herself on *Project Runway*.

When Sweetie passed in 2017—after bravely fighting cancer for several years—the outpouring of affection was tremendous. Tweeted condolences came from Laverne Cox, Andy Cohen, and the producers of *RuPaul's Drag Race*.

"Sweetie was an old-school drag legend whose dedication and craft helped pave the way for the current drag boom," Michael Musto said. "She gave everything onstage, and lit up a room with her pride, focus, and delivery."

Drag was anything but lowbrow when she did it.

OPPOSITE: Sweetie

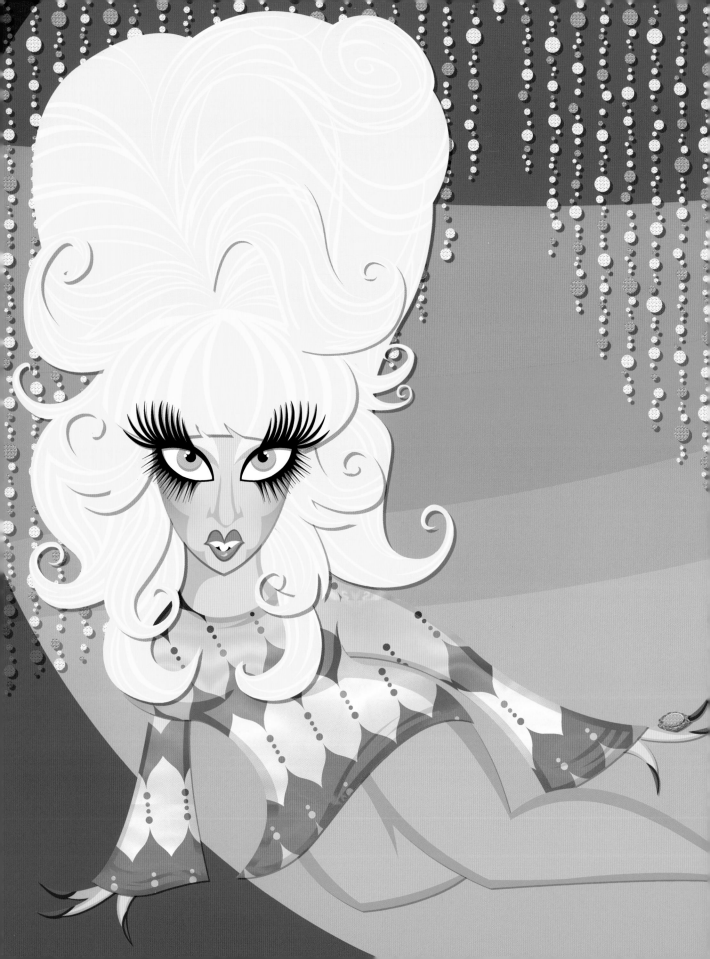

Lady Bunny

"I am the hottest mess of all."

—Lady Bunny

She calls herself "a pig in a wig"—which is weird for a gal with a cottontail's name—but Lady Bunny is so much more than just Arnold Ziffel in pin curls. "I'm RuPaul's wacky sister, just nasty and crazy," she says.

One of the founders of Wigstock, the outdoor festival that in the mid-Eighties brought East Village drag – and Ru herself – into the light of day, Lady Bunny is a true frock star. She is, as newnownext.com has declared, "drag royalty."

A Chattanooga, Tennessee native who moved to Atlanta in 1982 before finding her forever home in New York City two years later, Lady Bunny reigns as an accomplished comedienne, a much-sought-after DJ on the international party circuit, and an infamous personality and pundit who is both a hilarious vulgarian onstage and a formidable activist. Her infectious disco song "Take Me Up High" scaled the Billboard dance charts in 2013, too.

The *New York Times* has hailed Lady Bunny as "subversively funny." Truly, no drag-nabbit rabbit is quicker on her furry little lucky feet than this venerable hare hopper.

Bunny, I've seen you pull a dirty piece of fruit out of your panties while singing "I shit a banana" in a parody of "Hollaback Girl". *Where does the urge to work blue, and sometimes brown, come from?*
I love raunchy material myself, so naturally that's what I like to perform. I got my start in late-night gay bars. That was where we'd go to escape the world and we loved to make off-color jokes. I'm always the one who's going to tell the joke too soon. If you're not supposed to laugh at something, it's ten times funnier. Someone once said that although my jokes are filthy, it's almost as if a little girl found a dirty joke book. I think that's an interesting way to look at it, except I'm not little at all, or a girl.

Do promoters know what they're getting when they hire you?
When people call to book me, I send them a few of my videos and say, "You know that I'm a skank, right?" At pride events, I always tell the emcee to say, 'If you've got children, this is the time to take them to get a corndog. Because this next act is trash.' But I'm proud to represent the old hateful twisted drag queen element of our community and turn that into something audiences can cheer for.

Did any drag queens influence you early on?
There was Tasha Kahn—'Chattanooga's own Bubbling Brown Sugar!' Tasha lit up a room. Her lip syncs

OPPOSITE AND ABOVE: Lady Bunny.

to Patti Labelle are what made me want to do drag.

When you moved to Atlanta, what was the scene like there?
There were a lot of very polished pageant girls, many of them trans, who'd compete in Miss Continental. We worshipped them. They thought we were clowns and young fools, which we were. RuPaul and I were groupies for a band called the Now Explosion, fronted by Larry Tee, which was like a funkier version of The B-52's. We'd dance with the band.

How did you come to be called Lady Bunny?
My name was just a crazy joke that stuck. We were so artsy fartsy in those days. I would walk into a club carrying a branch I found on the street and act very haughty, as if it were a scepter. When I got to New York, I'd walk into the Pyramid Club wearing a piece of packing string as if it were a magnificent boa and say, 'Please take my wrap.' There was always an air of lunacy to the name Lady Bunny.

What was your first performance at the Pyramid Club like?
I'd come up from Atlanta with RuPaul to be a guest in her show. We had no money. We wore anything that we could squeeze into in a thrift store. I was bombed drunk and lip-synched to *I Will Survive*. I was so into it that I fell and lost a shoe. I managed to get up with my wig askew and finish the number with one shoe on. They went nuts and I had it made at the Pyramid because it was so fucking tragic. My god, it was booger! But I got enough positive feedback to know that there was something to my drag.

The East Village was a rough neighborhood in those days.
It was very scary. I was living with my sister and her boyfriend, who hated me, on 4th street between Avenue C and D, when it was all junkies and gangs. After my first night go-go dancing in drag at the Pyramid, a guy jumped out from behind a car and pulled a gun on me, and would you believe I ran from that gun because my life was worth less than fifty dollars? I said, 'This is the first money I ever made doing drag. You ain't touching this. I'm proud of this. But it was a

magic time in the city. We weren't on social media, we were actually socializing. We would see each other every night of the week. It was a New York where crazy nuts and creative people could afford to live. That energy is what made Wigstock a success as much as anything I ever did.

What made those queens who performed at Wigstock so special?

They weren't impersonating Tina Turner and Melissa Manchester, they were doing Janis Joplin and Mona Lisa. I'm not a lover of celebrity impersonation unless you put a sick twist on it or unless you ace it beyond anyone's imagination. All those girls were performing for free outdoors, sometimes in the rain. At the time, we had the specter of AIDS blighting what should be the most wonderful and natural expression of love and lust. I didn't know how to do ACT-UP. But I knew I was a jester and a fool and also that I had the camaraderie of other drag queens. Wigstock took our minds out of the gutter and us out of the dumps. It was a joy.

What made you so good at putting together a drag festival?

As a kid, I had organized ridiculous events from haunted houses in our garage to putting on self-penned plays, with a sheet stretched between two trees, and inviting all the neighborhood. It always led to this hambone showboating for days with unrehearsed, written-on-the-spot garbage, and I parlayed that into a career!

I've seen pictures of Dusty Springfield on social media that people have mistakenly identified as you. But I remember you once said your look was inspired by Sharon Tate…

I love Sharon Tate and Dusty Springfield. They come from the mid-sixties when girls had giant hair and wore upper and lower lashes. That's essential to my look and I'd never change it. All the other queens laugh at my makeup. Will it be coral lipstick and purple eyeshadow, or pink lipstick and blue eyeshadow

tonight, Bunny? But I say, 'Listen here, when and if you find a look that works for you, you might want to stick with it.' I'm a slob, but my secret is to get a lot on and keep moving, honey, and always appear in the dark before drunks and drug addicts.

Do you ever wonder why drag continues to be so popular?

Someone once asked me, 'Why do gay men, who like manly men, want to sit and watch drag queens?' I said, 'You know what? That's a very good question, but I'm glad there isn't an answer. I'm just glad they're watching. I don't need to find out why'.

What pleases you most about being a drag queen?

What I love about drag is the sisterhood. The way queens are in real life is not the way they are on a reality show where you're doing 13-hour days and you're pitted against each other and you're in HD and your fucking beard is growing. In the real world, drag queens call each other and say, 'Did Miss Thing get that dress to you for that pageant on time?' There are some wildcards who feel they can't make it without clawing everyone else out of the way, some Joan Crawford types, but they're universally disliked. My 'sisters' are my sisters, right up there with my real sister.

How has the drag scene changed?

I always cringe when I hear drag queens in their twenties discussing 'their brand.' There's nothing wrong with finding out what you do well, and what your audience likes, but to be breaking it down into numbers, that's kind of a soulless life. I say to them, please don't ever measure your self-worth by the number of retweets or likes or followers that you have. I started off with maybe a little skill, but not much. My goal was to be in drag and get drunk and take drugs and suck dick. I never discussed my brand. This may sound weird coming from a drag queen, but I think it's just very important to be yourself.

OPPOSITE TOP TO BOTTOM: The Original Gangsters of Wigstock, among them Barbara Patterson Lloyd, Hapi Phace, Kevin Aviance, Billy Beyond, John Kelly, Lady Bunny, and David Dalyrimple.

WIGSTOCK OPENED THE FLOODGATES OF DRAG IN THE 1990S.

"From the East Village, drag spread like wildfire to all of New York nightlife," Linda Simpson said in a presentation she gave at RuPaul's DragCon in Los Angeles in 2015. "Every hotspot in town was clamoring for queens and we were in demand." From Susanne Bartsch's glitter-caked parties at the Copa to the runways of Seventh Avenue, drag queens were the hottest things on three legs.

Simultaneously, the "club kid" phenomenon—when New York's most diehard partiers adopted a colorful aesthetic that Simpson describes as "cutesy and twisted and outrageous, but basically just another kind of drag"—became the nightlife flavor of the moment.

"It was a drag explosion," says Simpson, evoking the name of her drag history website and the multimedia presentation she gives around the world to drag fanciers, young and old. "If you had a great look, you could get hired to host and carry on all night. For East Village queens, it was the chance to expand out of the clubs and make a buck." And those girls did!

"In the 1990s, there were a hundred clubs and they all had shows every night," says Sherry Vine, the filthy song-parodying alter ego of actor Keith Levy. "I remember working twenty to thirty nights in a row! We were making great money, and there was enough work to support a hundred queens."

In July 1995, Charles Busch wrote a *New York* magazine cover story called "The New Feminine Mystique" about the ubiquity of drag—and appeared on the cover with Lypsinka and Simpson. He declared that New York was in the midst of a "golden age of drag" and wrote, "Manhattan, at this moment, is the drag capital of the world." A new generation of gay performance artists, Busch said, "were making drag more varied and interesting than it's ever been before."

Drag now could be Everett Quinton playing a courtesan and bringing an audience to tears, or Ira Siff singing deranged arias with his La Gran Scena Opera Company, or Varla Jean Merman hitting a high C while slathering herself with Hellmann's mayonnaise, or Misstress Formika metamorphosing the Beastie Boys' "(You Gotta) Fight for Your Right (to Party!)" into a queer anthem.

Drag became all of those things . . . and more.

"It was the first time that drag queens had collectively broken through," says Simpson. With the release of her 1993 album, *Supermodel of the World*, and her 1996 TV series on VH1, RuPaul led the way, inspiring other queens to shoot for a living more lucrative than the dollar bills stuffed into homemade cleavage. Ru inspired drag performers to believe that "if she could make it, so could we," Simpson says.

Many tried, of course, but no drag queen ever did manage to scale the heights that Ru did. "At least one ambitious queen made it into the stratosphere," Simpson says philosophically in her Drag Explosion lecture, "but for the rest of us, it just wasn't going to happen on that grand scale. Ultimately drag was a little too freaky for the mainstream."

Well, too freaky for the mainstream of the late twentieth century.

In the 1990s, RuPaul wasn't winning Emmy awards, and drag brunches hadn't yet become family-friendly weekend pastimes at places like Lips in New York, or the House of Blues in Anaheim, California. Today, drag is more mainstream than Simpson—or

★ ★

"It was the first time that drag queens had collectively broken through."

—Linda Simpson

OPPOSITE TOP TO BOTTOM: *A galaxy of stars from Wigstock's earlierst days: Mona Foot as Wonder Woman, Barbara Patterson Lloyd, Jimmy James and Lypsinka, Lady Bunny, and Perfidia.*

even Busch's prescient *New York* magazine article—ever imagined it could be.

To be sure, there is still subversive drag in New York City. At Bushwig, a drag festival first organized by the drag queen Horrorchata and held in the hip Brooklyn neighborhood of Bushwick, for instance, the spirit of Wigstock has been passed on to a new generation. Featuring performers who are still wet behind the earrings – including the biologically female drag queens Crimson Kitty and Miss Cuntstrude—Bushwig boasts a camp sensibility as recognizable to Original Wigstock Gangsters as Loretta Hogg's strap-on pig nose. One year, a nearly nude Bushwig performer named Qween Amor did unspeakable things to a Donald Trump mask. It was deranged, but as Bunny noted, "So were some of the acts at Wigstock!" Leigh Bowery *did* give birth to a full-grown woman onstage that time.

As for Wigstock, the festival of "hair peace" never did "curl up and dye," as Lady Bunny likes to put it, although full-scale versions ended in 2001. In recent years, Bunny reassembled her crew—Sister Dimension, Princess Diandra, and the legendary Jackie 60 DJ Johnny Dynell among them—for a number of special events, including Wigstock: The Cruise, a shipboard tea dance around New York City. Then something unexpected happened in 2018. On Labor Day weekend, Lady Bunny and Broadway's original Hedwig, Neil Patrick Harris, staged what was being called "Wigstock 2.HO," in Lower Manhattan. The show's stellar line-up was designed to mix veteran drag queens like Joey Arias, Jackie Beat, and Lypsinka—all veterans of Wigstock's earliest years—with newer talents like Alaska Thunderfuck, Jinkx Monsoon, and Willam.

Harris, who was working on the West Coast during the original's headiest years, never experienced Wigstock in person, so he decided to help bring it back. "It seemed so nasty and exciting, and even kind of horny," he told the *New York Times*'s Jacob Bernstein in 2018. Oh, Neil, you have no idea.

LEGEND OF DRAG

Leigh Bowery

{ 1961–1994 }

When, at Wigstock in 1994, Leigh Bowery in full drag gave birth to a grown woman—nude, covered in stage blood, and trailing an umbilical cord made of sausage links—even the most jaded New Yorkers were shocked. Boy George himself said it was an act that "never ceased to impress or revolt." Truly, it did both.

For Bowery—the London-based performance artist, and favorite life model of painter Lucian Freud—onstage childbirth was just par for the course. He once did a show in which he, covered in gold body paint and wearing only a metallic merkin, descended on a swing from the roof of a London nightclub, threw his legs over his head, and shot a geyser of water out of his ass to Strauss's *Also Sprach Zarathustra*. Bowery's friend Sue Tilley, an artist's model and writer, once explained, "Bodily fluids played a big part in Leigh's repertoire."

And what a repertoire it was, one that encompassed drag, fashion, art, party-throwing, and performing. In his brief life, and in the decades that have followed, Bowery has been as influential on all of those disciplines as anyone connected with drag.

His clownish, high-fashion aesthetic—body-distorting It-boy looks that melded both the terror of Pennywise and the glamour of Alexander McQueen—has been an inspiration to everyone from drag queen Acid Betty to fashion designer Vivienne Westwood.

Since his passing at thirty-three of AIDS-related causes, Bowery has been the subject of gallery exhibitions in his native Australia; museum panels in London; a documentary by filmmaker Charles Atlas; and the musical *Taboo*, with music and lyrics by Boy George, who also played Bowery in the 2003 Broadway production.

"The legacy that Leigh Bowery has left," the artist Donald Urquhart wrote in 2004, "is like a surrealist garden of surprising delights. He was a dandy and a great eccentric [whose] posthumous fame deserves to flourish." That it has.

Freud's painting *Leigh Bowery (Seated)*, a nude portrait of the corpulent queen, devoid of all drag, has hung in museums around the world. Bowery would, no doubt, be pleased to flash his not unimpressive junk to the world long after his death. As Tilley once said, "He made it his business to be unforgettable."

ABOVE: Leigh Bowery.

Tabboo!

"Judy Garland is my personal savior. That should tell you something."

—Tabboo!

Painter, illustrator, fashion muse, and the guy whose swirly letters so memorably decorated the cover of the 1990 Deee-Lite album *World Clique*, Stephen Tashjian has worn many hats—wigs, actually—since he established himself as the one-name drag queen Tabboo! in the 1980s.

A peer of photographers Nan Goldin and Jack Pierson—as well as a subject of their work, most notably on the cover of Goldin's 1993 book, *The Other Side*—Tashjian studied at the Massachusetts College of Art before moving to New York City. To say that "One-Calorie Tabboo!" helped to foment the East Village–centered drag revolution of that era is an understatement.

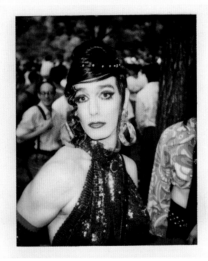

You grew up in central Massachusetts and, from all accounts, you were pretty precocious about doing drag.

As a kid, my mother would leave me alone in the house and I would get into her costume jewelry. At one point, she even had a wig! One time, the next-door neighbors gave away these old wedding gowns to the kids on our little country road. I threw on the best one and was flitting around and I got scolded for wearing women's clothing in public. But that didn't stop me in the least.

When you got to the East Village, did you start performing immediately?

Soon after arriving in New York City, I was in a show with the incredible Wendy Wild and she insisted I come up with a show-biz name. Being of exotic Armenian descent and having had to always spell out my first and last name, I decided to go Polynesian and spell the word "taboo" as TABBOO! with an exclamation point.

Was New York City really all that and a bag of hairclips when you arrived?

At one point in time Rome was the center of civilization, at another, Paris was the artistic hotspot. But in the late 1970s and into the early 1990s, New York was where everyone would rather be! I've lived here over thirty-five years in the same spot.

Do you still do drag?

With time—Grandma's closing in on sixty—it all slowly slipped away. But drag was never my sole means of creativity. I've always been an artiste.

ABOVE: Tabboo!

Joey Arias

"Let your hair down or wig up and be who you are!"

—Joey Arias

He is a drag legend on the international nightclub scene, in fashion circles the world over, and on stages from New York, New York, the city, to New York-New York, the Las Vegas hotel and casino, where for seven years, he was the original Mistress of Seduction in the Cirque du Soleil show *Zumanity*.

In his years as a performer, Joey Arias has sung backup for David Bowie on *Saturday Night Live*, played half man / half woman in the movie *Big Top Pee-wee*, walked the runways of Paris, costarred with Basil Twist's puppets Off-Broadway, appeared as Joan Crawford in San Francisco, and channeled Billie Holiday in such a brilliant way that the *New York Times* wrote, "More than most, Mr. Arias understands the risks and rewards of playing with fire."

He's been doing just that—glamorously and dangerously—since, at least, the 1970s, and the lives of drag lovers have long been the better for it.

Although he's originally from California, New York wouldn't be New York without him.

Three years after you moved to New York, you and your buddy Klaus Nomi, the New Wave countertenor, were on Saturday Night Live **wearing skirts and singing backup for David Bowie. What was that experience like?**
SNL was out-of-body! I was working at Fiorucci and hanging with Klaus and doing shows with him. We

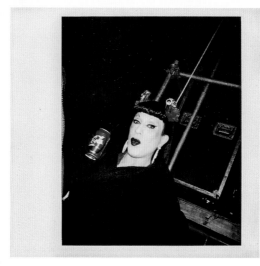

were at the Mudd Club one night, and David and Klaus ended up exchanging numbers. Later, when Klaus said that David was going to do *SNL* and asked if I would be interested, I screamed.

Where did those androgynous costumes come from?
Klaus and I got our outfits at Henri Bendel after a long search. Thierry Mugler, and they were perfect because they were neither male nor female. We never thought of it as drag, though. We just saw it as aliens putting on a costume to move within society.

You did eventually become a drag queen. How did that happen?
The drag thing happened because Andy Warhol and Truman Capote were having a Halloween party and you had to go in drag. I was gagging because I was afraid of drag queens! Their performances and their take on Judy Garland . . . I was terrified. But I knew that all my art friends were going to be there, the gang—Kenny Scharf, Keith Haring, Samo, Basquiat, Ann Magnuson, the list goes on.

I wore this rubber top from Vivienne Westwood that had these circles that were like deflated tits. We made these water balloons and packed them into the top. Andy said I should always look like this, and that was the beginning of my drag career.

ABOVE: Joey Arias.

The Dueling Bankheads

"Double your pleasure and it's a mind flip . . ."

—David Ilku

One Tallulah impersonator is madcap. Two Tallulah impersonators engaging in a black-clad battle of bitchery is just insanity, which is exactly what audiences from Los Angeles to London have loved about the Dueling Bankheads since they made their drag debut in New York in the late 1980s.

A collaboration between East Village actors David Ilku and Clark Render—both Detroit-area expats who met doing a New York University student film—the Bankheads began as drunken banter while hanging out at the Pyramid Club.

"We'd often quip in Tallulah tones and people started to gather around us," remembers Ilku, who is also a member of the comedy troupe Unitard. "Then Johnny Dynell and Chi Chi Valenti started a new nightclub experience called Jackie 60, and we were one of the first acts they booked."

That was in 1990 and the Bankheads were an instant hit.

Choosing their stage look from the actress's *Die, Die, My Darling* period, funeral attire accessorized with a few strands of pearls and a black handbag, Ilku and Render drawl their way through lowbrow chit-chat—"How is *your* yeast infection doing?"—then burst into song. It could be a Doors medley, "Moon of Alabama," "Ding-Dong, The Witch is Dead!," or "Dyke Wedding" sung to the tune of Billy Idol's "White" hot hit.

Both silly and sophisticated, this comedy act "created itself, completely organically. It was a groovy accident," Render says. While they may be called the *Dueling* Bankheads, he adds, "We never compete. Instead, we are innocuously sinister accomplices."

As Ilku says, "We're kind of like Heckle and Jeckle or *Spy vs. Spy*."

That combination—which adoring critics have called "an endearing train wreck" fueled by "sheer absurd bravado"—has worked for decades. Over the years, the duo has appeared on Comedy Central and the BBC, made the cover of the *Village Voice*, opened for Blondie, and taken the stage at Wigstock.

Would Tallulah herself have approved of the Dueling Bankheads' drag exploits? Ilku is convinced, yes. "I think she would absolutely love it and double over with laughter," he says. Most everyone who sees them does, darling.

ABOVE: Tallulah (David Ilku) gets a police escort.

Flotilla DeBarge

"Being Flo has helped me grow as a man."

—Flotilla DeBarge

Kevin Joseph began doing drag as a Brooklyn teenager, using sheets and towels to create a look that combined his favorite aunt's stylishness with *Soul Train* fabulosity and Flip-Wilson-as-Geraldine-Jones sass.

Coining a name that is both a nod to his size—at more than six feet tall, he *does* make a formidable girl—and his favorite 1980s singing group, Flotilla DeBarge was born at the Pyramid Club in 1992.

Known first as "The Della Reese of Drag"—"My look was very *Touched by a . . .* well, let's just say it was touched," she says—Flotilla got a makeover when she became a "Boy Bar Beauty," as drag queens were known at the popular East Village nightspot of that name in the early 1990s.

Once enshrined as the "Empress of Large" and rebranded as drag's answer to Louise Jefferson, Flotilla moved beyond St. Marks Place to become an annual favorite at Wigstock, a Star Jones impersonator for a 2005 "fur is a drag" PETA ad, and, most impressively, a legit actress. "I always wanted to be an actor since my mother took me to Radio City Music Hall as a kid," she once told the *Village Voice*.

Her film roles have included appearances in the

screen version of *Angels in America* and *To Wong Foo, Thanks for Everything! Julie Newmar*. Speaking of the latter, DeBarge says, "Wesley Snipes studied me to create his character. Not too shabby."

It is onstage, though, that she has shone brightest.

DeBarge logged performances in such legendary downtown stage parodies as *Raisinettes in the Sun* and *The Other Play About the Baby*, a spoof of *Agnes of God*. She made her Broadway debut in the 2006 Studio 54 revival of *The Threepenny Opera* starring Alan Cumming and Cyndi Lauper. Her brilliant turn as the all-sacrificing mother Annie Johnson in the 2000 Tweed production *Imitation of Imitation of Life*, opposite John "Lypsinka" Epperson, though, will forever be the cubic zirconia in her crown. "It was and is my dream role," DeBarge says.

Hilarious as ever after more than twenty-five years in the business, DeBarge says, "We do it for the joy of the art and we have a message in our madness. I admire anyone who puts his heart and soul in it and keeps it fun and entertaining."

ABOVE: Flotilla DeBarge.

Kevin Aviance

"You might be the 'it girl,' but you need to stay humble. There are new stars rising every day."

—Kevin Aviance

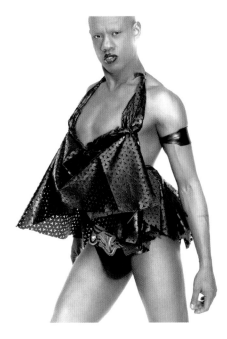

He looks like the love-child of Grace Jones and 7-Up spokesman Geoffrey Holder, and he has been fierce onstage since he first did drag in an elementary school talent show in Richmond, Virginia, sang "I Will Survive," and snatched that trophy baldheaded in 1980. Since then, there has been no stopping him.

Influenced by divas of every stripe from Siouxsie Sioux to Anita O'Day, Eric Kevin Snead first found his way to Washington, D.C., where he joined the House of Aviance and adopted the stage name Kevin Aviance. Then he moved to Miami for a time, and finally to Manhattan in 1992.

In his adopted New York City home, Aviance morphed from club kid to serious performer in places like Boy Bar. One of his earliest gigs—singing "Happy Birthday" to DJ Junior Vasquez at Sound Factory while dressed as Marilyn Monroe—established him as a strikingly glamorous presence on the nightlife scene.

Although Aviance had personal demons to overcome, drag won out over drugs. "It would change my life and give me, and others, something to hold on to,"

he says. His signature look—usually nipple-baring, untucked, and bald—and his onstage ferocity made his performances into bona fide events.

In 1996, Aviance released his first single, "Cunty (The Feeling)," which established him as a dancefloor-packing singer. Other singles like "Din Da Da" and "Rhythm Is My Bitch" followed and proved he was no fluke.

"Music is my life," Aviance says. "I'm very blessed to be critically acclaimed and travel the world." He has had four number-one dance singles and several more on top-ten lists, and his music has been heard on the TV series *So You Think You Can Dance*. In 2016, *Billboard* magazine included Aviance among the top one hundred dance club music artists of all time . . . and he doesn't take that honor lightly.

"When you see me," he says, "you will never forget it as long as you live."

ABOVE: *Kevin Aviance.*

Sherry Vine

"I will always be churning out parodies about poop and penis!"

—Sherry Vine

Keith Levy was living in Los Angeles in the early 1990s when he was struck with the urge to perform the Peggy Lee hit "Black Coffee" in a show at a hot weekly party there called Trade. "I didn't think anyone would want to see a skinny boy sing a torch song," he says, "so I created Sherry."

That one-name creation since has become Sherry Vine, a mainstay on the New York drag scene best known for her often smutty song parodies. Lady Gaga's hit "Bad Romance" became "Shit My Pants" once Sherry had her way with it.

Once known as a resident diva at the dragalicious Manhattan nightspot Bar d'O and a founder of the acting troupe Theatre Couture, Vine is today a frequent guest performer on the stages of cities around the world. Her motto, she once said, is "We shall overpaint!" and for twenty-five years, she's done just that.

Her penchant for working oh-so-blue hasn't stopped her from appearing on such mainstream hits as *Project Runway*, or from creating and hosting *She's Living for This*, a variety show on Here TV.

You were born in Florida but raised in Maryland. What was your childhood like?

My childhood was a mix of torment and fantasy. I was bullied relentlessly in school, so I would escape into a dream state. I was forever getting yelled at for daydreaming and being lost in my own world. While they were throwing spitballs at me or calling me "faggot," I was accepting my Oscar! Luckily my home life was great. My parents encouraged my love of acting and were 100 percent accepting.

How did you come up with the name Sherry Vine?

I was living in L.A. and my then roommate and I came up with the name Sherry—no Vine yet—together. We wanted her to be a broken-down ex-showgirl with a heart of gold. I was just Sherry for about a year. Then a friend I worked with told me there was a building on Vine Street called the Sherry. The Shari, I think. One night, I drove up and it looked like a crack whorehouse. I was like, perfect!

How does being an actor jive with being a drag performer?

At first, Sherry was going to be just for our theater company, Theatre Couture. But I hated waiting tables so when I had the opportunity to make money performing in clubs, I jumped. This led to meeting Joey Arias and doing Bar d'O, Squeezebox!, and Jackie 60, which led to shows around the world.

What has been your favorite onstage moment as Sherry Vine?

It's so hard to pick one! One of the Wigstock shows was on the piers and there were forty thousand people there. That was exhilarating. Certainly, performing as Madonna for the *MTV Video Music Awards* and then having her come up to me onstage and whisper, "Good job, you're gorgeous," was memorable.

Did a video of yours really get you accused of indecent exposure?

That's a true story! My parody video of Britney Spears' "Womanizer" was blocked on YouTube because they said they could see my vagina. I wrote them back, "Honey, I might be a good actor but I ain't that good!"

OPPOSITE: Sherry Vine.

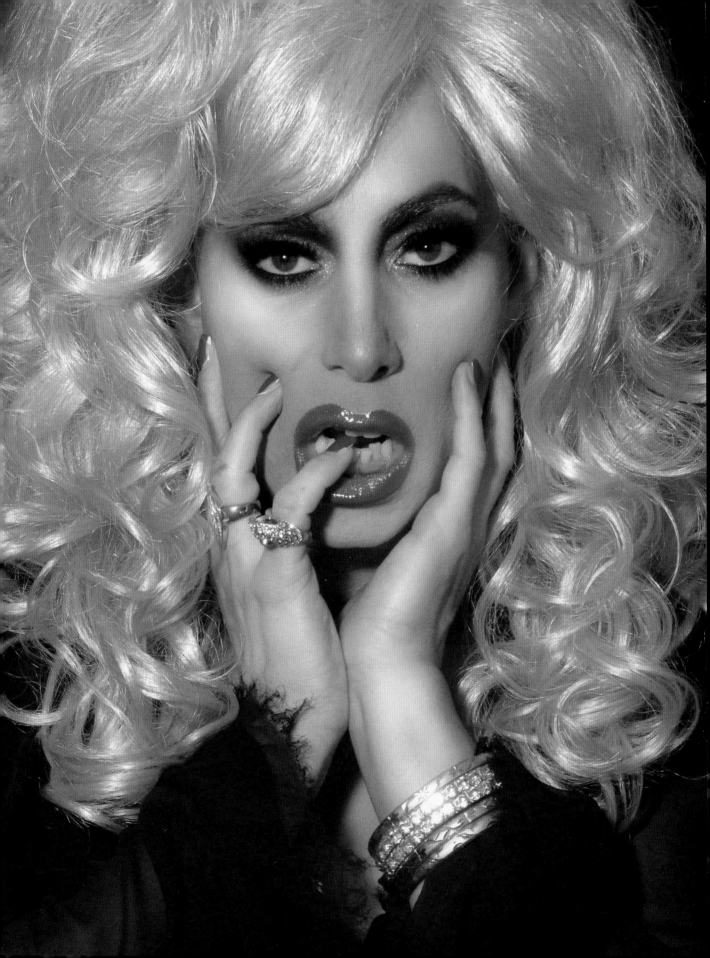

Hedda Lettuce

"Even I find drag weird sometimes. You have out-of-body moments when you think, I'm standing on stage in a dress and a green wig, what's happening here?"

—Hedda Lettuce

She is a stand-up comic with a tart tongue and a Mountain Dew–colored 'do, a popular movie hostess who functions as a one-woman *Mystery Science Theater*, an actress whose credits include *Sex and the City* and *Ugly Betty*, a singer, and an activist who was green before it was chic. She is Hedda Lettuce—the alter ego of Steven Polito—and since 1991, she has been one of the most colorful performers ever to take root in the New York drag scene.

Before becoming the self-styled "Queen of Green," Polito studied at New York's Fashion Institute of Technology. In the early 1990s, he became an East Village drag presence, performing at the Pyramid Club and Boy Bar. From there, he went on to become perhaps the first drag queen stand-up comic to play the prestigious New York comedy club Caroline's. As fresh as ever after all these years, Hedda Lettuce is still living her salad days . . . and dressing for it.

Your involvement with Queer Nation sparked your drag career. How did one lead to the other?

Some of my earliest drag experiences were on the street in the park across from the Monster, me and Miss Understood, lip-synching to make money for the organization. We were physically out there on the street working, really doing activism-slash-street theater. It was so much fun. Granted, I would get cigarette butts thrown at me, but there were also a lot of people who thought what we were doing was fascinating.

Hedda Lettuce wasn't always the green goddess that she is now . . .

The green transition happened when I was working in Provincetown. There I was standing on the street handing out flyers and I looked down the street and it was a sea of cheap redheads and blondes. I thought, how am I going to stand out visually in this crowd? I thought, well, my name is Hedda Lettuce, I should really do green hair. Now, I can't see myself in any other color really. It's like that green wig was just waiting for me to go claim it.

Has drag changed a lot since your early days?

When *Mona Foot's Star Search* was happening—she was one of the funniest drag queens in the city, the drunker she got, the better she got, she was hysterical—there was so much fucking talent. I know when you get older, you're like, oh, it's not like it used to be in my day. But I'm glad I came up when I did.

You've hosted a movie-screening series in Manhattan called Hedda Presents the Classics for many years and, during that time, you've interviewed a lot of terrific people. One of your finest moments was with Rutanya Alda, who played Carol Ann in Mommie Dearest . . .

I got her to say the C-word!

When you were growing up, did you ever think your job would include getting someone to call Faye Dunaway a C-word other than "costar"?

I came from Long Island, a little boy who all of a sudden became a big drag queen in New York City. I don't know how that even happened.

OPPOSITE: Hedda Lettuce.

Shequida

"Just like New York City is a melting pot, so is the drag here. Diversity makes shit amazing."

—Shequida

He is a Julliard-trained opera singer originally from Jamaica, who, one Halloween years ago, slipped into women's clothes and caught the attention of what his alter ego calls "the right people." Since then, Gary Hall has become known as the very glamorous and very musical drag queen Shequida.

"I wanted a name that would give me some street cred. I didn't want to sound like a diva," he says. And yet a diva, Shequida most certainly is.

Hall never intended to mesh opera and drag, but he's glad he did. "I totally separated the two for a long time, but once I sang in drag live, my life totally changed," he says. "My shows went to a different level. I would have never thought people would want to hear a drag queen sing opera, but I was wrong."

Performing first at clubs like the Roxy, then in theaters with shows like *Opera for Dummies*, Shequida has carved out a gorgeous niche for herself and won accolades—like a Backstage Bistro Award—doing it. "I've been all over the world, in some shitty bars and some amazing opera houses. The diversity keeps you humble and on your toes."

She also has done television. In 1997, Shequida was cast as Wendi Mercury, a mixologist with a sympathetic ear and a secret on the soap opera *One Life to Live*. "I had never acted in my life—watch the episodes, you can tell!—but I got really amazing support, and I still use what I learned there to this day." She also appeared on *America's Got Talent*, a 2008 experience she has called "weird."

Speaking of weird—but *good* weird in this case—Hall doesn't just have one drag-opera alter ego, he has two. He's also known as Jessye Normous. "She was a 'guest performer' in an Off-Broadway show I did called *Popera*. Then someone asked me to do an entire night of Jessye and that lasted five years!" Hall explains.

What's next for, well, all three of them?

"Shequida is going to get a foot massage and Jessye is dead," Hall says. "Or is she?" One can only hope she's not. A five-octave encore would be divine.

ABOVE: A spangled Shequida.

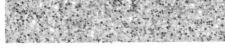

Marsha P. Johnson

{ 1945–1992 }

She said she was at the Stonewall riots in 1969. But unlike most who claim to have been at the birthplace of the gay rights movement, Marsha P. Johnson's story is believable. One eyewitness remembers the pioneering drag queen and trans woman "in the middle of the whole thing, screaming and yelling and throwing rocks, almost like Molly Pitcher in the Revolution or something."

Like Pitcher, Johnson was a fierce Jersey girl, too. She was born Malcolm Michaels there, but legally changed her name in her twenties when she left for the big city. The "P" in her name, she said, stood for "Pay it no mind."

Establishing herself as a popular performer at drag balls and at venues around New York City, Johnson became best known as a "street queen," a sometimes homeless but perennially cheerful Greenwich Village fixture who wore a smile on her face and flowers in her hair.

A radical as long as she was a drag queen, Johnson and her fellow trans activist Sylvia Rivera cofounded the group STAR, or Street Transvestite Action Revolutionaries, in the 1970s. Johnson continued to fight for justice well into the age of ACT UP.

Her end, though, was not a happy one.

In 1992, Johnson's body was found floating in the Hudson River. Her mysterious death was deemed a suicide, but in 2012 the case was reopened, although not solved. Her homicide became the subject of *The Death and Life of Marsha P. Johnson*, a 2017 documentary by David France, the filmmaker whose 2012 feature *How to Survive a Plague* was nominated for an Oscar. *Happy Birthday, Marsha!*, a short film directed by trans activist Reina Gossett and Sasha Wortzel, premiered at OutFest in Los Angeles in 2018.

Johnson, in her lifetime, had posed for Andy Warhol. But her fifteen minutes continued after her death. She was the inspiration for Antony and the Johnsons—a band whose collaborators have included Bjork and Lou Reed—and, in 2015, she appeared as a character in Roland Emmerich's ill-conceived 2015 drama *Stonewall*. Her role in the uprising was diminished in that big-screen retelling of the story, and modern-day activists took to social media to complain about Hollywood whitewashing. Johnson knew the role she played at the real Stonewall; and about the movie she, no doubt, would have said, "Pay it no mind."

ABOVE: *Promotional button from the 2017 documentary* The Death and Life of Marsha P. Johnson.

SASHAY YOUR WAY ACROSS THE U.S.A.

"Don't be a drag, just be a queen."
—Lady Gaga

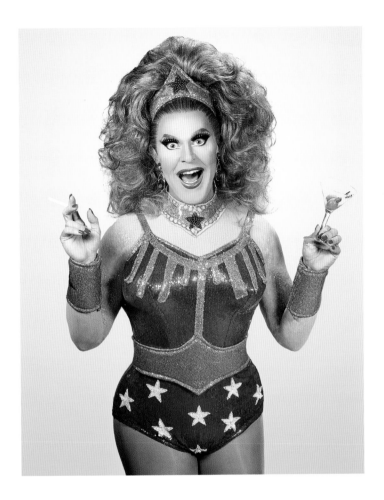

A newspaper story from 2013 began with the words, "Nothing adds pizzazz to a night out like a drag queen pulling numbers at a bingo game, lip-synching a Pink song on a laser-lit stage, Jell-O wrestling or navigating a trolley ride."

The piece didn't appear in the San Francisco Chronicle, as you might think, and the writer wasn't talking about the perennially drag-happy City by the Bay. No, she was writing in the *Herald-Tribune* about Sarasota—as in Florida, as in not even Miami or Orlando, but frigging Sarasota. Who would have thunk it?

Well, anyone who was paying attention, actually.

Drag is being celebrated across twenty-first century America with more widespread enthusiasm than ever before. While the traveling queens of *RuPaul's Drag Race* may be the hottest draws in venues from coast to coast, there is at least one drag queen in every city whose reputation has elevated her to a national level of notoriety, sometimes without much TV exposure at all. She is the local girl with, as no one says anymore, the sizzle in her shizzle.

Among connoisseurs of cross-dressing, these queens are among the best in the business. They know what they're doing—they've been at it since pussy was a cat—and they're here to stay. Here they are, in their own words, each and every one a drag superstar worth catching whenever and wherever they perform.

OPPOSITE: *Miss Richfield 1981.* **ABOVE:** *Varla Jean Merman as Wonder Woman.*

Tawny Heatherton

"No matter the age, gender, race, creed, or orientation, audiences always love a good drag show!"

—Tawny Heatherton

He is the artistic director of the Provincetown Theater, the celebrated playwright of *The Night Larry Kramer Kissed Me*; an Obie Award–winning solo performer; and a member of the original Off-Broadway cast of *Pageant*, Robert Longbottom's musical spoof of beauty competitions. He has appeared in such seminal gay films as *Philadelphia*, *Longtime Companion*, and, yes, *It's Pat*, too.

With all that going on, David Drake found time in 2009 to create a drag alter ego who has developed a cult-like following in his adopted home on Provincetown, Massachusetts. When the sun is bright—and the pay is high enough—Drake transforms himself into a dangerously tan beach beauty named Tawny Heatherton, the supposed niece of the Rat Pack–approved sex bomb Joey Heatherton. Cape Cod is all the fishier for her high-glamor, low-SPF existence.

Where did Tawny Heatherton come from?

Tawny came from my drag bag when I was getting dressed for carnival here in Provincetown the year Farrah Fawcett died. In my grief, I flipped a blonde wig upside down. In a little Hawaiian frock and a pair of Lucite platforms I'd found at the Methodist Thrift Shop, a pair of false eyelashes, and some pink lipstick, I was out the door—and Tawny was born. Tawny's my personal sunshine to counter my own cynicism, regret, and resentments. And she is also innately embedded in my fascination with the ethereal nature of Marilyn and all the Monroe Girls who exude that childlike wonder in the world.

Doing drag is certainly not new for you . . .

I got my Equity card replacing Charles Busch in *Vampire Lesbians of Sodom* Off-Broadway in the 1980s. I did it for nearly nine hundred performances, more than Charles even, and I loved every second of it. I also created the role of Miss Deep South in the original cast of *Pageant* in New York. *Pageant* was a phenomenon—the first truly mainstream drag show Off-Broadway. When we opened in 1991, the stars lined up for seats! Steve Martin, Joan Rivers, Joan Collins, Geena Davis, Liza Minnelli, Chita Rivera, even Madonna! I also played Peggy Day—the Joan Fontaine role—to Charles Busch's Mary Haines in the legendary staging of *The Women* at Town Hall in the mid-1990s.

That was an amazing night! You've done drag on TV, too, haven't you?

I shot my first *Law & Order* in 1991—the second season!—in drag. Most recently, I played a drag character on HBO's *Vinyl*. Provincetown made its mark there, too! Despite the costume department trying a bunch of expensive wigs on me, Martin Scorsese insisted I wear the wig I'd auditioned in—Tawny's!

Speaking of Provincetown, how would you describe the drag scene there?

For professional drag queens, and the audiences who adore them, the summers in Provincetown have long been their Las Vegas. Just a walk down Commercial Street an hour or so before curtain is a whole show unto itself. More than anywhere else, Provincetown audiences come looking for a party.

OPPOSITE: Tawny Heatherton.

Ryan Landry

"It doesn't matter what you're wearing, be it a wig or a clown suit. In my case, it's often both."

—Ryan Landry

Ryan Landry has been called the "Charles Ludlam of New England" and the "absolute anchor of subversive drag comedy" in conservative Boston, writing and starring in stage shows with such alluring titles as *Who's Afraid of the Virgin Mary?*, *Pussy on the House*, and *The Exorsissy*.

"I've played everything from an unborn embryo to *The Flying Nun*," he says.

For this always provocative playwright and performer, creating an epic mashup of *Grease* and *Clash of the Titans*, as he did with 2017's *Greece*, or mixing *The Miracle Worker* and *Gypsy*, as he did for 2016's *Legally Blind*, is all in a gay's work. In 2018, he had another hit with *Brokelahomo!*, a cowboy musical with corn as high as Eureka O'Hara's eye.

The *Boston Globe* has described Landry's work as "comically raunchy" and noted that his troupe of actors, the Gold Dust Orphans, "on skimpy budgets and with key players in drag . . . have attracted a devout audience and critical acclaim." Even the *New York Times* called him "a hoot" when his play *Mildred Fierce* transferred to the Big Apple in 2013.

"Some people may think that my mind is perverse and not worth tiptoeing through," Landry told the *Globe* in 2013. "But it's certainly different—you have to admit that."

Playwright, performer, emcee . . . where does drag fit into all the many things that you do?

Drag is simply an avenue to the truth. It frees me from the label of "man," or "woman." Transcending both male and female gives me the freedom to do and say exactly what I feel at all times.

You and the Gold Dust Orphans are known for such parodies as Peter Pansy, Thoroughly Muslim Millie, Whatever Happened to Baby Jesus?, and All About Christmas Eve. How would you describe your tribe?

The Orphans are a devoted family of freaks who help their audience see the world through a different lens—one conceived and created within my sick yet hopeful mind.

What's the Boston drag scene like?

It's lots of "You go, girl!" "Work, Miss Thing!" and "Yessssss, Hunty!"

Like so many Bostonians, you spend your summers in Provincetown. Your weekly anything-can-happen-and-usually-does variety show called Showgirls is legendary. What's it like working there?

I've made my living doing drag in Provincetown since the 1970s, so, of course, I've seen a lot of changes. When I started it was nothing but pageant queens lip-synching to Cher and Barbra Streisand. I did that too, but while jumping through a flaming hoop dressed in a garbage bag covered in mayonnaise. I wanted to change the face of drag and I believe I did, in Provincetown anyway.

What has been your finest moment on stage?

It was the opening number of *Showgirls* one Monday night and I was coming down from the ceiling, straddling a giant mirror ball, when the wire snapped and I fell crashing to the stage. The ball was crushed and the mirrored tiles lodged in my leg but I kept that fucking mic in my hand, baby, and never let go!

OPPOSITE: *Ryan Landry in* Mrs. Grinchley's Christmas Carol.

Brittany Lynn

"Putting on drag is taking the best parts of your personality and magnifying them a million times over."

—Brittany Lynn

Ian Morrison is a six-foot-five bartender—a popular, friendly face in Philadelphia's gayborhood—but when he puts on his hair and heels and becomes Brittany Lynn, he tops out at more than eight feet tall. "Ask me to show you pictures where I tower over every step-and-repeat," he says.

A former editor at the *Philadelphia Gay News* newspaper, who first dabbled in drag as a teenager playing Frank-N-Furter in a local production of *The Rocky Horror Show*, Morrison is a fixture in his community. And Brittany Lynn, well, she is as synonymous with Philadelphia as the Liberty Bell, and just as cracked.

Over the course of more than two decades, she has gone from performing at the bar mitzvah of gay twins to headlining on the stages of Atlantic City casinos. She has also received the kinds of civic honors few would ever imagine a city—even one of Brotherly Love—would bestow on a drag queen.

Brittany has marched in the Mummers parade— "The crowd loved us! The Mummers are straight men acting like drag queens in sequins themselves anyway!"—and local officials have designated March 15 as Brittany Lynn Day in Philadelphia. "That was the moment of a lifetime! I mean, I've opened for Lance Bass, Debbie Gibson, Taylor Dayne, and even my idol Sandra Bernhard, but getting my own friggin' day from the city council, how the hell do you top that?"

How would you describe Brittany's look?

Brittany's look is *Laugh-In* on acid. I live for the 1960s and 1970s—baby-doll dresses in crazy patterns with lots of fringe. Basically anything crotch-length because I have legs that go up to my tits. My makeup looks like Baby Jane painted Bea Arthur.

Where did her name come from?

When I decided to do drag, I thought "I'm gonna do it big," so I invested in a photo shoot. When I showed the photos to my mom, she made that face that Miss Vida's mom gave her in *To Wong Foo*. It was a look of confusion, disappointment, a my-son-is-gay-and-wears-a-dress moment. It was the 1990s, and my mom had no idea what she was looking at.

So the night of my first drag show, the hostess, Tinsel Garland, asked me my name, and I said "Ian." She told me I needed a girl's name, "something your family will see in lights one day." In my most passive-aggressive moment, I chose my little sister's name. I thought whenever it would appear in a paper, the name would empower me from that moment of my mother's disappointment. Now, I'm like "Gawd, I'm an asshole," but that's show biz, kid.

I take it that your first performance as Brittany Lynn went well.

I fell in love with what I saw that night, a big row of men in dresses not giving a shit about shit, and having the best time ever.

What changes have you made since then?

Brittany's makeup has improved a hundred times. Don't shine a bright light on her after a few numbers, though, but she's pretty when she starts.

OPPOSITE: Brittany Lynn.

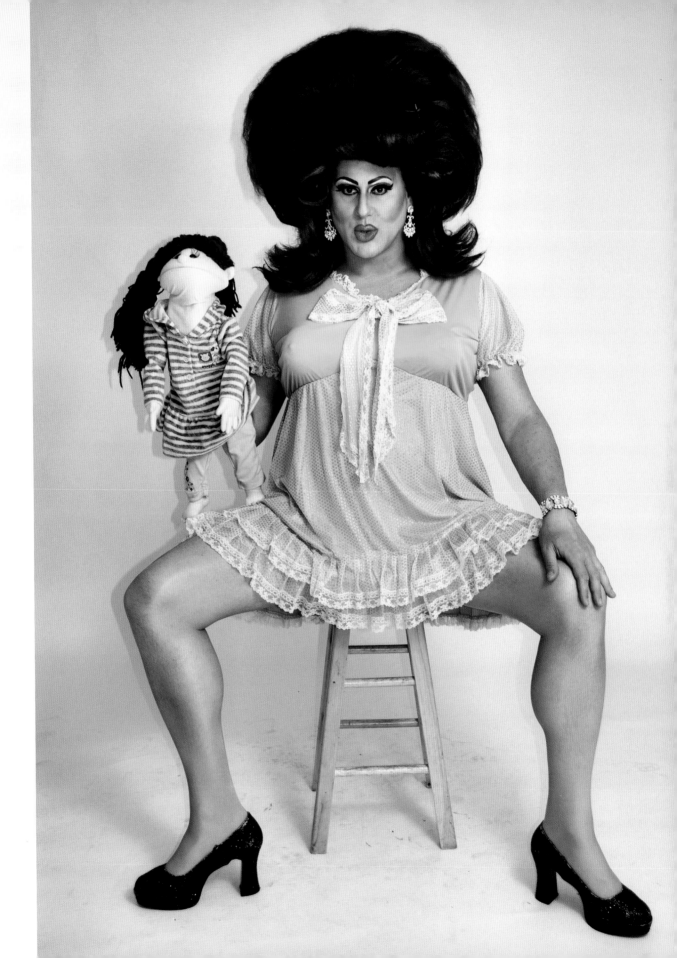

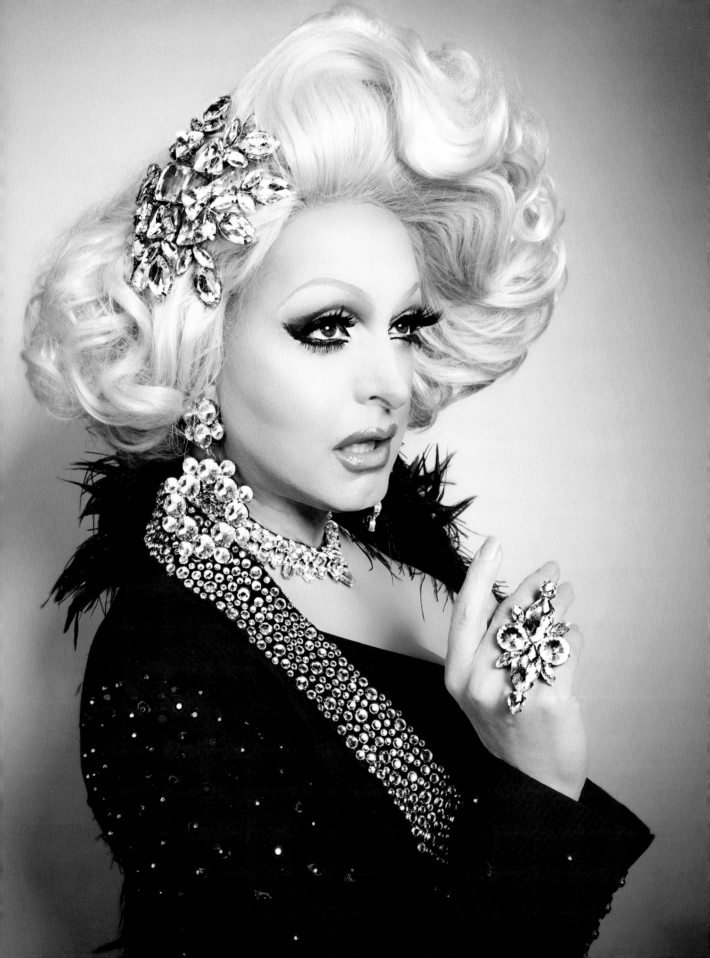

Aggy Dune

"At the end of the day, drag is a business, and I'm in business to win."

—Aggy Dune

Rochester, New York, is lousy with fabulous drag queens. And, if you ask any of them to name the queen of queens, they usually choose Aggy Dune. The creation of hair salon owner Tom Laurence, who chose her name after seeing the 1980 cult film *Times Square*, Aggy has been slaying them since the 1980s in upstate New York, and other ports of call from a Hogwarts-style same-sex wedding to the closing ceremonies of the 2014 Gay Games in Cleveland.

As a performer, Dune is one of the forces—along with *Drag Race* alum Mrs. Kasha Davis (Ed Popil)—behind *Big Wigs*, a two-(wo)man "celebrity impersonation, quick-change variety show," as Laurence says, that presents more than a dozen legendary divas from Bette Midler to Tina Turner on one stage.

"We've been doing this show in the mainstream since before there was a *Drag Race*," Laurence says. "Kasha Davis and Aggy Dune were ahead of the trend." *Big Wigs* is "like a little bit of Las Vegas in Rochester" and that, he says, makes it palatable to straight folks who may never have experienced female impersonation live before. "We're like a gateway drug for drag," he says.

Audiences do get hooked once they've tried it.

How did you get started as a performer?
I went to see the midnight showing of *The Rocky Horror Picture Show* in the summer of 1980 and that night set me on a path that I still travel on today. I started performing every weekend as Frank at the movie the-ater. When the theater in my town stopped showing the film, I moved to the next city it was playing at. I had no job; my obsession was finding a way to live my life and perform every Friday and Saturday night.

So what did you do for money?
It was the early 1980s, and a new TV show called *Puttin' on the Hits* was getting popular. It was sort of a lip-synch version of *American Idol*. Straight bars everywhere started having their own lip-synch competitions. I went from bar to bar, night after night, competing. I made a living off winning the weekly battles. I was Boy George, Prince, Billy Idol, and then I got the nerve to do it in drag. I sang Jennifer Holliday's "And I Am Telling You I'm Not Goin'" from *Dreamgirls*. I found the missing ingredient Aggy needed—a black woman's soul.

Rochester has given us not only Aggy Dune, but also Mrs. Kasha Davis, Pandora Boxx, and Darienne Lake. What gives?
There's something in the water here in Rochester that makes for great drag queens. I think it's the chemical runoff from the Kodak Kodachrome film.

What's the strangest place you've played?
I was hired to perform at my mother's bowling banquet in Montour Falls, New York. My dressing room was a Winnebago. You really have to have confidence when you perform under fluorescent lights, next to the buffet table, at the Mechanics Club in your hometown in front of your mom. After that, all other gigs are easy.

OPPOSITE: Aggy Dunne.

Sushi

"People love drag because we make them laugh with us and not at us so much anymore."

—Sushi

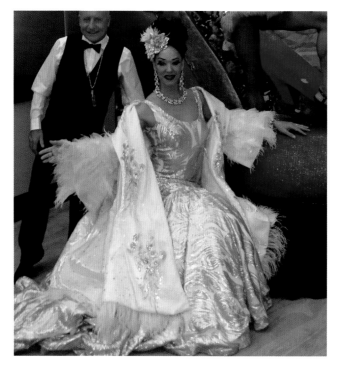

Drag queens and footwear go together like spicy tuna and rice, but none has as intimate a connection to a shoe as Gary Marion. Dressed to the nines as his dazzling alter ego Sushi, Marion has descended at midnight every New Year's Eve since 1996 from the roof of Bourbon Street Pub in Key West, Florida, sitting in a giant glittering red high-heeled pump.

She and her infamous "shoe drop" are fixtures of Anderson Cooper's December 31 countdown on CNN. If he is *Gay* Lombardo, Sushi is a ball.

The shoe drop began as a wild idea. "The owner of the Bourbon Street said, 'We built a shoe and we want you to sit in it.' That first year, we didn't have a city permit so the police tried to get me out of the shoe, but the owner called the mayor and he said, 'Leave her alone and just close the street down.'"

They did and the rest is footwear history.

Born in Bangkok but raised in Oregon, Marion originally performed in "high-fashion glamour drag" as Soy Sauce at Portland's City nightclub. But when his truck was broken into and his drag bag was stolen, his alter ego got new clothes and a new name. "My drag mother Marluxe Duval put me in drag and said I was so fishy, so she named me Sushi," he says.

The character— "very outspoken and wild, unlike me," Marion says—has performed in venues from San Francisco to Fire Island to Amsterdam to Tokyo. But Sushi rules Key West. "People say I'm the Queen of the Island but that's only because I've been here so long," he says.

Between New Year's celebrations, Marion runs one of the most popular clubs in Key West, the upstairs 801 Cabaret. "I have fourteen queens working for me doing two shows a night, seven days a week." Sushi and the 801 girls were the subject of Robbie Hopcraft's 2009 documentary short, *Audience with the Queens.*

Although Marion is not sure what's in store for Sushi, he doesn't plan to venture far from Key West, at least not on New Year's Eve, for many years to come. "I'm going to be the old lady in the shoe," he says.

You'd have to be a heel not to wish Sushi well.

ABOVE: Sushi.

Chilli Pepper

"I'm a showgirl and showgirls are ageless."

—Chilli Pepper

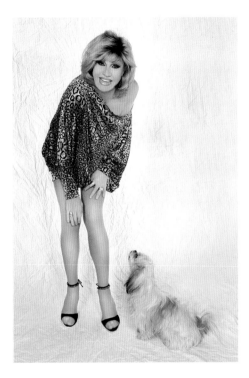

Chilli Pepper is the queen of Chicago female impersonators, a forever-and-a-day fixture at the Baton Show Lounge, a performer so charismatic even Oprah Winfrey considers her a star. It doesn't hurt that the talk show titan and the lip-synching legend have been Windy City friends for more than thirty years.

"Many men are called to dress as women. Few know how to loom larger than life," the arts critic Sid Smith wrote in the *Chicago Tribune* in 1995. "Chilli is different. Her cultivated sass and snide superiority are palpable."

To be sure, no one knows her way around a Millie Jackson song better than Chilli, not even Millie herself. The soul singer, known for her risqué lyrics, once told her, "I was watching you perform and I forgot it was my voice."

She has been lip-synching for her life at the Baton, making female empowerment anthems like "I Will Survive" her own, since at least the early 1980s. "Do you have to put dates?" she asks. "Can we just say Chilli is very youthful? It makes it more 'Madame X' when you keep them guessing."

For the record, she won't even reveal her given name because, well, if her mother can call her "Chilli," so can you.

Pepper grew up in the affluent suburbs of Detroit and, like so many queens to be, used Halloween as an excuse to test the perfumed waters of drag. Eventually she made her way to Chicago, and one night, found herself in drag at the Park West. "I went to a pageant and I won and I stayed," she says.

The name Chilli Pepper was bestowed upon her when she came home from a trip to South America with a bad case of sunburn. "My friend said, 'Where were you?' I said I was in Chile. He said, "Well, you look like a chili pepper, and people started calling me that."

Chilli, she says, is "the cartoon I've created for myself" and being her is a full-time occupation. "I don't do characters. I am the character," she says. It has been a colorful enough persona to get her booked on talk shows from *Oprah* to *Donahue* to *The Jerry Springer Show*. Those TV appearances helped to broaden her audience at the Baton over the years. "It's all about passion and a love for what you're doing," she says. "It's an illusion and we make it look fabulous. We may make it look easy. But it's a hard road, honey."

ABOVE: Chilli Pepper.

Mr. Charlie Brown

"For every queen working, there are ten wanting your job."

—Mr. Charlie Brown

It has been written that "you can't talk about Atlanta's drag scene and not talk about Mr. Charlie Brown," and it's true. Since the early 1970s, when he got his start doing drag at the Watch Your Hat and Coat Saloon in Nashville, Charles Dillard has made Mr. Charlie Brown one of the South's most popular drag queens.

Although he now describes his onstage persona as "a rich old white woman, you know, a bitch," Dillard first worked as a drag stripper, and won various pageant titles, Miss Midwest among them. But it is his tongue that has endeared Mr. Charlie Brown to audiences over the years, particularly at the popular watering hole, Lips. "I'm a big Don Rickles type of emcee," he says.

Still, Atlanta locals think he's a peach.

Where did your stage name come from?
The city ordinance in Nashville required you to have a male name if you were going to cross-dress and do a show and you had to have "Mr." in front of it. When that changed, a lot of the entertainers changed their names. But the show director said, "You've worked all these years under the name Charlie Brown." I liked it anyway. I wanted to be known as an old country boy and nobody else had "Mr." in front of their name, so it was like a little novelty thing.

How did audiences react to you?
When I first started, oh my god, they were thrilled to death. The only drag around at that time was at private parties, you know just one little kid who'd dress up and do Diana Ross. The kids were so crazy over it.

They loved drag because it was new. And if you had a good number, you could pay your rent!

Was it dangerous being a drag queen in those days?
The club I started out in, we had to take our drag in and out in trash bags so the rednecks wouldn't see it. I worked in Charleston, West Virginia, at a club under the interstate. You'd have to park under the overpass and the doorman would listen for traffic and tell you to run because rednecks would drive by and throw empty beer bottles at the club! He'd say "Run!" and everybody would run in the door and you'd hear the bottles, bam, bam, bam, bam.

You're known for your banter . . .
The greatest day of my life was when they handed me the microphone and told me to get out there and emcee. I'm the ultimate bitch on the microphone. I always pictured myself as the dirty old cartoon character in *Playboy* magazine, the little old woman sitting at the end of the bar, with her tits hanging down past her knees, who everyone was hanging around because she was so much fun.

After all these years, how does it feel to be the grand diva of Atlanta?
I never dreamed when I pulled into this town, I would have the success that I've had. My drag mother, Criss Cross, God rest his soul, told me the day you think you're a star, you'll never be one. I've never really thought I was the grand diva. I know what I've achieved. But tomorrow is another day.

OPPOSITE: Mr. Charlie Brown.

Varla Jean Merman

"I love when people I know tell me, 'I can't even see you in her.'"

—Varla Jean Merman

Once just a big-boned girl with a tragic back-story—the red-haired reminder of the rocky thirty-eight-day marriage of her show-biz parents, Ethel Merman and Ernest Borgnine—Varla Jean Merman has gone from spray cheese–eating drag infamy to superstardom since she burst on the scene in the early 1990s.

From Carnegie Hall to the Sidney Opera House, Broadway to the Big Easy, Varla has emerged as a stunning coloratura with a flair for outrageous comedy. the *New York Times* said it best in 2013: "There is nothing like this dame."

The creation of former advertising art director Jeffery Roberson, Merman has towered over Leslie Jordan in the Off-Broadway musical *Lucky Guy*, starred in the Tweed TheaterWorks version of *The Bad Seed*, appeared in Richard Day's cult film *Girls Will Be Girls*, and, quite memorably, played a prostitute named Rosemary Chicken on the venerable soap opera *All My Children*.

She may still be haunted by the fact that her mother gave her away. "I had his face, and she couldn't stand the ugly reminder," she says. But now there's no denying, she's a pretty girl, mama!

Varla began her life on video. How did that happen?
I met a videographer in college at Louisiana State University named Vidkid Timo. We started to make videos of me in drag doing stupid things. One had me running down the streets screaming while I was chased by a plastic rat on a fishing wire. The bars in New Orleans would play them, and even though they made no sense, people would be glued to the video screens.

You left for the Big Apple in the early 1990s . . .
My best friend had moved to New York City and he called me and said, "Last night I saw the most amazing drag queen, Miss Coco Peru, who did a monologue to Wagner's 'Liebestod'." I couldn't believe someone was combining opera with drag. It became my goal to become a part of a drag scene that wasn't about just standing and lip-synching in a beaded gown for dollar bills.

What were your early live performances like?
When I moved to New York in 1993, I did a slot at the Pyramid Club. It was my first time performing in New York, and that night, I did my patented, dramatic "belly flop" while French kissing a severed cow's tongue. From that one performance, I got booked all over town.

You were plus-sized at the time, then you lost a lot of weight, and, recently, you've gotten into amazing shape.
I went from morbidly obese to anorexic-model thin first. I had to figure out an entirely different angle for Varla. It was hard because fat jokes were all I knew! That's when Varla became less mean and I opted for "ditzy." Now that I've become muscular, I've added puff sleeves and I look dumpy again.

Are you okay with that?
It's the circle of life.

OPPOSITE: Varla Jean Merman.

Miss Richfield 1981

"I'm a hopeless adrenaline junkie always looking for the next audience to shoot me full of the good stuff!"

—Miss Richfield 1981

She has a big mouth and she knows how to use it. And, while that sounds dirtier than it is—probably—those fast-talking lips have helped her maintain her title as Miss Richfield 1981, and reign as one of the funniest drag queens around, since the mid-1990s.

A drag star in the Twin Cities and a Provincetown staple every summer, Miss R is the alter ego of former journalist and public relations man Russ King. He, like she, really is from the Minneapolis suburb of Richfield, Minnesota.

While some may take offense at her antics—honestly, who names a holiday show *We'll All Be Dead by Christmas?*—Miss Richfield is her hometown's favorite daughter. As one critic wrote in a review of her 2014 show *Play With My Poodle*, "Miss Richfield has a stellar sense of timing, pouncing like a lion on a gazelle when she senses an opportunity to land a joke."

No other Hennepin County beauty queen can boast that.

How was Miss Richfield, well, crowned?

I was graciously invited to a Miss America viewing party in 1995 at a friend's new home in a swanky Minneapolis neighborhood. My roommate and I thought we'd honor the festivities by dressing up like beauty contestants. I was Miss Richfield 1981 and he was Miss Little Rock 1986. Both were lovely, but only mine lasted more than one night.

How did you arrive at Miss R's look?

I bought this darling wig in a sassy bob style, but friends suggested I take it to a salon to have it spruced up. One day and twenty dollars later, I picked up a bouffant of enormous proportions. The glasses were an immediate decision after it became apparent that eye makeup was not my specialty. Soon to follow were gloves and a matching hand bag. I couldn't keep nails on, and Miss R would never set her bag down in a tavern for fear someone would steal her bus pass.

Does anyone ever get offended by your material?

Thankfully, not often. Miss R is quite accessible for all ages, sexual orientations, and gender assignments. On the surface, she appears to be clueless on issues of race, religion, and other delicate matters. But the real punchline of the material is white people. When someone does get offended, I try to remember that comedy is very personal.

How has appearing on television impacted your career?

I've been so blessed to get the visibility of TV. So many people see you at one time! It creates a level of visibility that is so different from stage performances.

What has been your finest moment as Miss Richfield?

The most amazing honor ever was to be named Richfield Citizen of the Year in 2015. It was an honor to have my hometown recognize my work and officially recognize me at a city council meeting. My mom was able to come and I received the award at the council meeting—in drag! How cool is Richfield?!

OPPOSITE: *Miss Richfield 1981.*

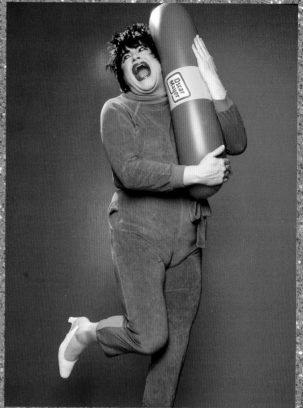

Dina Martina

"Know your audience. Even if they don't want to know you."

—Dina Martina

Dina Martina calls herself a "tragic singer, horrible dancer, and surreal raconteur" and while all of that is true, others have been more kind since she burst on the performance art scene in the late 1980s. the *New York Times*, for instance, has described her as "offbeat and inimitable."

Truly, no one could—or, perhaps, would even want to—imitate Dina.

Her voice is indescribable in polite company. Her look? Well, she appears to have put on her lipstick in an earthquake, considers camel toe de rigueur, and wouldn't be caught dead without a soupçon of back hair peeking out from beneath whatever barely zipped thrift-store ensemble she's wearing.

Despite, or perhaps because of all of this, Dina is beloved from Los Angeles to London. Her annual Christmas shows in Seattle are legendary—she has been known to dress as the world's largest holiday turkey—and her summer-long residences in Provincetown have left audiences dazed since 2004. *Out* magazine dubbed her the "Queen of Pee Town," which is yucky but apropos.

No one in show "bidness," as she calls it, does anything close to what she does. So totally bonkers is the world she creates that one might describe Dina as the Pee-wee Herman of drag. But she is not a drag queen, just a lady who looks her prettiest in a funhouse mirror.

You made your debut at Seattle's Center on Contemporary Art in 1989. What did you wear, what did you perform and how did it go?

I wore an attractive, butterscotch-colored jumpsuit that fit like sausage casing and I performed the "Theme from Mahogany." It went well from what I could tell, but the audience was viewing me through peepholes in a wall, so you could only glean so much.

Since then, you've gone on to become, in your words, the "Gold Standard in Entertainment." What does that mean exactly?

It means that you can conjure up an entire evening of cream-of-the-drawer entertainment and serve it up hot, or at least room temperature. Get it while it's tepid!

How would you describe your look?

You know that saying "less is more"? Well, I describe my look as "more is more." I've always tried to capture the innocence of Baby Huey, coupled with the glamour of Clarabelle the Clown. I wear whatever ensemble best shows off my ballpark figure.

You've performed all over America and in parts of Europe. Does your daughter Phoebe travel with you?

She doesn't travel with me often because I usually already have two carry-ons and they won't let me check her. That's probably for the best though, because if I ever lost her in an airport I think I'd be sad. I'd also be in a whole bunch of trouble, 'cause they really don't like it when you lose the adopted ones.

OPPOSITE: Dina Martina.

Sister Helen Holy

"Drag is funny. Drag is fascinating. Drag is commentary."

—Sister Helen Holy

Paul J. Williams was delivering singing telegrams in Dallas, Texas, in 1988 when his boss asked if he could impersonate Dana Carvey's "Church Lady". For the next two years, Williams made his living showing up on people's doorsteps dressed as the popular *Saturday Night Live* character.

After a chance meeting with Carvey in 1990, Williams decided it was time to create a religious zealot character of his very own. "I didn't want to do anything to profit off someone else's creation," he says. And, so with a nod to Carvey, and the inspiration of his childhood idol, Lily Tomlin, he became Sister Helen Holy.

Certainly Williams knew the type of woman he would be playing. He was raised Southern Baptist in San Antonio. Helen, he says, is "prim, proper, and pink." Although some hear her name and assume she's a nun, Williams says, "Helen is quick to point out that her Baptist faith is the only true religion."

A stand-up and improv comic, Williams first got Helen's sensible shoe–clad feet wet at small private parties, but soon the venues got as big as her self-righteousness. "I was even hired to roast Ross Perot's sister, Bette, at her sixtieth birthday party," he says. More recently, Helen playfully shish-kebabbed an ultra-conservative Supreme Court justice who was the guest of honor at a large party.

"I take special joy in the chance to make ultra-wealthy straight crowds laugh at life," Williams says. Playing Helen gives him "the ability to comment on the often narrow-minded thinking of church people and prejudice at large." But mostly, he says, his motivation comes from "the desire to make other people laugh and have a good time."

That includes audiences on gay cruises, where Helen is a fixture. "Over the years, returning passengers have become my biggest fans," he says.

Sister Helen Holy continues to court that audience even on dry land via her blog, The 701 Club, and a stage show of the same name. She calls it that, Williams explains, because Helen is "just a little bit better than Pat Robertson."

Well, isn't that special?

ABOVE: Sister Helen Holy.

LEGEND OF DRAG
Cashetta

{ 1970–2015 }

Growing up in the New Jersey suburbs—a rhinestone's throw from Manhattan—Scott Weston dreamed of a life in show biz. "I never thought of any other career," he told the *Las Vegas Sun* in 2009. He thought it would be Broadway and he was almost right—he ended up becoming a star the broad way, as the one-named drag queen Cashetta.

"The fact that I'm in drag is incidental," he once said. "It's just a way to have a larger-than-life character."

After cracking up crowds at the drag restaurant Lips and hosting a live version of *Star Search* at Barracuda, shooting an episode of *Law & Order: SVU*, then singing herself silly at Bar d'O in Manhattan, Weston struck gold when he became a prestidigitator-in-press-on-nails, one of the world's very few cross-dressing magicians.

Although Cashetta joked that she was a born conjurer—"I've been turning tricks since I was a little girl," she once said—she worked to improve her sleight-of-manicured-hand and hone her act. The result was the hit show *Magic's a Drag*, which took her from New York to Fort Lauderdale to the Las Vegas strip—not to mention the cruise circuit, and the *Today* and *Conan O'Brien* shows. When the plus-size performer added mentalism to her repertoire and became an "Extra Large Medium," she soared to even greater heights.

Describing herself as a three-way mélange of Dolly Parton, Bette Midler, and David Copperfield, Cashetta would often end her act by swallowing a five-foot balloon. "I'm an anaconda," she joked. "That one trick has taken me all over the world. The first time I did it, I knew I was going to do it for the rest of my life."

That life was cut short on a trip to Mexico in 2015. She was performing in Puerto Vallarta. Although she had lost weight and become more glamorous than anyone had ever seen her, Cashetta had a fatal heart attack at age forty-four. "She's done the ultimate disappearing act," Lady Bunny said in an online tribute to her friend. "I wish that were a trick she'd return from."

ABOVCE: Cashetta.

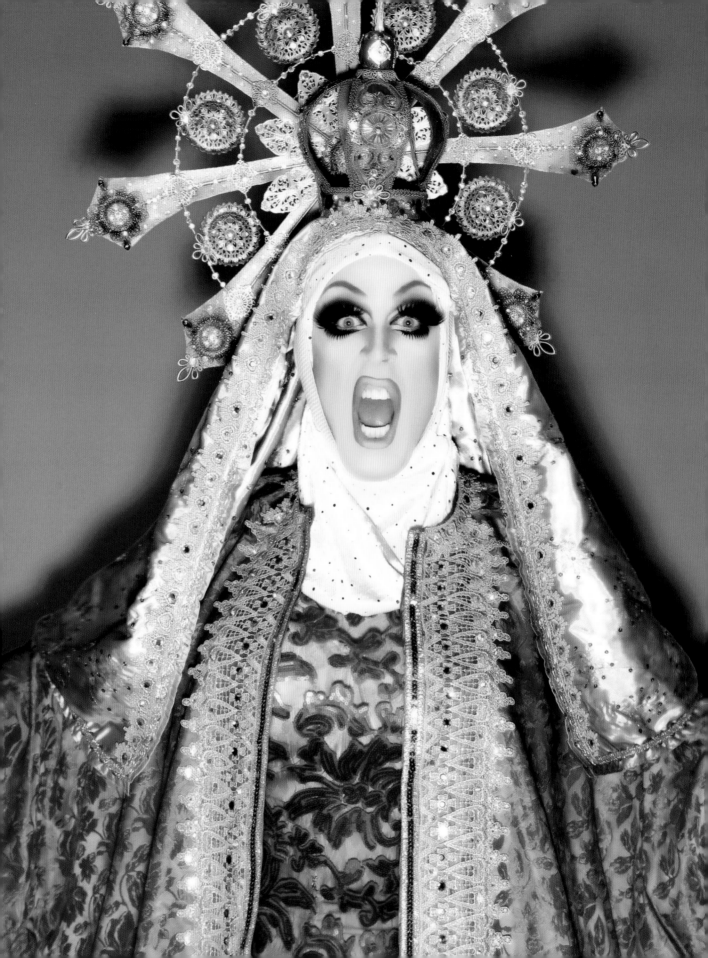

Tempest DuJour

"Live your truth. You're never too old to dream."

—Tempest DuJour

Patrick Holt is a father of two, a college professor, oh, and one more thing—he is Tempest DuJour, "Tucson's favorite drag queen."

Those are the words that appeared in 2016 in the *Daily Wildcat*, a newspaper serving the University of Arizona where Holt is the head of the costume design program. The man knows his craft, just as he has known how to make the most of his brief stint on *RuPaul's Drag Race* in 2015.

Tempest was the first to be eliminated in season seven—the "sacrificial lamb," he says—but that hasn't stopped him from becoming a fan favorite and a sensation beyond Arizona. In 2016, Holt appeared in director Assaad Yacoub's drag film comedy *Cherry Pop*.

One of the most mature and tallest contestants ever to appear on *Drag Race*, Holt is a proponent of what he calls "over-the-top, hyper-theatrical entertainment"—and that's just Tempest's wigs.

His life has been eventful in ways both good and bad—he was on the *Bozo the Clown* show as a kid, lived in Saudi Arabia as a teenager, and, as an adult, nearly died in a car accident that almost cost him a leg. And all that has made him that much more fascinating a creature, in and out of his evening frocks.

Tempest may call herself the "Delicate Flower of the Desert," but Holt is nothing less than, well, a steel *drag*-nolia.

What attracted you to drag?

I was a late bloomer, but I was always infatuated with drag. Snobby, A-List gays and beautiful people who would never give me the time of day were suddenly disarmed by me as a man in makeup and a wig. So drag became my drug.

Your look has changed over the years . . .

When I began doing drag, I was 150 pounds heavier, so it was a lot of sequin tents. Now my style has evolved to more fitted and vintage-inspired looks. I love the sense of theatricality and campy glam that I can get away with in drag now, so I embrace it. I think of my style as campy, kitschy, comedic-based, improvisational, controlled mayhem. The name Tempest came as an homage to my professional career as a costume designer in the theater. I've designed a lot of Shakespeare in my time and it felt fitting that the name evokes some tumultuous imagery. DuJour is just silly and stupid, so I love it.

What did appearing on RuPaul's Drag Race *mean to your life?*

Being on *Drag Race* definitely moves you into the 'top shelf' category of drag entertainers. People now have a certain level of expectation of me and my performance and I feel like I owe that to a paying audience. The exposure and demi-celebrity status that comes with being cast is a huge gift to those of us lucky enough to have been chosen. But I know very few *Drag Race* girls who've made a lot of money as a result of appearing on the show. Thank God I have a career and life to fall back on that complements my drag. It keeps me grounded, it keeps me honest, and it makes me work harder for that next booking!

OPPOSITE: *Tempest DuJour.*

Edie

"It has always been funny to see a man in a dress. It's just more mainstream now."

—Edie

An accomplished ballet dancer in Seattle before becoming the drag queen known as the fabulous Edie in New York City in the 1990s, Christopher Kenney since has logged more than four thousand performances as the mistress of ceremonies of the long-running Cirque du Soleil spectacle *Zumanity*. Edie's still in New York, New York, but now it's the Las Vegas hotel and casino of that name.

"In a black negligee and her trademark black bouffant wig, Edie's presence is refined and elegant," to quote a 2015 story on *Zumanity*, "or as elegant as one can be in a show that features two women juggling dildos."

Okay, it may not be *Swan Lake*, but it's a living.

How did Edie make her debut?

I was dancing with Pacific Northwest Ballet in Seattle in 1990, and all the boys decided we were going out, all in drag, for Halloween. We all went shopping together, running around to vintage stores. I spotted a beautiful long green sleeveless gown with a mock turtle neck—very elegant with a distinct Jackie O feel. I added white opera-length gloves and white drop ball earrings. After that evening, I knew it was the road I would travel with this character. Simple elegance for parties and a 1960s go-go look for performances.

ABOVE: Edie

Is it true you've performed for millions as the "Mistress of Sensuality" in *Zumanity*?

Yes, millions! I don't really think about it. But Jamie Morris, my partner, loves to remind me. It's overwhelming. I'm just glad it's not millions at once. I might die! Honestly, it's an honor beyond belief. Cirque du Soleil is the crème de la crème of shows. Before getting this job, I was traveling around the world, performing in cabarets, in bars, and on cruise ships. I truly enjoyed it, but I love the stability of being in one place now. If there is a downside, it would be the schedule. Ten shows a week for years is brutal!

How does your family feel about you being Edie?

They have always been supportive. I'm very lucky that way. They are the same amazing parents that put all of us kids into dance classes. That was in Portland, Oregon. Well, actually six blocks from the sign that said "ENTERING PORTLAND." They made little money, but they made it their mission to give us more. My parents are still supportive to a fault. I try to get them tickets to other shows when they visit Vegas but my mom always says to me, "We only want to see you!" Sweet, huh?

The Lady Chablis

{ 1957–2016 }

No drag performer has ever been more closely associated with a city, and reached a higher level of fame for that connection, than the Lady Chablis.

The "Grand Empress" of Club One in Savannah, Georgia, she is the most memorable character in John Berendt's nonfiction best seller *Midnight in the Garden of Good and Evil*. So irreplaceable was Chablis that Clint Eastwood cast her to play herself in his 1997 movie version.

The Lady wouldn't have it any other way.

"She said, 'If I'm not cast as myself in that movie, there won't be a movie,'" Berendt once told the *Los Angeles Times*. Certainly, there wouldn't have been much of one without her. *Reelviews* critic James Berardinelli singled out Lady Chablis's performance as "a delightfully comic, over-the-top interpretation of herself," and Roger Ebert noted, "She has some one-liners that are real zingers."

Born Benjamin Edward Knox in Quincy, Florida, in 1957, Chablis honed her comic timing as a drag queen before she began identifying as a transsexual actress. In an earlier incarnation known as Brenda Dale Knox, Chablis had won various pageants. She was named Miss Dixieland and Miss Gay World in 1976, the Grand Empress of Savannah in 1977, and

Miss Sweetheart International in 1989, before reaching the height of her prominence via Berendt's book in 1994.

In the years that followed its publication, Chablis appeared on *Oprah* and *Good Morning America* and published her own book, *Hiding My Candy: The Autobiography of the Grand Empress of Savannah*. In that 1996 memoir, she recounted her colorful life from her earliest performances in Tallahassee, Florida, to her formation of the Savannah League of Uptown White Women, a social club whose dinner parties were called P.T.A. meetings (as in "Party, Talk, and Alcohol").

Lady Chablis died of pneumonia in 2016. Less than a month earlier, she had performed to a packed house in her signature risqué style. "This is not a Disney production," she liked to say. She'd been doing that same naughty act for thirty years and she was happy and confident in her standing as a Savannah institution.

"It's not as if she died without knowing," Berendt said in Chablis's *New York Times* obituary. "She knew. And she also knew she was everybody's favorite."

Chablis's sister, Cynthia Ponder, spoke to the *Los Angeles Times* upon her death, saying, "The legacy that she wanted to leave was one of 'Believe in who you are and never let the world change who you are.'"

Not even Clint Eastwood.

ABOVE: *The Lady Chablis in the film* Midnight in the Garden of Good and Evil.

Darcelle XV

"Put everything on that you're going to wear—jewelry, feathers, rhinestones, sequins— and then just add to it."

—Darcelle XV

After serving in the Korean War, Walter Cole used his savings to buy a coffeehouse in a down-at-the-heel Portland neighborhood. An urban renewal project soon seized the property, as it did with the ice cream parlor and an after-hours jazz club in which he subsequently invested.

Finally, in 1967, with the five thousand dollars he got for that late-night boîte, Cole bought the Demas Tavern at the corner of NW Third and NW Davis. His life—and Portland's—hasn't been the same since.

An amateur actor before becoming a barkeep, Cole decided one night that the tavern's patrons deserved a show, so he began doing drag. "I was always playing an attorney or a doctor. I just changed costumes and put on a dress," he says. He recruited his lover Roxy and their friends to perform along with him.

Once word got out about his alter ego, Darcelle XV—"A local newspaper wrote us up as the best-kept secret in Portland," Cole remembers—he rechristened the bar the Darcelle XV Showplace.

After fifty years on stage, Darcelle—named for the French actress Denise Darcel—was bestowed in 2016 the Guinness World Record title of the oldest, still-performing drag queen. Without eminent domain, this preeminent drag queen might never have been born.

Was it dangerous to be a known drag queen when you started?

It could have been dangerous if the wrong people saw you. We didn't take a chance. We stayed inside. We cleaned our faces off and then went where we wanted to go. Now, drag queens are everywhere. People wave at you on the street and yell, "Darcelle!" and it's pretty exciting.

Who influenced the creation of your drag style?

I was thirty-seven the first time I put a dress on. There wasn't much to go by then. Here in Portland, there was an entertainer named Gracie Hansen at the Hoyt Hotel. When I decided to do drag, I decided I wanted to look like her. She was a woman, but she was as drag queeny as anybody could be. I helped her with some of her costumes. When she died, I got most of them.

Did they fit?

I beg your pardon! Yes, they fit. They were a little short. But she wasn't exactly a tiny woman.

Your son has worked at your bar for more than thirty years and you're still married to your wife. What was it like coming out to them?

My son was just ready to go to high school and my daughter was a little younger. I told my wife, then we went to a bar close to our house and got drunk. The decision to come out ended up being beautiful all around. My family is very proud to be involved with everything I've done. We're all still friends.

How long have you and Roxy been a couple?

We've been together almost fifty years. The best three years of my life!

Out of drag, you seem like such a man's man. But I've heard you say you were a "four-eyed sissy boy" when you were a kid.

That was me. When I was in grade school, I never got picked for any sport, but I could hopscotch just perfect.

How did Guinness World Records find out about you?

A friend, unbeknownst to me, gathered up letters

proving that I was still working and proving my age with a birth certificate. The governor wrote a letter. The mayor of Portland wrote a letter. Two commissioners wrote letters and several dozen friends wrote letters proving that I was still on the stage, and that I was doing my thing, and it was approved.

They had given the title to the Canadian drag queen Russell Alldread, but they realized you were born in 1930, a year before he was, and they took it away from him. Did you ever meet his alter ego Michelle DuBarry?

She's so pissed at me!

ABOVE: Darcelle XV, performing at Wigstock 2.Ho in New York City, 2018.

CALIFORNIA GURLS

"There's something happening here. It feels like it's the place to be."
—Miss Coco Peru

California has been called the Left Coast, the Best Coast, the Land of Fruits and Nuts, and the hottest hotbed of drag in America, and it's all kind of true, give or take a pair of size-14 slingbacks, an economy-sized bottle of Coppertone, and a three-picture—all of them Photoshopped—deal with a major studio.

From the glitteringly subversive, sex-positive hedonism of San Francisco's hippest clubs, to the packed-to-the-rafters, if-you-shave-it-they-will-come alternative performance spaces of sunny Los Angeles, the Golden State is an almost too dragalicious destination. And, it has been that way, up and down the coast, since at least the early twentieth century.

Since the late 1930s, when Finocchio's opened in North Beach and became the West Coast mecca of female impersonation, San Francisco has been a breeding ground for all manner of creative crossdressing, from the goateed flamboyance of the Cockettes in the Castro of the 1970s to the ongoing no-holes-barred party called Mother, thrown by the Icelandic drag queen Heklina and populated by some of the most creative drag queens imaginable.

"A lot of that art for art's sake energy and focus on the performance and comedy and political versus the 'look' is still here in San Francisco," says Joshua Grannell, a filmmaker whose alter ego, Peaches Christ, is a mainstay on the Northern California (and now international) drag scene.

The burg-by-the-bay remains a place where a musical called *Beach Blanket Babylon*, in which even the women look like men dressed as women, can run for decades, a "dragapella" group can combine politics and song and find fans from across the ideological spectrum, a team of ice queens can celebrate Christmas on skates every year in Union Square, and a convent-ful of drag nuns—the Sisters of Perpetual Indulgence—can dress in full habits but not shave their beards, and still brighten the city's day with so much good cheer, it's practically sinful.

OPPOSITE: *San Francisco legend Heklina.* **ABOVE:** *The car wash cutie known as Love, Connie.*

hosted by *Big Gay Sketch Show* alum Jonny McGovern and his largely fabulous cohost Lady Red Couture.

Unique to Los Angeles is the fact that some of the funniest drag is performed by men who aren't even drag queens. Crazed character actors—Tom Lenk of *Buffy the Vampire Slayer* and internet sensation (and Off-Broadway darling) Drew Droege among them—frequently don thrift-store attire and spout filth while playing a cracked version of *The Match Game* for charity at the city's LGBTQ center. *Drag Race*'s Snatch Game has nothing on them.

Others peddle their sequined papayas on a tiny stage in the basement of a Mexican restaurant called Casita Del Campo in Silver Lake. The Cavern Club Celebrity Theater—presided over by Mr. Dan, a man who was known as Gina Lotriman when he was cohosting the legendary L.A. drag party Dragstrip 66 in the 1990s—is home to some of the most inventive drag productions in Los Angeles.

The chiquitito showplace has played host to all manner of drag over the years from a make-believe morning show presided over by a faux Juliette Lewis and Bette Midler (Chris Pudlo and Craig Taggart) to various 1980s-style extravaganzas featuring Love, Connie (John Cantwell), a hairy gal whom one critic alliteratively described as a "hirsute high-kicking heroine."

Meanwhile, in a revivified downtown Los Angeles, the horror-drag of the party-giving duo the Boulet Brothers is helping to make the city a drag-lover's paradise like no other.

"I don't really have enough objectivity to comment on the L.A. drag scene as a whole," says Sam Pancake, a character actor whose drag antics as a very drunk Lucille Ball, an extra hot-to-trot Rue McClanahan, and a supremely potty-mouthed Lisa Whelchel have made him a local favorite. "But I do know that it is high-heeling on full-speed ahead and it's only growing and getting better, bigger, brighter, and more fantastic and creative. Dare I say it's a Golden Age?"

Dare, dare!

Meanwhile, in Southern California, Los Angeles "gurls," to quote Katy Perry, "don't mind sand in their stilettos." As long as they look fierce, they'll draw a crowd, especially if they've appeared on *RuPaul's Drag Race*. The Entertainment Capital of the World is a smorgasbord of drag, feeding its creativity to—and being nourished by—the movie and TV industries.

"You have club queens, comedy queens, theater queens, and even Tupperware queens here. You name it, we got it," says Oscar Quintero, who, as his alter ego Kay Sedia, writes and performs in *Chico's Angels*, a Latina-flavored spoof of *Charlie's Angels*, and sells plastic storage containers on the side.

The town that, for ages, played host to *An Evening at La Cage*, a popular female impersonators show that drew a Hollywood clientele, continues to boast a vibrant drag scene from the girls of drag bingo at Hamburger Mary's to the talk show *Hey Qween!*, a hilarious web series

ABOVE: Lady Red Couture gets a (hairy) hand from Jonny McGovern.

Momma

"A true drag queen is a goddess who brings life and light into your dark days"

—Momma

She says her look is "an older Marilyn Monroe/ real estate/senator woman," but anyone who has seen the California drag wonder known as Momma dressed as, say, a very tall Alice in Wonderland, or as Sleeping Beauty's glitteringly curvaceous fairy godmother, Merryweather, knows she's a lot more fabulous than that.

Since the mid-1990s, Worthie Meacham's one-name alter ego has delighted audiences in and around Los Angeles, whether leading an Enchanted Tiki Room sing-along at Gay Days at Disneyland, spreading holiday cheer while dressed as a bouquet of poinsettias at the *Fruitcake Follies*, the annual Christmas spectacular in Silver Lake, or performing in *Pagliacci* with the L.A. Opera at the storied Dorothy Chandler Pavilion downtown.

"For over two decades, I was the Queen Bee of the Southern California drag scene," Momma says. "I was working six days a week, doing eight shows a week." That's a lot for anyone, but especially for someone who never intended to be a drag queen, and, in fact, was horrified at the prospect at one point in his life.

It's not a happy story: Meacham spent years of his early life in ex-gay therapy. "I was terrified by drag queens," he admits. But when he realized he was gay to stay, he decided he had to get over his fear of crossdressers.

One fateful evening in the early 1990s, Meacham was invited by a friend to attend the monthly L.A. shindig called Dragstrip 66, a long-running club night that the Los Angeles Times once described as falling "somewhere between a John Waters film, a Bob Mackie fashion show, and a drunken punk dance party."

"I took the challenge and dressed in drag," he remembers. "That night, there was a beauty contest. I walked out of the club as Miss Dragstrip 1994!"

Since then, Momma has honed her look and her performance skills with the encouragement of some stellar talents. The cabaret performer Rudy de la Mor, who'd been a protégé of Jimmy Durante, was one of her mentors. Charles Pierce, the comic genius in a dress, offered encouragement and friendship. And then there was the influence of the *ne plus ultra* costume designer Bob Mackie.

"I don't think I would have a drag career without them" says Meacham.

Although health issues have sidelined much of Momma's performing activities in recent years, Meacham is on the upswing and his own personal diva along with him. He doesn't regret his time out of the limelight, though. "I had to step away for a while," he says. "Momma was oversaturated and the community needed a break." But don't count her out. Meacham is planning to relaunch Momma as soon as he is able. "I love her," he says, "and she's not going away!"

ABOVE: *Momma.*

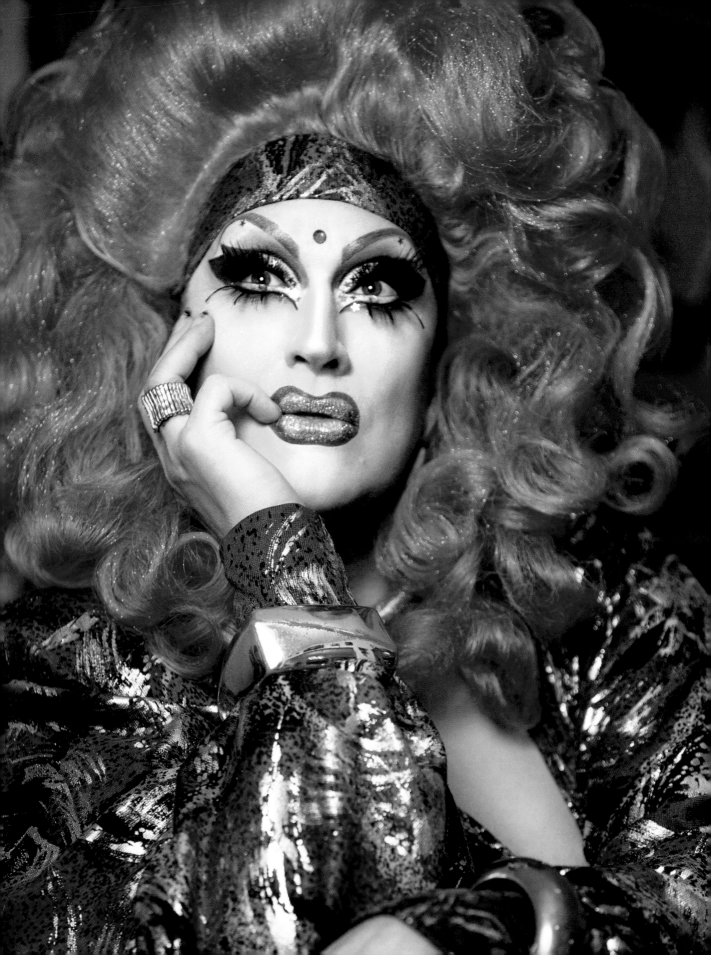

Jackie Beat

"You can see them fighting it. 'No, I will not laugh!' But then they do."

—Jackie Beat

She is one of the funniest, most fearless, and, one should say, naughtiest drag queens in Los Angeles. She is Jackie Beat—the larger-than-life creation of comedy writer, actor, and singer Kent Fuher—and no one is sharper tongued or more silver tonsil-ed than she.

Whether beautifully intoning taste-defying song parodies, leading her band Dirty Sanchez, or withering everyone in her gaze as Dorothy in a *Golden Girls* tribute show, Beat is the one to beat in a city of devilish angels.

On-screen, she has appeared in such films as *Grief*, *Flawless*, and *Wigstock: The Movie*, and on such TV shows as *Sex and the City* and *Last Comic Standing*. Behind the scenes, she has written comedy material for no less than Joan Rivers.

"Joan would say anything," Beat boasts. So, too, will Jackie.

How did your alter ego enter the world?

When I moved from Scottsdale, Arizona, to Los Angeles back in the 1980s, they used to have these open-mic poetry nights every Monday night at Café Largo and I would go and sign up. But thanks to all the C-List celebrities who obviously were much more important than I was, I would never get onstage.

So one week I was completely fed up and just wanted to piss on their unfair, pompous poetry bullshit, so I dressed up like a big, bitter girl dressed all in black. I wrote a ridiculous poem, which was really just a stand-up comedy routine, and went to the club. Well, they wouldn't even let me in! Not wanting to waste my beatnik drag—or my genius "poem"—I went to the club Rage in West Hollywood, where they had a Monday night talent competition. I told the audience to snap instead of clap, I read my poem, and I won the contest!

Your humor is as edgy as it is funny . . .

It's important to make people laugh at things they don't want to laugh at. We need to joke about the horrible stuff. But it needs to go beyond mere shock value.

A song parody needs to "go somewhere" and maybe have a plot twist or two. In my song "Beaver" I go on and on about my new vagina, but at the end I admit that I really miss my dick. You know, real classy stuff like that!

What pleases you most as a performer?

Anytime I can stun an audience into complete and utter silence, I am thrilled. I mean, this is the "community" that invented double-fisting, so if I can shock them to the point where a song ends and they all look like deer in headlights, that silence is actually music to my ears.

Who are you in drag versus out of drag?

I try not to do too much of a put-on phony voice or too much shtick. I find that being neither male nor female and/or somewhat both gives me license to say whatever I want. It's theater of the ridiculous. And that makes it easy to sneak in some harsh reality, too.

Sneaking some real commentary in is important to you.

It's not my job to make people comfortable. Anyone who thinks I am homophobic, misogynistic or racist is either not really paying attention or is just plain dumb. Don't blame me because you have irony-poor blood!

OPPOSITE: Jackie Beat.

Drew Droege, Tom Lenk, Sam Pancake, and Jack Plotnick

"Fuck you to anyone who says drag can hurt your career!"

—Jack Plotnick

Few would call them drag queens. Not anyone who really appreciates what they do. More accurately, they're enormously talented character actors, having played memorable roles on everything from *Key & Peele* to *Bones*. Yet Drew Droege, Tom Lenk, Sam Pancake, and Jack Plotnick do what may be their funniest work when they're impersonating women—living, dead, famous, and not-so—from an uber-pretentious Chloë Sevigny to a super-drunk Lucille Ball.

Between auditions for paying gigs, these four performers—all friends and all well-known on the West Coast comedy scene—take drag to places it desperately wants to go in an era of fame for fame's sake.

Their looks are never glamorous. Lenk has worn a wig made of macaroni to transform himself into Sarah Jessica Parker. Their portrayals are not even particularly true to life. Pancake's version of Lisa Whelchel, for instance, features a sailor's salty vocabulary, something for which the goody-goody *Facts of Life* star is decidedly not known.

Somehow, though, these guys get to the very essence of the celebrated women they so vividly portray. Hell, Droege's viral video version of Sevigny is more clearly Chloë than the designer-clad genuine article herself, and Plotnick's character Evie Harris might as well be real. The booze-soaked lovechild of Elaine Stritch and Baby Jane Hudson has appeared as "herself" in at least two movies.

"I love my L.A. tribe of wig trolls," says Droege. "We all go out for the same gay characters on TV, many of whom have richly layered names like Restau-

rant Manager, Floral Attendant, or Lancie. But onstage at night, we get to be alive and full and together."

Their brand of drag "is the performance equivalent of a caricature done by an artist at Disneyland," says Dennis Hensley, a writer-performer who created and hosts the live game show spoof *The MisMatch Game* in which the foursome often appear. "They take a few things that are true about a celebrity and blow them up and then season it with their own unique touches."

Touches like smeared lipstick and an open bottle of cheap wine.

"I'm by no means an impersonator," says Pancake, who has appeared on such TV series as *Arrested Development* and *Will & Grace*. "My goal is to try to capture the audacious, larger-than-life quality these characters embody."

With his ribald stage version of the classic game show *The Match Game*, Hensley has given the four men the perfect venue for their drag alter egos.

"These guys perform all over the place, but *The MisMatch Game* is a great sandbox for developing characters and trying new bits," he says. The show always is done as a benefit for the Los Angeles LGBTQ Center, and has raised more than $120,000 for homeless LGBTQ youth.

Droege frequently plays the game in the guise of replacement *Charlie's Angel* Tanya Roberts, albeit a drunken, infomercial-reenacting version of the actress that has little relation to the actual actress. "I heard her as a spokesperson for the Tahiti Village resort on the radio and became obsessed with the manic, throaty party screams that emanated from her. I based my

Tanya on that. I'm sure the real woman is awesome, but I'm not as interested in an exact impression of her as I am a bizarro, hall-of-mirrors rendering," he says.

Lenk had impersonated Heidi Klum and Margot Kidder on the panel of *The MisMatch Game*, but when he began doing Zooey Deschanel, he struck gold. His impression of her, he says, "is just basically me being myself but with a slightly Kermit-like voice." But along with that Muppet-like voice comes inspired comedy.

"Tom's Zooey is super twee and he delivers every answer on *The MisMatch Game* as a craft project," Hensley explains. "I've seen him make amazing creations with glitter, pipe cleaners—one time he made a clay pot!"

What Lenk and his partners in crime have in common, says actor-playwright-director Plotnick, is "they're brilliant actors and terrific creative forces, and whatever scene they're in, they're always the funniest thing happening."

Although his Evie character is decidedly out there, Plotnick says playing her hasn't been a detriment to his career. "It's possible that she may have turned off some casting directors, but if I ever lost a role because of Evie, I'm not aware of it. I did a lot of commercials, and I was always shocked when I'd be hired to be the spokesman for some nationwide company, like WD-40 or Chex Mix, with all those clips of Evie on the internet doing and saying such reprehensible things."

If executives at those companies knew of Evie's existence, they never mentioned it to Plotnick. "It's possible that drag is just sort of invisible to straight people," he says. "But I really see my whole Evie experience as such a blessing."

Lenk, who is best known for playing Andrew Wells on *Buffy the Vampire Slayer*, concurs. "Working in Hollywood," he says, "it's exhausting to worry about how gay I'm supposed to act for the gay roles, and am I passable for the straight roles? Sometimes it's just so much fun to throw all that out the window and embrace my inner lady. It's very liberating to say 'I'm wearing a wig and panty hose and some clearance-rack pumps and I don't care!'"

Certainly his series of drag photos so popular on Instagram—"Lenk Lewks for Less," he calls them—has been a plus for his career. "Tom Lenk slays, OK?" *US* magazine wrote of the photos in which the actor uses junk-drawer staples like duct tape and kitchen tongs to re-create the couture ensembles worn by the likes of Katy Perry and the Olsen twins on the red carpet at high-profile events. "It's like Ross Dress for Less, but, like, way less," he says.

Such inspired lunacy is the hallmark of the creativity that Lenk and his cross-dressing compatriots bring to the L.A. comedy scene. "It has been amazing decade or so for L.A. drag, and mostly a joy to participate in," says Pancake. "That we make a little money at it sometimes is just extra gloss on the lips!"

ABOVE LEFT: A crafty Zooey Deschanel (Tom Lenk). ABOVE MIDDLE: A drunk Lucy (Sam Pancake) with actor Patrick Bristow. ABOVE RIGHT: A desperate Tanya Roberts (Drew Droege) at The MisMatch Game.

Miss Coco Peru

*"Becoming a drag queen was a complete revolution inside my own body.
For the first time in my life, I felt like a balanced person."*

—Miss Coco Peru

An activist, an autobiographical monologist, and the actress who practically stole the 1999 movie *Trick* from Tori Spelling, Miss Coco Peru is a California girl by way of the Bronx, which means she's a tough-talking but tender-hearted story-teller and chanteuse. Both funny and inspiring, she has something to say and she isn't afraid to say it, which is why her fans are legion.

Whether acting on-screen or appearing onstage in a cabaret show of her own devising—her most infamous was titled *She's Got Balls*—Peru has earned the right to be called, as one reviewer wrote, "hilarious, inebriating and elegant all at the same time."

The creation of writer-performer Clinton Leupp, who named his alter ego after the first drag queen he ever befriended and the South American country in which they met, Coco Peru is known, too, as a celebrity interviewer par excellence. Her live onstage *Conversations with Coco* events featuring such megawatt talents as Lily Tomlin, Liza Minnelli, and Jane Fonda are legendary—tough-ticket nights always staged to benefit the Los Angeles queer community.

She has appeared in some of the most beloved gay movies of the last twenty-five years—*Girls Will Be Girls* and *To Wong Foo, Thanks for Everything! Julie Newmar* among them—and on such mainstream TV hits as *Will & Grace*, *How I Met Your Mother*, and *Arrested Development*. Lately, Coco has added "internet sensation" to her list of credits with a string of viral YouTube videos, and, sequels to *Girls Will Be Girls* and *Trick* are in the works, too.

For a gal who looks totally 1966, she has turned out to be very twenty-first century.

What were your earliest performances in the late 1980s like?
My first show was called *My Goddamn Cabaret*. I called a club, Rose's Turn, and told them that I was writing a show and it would be ready in three months. I put it together and got really creative trying to get people in there to see it. I went around spray painting the sidewalks of New York City with a stencil I had made that read, "Miss Coco Peru, she knows," just so people would wonder, "Who is Coco Peru and what does she know?"

Did people get it?
When I first tried to explain what I wanted to do, they were very confused. "Drag queens don't talk, they lip-sync." "You're telling autobiographical stories?" It didn't make sense to them. I remember people would be kind of rude to me when I first went out to promote it. I didn't take it personally. I thought they just don't know me, but I said someday they'll know."

Your shows are always uplifting. That's by design, yes?
My experience growing up gay was very painful. My entire childhood and college years were wasted because I wasn't myself. One of my main missions, early on, as a drag queen, was that I was going to create a world where that didn't have to be. One of the best things all these years later is getting emails from people who thank me. It's very validating.

How was doing the movie To Wong Foo?
When I went in for the audition, I was absolutely terrified because every drag queen in New York City was in that room vying for a big Hollywood movie. We all had to work an imaginary runway. These queens were doing

drops and splits. I thought, I don't do this, I do monologues—what am I going to do? I saw a cup sitting off to the side and I grabbed it. I thought, I'm just going to do the opposite of what all these people are doing and I'm going to give Kenny Ortega, the choreographer, nothing. I walked down the runway, just dead inside and out, sipping from this drink, and at the very end, I crushed the cup and then turned and walked back. As I walked past all the drag queens, they said, "Girl, you are fierce." I felt so happy, not because I thought I'd gotten that movie, but because I'd been accepted by the crème de la crème of drag in New York City.

How did Conversations with Coco get started?

I did an event at the Los Angeles Gay and Lesbian Center where I was being interviewed. Then, in early 2005, they asked me if I'd take over and be the interviewer. I called Bea Arthur and asked her to do it. The day after, I had to deliver something back to her house. She came out and gave me a big hug, and said, "I guess now this really does make us bosom buddies." To have Bea Arthur, my idol, call me her bosom buddy was just the biggest highlight. I look back now, and say, if I hadn't done drag, moments like that would never have happened.

ABOVE: Miss Coco Peru.

Willam

"I'm not a character. I'm just a person."

—Willam

Don't hate Willam Belli because he's beautiful in drag. Hate him because he's beautiful and talented and beyond funny in drag.

An actor, author, model, recording artist, viral video sensation, Los Angeles scene-maker, and—so far—the only queen to be kicked off *RuPaul's Drag Race*, Belli is outrageous, fearless, hilarious, and, as a girl, gorgeous.

He had no choice but to be all of those things.

"The first queens I saw on TV were in *Don't Tell Mom the Babysitter's Dead*," he says. "They stole a car. Typical." Such beautiful outlaws—and "lots of iconic blondes," among them Lady Bunny, Miss Piggy, Angie Dickinson, and even the serial killer Aileen Wuornos—set Belli on a path toward drag infamy.

He played transsexual Cherry Peck on Ryan Murphy's provocative series *Nip/Tuck* from 2004 to 2006 and subsequently was cast as drag queens on such shows as *CSI: NY* and *Women's Murder Club*. He played stewardess Nancy Needsatwat in the movie *Another Gay Sequel: Gays Gone Wild!*, and a character named Rachel Slurr in *Ticked-Off Trannies with Knives*, a thriller with a title that managed to tick off any number of transsexuals, with and without cutting tools.

"My career was okay," Belli says of that period, "but it was slowing down. I had been an actor who played mostly trans and drag roles on TV, but by then actual transsexuals were playing their own roles instead of me."

Then came *RuPaul's Drag Race*.

Belli was cast on the fourth season of the reality competition show in 2012, but was disqualified during production when, as *Entertainment Weekly* reported, he received conjugal visits from his spouse. "My husband was coming to bang me out," Belli said at the time. On a sequestered set, that's a no-no, of course, and he had to sashay away.

The controversial elimination didn't slow Belli down one bit, though.

The following year, he released the video "Boy Is a Bottom"—a spoof of the Alicia Keys song "Girl on Fire" featuring fellow queens Vicky Vox and Detox—that went on to upwards of twenty million YouTube hits.

In 2014, Belli became an American Apparel ad girl along with fellow *Drag Race* alums Alaska Thunderfuck and Courtney Act, and the next year, he released his second album, *Shartistry in Motion*.

"I just try to do stuff that no one else does and things that make audiences smile," he says. "If some other queen tries to fist someone while singing, 'I'm Not a Girl, Not Yet a Woman,' know that I did it first."

Belli got a big arm up—or rather a big leg up—on many other queens when in 2016, he published *Suck Less: Where There's a Willam, There's a Way*. The self-help book, offering advice on everything from shoes to anal sex, featured a foreword by Neil Patrick Harris, whom Belli had tutored in the ways of drag when the actor was cast as the transsexual lead in *Hedwig and the Angry Inch* on Broadway. "Willam," Harris wrote, "helped me win a Tony."

If she can turn Doogie Howser into a draggy Hedwig, she can help anyone.

OPPOSITE: Willam.

Chi Chi LaRue

"I always say anybody who gets in drag deserves a round of applause and a foot massage."

—Chi Chi LaRue

arry Paciotti was a naughty boy from northern Minnesota who moved to Minneapolis in the 1980s and became Chi Chi LaRue, an even naughtier girl who, as one observer put it in 2001, looked in drag like "a chubby Marc Almond . . . sporting a pencil-thin moustache and no boobs." Even so, she was, as that critic said, "a loud, brash broad who'd say anything to anybody."

Being able to do that, especially on a film set, has come in handy.

Since moving to Los Angeles in 1988, Chi Chi has succeeded at something few drag queens have even attempted: She has become an internationally famous porn director, helming such wink-worthy titles as *Huge Deposits, Hole Patrol,* and *Daddy It Hurts!*

What doesn't hurt—unless you try to carry them all at once—are the armloads of adult entertainment awards she has won over the years. They prove that when it comes to filming scrumptiously unspeakable acts, Miss LaRue knows a thing or two about what she's doing.

Also a popular DJ, Chi Chi has been the subject of a documentary, *Sex Becomes Her: The True Life Story of Chi Chi LaRue,* appeared on Kathy Griffin's *My Life on the D-List,* and made non-sexual cameo appearances in her own films. These days, she divides her time between Los Angeles and Minneapolis. Like another famous girl from the Twin Cities, she knows love is all around.

Chi Chi made her debut in Minneapolis in the 1980s. What was that like?

A group of us decided to enter a contest at First Avenue in Minneapolis—that's where Prince filmed *Purple Rain*—and we won the contest by doing "It's Raining Men" by the Weather Girls. We all had to choose names and my friend Scott came up with Chi Chi LaRue, which means "very fancy street" in French.

You used to do "hag drag," a term I haven't heard in years . . .

Yes! I left my mustache on and beard stubble and dressed in really tragic thrift-store clothes and ratty secondhand wigs. Nowadays having facial hair is very chic and very "in" again. Back then, the scene in Minneapolis was a little lowbrow but fun. There's something about a down-and-dirty drag show that still makes me happy and makes me smile. Now it's taken a little too seriously and a lot of drag queens are starting to look alike. At least no one's trying to look like me!

So how did you go from doing "tragic" drag to directing porn?

I decided to go to the big city to see a lot of big dicks, and, boy, did I get my wish! I was living in Los Angeles for only two weeks when I got a job at Catalina Video. Since then, I've directed thousands upon thousands of films. The real question is how many are good ones, and to that I say, a lot!

You also run an "adult novelty" shop in West Hollywood. What's it like to be a retailer? Do you want to expand?

I love my store. It's so pretty and inviting and, of course, naughty. But I definitely don't want to be the Forever 21 of porn stores.

OPPOSITE: *Chi Chi LaRue.*

CHICO'S ANGELS

Kay Sedia, Frieda Laye, Chita Parol

"Like the original Charlie's Angels, we had to go through a few cast changes before we finally found the right chemistry."

—Kay Sedia

Once upon a time, there were three not-so-little boys and they were each assigned not-very-hazardous duties. One was working in the meat department of an upscale supermarket. Another, selling lipstick at a makeup counter. The third was pushing paper for the city of West Hollywood. But drag took them away from all that and now they work for laughs. Their name is Chico's Angels.

Since 2003, this Latina trio has spoofed *Charlie's Angels* onstage, on film, and on the web, and become a staple on the Los Angeles drag scene. The brainchild of Oscar Quintero, better known as Kay Sedia, and nurtured by director Kurt Koehler, *Chico's Angels* mines what used to be called "jiggle television" for camp as they parody classic episodes of the 1970s crime series.

"Kay Sedia is the self-centered one who makes everything all about her, but is always there for her fellow angels. Mostly," says Danny Casillas, an actor better known as the saucy Frieda Laye. Chita Parol, played by the svelte Ray Garcia, "is the tough one with the kicks to get the job done, but a vulnerable side. My character, Frieda Laye, is a slut who's willing to go under the covers to solve a case. She's also innocent in spirit, or just dumb."

Not so dumb, though, that she can't conduct a probing interview. In 2017, Laye and the other crime-fighting south-of-the-border sex symbols added "talk show hosts" to their resumes, launching a chat program via Facebook Live that not only promotes their stage shows but also helps raise awareness of the feature-length *Chico's Angels* movie they're hoping to make someday.

Their stage version of the show that launched Farrah Fawcett's major career began in the basement of the Mexican restaurant Casita Del Campo, at the Cavern Club **Celebrity Theater**, a hotbed of drag in L.A.'s Silver Lake neighborhood. The first installment was a taco-flavored retelling of the episode "Pretty Angels All in a Row," set at a beauty pageant. "We mounted it and, after the first night, our entire run sold out," says Quintero.

A critic for *Broadwayworld.com* once called them "the best scripted-comedy drag troupe in Los Angeles."

The Angels may be the slyest devils around because their—what's Spanish for *gestalt*?—is far from politically correct. Their costumes are as subtle as a piñata bat, their Spanglish falls thickly between Charo on *The Love Boat* and Rita Moreno doing her best Googie Gomez in *The Ritz*, and, well, they're queens.

"We lovingly poke fun at our culture and turn stereotypes upside down," says Casillas. "One of the best compliments we ever got was when someone called us the Three Stooges in drag!"

Chico's Angels are prettier than Larry, Moe and Curly—after a few shots of tequila, at least—and each girl brings something special to the margarita mix. Like all teams who've stood the test of time, Casillas says, the Angels "have formed a special kind of dysfunctional family. Yes, we've fought like sisters sometimes. But we've worked together on five full-length stage shows, fifteen webisodes, three music videos, and various club and Pride performances. We're not going to let all that go just because we disagree on who's the prettiest. It's Frieda."

OPPOSITE: Chico's Angels.

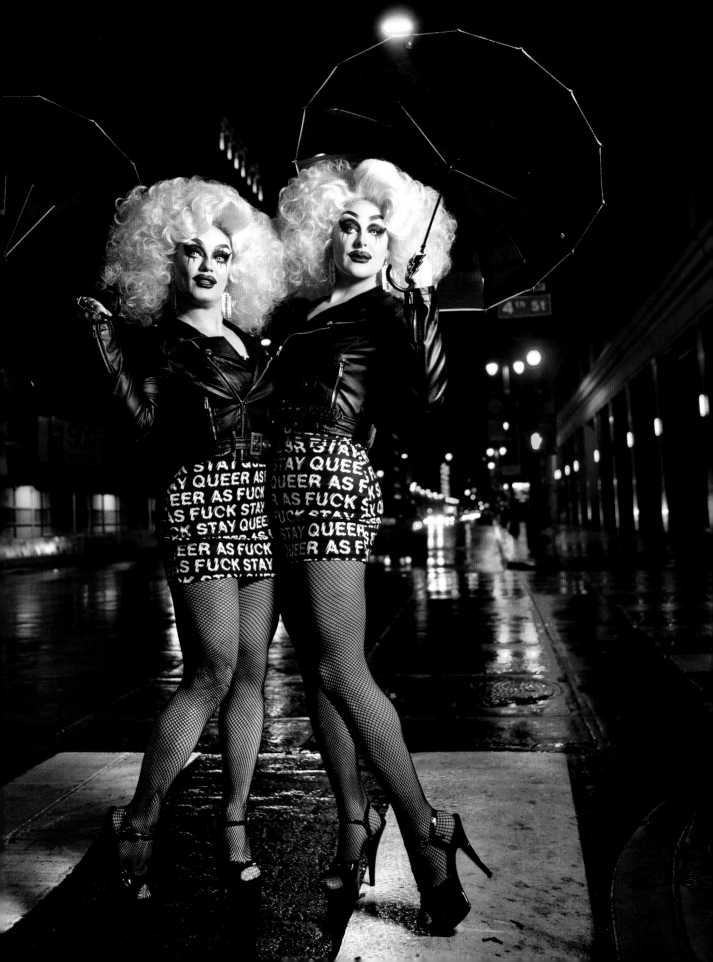

The Boulet Brothers

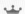

"The boundaries of the drag frontier are being redefined and the future is unknown. We're all about it."

—The Boulet Brothers

They are ambitious party-throwers, fabulous scene-makers, and frighteningly beautiful drag stars who, since arriving from New York, have turned Los Angeles nightlife on its earring.

As "modern day circus barkers," the Boulet Brothers—Dracmorda and Swanthula—are taking drag to destinations that are darkly delicious, perpetrating an aesthetic that is as much Ursula the Sea Witch as Ursula Andress, and as glamorous as both combined. With their Queen Kong parties in downtown Los Angeles and their web series *Dragula*, they're doing things few would dare to do. Put it this way: Lots of other parties have go-go boys; the Boulet Brothers have white-trash strippers eating buckets of fried chicken.

"We celebrate being queer, wild, free, in-your-face, and politically incorrect," the mysterious duo, who prefer not to reveal their real names, told the *Huffington Post* in 2016. "We want to be 100 percent gay as hell, and we don't need anyone's acceptance to do that!"

How would you describe your aesthetic?
We're powerful, campy, high-fashion scream queens who dabble in sorcery and adore John Waters films.

A profile I read used the word "sinister." Would you say that applies?
I would say the word "sinister" *does* apply to us in certain ways. I would be ashamed of us if we didn't star in the nightmares of many of the more conservative people of the world. For the Boulet Brothers,

drag and villainy go hand in hand. If we had it our way, everyone would be free to live and express themselves exactly how their inner voice tells them to. No judgment, no shame, no fear. For some people, that is the scariest thought imaginable.

Tell me about Dragula and Queen Kong.
Dragula is a party brand we've had for years that we developed into a drag reality competition show, *Dragula: Search for the World's Next Drag Supermonster!* Each episode we take drag queens and, through a series of challenges, develop their skills to help them become the most powerful and fearless versions of themselves. The show celebrates untraditional aspects of drag like filth and horror. It's *Drag Race* meets *Fear Factor* meets *Jackass*.

Queen Kong is a behemoth queer party palace and stage-show spectacular in downtown Los Angeles. We curate a revolving cast of queer performers, drag stars, and artists to feature weekly. The party has played a huge role in redefining the culture of DTLA. Putting the queer presence right out in front, we've created a new center of the gay universe for many people who live in Los Angeles.

No one ever seems to ask this, but who are you when you're not the Boulet Brothers?
We love that you asked this question because no one ever asks. Unfortunately, to answer that would shatter a very beautiful, elaborate illusory spell we've worked hard to cast. Sorry, darlings, you'll have to remain in the dark.

OPPOSITE: Boulet Brothers.

Heklina

"When I put on drag, I turn everything up to 10!"

—Heklina

Since she entered a drag pageant at the renowned San Francisco dance club The EndUp in the early 1990s, Heklina has become arguably the most seismic force on the Golden City's drag scene. Certainly, she is the only queen named for an Icelandic volcano, a nod to her creator Stefan Grygelko's heritage. His mother is from Iceland and he lived there as a kid.

A fixture at events like the Folsom Street Fair—"If there's a party in San Francisco that involves lots of makeup, leather and nudity, chances are Heklina will be the hostess," a columnist once noted—she is best known as the dynamo behind the popular drag party Mother. Originally called Trannyshack, the glittering performance event began in the 1990s at the Stud bar, moved to the DNA Lounge, and is now a fixture at the Oasis, of which Heklina is a co-owner.

The parties, and the corresponding Miss Trannyshack pageant, have been chronicled in publications around the world, been the subject of the 2005 film documentary *Filthy Gorgeous: The Trannyshack Story*, and spawned satellite events in other cities from Los Angeles to Honolulu. All of this has burnished the reputation of a queen who once said, "I don't think anybody looks at Heklina as a woman. Heklina is just me in drag."

What are Heklina's origins?
Heklina originally came about when I entered the Miss Uranus pageant in 1992. I made a fool of myself, and lost the contest. After that I just dabbled in drag until I joined the Sick & Twisted Players theater troupe. I reclaimed the name Heklina in earnest once I started Trannyshack in 1996.

What was San Francisco like when you moved there?
I moved to San Francisco from Iceland. Talk about culture shock! There was such amazing creativity everywhere. Every night when I went out, I saw people and things that inspired me immensely. I fell in love with San Francisco in large part because of the people I met. In those days—the early 1990s—things seemed so vital because we were losing so many people to AIDS. As the saying goes, "It was the best of times, it was the worst of times . . ."

How would you describe the drag scene you found?
A lot of people characterize the scene as before or after Trannyshack, but that's giving me way too much credit. San Francisco has always been known for a certain type of unpolished, genderfuck, punk-rock, no-rules drag sensibility. There's a disdain for the polished traditional look, which may explain why nobody from San Francisco ever gets on *RuPaul's Drag Race*!

What would you change about the business if you could?
Hardworking, professional queens—myself included—need to dispel the general attitude that drag queens love to perform for free. I can't tell you how many times I am asked to perform for free, only to find out later that everyone—the DJ, the caterer—got paid. It makes me crazy.

OPPOSITE: Heklina.

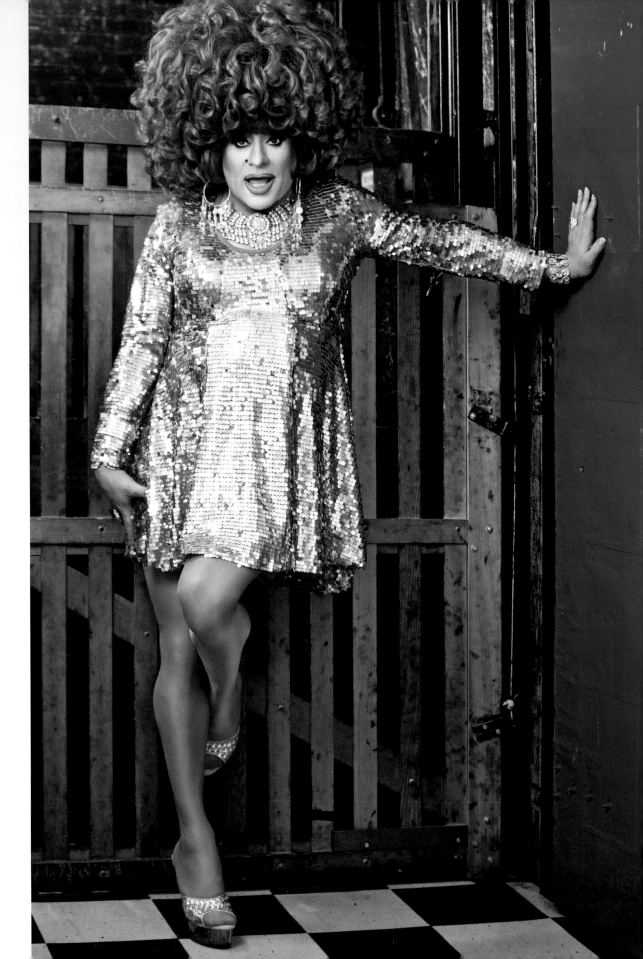

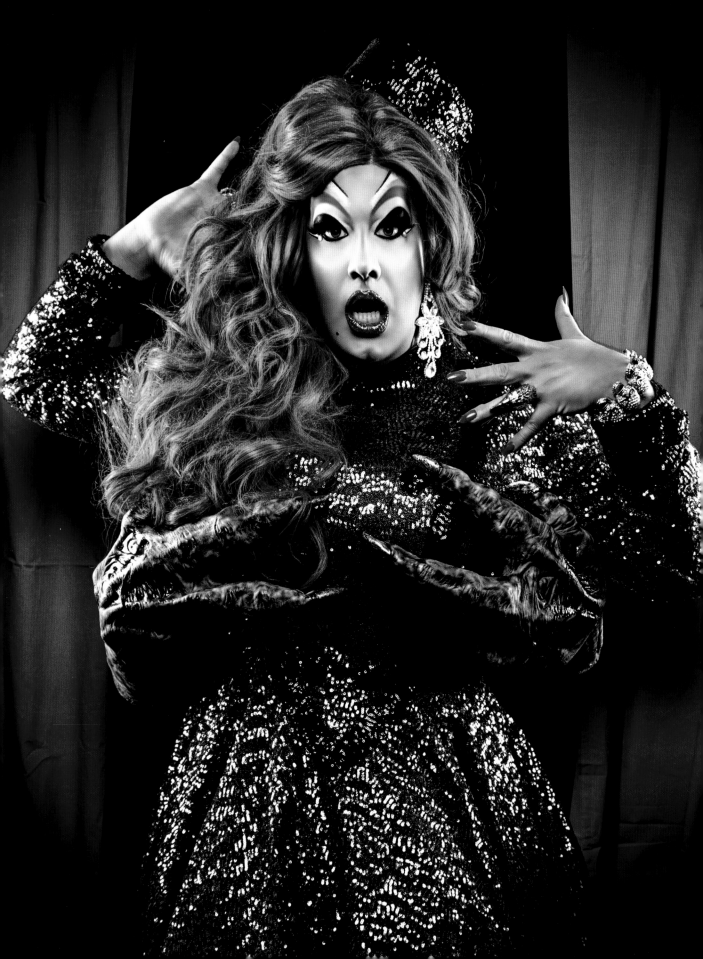

Peaches Christ

"Drag performers see each other as artists, but if the wider world wants to keep us on the outside, I'm fine with being relegated to carny."

—Peaches Christ

The *Bay Area Reporter* called Peaches Christ "San Francisco's scariest drag queen," which is really saying something. But Peaches is as friendly as she is frightening, a sort of Casper of the Castro, a ghostess with the mostest, whether hosting a midnight movie or performing onstage in such camp outings as *Mister Act, Return to Grey Gardens, Showgirls! The Musical,* or *Peaches Christ Superstar*.

The alter ego of filmmaker Joshua Grannell—a John Waters–worshipping native of Annapolis, Maryland—Peaches first found a home onstage in San Fran at Trannyshack in the 1990s, and since has become an institution in a city with a long history of colorful characters.

"I always say you're not really a San Franciscan unless you've got a spare costume in your closet," Peaches told the Thought Catalog blog in 2014. "Even straight people do drag here."

How did Peaches Christ get her start?
Peaches was born in my senior thesis film, *Jizmopper: A Love Story*, at Penn State University. The actor we'd hired to play the drag queen in the movie didn't pull through for us, so I stepped in to play the part. My advice to first-time drag performers is always, "Try not to put your first time in drag in a 16-mm film that people can discover forever."

How did you arrive at Peaches Christ's look and her name?
The look was inspired by my hero Divine, as well as my love for carnival clowns. The name was really about my anger toward the Catholic Church. I'd been raised Catholic and had been taught that this stuff was all so sacred while being told people like me would burn in hell. I figured it was a way to use the name "Christ" to entertain people who'd similarly been hurt.

When you moved to San Francisco, what was the drag scene like?
I arrived in 1996. Back then, Trannyshack was really wild. The scene offstage was just as dragged up as the performers onstage. It was an art-for-art's-sake time where performers simply performed for the love of performing. We weren't making any real money. It was punk rock and transgressive and weird and really grungy. Performers would turn garbage into fashion.

**Your first feature film All About Evil *starred Cassandra Peterson, Mink Stole, and Natasha Lyonne. What's next?*
I'd love to make another movie and continue putting one heel in front of the other and just see where we end up.

The Kinsey Sicks

"Drag can be so much more than eyelashes and snarky quips."

—Ben Schatz

In 1993, at the height of the AIDS crisis, Ben Schatz and four of his friends—mostly lawyers and gay rights activists—went to a Bette Midler concert in San Francisco dressed in full Andrews Sisters drag. When a woman in the crowd asked these "Boogie Woogie Bugle" girls if they'd perform at her birthday party, the "dragapella" singing group the Kinsey Sicks was born.

Schatz became Rachel, Irwin Keller was rechristened Winnie, Maurice Kelly was now Trixie, Jerry Friedman was Vaselina, and Abatto Avilez renamed Begoña. Since the group's first public performance on a street corner in the Castro in 1994, the Sicks have gone on to tour the world, make a slew of videos, and record such albums as *Boyz 2 Girlz*, *Sicks in the City*, and the holiday hit *Oy Vey in a Manger*.

Although there have been numerous personnel changes—Schatz is the only original member still performing with the group—the Sicks continue to thrill audiences as a "beauty shop quartet" that skillfully and hilariously glides from poop jokes to pop music spoofs without ever missing a beat.

Ben Schatz, you were once a Harvard-educated lawyer. Was dressing in drag to attend a concert out of character for you?
Back when I was an executive director of the Gay & Lesbian Medical Association and pretending to be a respectable homosexual, I used to organize drag outings. We would go to San Francisco airport to surprise a friend who was coming off a plane. We'd stand there in drag, saying "Welcome to San Francisco!" The Bette Midler concert was another one of those excursions.

How did you come up with the name?
When the group was formed, there were five of us. I thought the idea of a "quartet" of five called the Sicks would be funny. And back in those ancient days, people knew what it meant to be a Kinsey 6. Basically, it was a way to say we're gay-gay-gay-gay-gay and we have a sick sense of humor and we play with words.

What has it been like attracting new castmates over the years?
To find people who can do drag, sing a cappella, and do comedy, who are not divas, and who have politics that are congruent with the group's, is an enormous pain in the ass. But we have good longevity with people. Jeff Manabat has been with us for thirteen years, Spencer Brown for nine, and Nathan Marken for three. Our brand of comedy is so exaggerated, so vaudevillian, that it takes a while for people to lower their standards enough to fit in.

What do you think is the key to the group's popularity?
We have our appeal because of a certain kind of fearlessness. That kind of Gay Liberation/ACT UP spirit is in the group's DNA. There's nothing more delightful to me than finding a way to say something that truly shocks and provokes people and to see an audience gasp and love it.

What has been the Kinsey Sicks's greatest triumph?
Surviving this long! I'm living proof that perseverance is more important than talent. I'm kind of like Sigourney Weaver: You're not going to kill my baby!

OPPOSITE: The Kinsey Sicks.

The Sisters of Perpetual Indulgence

"What better way to have people pay attention to you than by wearing a dress and extremely painful, yet fabulously stylish shoes?"

—Sister Girtha Rotunda

They were founded on the holiest day of 1979—Easter Sunday—in San Francisco by a group of men in habits and, like all good nuns, the Sisters of Perpetual Indulgence have made charity work their calling ever since.

God bless them.

The brainchild of Ken Bunch, Fred Brungard, Baruch Golden, Edmund Garron and Bill Graham—who adopted names like Sister Vicious, Sister Missionary Position, and Sister Hysterectoria—these drag missionaries set out to "promulgate universal joy and expiate stigmatic guilt." Since then, they have inspired orders around the world, but their frequently-fuzzy-always-glittery ethos remains quintessentially San Francisco.

"Our roots come from iconic groups like the Radical Faeries and the Cockettes, groups which personified the artistic, hedonistic, drug counterculture of the Sixties and Seventies," explains Sister Roma, who joined the original order in 1987 upon the urging of her friend Sister Luscious Lashes. "The Sisters represent an in-your-face radical activism and take gender-fuck to an art form."

Championing freedom of expression and pansexuality, the Sisters initially focused their drag-tivism on HIV/AIDS, but now raise money for causes as varied as breast cancer research, rape prevention, humane treatment of the incarcerated, and issues facing youth and the elderly in the LGBTQ community.

Although those uninitiated in the ways of Perpetual Indulgence may at first resist these painted men in Technicolor habits, they usually come around. "I get the entire spectrum of reactions from 'What the hell?' to 'Where have you been all my life?'" says Sister Girtha Rotunda, a member of the Minneapolis-based mission known as the Ladies of the Lakes.

On her first day in public, she remembers encountering a family who took one look at the ladies and "stared at us, slack-jawed." Girding herself for what she expected would be disgust and anger, Sister Girtha explained to the mother who the Sisters were. "After what felt like an eternity of silence," Sister Girtha remembers, "She burst into a contagious cackle and declared 'Kids! Get in there, we need a picture!' and thanked us for our service."

Such "service" can take as many forms as there are sisters.

"In thirty years, I've done everything from feeding the homeless to emceeing on the main stage of San Francisco Pride and the Folsom Street Fair," says Sister Roma. "I've appeared in movies, on stage, on TV, and all over the media. I've traveled the world from Paris to Shanghai to Sydney hosting events and speaking on everything from LGBTQ history to HIV/AIDS. I honestly cannot believe the amazing opportunities that being Sister Roma has provided."

Each sister does what she does best, says Sister Girtha, who was working as a puppeteer in Las Vegas when she first encountered the Sisters. "Every nun is called to the order for a different reason. What speaks to me most is the use of humor and irreverent wit. It's like a superpower."

Amen.

OPPOSITE: Sister Girtha Rotunda at the Cathedral of Saint Paul.

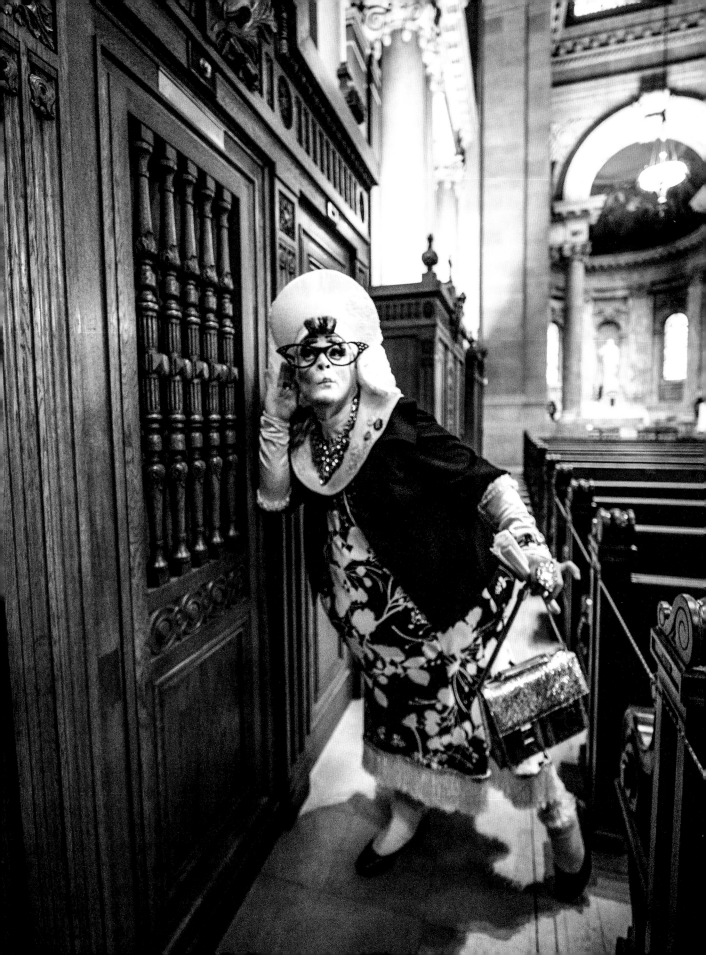

The Cockettes

RuPaul considers them the foremothers of modern drag. Holly Woodlawn was so staggered by their audacious behavior that she found herself speechless when asked to describe their antics. And even director John Waters, the ultimate perpetrator of cinematic atrocities, sits in awe of their commitment to flying the freak flag.

They were the Cockettes—hirsute, glittered, LSD-fueled, diverse, frequently naked, and always fabulous performers who stand as the ultimate symbols of drag as a countercultural revolution.

Spawned on New Year's Eve 1969 at the Palace Theater in San Francisco, the drag theater troupe was founded by George "Hibiscus" Harris, a charismatic leader who "looked like Jesus Christ with lipstick," according to one of his acolytes. "They were the first bearded drag queens," says Waters in Bill Weber and Daniel Weissman's 2002 documentary *The Cockettes*.

During their brief but shining reign, the Cockettes made short films, launched Sylvester's singing career, and gave Divine her first stage time in *Journey to the Center of Uranus*.

In that show's big number, Divine, then just a Baltimore girl with dreams of stardom, sang "*A Crab on Your Anus Means You're Loved*" dressed as shellfish.

Such cheeky, off-the-wall performances were what the Cockettes did best. Their shows—*Gone with the Showboat to Oklahoma*, *Tinsel Tarts in a Hot Coma*, and *Pearls Over Shanghai*—parodied American musicals, and played like combinations of H.R. Pufnstuf and soft-core porn, always with as many penises on display as paillettes. It didn't matter that most of the Cockettes couldn't sing or dance very well, they had pizzazz. "It wasn't just a drag show, it was a hippie sideshow," a female member named Sweet Pam says in the documentary.

Offstage, living in communes in the Haight-Ashbury district, the group was blind to societal constraints. As Waters says, "It was complete sexual anarchy." Some Cockettes even had babies together and then dressed them up. They often lived on the dole while trying to convince the government they were too disabled by their artistic ambitions to do more traditional work.

Once established as a must-see in San Francisco, the troupe caught the eyes of visiting East Coast hipsters. The critic Rex Reed wrote about the Cockettes in his nationally syndicated column. But success proved their undoing. Abhorring any sort of commercialism, Hibiscus left the group to form a rival troupe called the Angels of Light.

Those Cockettes who remained—almost fifty of them—flew east in November 1971 to stage a show in a threadbare theater on New York City's Lower East Side. The in-crowd treated their arrival like the Beatles landing at JFK in '64 and the Cockettes became the toast of *le tout* Manhattan during their stay.

As news of their antics spread, the opening night of their New York show became the hottest ticket in town. The audience included John Lennon, Anthony Perkins, Angela Lansbury, Peggy Cass, and Andy Warhol. But the production was a bomb, so unprofessional by New York standards that the audience was aghast. Gore Vidal sniffed, "Having no talent is not enough."

Although the troupe, smarting from their Manhattan debacle, disbanded in 1972, the Cockettes ultimately were vindicated. Decades after their moment in the sun, they're regarded as drag icons whose work, even while closely associated with Summer of Love–era San Francisco, transcends time and place. As John Waters said in 2002, "They were like hippie acid-freak drag queens, which was really new at the time. It still would be new."

OPPOSITE: The Cockettes on their ill-fated 1971 trip to New York City.

BIG
WIG

Sylvester

"You have to do what you have to do in order to do what you want to do."

—Sylvester

★★

When, in 1987, he guested on *The Late Show* starring Joan Rivers, performing his hit single "Someone Like You," Sylvester wore a big-shouldered, beaded-lapel pantsuit, tons of vintage jewelry, and enormous orange cotton-candy hair. He looked as if the lovechild of Chaka Khan and the Cowardly Lion from *The Wiz* had gone shopping at Liberace's garage sale. It was outrageous androgynous disco drag on mainstream television, and it was genius.

Sylvester chatted, that night, about being married to a man—decades before marriage equality was even a thing—and then thanked Rivers and his couch companion to his right, the actor Charles Nelson Reilly, for being among the first performers to lend their star power to various AIDS benefits at a time when many in Hollywood were reluctant to do so. Suffice to say, late-night television doesn't get any gayer than that installment of *The Late Show*.

But here's the thing that stands out most: When Rivers, clearly a fan, called the flamboyant bewigged singer a drag queen, he corrected her.

"I'm not a drag queen," he said, "I'm Sylvester."

Although he had played a Diana Ross impersonator in Bette Midler's 1979 star vehicle *The Rose*, Sylvester wasn't really a drag queen. He didn't fit neatly into that wig box. Yet as his biographer, Joshua Gamson, author of 2005's *The Fabulous Sylvester: The Legend, The Music, The Seventies in San Francisco*, puts it, "It's safe to say that without Sylvester there would be no RuPaul."

For Sylvester, "the role of drag was different at different times of his life, but it was always a big part of who he was," says Gamson. As a teenager in his native Los Angeles, Sylvester hung out with a group of queens called the Disquotays. They were "a cross between a sorority and a street gang," the author says. When he moved to San Francisco in 1970, he fell in the Cockettes.

After taking a stab at a rock career, Sylvester embraced disco, releasing a self-titled dance album that was a modest success in 1977, then followed it up the next year with the classic *Step II*, the record that spawned the LGBTQ anthems "Dance (Disco Heat)" and "You Make Me Feel (Mighty Real)." All told, five of his songs went gold, selling five hundred thousand copies. "Dance (Disco Heat)" sold twice that.

Sylvester became a household name among the cognoscenti. When he asked, in 1982, "Do Ya Wanna Funk," the answer was a resounding yes. They didn't call Sylvester James Jr. the "Queen of Disco"—sorry, Donna Summer—for nothing. As the music critic John Rockwell wrote in the *New York Times*, "Sylvester gives a show that makes most performers seem positively dowdy."

Onstage, his style "varied from more conventional drag—wigs and femme outfits—to more androgyny and even some butch drag, although always with jewelry," Gamson explains. "He was a singer who was liberated about gender. For him, drag was part of the pursuit of fabulousness."

Sylvester attained major fame, particularly in his adopted home of San Francisco, where then-mayor Diane Feinstein proclaimed March 11, 1979, to be Sylvester Day. He was even given the key to the city. "In many ways, Sylvester was Mr. San Francisco," California state senator Scott Wiener said in 2016.

The singer of "Body Strong" and "Don't Stop," and a tireless AIDS activist, Sylvester died at age

forty-one in 1988 of complications of the disease. His obituary, syndicated by the Associated Press to newspapers around the world, said, "Sylvester delighted audiences of every race and sexual persuasion with his funky, spiritual-style singing in his nightclub routine in which he wore exotic costumes."

Since then, Sylvester's fabulousness has been celebrated posthumously. The singer was inducted into the Dance Music Hall of Fame in 2005 alongside Chic and Gloria Gaynor, and made the subject of a 2010 TV documentary. In 2014, he was celebrated in the "glitter-drenched," to borrow one critic's words, Off-Broadway show called *Mighty Real: A Fabulous Sylvester Musical*, created by Anthony Wayne and Kendrell Bowman.

"It's a big party with all ages and races," said Wayne, who also portrays the singer onstage, when the show played San Francisco in 2016. "That's how Sylvester would have wanted it. He just wanted everyone to feel good."

Just don't call him a drag queen.

ABOVE: Sylvester, the Queen of Disco.

YOU BETTER BURP!

"I made enough money selling Tupperware that
I got myself a trailer with a bathroom right inside it."

—Dixie Longate

When Earl Tupper invented Tupperware in 1946, revolutionizing home food storage with a line of smartly designed plastic serve-and-store products, he could never have imagined that, more than six decades later, drag queens would be among his top-selling ambassadors. But they are, Earl, they are!

These sales "ladies" have merged the worlds of freshness and falsies, and made Tupperware parties hipper than they've been in decades. They've taken the template set in the late 1940s by the enterprising businesswoman Brownie Wise, who showed suburban housewives how to sell, sell, sell while having fun, fun, fun, and turned Tupperware parties into popular theatrical experiences.

By all accounts, the drag-Tupperware connection leads back to the mid-1990s and an out-of-work Los Angeles actor named Jeff Sumner. In 1995, he created a character named Pam Teflon, an "attention-starved" mother of two from Moline, Illinois, and built a combined ninety-minute show and sales presentation, complete with musical numbers, around her. Actress Jane Lynch, much less well known at the time, played Martha Stewart in productions.

"By the time I got done, most guests would spend upwards of $200 on plastic products," Sumner says. "Pam's parties got to be very popular, my sales skyrocketed and I became the number one 'personal seller' of Tupperware in the United States and Canada." Hollywood celebrities including Jennifer Aniston, Blythe Danner, and Marlee Matlin hired her for in-home parties, TV shows booked her for on-air appearances, and newspaper reviewers gushed. The *Los Angeles Times* said, "Pam is what would have happened if Ethel Merman had given birth to Betty Crocker." Another critic wrote, "She makes stackability sound better than good sex." Even the *National Enquirer*, in a banner headline, revealed, "THE TUPPERWARE LADY IS A MAN!" When a cease-and-desist letter from DuPont, maker of Teflon, came, Pam changed her last name from Teflon to Tastic, but by either name she was a sensation.

Although a conservative corporation in the 1990s, Tupperware realized they'd found gold in Pam. "Tupperware basically turned its back and allowed me to do all of my shenanigans. I was making a lot of money for the company and getting them millions in free publicity," Sumner says. He made sure not to say anything that would jeopardize his relationship with the parent company back in Ohio. "Pam never made fun of the products. She always had fun with the products," he says, "and you can bet she sold a crapload of cereal keepers."

Since then, at least a half-dozen drag queens across America have followed Pam's lead and found success selling Tupperware, demonstrating the wonders of Wonderlier bowls and the rewards of Rectangular Cake Takers in performance venues big and small, and, in the process, earned cars, trips, and other prizes and made six-figure salaries.

Kris Andersen, a Florida-based actor, joined the salesforce in 2001 as Dixie Longate, a Southern-fried, gingham-clad, mechanical bull-riding spokesmodel. The character—a three-time widow from Mobile, Alabama, with a son named Absorbine Jr. in her brood—has sold her goods around the world. "I have been to places that I didn't even know had food," Dixie says. Her show, *Dixie's Tupperware Party*, has played more than a thousand performances, including an Off-Broadway run in New York City. "I always want people to have a good time," she says. "If they're having fun, they buy more crap and then everybody wins."

Oscar Quintero, a Los Angeles actor-writer, began selling Tupperware in 2000 as his zany Latina alter ego Kay Sedia, who also performs as one of Chico's Angels. The connection between drag queens and Tupperware is simple, he says. "They're both shiny and plastic!" Kay Sedia, a former Miss Tijuana Natural Springs Water, has an accent that makes Sofia Vergara sound like Maggie Smith, but she clicks with audiences in any language.

Those who book parties—almost always straight women with children, Quintero notes—are beyond enthusiastic. "For these soccer moms," he says, "hav-

OPPOSITE: Aunt Barbara.

ing a drag queen in their living room is like having a unicorn in their house."

The flexibility of the work makes it a good job for actors.

Kurt Koehler, a Los Angeles–based writer-performer who sells Tupperware as Aunt Cassie Rolle, explains that "as an actor, survival jobs can really suck your soul dry. But selling Tupperware allows me to audition, direct and write comedy shows, and perform." His Tupperware parties, he says, are real shows. "It's costumes, makeup, big hair, singing, jokes, and improv every time."

That formula for selling Tupperware can be lucrative.

Aunt Barbara is the glamorously suburban creation of Jennifer Bobbi Suchan, a transgender performer from Long Island, New York. She gave up her low-paying job as a social worker to become a full-time Tupperware lady. The character, "a brassy, sassy, quick-witted Long Island housewife who always speaks her mind," became a hit, particularly after her promotional videos took off on YouTube. According to a *Huffington Post* report, Aunt Barbara brought home upwards of $250,000 one particularly good year. She did it by trafficking not just in kitchenware, but also in nostalgia.

"Most people in the U.S. have an emotional connection to Tupperware," says Suchan. "It's iconic and retro and we all remember our mothers and grandmothers having certain products like the salt and pepper shakers, cake takers and Jell-O molds. Tupperware brings us back to a simpler time in our lives."

That these Tupperware ladies are drag queens doesn't seem to bother anyone terribly much, give or take a little side-eye at conventions from a few jealous rivals. Most people quickly become fans when they realize what a loving sendup of twentieth-century Tupperware salesmanship they provide.

"When I attended my first Tupperware Jubilee convention, I learned that at corporate headquarters, I had a huge cult following," says Suchan. "I have received nothing but positive feedback from company leaders. The president of Tupperware Global is a huge Aunt Barbara fan, watches my videos, and has my photo hanging in his office."

Dixie Longate's experience with the company has been "truly amazing," she says. "Tupperware Brands has been so stinking neighborly. They want you to succeed, so they really encourage you to find a way to host the parties that truly excite you. I can do them like a woman on the PTA, or I can race into the party carrying a tray of Jell-O shots and holler like a Pentecostal priest with my hair on fire and really have some fun." Both methods work and have led Dixie to become one of the top-selling Tupperware ladies in the country.

"The best day was when I went to the Jubilee and got invited up on stage and was crowned the number-one-selling Tupperware lady in the company," Dixie says. "They gave me a sash and roses and a little crown for my head. I felt like Miss America at a pageant that Steve Harvey didn't make a mistake at."

The success these drag queens have found selling Tupperware surprises even them. "What started out as something to do for shits and giggles literally changed the course of my life," says Quintero. "As I became more successful, I became more confident. I started to dream bigger and before I knew it, I had earned cars and prizes and I'd traveled the world on Tupperware's dime."

That added confidence has allowed these performers to take on new challenges away from selling burpable bowls. "Those of us who have been really successful are now branching out into other arenas," says Kevin Farrell, an Ohio-based actor whose alter ego is the frequently tipsy Dee W. Ieye. He polished his performing skills in Hollywood, appearing on such hit shows as *Frasier*, *Friends*, and *Gilmore Girls*, before moving to the Midwest.

Success as Tupperware ladies may not be the superstardom that led these drag queens to enter show business, but it's nothing to bat a false eyelash at. "I always wanted to be on TV," says Koehler. "At one Tupperware party, someone snapped a picture of Cassie Rolle standing in front of a 60-inch TV. I realized I'm making it as household entertainment—just one house at a time."

OPPOSITE: Tupperware Queens (Left to Right): Dixie Longate and Cassie Roll.

Brini Maxwell

"Brini is so much like what a certain type of woman in our society was once like and, in some places, is still like . . ."

—Brini Maxwell

It wasn't Tupperware but another mid-century kitchen staple, a set of Pyrex mixing bowls, that gave birth to Brini Maxwell, the lifestyle guru known as the Martha Stewart of drag. A pert, poised, and practical blonde—half Kim Novak, half Sue Ann Nivens—the mod-mad Maxwell was the reigning Queen of D.I.Y. (Drag It Yourself) as the twentieth century remodeled itself into the twenty-first.

The brainchild of interior designer Ben Sander, she had been kicking around in his mind for years before her debut. "Brini was borne of a desire for glamour, but glamour seen through the lens of mid-century suburbia—the hostess with the perfect home, the perfect wardrobe and the perfect manners," he says.

Sander, who studied at New York's Fashion Institute of Technology, built the character (and his design aesthetic) on his own past. "I had grandparents who lived that life in an amazing modern ranch home with a sunken living room, terrazzo floors and a kidney-shaped pool, in Springfield, Ohio. My parents on the other hand were more counterculture academics and artists, so Brini became a blend of the bourgeoisie and the intelligentsia."

It took something as plebeian as Pyrex bowls, though, to launch her into society. As the story goes, Sander's domestic-goddess-in-capri-pants came to life when he found a set of the vintage nesting necessities in a Salvation Army thrift shop. "It occurred to me when I got them home that no one would ever see them. So I thought to myself, 'Why not do a TV show and everyone can see my mixing bowls?'" Sander told the *Village Voice* in 1999.

That show was *The Brini Maxwell Show*, launched in January 1998 on public access Channel 35—an outlet that was sort of the twentieth-century television equivalent of YouTube—in New York City. Shot on the cheap in Sander's tiny Chelsea apartment, the program aired in primetime in Manhattan. In each episode, Brini offered useful tips on such topics as making bridge-party finger sandwiches, hosting a proper wine and cheese social, removing scuff marks with lighter fluid, and storing balls of string in old teapots.

The series quickly garnered a cult following and made Maxwell the toast of New York. Pop-culture chronicler Guy Trebay wrote, "In his loopy cable show, Ben Sander invokes the spirit of a pre-feminist WASP housewife in the Donna Reed mold with eerie precision." *HX*, a ubiquitous gay bar magazine of the day, put Brini in all her Lemon Pledged glory on its cover.

One fan, it turned out, was a director of development for a production company who took Sander to lunch, then pitched the show to various cable outlets. The Style Network fell for the Martha Stewart of gay Manhattan and bought thirteen episodes of *The Brini Maxwell Show*.

The show premiered in January 2004 to good notices. Beth Gillin of the *Philadelphia Inquirer* called the program, "a throwback to a gracious age when women wore floral aprons and welcomed husbands home from the rat race with a cold drink and a cocktail weenie." Another critic praised it as "a fun and silly half hour that might teach you something if you aren't careful."

A second season followed later that year, along with a book, *Brini Maxwell's Guide to Gracious Living*, in 2005. After her Style Network series ended, Brini continued making public appearances, published an e-cookbook called *Have a Ball with Brini* filled with

recipes for "food in the shape of fun," and, now that YouTube has replaced public access cable, launched her own web channel.

One style blogger, noting the rise of Etsy and the craft resurgence in the decade after Brini's show aired, suggested, "Where the character may have seemed like a campy novelty or delightfully regressive blast from the past a few years ago, today Maxwell seems more in step with our nostalgia-crazy cultural milieu." She may have looked retro, but she was ahead of her time.

In 2017, Brini began hosting Knit at Nite at the hip Club Cumming in New York's East Village. It's a weekly knitting party that *Time Out New York* calls "an Amy Sedaris wet dream." Meanwhile, Sander creates a line of home accessories, and has thrown himself into interior design, specializing in what he calls "20th Century–inspired statement interiors." As for Brini's renewed popularity, Sander told a decorating website, "I think second acts are fun, don't you?"

ABOVE: Thoroughly Modern Maven Brini Maxwell.

BORN NAKED

"We're born naked and the rest is drag."

—RuPaul

Just as RuPaul had been at the epicenter of the East Village drag scene in the late 1980s and early 1990s—the brightest star to emerge from the Wigstock generation—he ushered in the modern drag era with the premiere of the reality competition series *RuPaul's Drag Race* in February 2009.

In the world of drag, the TV show was a game-changer.

Produced by World of Wonder—the quirky company helmed by Randy Barbato and Fenton Bailey, two transplanted New Yorkers who had moved to Hollywood to make such cult films as *Party Monster* and *The Eyes of Tammy Faye*—*Drag Race* pitted queens from around the country against each other for the title of the "Next Great Drag Superstar."

The series made its debut on Logo, the LGBTQ-centric cable channel that had been launched by the media giant Viacom in 2005, and quickly established itself as the shining jewel in the network's gold-plated crown.

"This is the show that basically drew people who would never have found Logo to Logo," says *TV Guide* critic Damian Holbrook. "It helped them establish their identity. This was their *Queer Eye for the Straight Guy*."

But the show that kept the lights on at Logo almost didn't happen.

"When I started working at World of Wonder in 2006," says *Drag Race* executive producer Tom Campbell, "I said, 'Why aren't we doing a show with RuPaul?' Randy said, 'You talk to him.'"

At the time, those close to RuPaul say he just wasn't up for it.

Bailey and Barbato had been guiding the famous drag queen for decades. They'd executive produced the groundbreaking 1996 talk variety program *The RuPaul Show* on VH1, and shepherded successful proj-

ects in all facets of his career, from his first hit album *Supermodel of the World* to his fondly remembered holiday special *RuPaul's Christmas Ball* and beyond.

Bailey and Barbato had been New York University graduate film students when they first met RuPaul in the 1980s. "He was doing his jock strap and wader boots and football shoulder pads, that very early kind of genderfuck drag," Barbato remembers. The look was striking, if not exactly chic.

Barbato and Bailey knew they had found in RuPaul Andre Charles someone who could go all the way in show biz. A Diana Ross–worshipping beanpole, Ru had moved from his native California to Georgia in his youth. As a young drag queen in Atlanta in the early 1980s, he had wheat-pasted the town with posters that read "RUPAUL IS EVERYTHING," and drag fans took notice.

"We all knew RuPaul was going to be someone to be reckoned with in the future," says the Atlanta drag stalwart Mr. Charlie Brown. "Every telephone pole and every mailbox had a picture of him on it."

Once Ru had conquered Atlanta, he moved to New York, and then there was no stopping him. "Listen, I've always been an oddball, even as a kid," RuPaul told me in 2017. "I wasn't necessarily popular, but everyone knew of me. I knew that my destiny would be to be someone who would stand out."

How could he not? RuPaul was over seven feet tall in heels and hair and had a smile that could light up Times Square. "Ever since we first met him, we were like, oh my god, he's a superstar," says Barbato, who along with Bailey began managing Ru's career around 1990.

Even Barbato wasn't sure, though, that the world was ready for a drag queen supermodel. "I remember when we were out there trying to get Ru his first record deal, there was a moment where it was like,

★★★★★★★★★★★★★★★★★★★★★★

"The most important thing you can do on this planet is become the realization of your own imagination."

—RuPaul

wait, can we really do this? It did seem crazy. But we thought, the music is so good and this is the time. We all thought, wow, if we can get some kind of a hit, we will have accomplished the most radical thing ever."

And, they did. The album *Supermodel of the World* was released in June 1993 on Tommy Boy Records and, while it may not have been the most radical thing ever, it was a hit.

The single "Supermodel (You Better Work)" became huge in the clubs, a certified gold record that peaked at number forty-five on the *Billboard* charts. The song popularized the words "sashay" and "shantay"—both still a big part of the RuPaul drag lexicon. The album reached number 109 on the *Billboard* charts and led influential critics to recognize RuPaul as "the Little Richard of '90s Dance Music" and to admit that the pioneering drag queen had "a lot less attitude and a lot more down-to-earth talent than you had any reason to expect."

In 1996, RuPaul and the World of Wonder boys launched the VH1 talk variety series *The RuPaul Show*. Michelle Visage, who'd go on to be a popular *Drag Race* judge, served as cohost. Guests included icons like Cher, Diana Ross, and Cyndi Lauper, and outré celebs like John Waters and Dennis Rodman, with whom RuPaul shot hoops. East Village drag had hit the sorta-bigtime.

The *New York Times* called RuPaul a "Drag Queen of All Media" when the show premiered, noting that he was juggling these new TV responsibilities with a gig as a morning disc jockey on the New York radio station WKTU, modeling jobs for MAC cosmetics—a first for a drag queen in the beauty industry—and acting work, most notably as Jan's guidance counselor Mrs. Cummings in several *Brady Bunch* movies. Ru did it all while pushing a new album called *Foxy Lady*, an autobiography titled *Lettin It All Hang Out*, and a pictorial calendar that every gay boy and his mother—mine included—wanted for Christmas that year.

It was RuPaul's moment.

He scaled the heights of mainstream acceptance, becoming America's drag queen, but by the early 2000s, to paraphrase one of his songs, his pussy was not on fire anymore.

RuPaul "had stepped away from the canvas," as Campbell, a former MTV executive, put it. The drag queen hadn't quite sashayed away from the limelight, but he certainly needed a new gig to put him back where he belonged.

"When we met, Ru told me he was up for doing anything except a reality competition show," remembers Campbell. "Over the next few weeks, we developed a different, totally hilarious, loosely scripted idea. When we were done, Ru looked at me and said, 'You know what we should really do? A reality competition show.'"

RuPaul, Campbell, Bailey, and Barbato began brainstorming ideas about what that show should be. They looked at what it means to be a drag queen and how that could be ramped up to make exciting television.

"We thought, well, drag queens lip sync, and that quickly escalated to 'they won't just lip sync, they'll lip sync for their lives!' The rest of the format fell into place quickly after that," says Campbell. *Drag Race* contestants, they decided, would square off against each other in challenges that tested their skills in costume design, writing, acting, and celebrity impersonation. These tasks would determine which queen had enough "Creativity, Uniqueness, Nerve and Talent"— picture that acronym!—to become America's Next Drag Superstar.

"All the challenges were based on something Ru had achieved in his career. The whole series really is Ru's legacy work," says Campbell.

The creators of the show instantly knew they had happened onto a magic formula. "The laughter and joy expressed in the room as we first created the show told me we were on to something big," says Campbell. The first season, Bailey says *Drag Race* "was perhaps the cheapest show ever made. It was made for no money. We didn't even have good lighting people, so we gave it a glow job!"

Today, Barbato says, the show "looks better, but the spirit's the same."

That spirit, it turns out, is rooted not just in the

entertainment value of *Drag Race*—who can forget watching season eight winner Bob the Drag Queen transform from *Orange Is the New Black*'s Uzo Aduba into Carol Channing while playing Snatch Game?—but also in the bare-naked emotional revelations of each season's contestants. The show reveals, as *TV Guide* critic Damian Holbrook says, that "drag queens are not just the persona they've created, they're also the person behind that persona."

The depth of the show surprised even its creators.

"It wasn't until magical moments started to happen during the shooting of season one—like Ongina revealing she was HIV positive on the main stage—that we totally understood the heart and soul of the show," says Campbell. "Under all the wigs, makeup, and shenanigans, the show is a platform for sensitive, creative and often marginalized souls to tell their stories and to inspire us all."

That message wasn't lost on critics.

RuPaul's Drag Race succeeds, says Holbrook, because "it's one of the best reality competition shows out there. It just happens to feature men in drag. Their back stories are far more compelling than on a lot of the other reality shows. In creating themselves as incredibly flamboyant and dramatic 'women,' the best contestants prove themselves to be the toughest men out there. You really can't help but root for all of them."

Because the show is rife with balls-out honesty about LGBTQ lives, it "holds a super-important and a super-groundbreaking place" in TV history, says series regular Michelle Visage. "In the way that Madonna changed the face of pop music, *RuPaul's Drag Race* has changed the landscape of reality competition television. There's so much heart in our show. You see what these kids have gone through to shed their skins and

ABOVE: Christina Aguilera joins RuPaul and the show's judges: Ross Matthews, Michelle Visage, and Carson Kressley.

be the artists that they are."

Drag Race, RuPaul says, "has become a symbol of forward-thinking in America. Our show has come to represent an openness, a way to see the world in the future, and that is really important. I love the fact that people enjoy the show. We do entertainment. If people get a deeper meaning, a political meaning, or a cultural meaning out of it, that's even better. That's great, but our purpose is to celebrate the art form of drag."

In its first ten seasons, *Drag Race* has boosted the careers of more than a hundred-twenty queens, unleashing an army of cross-dressing comedians such as Bob the Drag Queen, Alaska Thunderfuck 5000, Ginger Minj, Katya Zamolodchikova, Jinkx Monsoon, Eureka O'Hara, and, in particular, Bianca Del Rio, the New York–based insult comic who has parlayed her season six win into several cable specials, a string of sold-out theater dates from Great Britain to Australia, and appearances in movies, two of her very own.

Thanks to the show, America is now familiar with top pageant queens like Alyssa Edwards, Coco Montrese, and Nina Flowers, and outré queens like Thorgy Thor, Acid Betty, Laganja Estranja, Milk, and the fourth season's winner Sharon Needles, a performer who counts Gaga among her fans. They know rock star queens like Adore Delano, fashion queens like Miss Fame, and the seventh season's winner Violet Chachki, club kid queens like season-ten champ Aquaria, and performance art queens like the life-size anime character Kim Chi, living doll Trixie Mattel, and winner of season nine, Sasha Velour.

"RuPaul opened so many doors for so many people," says Alaska Thunderfuck. "With *Drag Race*, he's sharing the wealth of his career with young performers who are basically going out into the world as brand ambassadors for his empire, which is brilliant."

★ ★

"Under all the wigs, makeup, and shenanigans, the show is a platform for sensitive, creative and often marginalized souls to tell their stories and to inspire us all."

—Tom Campbell, Executive Producer, *RuPaul's Drag Race*

If there has been a downside to the success of the series, it is the price that some performers feel they've paid for not appearing on it. "It's much more difficult to get booked if you are not a Ru girl," the San Francisco drag icon Heklina has said, suggesting that younger audiences in particular "refuse to explore any queens not on the show."

Aggy Dune, a Rochester, New York, performer who has been the drag mother to a number of *Drag Race* contestants, says the show's impact has been felt on the club scene. "Every gay boy with a bronzer and mascara thinks he's fabulous," she says. "Everyone is a drag queen these days."

That's not a bad thing, she says, but these new audience members are "not as interested in watching a drag show anymore as much as they are interested in taking a selfie with a Ru girl. The success of *Drag Race* has changed how we view our local queens. If you haven't been on the show, you must not be good."

But drag legend Miss Coco Peru says, "The show has done a lot more good than anything bad that people can say about it. When I did the 'Drag Queens of the Sea' cruise, which was all RuPaul girls and their fans, I was sort of a dinosaur. But the *Drag Race* queens would get up onstage and say how excited they were that I was on the cruise. That made the guests who didn't know who I was want to get to know me."

Certainly being connected to *Drag Race* can be an enhancement to the career of any queen, veteran or newbie, if she plays her cards right.

"That little TV show is pretty powerful, which is kind of nuts. It has gotten bigger than ever, so we've all been benefiting from it," says Bianca Del Rio.

"Ru does a really good job of being generous in ways he can to the majority of queens," Barbato says. But their careers after *Drag Race*, he admits, "are not his responsibility. RuPaul is always reinforcing the

message that it's not easy. I'm sure a lot of people just want to get on the show because they think it's going to translate to some big career. But it never translates into anything more than what you make of it."

RuPaul herself has certainly set that example.

"Before getting on the show, I saw RuPaul as a performer and businesswoman who captured lightning in a bottle," says Darienne Lake, a Rochester, New York, queen who finished the sixth season in fourth place. "After meeting her, I realized how she got to be so successful. She's smart, quick, funny, and as serious as a heart attack. When all is said and done, you know who's the boss."

In 2017, original broadcasts of *Drag Race* moved from Logo to VH1, bringing the show its largest audiences ever. The relocation to the more pervasive cable channel signaled not only that Viacom, the parent company of both networks, had finally realized the crossover potential of the show, but also that audiences outside the gay community were eager to see what the fuss was about.

When *Saturday Night Live* featured a skit in May 2017 in which macho auto mechanics discussed their love of *Drag Race*—guest host Chris Pine said he was particularly taken with one contestant's "flat crotch illusion"—it was the ultimate mainstream validation.

The numbers backed that up. Nearly a million people watched season nine's debut on VH1. For the season finale, ratings among the most highly prized viewers, those between eighteen and forty-nine years of age, were up 218 percent. According to the network, 859,000 viewers watched as Brooklyn queen Sasha Velour snatched the crown from her fellow final-four contestants Peppermint, also from New York City, Chicago sensation Shea Couleé, and Trinity Taylor, the Orlando queen who'd been the object of Pine's fascination on *SNL*.

The ratings spike didn't surprise the show's producers.

"I feel like it's just the beginning," Barbato said.

Already *Drag Race* has been broadcast in countries around the world.

A June 2017 survey in *Billboard* of queens from Little Rock to London and Manila to Melbourne attested to the far-reaching impact of the show. Enigma Von Hamburg, a performer from Cape Town, told the magazine, "Almost everyone nowadays has RuPaul on their lips" in South Africa. While a Beijing queen named TigerLily said *Drag Race* "has encouraged drag queens and aspiring drag queens to dare to be fab," even in China.

"It has become a global show—37 countries, I think," Bailey says. "Ultimately it's an intergalactic show. Our work is not yet done."

In 2016, RuPaul won the Emmy as Outstanding Host for a Reality or Reality-Competition Program and, in accepting the award, said, "Earlier this year, I was quoted as saying I'd rather have an enema than an Emmy, but thanks to the Television Academy, I can have both!" He was kidding, but clearly honored to receive the award.

While appearing in June 2017 at a West Hollywood party to honor *Drag Race*—a "For Your Consideration" event asking Emmy voters to support the show when their ballots arrived—RuPaul said he doesn't do the show for the glory, but because it's his duty as an entertainer and an LGBTQ American.

"We don't do this to snatch trophies," he said that night. "We do this because we must do it. This is our calling to bring love and colors and music and laughter and dancing and joy. This is actually our secret weapon in these trying times. This is the one thing that we have that they don't have, that they will never have, and that's how we will prevail and that is how we will ultimately win."

Three months later, *Drag Race* took home two more primetime Emmys.

In 2018, not only did RuPaul win another Emmy as host, but the series beat the network juggernaut, *The Voice*, to win the award for Best Reality-Competition Program.

Can I get an "Amen" to that?

Pandora Boxx

"What I do is like being a show pony: I just parade around in silly hats to cheering crowds."

—Pandora Boxx

Michael Steck was born in Lucille Ball's hometown of Jamestown, New York, and he, too, is a gorgeous comedienne. As Pandora Boxx, Steck is one of the most popular runners-up in *Drag Race* history. *Entertainment Weekly* didn't give a fig that she didn't take home the crown. They dubbed her the breakout star of season two. Boxx was so cheerful, she won Miss Congeniality.

With a middle name of Olivia—chosen to honor Olivia Newton-John and so her initials would make her "P.O. Boxx"—Pandora cemented her standing as a fan favorite when she impersonated Carol Channing for a Snatch Game challenge. It was a star turn that got even RuPaul laughing out loud.

Having established herself as one of Rochester, New York's most popular queens, Pandora relocated to Los Angeles after *Drag Race*, and since has appeared on the spinoff series *RuPaul's Drag U* and written the play *The Lipstick Massacre*, which costarred her friend and fellow *Drag Race* alum, Mrs. Kasha Davis.

She says she's a show pony, but Pandora's so sweet, she's really a unicorn . . .

What made you want to be a drag queen?
I saw my first drag performance and said, "I want to go to there." It was just captivating and fun and people gave you money. I always loved actors like Goldie Hawn, Lucille Ball, and Madeline Kahn. They were so gorgeous, yet could be total goofballs. Carol Burnett was a major influence. She was everything I wanted to be. I also am a huge Madonna fan. She just isn't afraid to be who she is. I wanted Pandora to be like that. The name comes from Greek mythology and, with that name, you never know what to expect.

What was your drag career like before you were cast on Drag Race?
I've been doing drag since Abe Lincoln was in office. I was literally about to quit drag because I felt like it had run its course for me in a small town. I said to myself that if something didn't change soon, I was done. I got the call and it was like the universe saying, "Keep those panties on, Lady Boy!"

What was your most vivid memory of shooting season two?
I will never forget Kathy Griffin's face when I walked down the runway in my Kathy wig. She gagged. It was glorious. I also loved the Snatch Game. RuPaul was giddy when I told her I was going to do Carol Channing. It was completely amazing to make RuPaul laugh.

I've seen fans go nuts when they meet you. What is it like to be on the receiving end of such enthusiasm?
It's quite odd but lovely, and it's super flattering. But I always think, well, it's just me. Why are you going so crazy?

OPPOSITE: Pandora Boxx.

Alaska Thunderfuck 5000

"I saw what Drag Race *did for the queens who got on
the show and I definitely wanted to be a part of the action."*

—Alaska Thunderfuck 5000

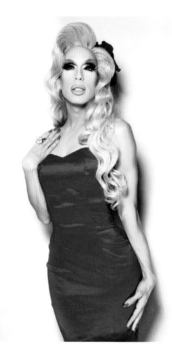

She hails from the planet Glamtron, is named for a potent strain of marijuana, and claims she became a drag queen "because of a divine calling, like being a nun." That last bit would explain the religious fervor with which fans have greeted Alaska Thunderfuck 5000 since she appeared on *Drag Race*'s fifth season in 2013 and won the second edition of *RuPaul's Drag Race All-Stars* in 2016.

The creation of Justin Honard—an Erie, Pennsylvania, native who studied theater at the University of Pittsburgh—Alaska calls herself an "absurdist comedic performance artist." As such, she has established herself as an actress, a comedy queen, and a recording artist whose singles "Your Makeup Is Terrible" and "This is My Hair" are as hysterical as they are danceable.

Check out her *Anus*—the album that spawned those tunes—and, please, pay no attention to the lace on her forehead . . .

How did you come up with Alaska and her look?

I was smoking a lot of weed in my early twenties and Alaska sort of channeled herself into my brain. Her aesthetic was heavily influenced by Trannyshack and the queens of San Francisco with their twisted way of telling a story through drag. I love using garbage and plastic and disposable materials and endowing them with beauty. There's a magic to that that can be applied to anything in life.

What does "drag" mean to you?

I think drag has to do with the indulgence of the modern consumerist idea of beauty. It's taking all these things that our culture has decided are necessary to be "beautiful" and pouring them all on at once and indulging them completely. In this process of gluing things to my eyes and my fingers and my hair, something inexplicable and magical happens, and that's drag.

How different was your actual experience on Drag Race from what we saw on TV?

It all happened. It just didn't have scary music behind it in real life.

Are you enjoying the fame you've found?

I don't consider myself famous; I just consider myself popular. Interacting with the fans is one of the best parts of doing what I do. What we're doing really means a lot to people, and people find inspiration and bravery from this crazy thing we do called drag, so that's great.

ABOVE: Alaska Thunderfuck 5000.

Courtney Act

"I'm the Jack of all trades and the Jill of none."

—Courtney Act

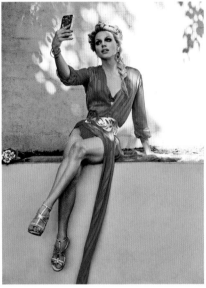

He has been singing and dancing since he was a six-year-old acting student in his native Brisbane, Australia. Since he first tried his hand at drag in 2000 in Sydney, Shane Jenek—better known as Courtney Act—has tasted fame on two popular TV shows, *Australian Idol* in his homeland and *RuPaul's Drag Race* in the States, and toured the world as an actor, singer, and comedian. Courtney's a video artist, and a wig company entrepreneur to boot.

Courtney is not-so-arguably the most beautiful, not to mention one of the most talented and sweetest, queens to have appeared on *Drag Race*. It came as little surprise when she finished in the top three of season six.

What inspired you to become a drag queen in the first place?
I lived in Sydney in a post-*Priscilla* era, and drag was very popular. Drag queens were like the touchable celebrities. It was before the internet. The only way you could find out about a celebrity was to read about them in a magazine, but you could go to the Imperial Hotel any night of the week and see drag queens onstage performing fabulous numbers in big production shows. I just remember staring up at these drag queens and thinking they were magical creatures.

Where'd the name "Courtney Act" come from?
My friend Vanity and I were sitting at lunch at a café in Sydney on Crown Street, planning my first time in drag, which was to be New Year's Eve 2000. I had visions of being a burgundy-haired, shag-cut smoky nightclub singer. I wanted to be called Ginger Le Bon. But Vanity suggested I be called something a bit more girly and fun like Courtney. A lot of Australian drag queen names are a play on words. So I said it slowly in my Australian accent. It kind of sounded like "Caught in the . . ." and then I just decided "Caught in the Act"—Courtney Act.

Who were your influences as a performer?
Priscilla, Queen of the Desert was a big influence. Also, Dame Edna is a huge Australian drag icon. I find her fascinating and entertaining, and then, you know, pop stars like Kylie Minogue and Madonna and Cher and Bette Midler.

What has appearing on Drag Race meant for you as a performer?
My career has become a global thing. I'm flying around the world constantly performing, doing club gigs and my cabaret show. It has just afforded me these amazing opportunities that I didn't have before.

ABOVE: Courtney Act.

Chad Michaels

"Anything can happen and there's no way to be prepared for it—just say 'Yes' and go for it!"

—Chad Michaels

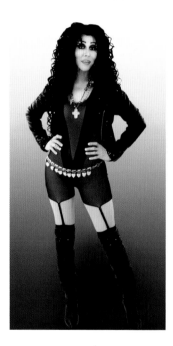

Chad Michaels has played a Cher impersonator on television shows from *MADtv* to *2 Broke Girls* since 2002. But it's not mere typecasting. Michaels *is* a Cher impersonator—many, including Cher herself, would say he's *the* Cher impersonator. It is his calling and few do Cher any better.

Originally known as Brigitte Love—a moniker he dropped when he joined the now defunct Las Vegas revue *An Evening at La Cage*, which required performers to use a male name—Michaels was a runner-up on *Drag Race*'s season four. Later in 2012, he returned to win season one of *RuPaul's Drag Race All-Stars*.

He continues to produce and perform in the long-running *Dreamgirls Revue* in his hometown of San Diego. That show, which has been running for more than thirty years and also has productions in other Southern California cities, has sent more contestants to *Drag Race* than any other show in the United States, Michaels likes to say. Among those *Dreamgirls* alums to appear on the series are Delta Work, season three's winner Raja, Detox, and Michaels's drag daughter Morgan McMichaels.

Michaels, of course, performs as Cher every chance he gets. To paraphrase one his doppelganger's hits, you haven't heard the last of him yet.

How did Cher become such a big part of your life?

Cher was always on the television when I was growing up in the 1970s. I was intrigued by the beautiful lady with the long black hair, the tan skin, and the sparkly costumes. My first time doing Cher was at the Brass Rail in San Diego in 1992. My career really started then and snowballed quickly through the 1990s.

What has made you so good at doing Cher?

I have dedicated a scholarly amount of time to knowing how to do my job. Less is more when impersonating Cher. The gestures and body language have been exaggerated over the years, but Cher herself is really quite subtle.

You've done your Cher for the actual Cher. What's that like?

Cher has always been generous and kind. I opened for her in 2002 at a fundraiser. After performing for her in L.A. in 2014 at the *Woman's World* release party, she tweeted I was "genius," so that was amazing. The appearance with her on *The Talk* in 2017 was awesome and she told me I looked great. As always, she's a sweetheart. My respect for Cher has developed through the years that I have been impersonating her. It's been a long character study that's still a work in progress, but it's always a labor of love.

ABOVE: Chad Michaels as Cher.

Mrs. Kasha Davis

"I am not a delicate flower—I'm a man in a dress with a burning desire to entertain."

—Mrs. Kasha Davis

Although originally from Scranton, Pennsylvania—"that town known for coal mining and *The Office*," she says—Mrs. Kasha Davis, the alter ego of Ed Popil, has made a name for herself on the Rochester, New York, drag scene in a show called *Big Wigs*.

Since appearing on *Drag Race*'s seventh season, she has performed her one-woman show *There's Always Time for a Cocktail* at various venues, including the prestigious Laurie Beechman Theatre in New York City, where one of her idols, Joan Rivers, often played.

Davis is philosophical about finishing in eleventh place on the reality show.

"Nice gals may finish last, but they stay around for the long haul," she says. "There are nearly a dozen people who are fans of Mrs. Kasha Davis, and I love them all. On social media, I have been very lucky to have a nice balance of 'You were robbed' and 'You are too old.'" Age is no problem for this housewife, however. As she says, "I'm making so much money that I can now upgrade to name-brand adult diapers."

How did you come up with your character and her name?

I modeled myself after my diva Italian mom, my crazy fun aunts, and my grandmother, who was a vaudeville whistler and housewife, and Miss Richfield 1981. My husband and I saw Miss R in Provincetown and I fell in love. After I saw the character she created, I thought, "Okay, I've got this." For my name, I used the old-school process of combining my first pet—an angry poodle—and my first street, and Mrs. Kasha Davis, International Suburban Celebrity Housewife, was born.

Were you a RuPaul fan before you did Drag Race?

My first time learning about RuPaul was in the kitchen of our Scranton home. My very Italian uncle was making chicken wings with my mother, and he would take the tray out of the oven singing, "Shantay, shantay, shantay." My siblings and I kept giggling, wondering if they knew RuPaul was actually a man.

What has being on the show meant to your life?

I was so damn grateful for the opportunity. I struggled with being myself all my life. I was always too fat, too gay, too emotional, a closet case, you name it, and I worked on loving myself for years. Ru was always there in drag on my shoulder encouraging me to just be myself. My most vivid memory of the shoot was on day one, standing backstage. Before I made my entrance, I looked right into the mirror and thought, "Eddie, you did it!"

ABOVE: Mrs. Kasha Davis.

Darienne Lake

"Drag is not one thing, but it is everything."

—Darienne Lake

Darienne Lake is what the talk show hostess Virginia Graham used to call "ample not sample." Lucky for drag fans, her talent is as big as her dress size.

The alter ego of Greg Meyer and a fixture on the Rochester, New York, scene, Lake has spun her season six notoriety into a career that includes international performing engagements and a slot on the Big Phat Losers tour, a string of shows featuring such plus-size *Drag Race* alums as Latrice Royale, Victoria Porkchop Parker, Jiggly Caliente, Delta Work, and Mimi Imfurst.

"The energy, love, and support I get from the crowd compels me to show the world that you can do drag no matter how young or old, fat or thin, ugly or pretty you are," she says. Funny and bitchy, she finished fourth on her season and was featured in Mark Kenneth Woods's 2015 Canadian documentary *This is Drag*.

This is Darienne Lake . . .

How did you come up with your look and your name?
Before *Drag Race*, I had been performing for twenty years. When I was first painted up, I looked like Ricki Lake in *Hairspray*. My drag mothers said I should name myself after her, but I wanted something special. There's an amusement park between Rochester and Buffalo named Darien Lake, so I decided to be Miss Darienne Lake, two tons of steel and twisted sex appeal.

What was the Drag Race *audition process like for you?*
The first time I auditioned, I told my story of growing up an obese, lonely middle child and how drag was so important to my staying alive. The second time I auditioned, I thought they wanted drama, so I talked about the death of one of my drag mothers. The last time I auditioned, I structured it like an episode of Snatch Game. I impersonated Paula Deen, Anna Nicole Smith, Big Ang, and Regan MacNeil, Linda Blair's character from *The Exorcist*. I think seeing the growth from year to year helped get me on the show.

How did it feel when you got the call that you'd finally made it?
I was scared shitless to be cast on the show. All of a sudden you question if you have enough drag for any situation that they throw at you. I didn't want to repeat outfits, but I had to pack everything into five suitcases under fifty pounds each. That's not a lot of room for a size-28 drag queen who loves sequins, rhinestones, and bugle beads. Not to mention one of the suitcases had to be hair that wouldn't get crushed, and boy clothes. I packed all my jewelry in my carry-on bag, which was a nightmare for the TSA.

What was it like filming the show?
Stepping onto the set was completely surreal. It was like being in Oz. Everything was so familiar, yet so strange. During the six weeks of filming, I had an amazing time, filled with self-realization and over-coming self-doubt. We all didn't think we had enough drama or fights to make the show what we were used to seeing from the fifth season. But there is so much fun and laughter on the cutting room floor that they could release "Season 6.1."

OPPOSITE: Darienne Lake.

THE SWEETHEART

BenDeLaCreme

"The more you do something, the more you can find small nuances in it."

—BenDeLaCreme

From his first appearance on *Drag Race*'s sixth season, BenDeLaCreme has endeared himself to fans as a performer both smart and sweet—not to mention hilarious. He finished the season in fifth place, although his Snatch Game win as Dame Maggie Smith led many to believe he'd at least make the top three.

Ultimately, he snagged the Miss Congeniality trophy, a title he says he'd never have gotten when he first started doing drag in high school. When he returned for the third season of *RuPaul's Drag Race: All Stars* in 2018, he was the early frontrunner, easily winning a variety of challenges. But when it came time for BenDeLaCreme to eliminate one of his competitors, as per the reality show's playbook, he chose to eliminate himself instead.

Miss Congeniality was congenial once more.

Now a fixture on the Seattle burlesque scene—he got there by way of Chicago, although he grew up in Connecticut—DeLa describes herself as part vintage MGM musical diva and part Saturday morning cartoon. She is, to borrow the title of her one-woman show, "terminally delightful."

But don't let BenDeLaCreme's cheerfulness fool you.

"My character can be upbeat and chipper, and a little dumb," she said in 2015. "But I can use that set of characteristics to talk to an audience about something that I actually think is serious. I've always believed in camp and comedy as vehicles to trick people into thinking more and feeling things they may not feel otherwise."

One thing they feel is admiration for her creator, Benjamin Putnam.

"I get tons of letters and emails with people telling me how they connect to the character and they feel inspired," he has said. "Getting this kind of response really makes it feel like I am doing the right thing with my life."

How has your drag evolved since you started being BenDeLaCreme?
My character has gotten much nicer as I've gotten older. When I was first doing it, my character was a bitch. At some point, I decided I had enough angst going on inside me, so DeLa could be nicer and kinder, and she could help me to be a more positive person. When you're bubbly and you're being sweet to everybody, in some ways, that's more transgressive than being a bitchy drag queen.

You went to the prestigious School of the Art Institute of Chicago. Did that help you create your looks on Drag Race?
The school encourages you to focus, in a multidisciplinary sense, on learning different techniques and a broader sense of problem solving. I think that came in really useful. But I'm not a fashion person. I am just a huge fan of a lot of vintage fashions and I come from the world of burlesque. I've been working on burlesque stages for years now, with a lot of biological women.

OPPOSITE: BenDeLaCreme.

228

Who has inspired you, besides those women?

I look up to so many of the drag queens who were big names when I was growing up in the 1990s. RuPaul was always this beacon of positivity and love. Miss Coco Peru, Lypsinka, Varla Jean Merman, Dina Martina—all those queens in the 1990s had these kind of leadership sides, where they were creating a loving, safe space for the queer community. That's what I'm interested in seeing.

Are you much different when you're Ben rather than DeLa?

I tend to be very shy as a boy, and a little bit more reserved, and kind of a homebody. I look and act really different. With drag, there's always going to be a lot of talk about multiple personality stuff. Some of us struggle against it, while others of us just dive in. I'm not pretending my brain works normally, but I have embraced the way that it works, and I think I've made something cool out of it.

Bianca Del Rio

"Being a bitch onstage is a treat, but you can't be that in real life. It's too much work."

—Bianca Del Rio

As a teenager in his native New Orleans, Roy Haylock worked in the costume shop of a dinner theater, before being cast in local productions of shows like *Pageant* and *Psycho Beach Party*. He played the pansexual emcee in *Cabaret*, Angel in *Rent*, and he was even a stripper in *Gypsy*. "I wasn't necessarily stretching my acting skills. I mean, Mazeppa? Hello!" he says.

Acting led him to drag and his greatest role, playing Bianca Del Rio, insult comic extraordinaire, actress, and the winner of *RuPaul's Drag Race*'s sixth season. Most consider Bianca the greatest "drag superstar" the show has ever produced.

Since her win in 2014, she has toured the world with her one-woman shows multiple times, playing to thousands a night in theaters from Great Britain to Australia. She made the movie *Hurricane Bianca* and the 2018 sequel *Hurricane Bianca 2: From Russia with Hate*, the TV specials *Rolodex of Hate* and *Not Today, Bianca*, and done commercials.

But rest assured, success hasn't spoiled her: Bianca is still as evil as ever.

Where did the name Bianca Del Rio come from?

I was performing in a bar, using the name Marvel Ann, from *Psycho Beach Party*. A friend of mine, this brilliant drag queen, said, "You remind me of my friend Bianca." So Bianca Del Rio became the name. Then she told me, "You know, the reason I'm calling you Bianca is because you remind me so much of her, and she's no longer with us. She passed away." When I won *Drag Race*, I got a text saying, "I'm so proud of you, but I have to let you know, Bianca is alive, and she's pissed." Apparently I had taken someone else's name, and now she's ruined. All these years I thought that bitch was dead, and sure enough, not the case!

ABOVE: Bianca Del Rio.

Did any other drag queens influence your career?

One of the first people I met, when I was twenty, was Lady Bunny. She was doing a guest spot in New Orleans, and she came in and she saw me. I was hosting the show and also doing Cher, because you know every brown boy with a big nose does Cher. Bunny thought I was really funny, but she thought that the Cher thing was something other people could do, and do better. She said you should find your own look, and work on that, and you'll be more successful. Fifteen years later, we were working together in New York, and I reminded her of that story, and she said, "Girl, I didn't tell you to do drag. I told you to die!'"

How did you get cast on RuPaul's Drag Race?

I was doing a show with Bunny at XL, this club in New York. Michelle Visage saw the show and afterwards came to me and said, "Why haven't you auditioned?" At the time, I was thirty-seven. I said I thought it was for kids, and I'm not a Beyoncé queen who does splits. She said, "We could definitely use someone like you on television." So a friend and I put together a video. It was a couple of months before I found out anything. Five days before I had to leave, I got a call saying I got on. So I scrambled to get all of my shit together. Then I left to go film the show and everything changed.

Did you think you were going to win?

Hell, no! I thought Adore Delano was going to win, because she cried and had this roller coaster, and I was over there just being a bitch and staring at people. I wasn't left at a bus stop, I didn't have a disease, and I didn't have family that dissed me. So I didn't think I was going to win at all. But I thought, no matter how far I get, I'm going to use this opportunity to extend what I love doing.

Many of us were really happy you won . . .

Oh, I'm glad, too. Trust me. I thank that big black man every day!

How did "Insult Comic" become your official job title?

I think it was other drag queens who started saying, "Well that's what she does, she reads people." Honestly, drag is just a ticket to get away with murder. If I don't wear a wig, I'm called a nasty fag. When I wear a wig, I'm called hysterical.

What has been your most exciting moment as Bianca Del Rio?

I'm supposed to say winning *Drag Race*, but my absolute favorite thing was doing *In Bed with Joan*. Joan Rivers and I were supposed to film seventeen minutes of dialogue, and we ended up doing an hour and a half, talking about everybody we hated. There was one point where I said something to her and she put her head in my lap. My little ten-year-old heart was saying, "This is not happening!'"

Who gave you the best advice of your career?

I got to meet Chita Rivera. She said, "Every night you have to prove that you deserve to be up there." I've never forgotten that. Whether it's two thousand people or ten people, I just have to do it the best way I know how, without losing focus or getting wrapped up in ego, or being an asshole, because that gets you nowhere.

Bianca, you just blew your cover as an awful person . . .

No, I am awful! I've always been that hateful person, laughing at a funeral, and I would do that in or out of drag.

Sasha Velour

"I've always wanted to make entertainment that has a real positive effect on the world, and I believe that's what drag does."

—Sasha Velour

Bald, beautiful, and oh-so-Brooklyn hip, Sasha Velour won *Drag Race*'s ninth season in a chills-inducing rainstorm of rose petals. Her art-rock aesthetic—one that falls somewhere between Eurythmics-era Annie Lennox and the downtown New York punk-drag pioneer Dean Johnson—made her the unexpected (and yet, to many, totally expected) choice for America's Next Drag Superstar.

Born Alexander Hedges Steinberg, a Vassar-educated, Fulbright Scholarship–winning son of a Russian history professor, Velour seemed the freshest, most future-thinking choice in 2017.

Known as Sasha long before he began rummaging around in his grandmother's clothes closet as a kid, Velour is a cartoonist, a designer, and the cofounder of an "art magazine about drag" called *Velour*, formerly *VYM*, as well as a drag performer. His is a combination of talents that has proven to be as fascinating as it is fierce, as smart as it is strange, and just pretentious enough to make Sasha Velour more interesting than most other drag queens. "For me, being really strong in my character means being confidently weird," he once said.

Weird, yes, but wonderful, with or without the floral downpour.

What made you want to become a drag queen in the first place?
I always had experimented with drag. When I was four, I dressed up as the Wicked Witch of the West and Little Orphan Annie. I knew I was a femme, I guess, and wanted to play around with some variet-

ies of expression. But the thing that really made me want to be a drag queen, to perform for audiences, was reading an essay by Sylvia Rivera about the role of drag queens and trans women in the Stonewall riots. That helped me see how drag performance—along with queer gender identities—have real political importance. Drag pushes against conservative aspects even within gay culture itself, and inspires our community to direct and necessary action.

How did you come up with your character, her name, and her look?
Well, her name is my name too, mostly! I was born with the name Sasha, a nod to my Russian ancestry. In this country, it's considered more of a girl's name though, so my name became a source of lots of teasing and jokes. I wanted to celebrate and reclaim those tough moments with drag. I added the surname "Velour" because it sounds and looks glamorous but it's really considered a rather cheap and tacky fabric! For me the essence of beauty lies in bending the rules of glamour—I think that applies to my "look" and "style" as well. It's really a synthesis of everything I personally find beautiful, so I suppose that's why it's a combination of vampires, modern art, Russian spies, and my mom.

Who were your influences and your idols?
Dracula—any and all versions—Grace Jones, Annie Lennox, Keith Haring, Divine, Shirley Bassey. All have shaped what I find beautiful and important in pop culture and art.

OPPOSITE: Sasha Velour.

What has it meant to your life to appear on and win Drag Race?

Not to sound clichéd but it's really been a dream come true. My life has changed overnight. I mean I'm still doing the things I would have done: listening to music, sketching out looks and performances, designing magazines with my friends about drag, and producing shows starring drag queens. But the audience has shifted. I was basically unknown before the show started airing. And now I feel insanely lucky to entertain huge audiences! I've found that people around the world are yearning for beautiful and strong drag. It's the coolest thing to experience, and it keeps me going, even when it's exhausting or scary. My drag feels so much larger than just me now, and I know that my win spoke to so many people on a personal level, and gave them hope in their own lives.

How do you feel about the notion that you, Sasha, point the way to the future of drag?

Oh, I always run away from statements like that! I feel like I represent a side of drag that's always been part of the mix,that pushes against the standard ideas of beauty (even in little ways like being bald or having a unibrow!) and encourages people to write their own rules. I am really invested in developing drag in new future-thinking directions, though, not for me personally, but for the whole community of drag and queer people generally. I think that drag is playing an increasingly integral part in our culture, and shaping how people think about gender, and I want to be part of that conversation!

EATING CLEVELAND

"There are now more drag queens per square foot than there are Chipotles and TD Banks."
—Michael Musto

Michael Musto—the great chronicler of downtown New York and no stranger to crossdressing himself—nailed it in 2016 when he wrote an Out.com column headlined "There Are Now Officially Too Many Drag Queens Running Around."

With measured alarm, this most incisive of LGBTQ pop culture commentators wrote, "My wish has come true—and I'm afraid! Everywhere you go, there are guys shaving, tucking, teasing, frosting, and trying to be funny."

It's not quite the world he had wished for when he was shopping for oversized girl shoes at Lee's Mardi Gras, a now legendary crossdressers emporium in Manhattan's then-ungentrified Meatpacking District, or when he was photographed naked as Madonna in a parody of her *Sex* book. It is too much.

Like Audrey II, the carnivorous plant in *Little Shop of Horror*s, drag has eaten "Cleveland and Des Moines and Peoria and New York"—especially New York— "and where you live." Drag has become so prevalent, in fact, that is impossible to wrap your arms around what drag means, even if you're wearing batwing

sleeves the size of a Jonathan Adler queen-size duvet.

Is drag an unshaven queen named Conchita Wurst (as Austrian recording artist Thomas Neuwirth is known) winning the Eurovision Song Contest in 2014, or is drag the shaved-headed Tony-winning actor Denis O'Hare playing a chrome-domed "Liz Taylor" on *American Horror Story: Hotel* in 2015?

Is drag a *Golden Girls* parody performed in the basement of a Mexican restaurant in Los Angeles or is drag a festival in Brooklyn called Bushwig, starring queens who weren't born when that classic sitcom went off the air in 1992?

Is drag two octogenarian cross-dressers slugging it out for the Guinness World Records title of World's Oldest Drag Queen, or two young Broadway actors like Prescott Seymour and Courter Simmons finding even more success as their alter egos Sutton Lee Seymour and Cacophony Daniels than they have in trousers?

The answer, in a word, is "Yes."

Drag is all of those things and so much more.

OPPOSITE: Darienne Lake at DragCon. ABOVE: Writer, performer, and occasional drag queen Michael Musto.

Murray Hill

"Hearing the audience roar is magic."

—Murray Hill

He is the Kleenex, the Xerox, the RuPaul of drag kings—the one that audiences reach for, the one that other cross-dressing women in show biz want to copy, the best known of the whole comedy bunch.

While being a drag king doesn't get the same attention that being a drag queen does—not yet, anyway—Murray Hill is the King of the Hill. Nobody does what he does better, and certainly not in that outfit.

Hill performs the world over—they don't call him "the hardest-working middle-aged man in show business" for nothing—but the New York–based comedian, whose female name has been struck from the record, still puts his baggy pants on one very funny leg at a time. Not that his legs are funny. He's funny. His legs are fine.

Part Don Rickles, part Milton Berle—not that part!—and totally a throwback to the hilariously schticky lounge acts of old Las Vegas, Hill is retro and yet points the way to the future of drag, a fast-approaching day when men perform as women, women perform as men, biological females perform as drag queens, and no one really cares what gender anyone is when they wake up in the morning, as long as the audience is mesmerized when the curtain goes up at night.

Who were your influences as a performer?

So many and all over the place! The legendary Mr. Don Rickles, Shecky Greene, Dean Martin, Liza Minnelli, Bea Arthur, Joan Rivers, Tina Turner, Dame Edna, Lady Bunny, Justin Bond, Bridget Everett, Alan Cumming, Totie Fields, Belle Barth, Rusty Warren

. . . Norman Fell, Mr. Roper on *Three's Company*. They're all entertainers I've listened to, seen, and studied more than I should admit.

Does Lily Tomlin's drag king character, Tommy Velour, impress you?

Everything Lily Tomlin does impresses me. Her body of work is mind-blowing. She was one of the first female comedians to do male drag. There's a great video clip of Tommy singing to Liz Taylor and Michael Jackson. It's the classic lounge lizard act and she nailed it.

How has the drag king scene changed since you began performing?

When I first started in mid-1990s, there were fantastic kings in San Francisco, such as Elvis Herselvis. In New York, Club Casanova on the Lower East Side was getting going with Mo B. Dick, Dred, and a great group of drag kings. Diane Torr and Shelly Mars were doing drag in performance art spaces. There was a lull for a while, but now drag kings have been coming back all over the world. There's a performance group in Brooklyn called Switch n' Play, which includes drag kings, gender warriors, and burlesque. It's all fluid and mixed now.

How have things changed for you personally?

I started off in a seedy club on Avenue A on the Lower East Side, and just performed at the Sydney Opera House. I like to tell myself, every gig counts. Nothing compares to show biz . . . well, maybe a bag of Utz potato chips.

Is it tough to blaze a trail as a male character in a world of drag queens?

Doing an act as a male character has certainly felt like an uphill battle at times, but I don't think the craft is harder. What's harder is the economics of it. There are exponentially more opportunities for drag queens. For most of my career, I've had to create my own opportunities. My personal mantra has always been, "You'll never be out of work, if you give yourself a job!"

Do you think RuPaul's Drag Race *should do a drag king edition?*

They should definitely do a spin-off to support other expressions of drag and give much needed national and international exposure to drag kings. A drag king *Race* show would have an immediate positive impact.

What positive impact did creating Murray Hill have on you?

Creating Murray saved my life! This character has allowed me to travel all over the world and meet and work with incredible people. Never in my wildest dreams did I think my life would be like it is now. So, kids, leave the suburbs and head to the big city. It does get better . . . eventually.

ABOVE: The hardest working man in show business, Murray Hill.

Nowhere was the scope of this drag cornucopia any clearer than at the Los Angeles Convention Center on a late April morning in 2017. That day, thousands of people—young and not-so-young, in and out of drag—turned out for the third edition of RuPaul's DragCon, a hugely popular annual event put together by World of Wonder, the production team behind *Drag Race*.

From morning until night in the vast exhibition space, hundreds of retailers peddled their drag-related wares—from wigs and heels to vegan drag queen cookbooks and photo-realist drag queen shower curtains—in booths arranged along both sides of rows named Death Drop Alley and Lace Front Blvd., while performers from all sissy-that-walks of drag interacted with their fans.

Frank Marino, who has been impersonating Joan Rivers in Las Vegas for more than thirty years, was perched on a lamé settee in mottled jeans and gold Versace high-tops taking pictures with a young Asian woman, while Larry Edwards, aka Hot Chocolate, the best Tina Turner impersonator in the business, modeled with geisha garb over his shoulder.

Valentina, the alter ego of James Andrew Leyva, an L.A. kid who had been doing drag for only ten months before he began competing on the ninth season of *Drag Race* in 2017, was drawing a crowd of screaming well-wishers in another corner. Meanwhile, Elvira—a cisgender ghoul last time anyone checked under Cassandra Peterson's hood—had a line a hundred people deep, dying for a moment with their busty vampire idol.

Glitter-bearded men—some bear-shaped, some bare-assed—were buying T-shirts with the late, great Divine on them in a booth that doubled as a mini-museum to the man born Harris Glenn Milstead.

Katya—the popular queen from season seven of *Drag Race* who calls herself "the sweatiest woman in show business"—was working up a lather at a booth near the front of the huge hall, while in a ballroom upstairs Mark Indelicato, the actor who played a little gay boy on *Ugly Betty* before he even knew he was a little gay boy in real life, was wearing Cleopatra eye makeup and a fishnet top discussing LGBTQ portrayals on television on a panel that included a trans man, the actor Elliot Fletcher of *Faking It*, *The Fosters*, and *Shameless* fame.

That day at DragCon, there were go-go boys who'd been grinding all day in the same schvitzy studded jockstraps they'd had on since the morning. But Lili Whiteass, the alter ego of actor Todd Lattimore who had appeared in the 2010 Broadway revival of *La Cage Aux Folles*, was rocking her second look of the day, a Rastafarian-inspired miniskirt and dreads that belied her Caucasian drag name.

Early that evening, as spent DragCon attendees were sashaying away, their feet sore from walking in heels for eight hours, I snapped a picture of the back of a drag queen wearing a potted urn on her head and square-trimmed shrubbery for shoulder pads. I posted it to Instagram and, within seconds, there was an "OMFG" comment on the photo. The high-fashion human hedge, it turns out, was a New York recording artist named Linux. Apparently, I should have known that.

Among Linux's fans is the young man who wrote that comment, a teenage drag queen named Obscura, who, as it turns out, is my college roommate's son. He is developing a following of his own via social media and drag competitions in his native New York City. If he has his way, Obscura won't be obscure, uh, for very long.

Michael Musto may have been right. There are too many drag queens in the twenty-first century to keep up with. But the great pianist Liberace—a sort of drag queen in his own unique way—was also right when he quoted his friend Mae West, a female drag queen if ever there were one. She liked to say, "Too much of a good thing can be wonderful." It turns out, in the right outfit, too much of a good thing can be not only wonderful but also downright sickening.

OPPOSITE: *Drag: The Next Generation. Obscura, the alter ego of Marcello Bevilacqua.*

But Wait, There's More!

A Timeline of Highlights and High Hair

1904: Julian Eltinge opens in his first Broadway musical, *Mr. Wix of Wickham*. It closes after only forty-one performances, despite featuring songs by Jerome Kern.

1913: Roscoe "Fatty" Arbuckle is a cowboy's wife in Mack Sennett's *Peeping Pete*.

1914: Long before winning an Oscar for 1931's *The Champ*, Wallace Beery shoots a series of drag shorts beginning with *Sweedie the Swatter*.

1929: *That's My Wife*? Actually, it's Stan Laurel in flapper drag.

1933: Reinhold Schunzel writes and directs *Viktor und Viktoria*, which two years later hits American shores as *Victor and Victoria*.

1941: *You're in the Army Now*, Jimmy Durante—what are you doing in drag? Dancing.

1941: Mickey Rooney almost makes a better Carmen Miranda than Carmen Miranda in the Busby Berkeley musical comedy *Babes on Broadway*.

1942: Joe E. Brown is not only *The Daring Young Man* but also his chic grandmother in this World War II comedy.

1944: When Abbott & Costello get *Lost in a Harem*, Lou ends up in drag. Two years later, Bud gets his turn, playing his own grandmother in *Little Giant*.

1947: Tim Moore appears as a female impersonator named Bumpsie in the so-called race film *Boy! What a Girl!*

1949: Frank Sinatra, Jules Munshin, and Gene Kelly infiltrate Rajah Bimmy's Oriental Extravaganza dressed as harem girls in the MGM musical *On the Town*.

1949: Cary Grant wears a horsetail wig and a WAC uniform—and still looks absurdly handsome—in the Howard Hawks comedy *I Was a Male War Bride*.

1950: A "circus clown put on a lady's gown" and a chandelier falls down when Bing Crosby and the Andrews Sisters sing "Poppa Santa Claus."

1952: In *Old Mother Riley Meets the Vampire*, Arthur Lucan, in granny drag, meets Bela Lugosi. Scary.

1953: Jerry Lewis impersonates his costar Carmen Miranda in the Martin and Lewis comedy *Scared Stiff*.

1953: Director Ed Wood—the Orson Welles of bad movies—stars in *Glen or Glenda*.

1954: "Sisters" Danny Kaye and Bing Crosby lip-synch a duet in *White Christmas*.

1954: Joan Fontaine and Bob Hope cross-dress to impersonate the Baron and Baroness of Cordovia in *Casanova's Big Night*.

1954: Alistair Sim plays both the headmistress Millicent Fritton and her brother Clarence in *The Belles of St. Trinian's*.

1955: Overgrown lummox Stretch Snodgrass (Leonard Smith) celebrates "Turnabout Day" at Madison High by showing up to class in a tulle-skirted dress on the classic Eve Arden sitcom, *Our Miss Brooks*.

1957: His brother wears a dress, or so Jets gang leader Riff tells Officer Krupke, in the Broadway musical *West Side Story*.

1958: Ray Walston goes native in a straw wig and coconut bra in Joshua Logan's *South Pacific*.

1959: Jackie Coogan and Sid Melton are cross-dressing cops on a Lovers' Lane stakeout in the Mamie Van Doren film noir oddity, *The Beat Generation*.

1960: Child actor Rusty Hamer impersonates "Inez" to fool his father's booking agent (Sheldon Leonard) on Danny Thomas's *Make Room for Daddy*.

1960: When Wally (Tony Dow) is cast as "Queen of the Dance Hall Girls" in a school play on *Leave It to Beaver*, Ward (Hugh Beaumont) admits he once dressed as a hula girl and June (Barbara Billingsley) once played George Washington. Who knew the Cleavers were so drag friendly?

1961: Nutrix of Jersey City, New Jersey, publishes *Letters from Female Impersonators*, a magazine featuring "actual correspondence on femme mimics."

1961: Tommy Sands dresses as a gypsy woman who's anything but a babe in Disney's *Babes in Toyland*.

1962: Jack Gilford plays Hysterium—"the slave who ends up in drag," as his 1990 Associated Press obituary put it—in the Sondheim musical *A Funny Thing Happened on the Way to the Forum*.

1963: Impressionist Stanley Baxter, the first person to impersonate Queen Elizabeth II on British television, gains fame with *The Stanley Baxter Show*. One critic calls him "Scotland's greatest transvestite." His Liberace is wonderful, too.

1965: Jose Sarria, the first openly gay political candidate in America, founds the Imperial Court System in San Francisco. More than forty years later, it's one of the largest LGBTQ organizations in the country.

1970: George Sanders—Addison DeWitt in *All About Eve*—plays a San Francisco drag queen in John Huston's *The Kremlin Letter*.

1970: Jeremy Stockwell is *Dinah East*, a 1950s movie queen who secretly is a transvestite. Warhol acolyte Ultra Violet is featured in Gene Nash's must-see cult curiosity.

1971: Paul Hunt, a Utah coach and "gymnastics comedian," begins performing parallel-bar, balance-beam, and floor routines as his tutu-clad alter ego Paulette Huntesque, aka Huntenova.

1971: *Sometimes Aunt Martha Does Dreadful Things.* Like dress in drag and kill people.

1971: Blond, James, Blond. The villainous Blofeld (Charles Gray) dresses in drag and strokes his pussy in the back of a cab in *Diamonds are Forever*.

1972: Jonathan Winters appears as an animated Maude Frickert on *The New Scooby-Doo Movies* and Saturday morning cartoons are never the same.

1972: Weimar? Why not? Elke (Ricky Renee) stands up for herself—in the men's room—in Bob Fosse's *Cabaret*.

1972: The campy comedy troupe the Campers begin camping it up in California's not particularly campy San Fernando Valley.

1973: Impersonator Pudgy Roberts launches her own magazine, *The Great Female Mimics*, featuring profiles of Arthur Blake, Ricky Renee, and Frank Quinn.

1974: The all-male Les Ballets Trockadero de Monte Carlo is founded in New York to prove that men really can dance en pointe. The dance troupe goes on to perform in more than five hundred cities around the world, and, in 2017, is the subject of Bobbi Jo Hart's documentary *Rebels On Pointe*.

1975: Dressed as a showgirl, Paul Jabara sings "Hot Voodoo" to a terrorized Homer Simpson (Donald Sutherland) in John Schlesinger's brilliant big-screen adaptation of Nathanael West's *Day of the Locust*.

1975: Jovial actor James Coco dresses as a plus grand eighteenth-century French noblewoman in James Ivory's *The Wild Party*.

1975: On the cover of his comedy album *The Dirty Old Man*, *Gilligan's Island* star Jim Backus is both an obscene phone caller and—in a blonde wig, blue eye shadow, and a peignoir—his unsuspecting target.

1975: The Cycle Sluts—a Los Angeles performance company whose look mixes Frederick's of Hollywood and fetish of Silver Lake—become, as one critic called them, "the 'It Girls' of gay culture" at such hotspots as Whisky a Go Go, the Roxy, and the Blossom Room of the Hollywood Roosevelt Hotel.

1976: Wear a towel or dress in drag when you check into Terrence McNally's gay bathhouse comedy *The Ritz*.

1977: Jilted lover John Ritter dresses in drag to snag the only available cabin aboard *The Love Boat*. The season-one episode is the first of several featuring shipboard drag.

1977: After attending the annual Halloween parade in Greenwich Village, Rollerena skates into Studio 54 for the first time, and disco's favorite drag-queen-on-wheels begins her more-than-fifteen minutes of fame.

1978: Salvador Dalí muse and Studio 54 scene-maker Potassa de la Fayette is dubbed "the world's most famous transvestite."

New York PREMIERE!

Limited Engagement Begins JANUARY 14!

THE
Third
STORY

BY *Charles* BUSCH

Charles BUSCH *Scott* PARKINSON

WITH

Sarah RAFFERTY *Jennifer* VAN DYCK *Jonathan* WALKER AND *Kathleen* TURNER

DIRECTED BY *Carl* ANDRESS

1978: Punk icon Jayne County plays a transvestite rock star named Lounge Lizard in Derek Jarman's film *Jubilee*.

1978: Rene Auberjonois dresses as Faye Dunaway and gets murdered for his trouble in *The Eyes of Laura Mars*.

1979: As a Janis Joplin–esque singer in *The Rose*, Bette Midler meets a drag version of herself played by Kenny Sacha.

1980: Richard Gayor's *The Alternative Miss World* documents the cockeyed London drag pageant.

1981: "Defective Russian" Madame Vera Galupe-Borszkh (Ira Siff) founds the all-male La Gran Scena Opera Company di New York and makes a travesty of every opera from *Aida* to *Il Trovatore*. Leontyne Price and Joan Sutherland become fans.

1981: Undercover detective Kelly Garrett (Jaclyn Smith) finds that a mentalist named Margot is not only out to murder her, but is also a man (Bruce Watson), on the season five *Charlie's Angels* episode "Angel on the Line."

1981: Max (Lionel Stander) in blue eyeshadow and a blond wig is anything but gorgeous on the season two *Hart to Hart* episode, "Murder is a Drag." In season four, it's Robert Wagner's turn to cross-dress as a countess in leg warmers in an installment, set in an exclusive spa, called "One Hart Too Many."

1981: Lily Tomlin dons a chest wig as lounge lizard Tommy Velour on her TV special *Lily: Sold Out!*

1981: Judd Hirsch, Tony Danza, and Andy Kaufman masquerade as the Andrews Sisters on the *Taxi* episode "The Costume Party."

1981: Andy Warhol photographs himself in drag.

1982: Audiences embrace the invisible aliens and visible androgyny of Anne Carlisle, who plays both Margaret and Jimmy, in the cult hit *Liquid Sky*.

1982: Steve Martin is dressed to thrill—sort of— when he impersonates Barbara Stanwyck in Carl Reiner's *Dead Men Don't Wear Plaid*.

1983: Barbra Streisand stars in *Yentl*. Papa, have you seen her in drag?

1984: Fred Barton sings "I'm a Bitch" as the title character in his one-man show *Miss Gulch Returns!*, a cabaret hit in New York City. You were expecting Kansas?

1984: Linda Hunt wins the Oscar for Best Actress in a Supporting Role playing the male photographer

Billy Kwan in Peter Weir's *The Year of Living Danger-ously*.

1985: Teen journalist Joyce Hyser is *Just One of the Guys* when she goes undercover at a rival high school dressed as a boy.

1985: Plus-sized greeting card model Billi Gordon publishes his *You've Had Worse Things in Your Mouth Cookbook*. Decades later, he becomes a neuroscientist. Really.

1986: A clean-shaven Dom DeLuise plays Aunt Kate in Gene Wilder's ghostly comedy *Haunted Honeymoon*.

1986: Oscar-winning songwriter Paul Jabara is a good-girl-gone-tropical in the video for "Ocho Rios," a single from his "poperetta" *De La Noche: The True Story*.

1986: Sally's Hideaway—the Times Square home to *Dorian Corey's Drag Doll Revue*—opens on 43rd Street in Manhattan.

1986: Sybil Bruncheon (John Burke) becomes the first empress of the Imperial Court of New York then the queen of the pioneering Gay Cable Network, as the hostess of such shows as *Be My Guest* and *Stonewall Place After Dark*.

1988: David Henry Hwang's play of mistaken gender identity *M. Butterfly* opens on Broadway. Spoiler Alert: John Lithgow is shocked when he sees BD's Wong.

1988: Kenny Kerr, the female impersonator whom the Las Vegas Review-Journal called "the bad girl that Las Vegas fell hard for in the '70s," ends an eleven-year run as the star of *Boy-lesque*, a drag revue that some ranked with Lake Mead and Hoover Dam as the top three Sin City must-sees.

1989: Michael J. Fox is his own daughter/sister

Marlene McFly in *Back to the Future Part II* and it's not that creepy at all. Maybe a little . . .

1989: Alexis Pittman launches the drag fundraiser Quest for the Tiara in his West Hollywood living room and collects four hundred dollars. Decades later, the lavish beauty pageant spoof, now known as the *Best in Drag Show* and playing the Orpheum in downtown Los Angeles, makes millions to benefit HIV/AIDS-related services.

1990: Chicago's Cloud 42 programs *Craig's Wife* and *The Bad Seed* as B Plays in Rep with actor Harry Althaus in roles made famous by Joan Crawford and Nancy Kelly. The *Chicago Tribune* says the casting provides a "weirdly invigorating spin."

1990: Ted Danson goes bananas in Carmen Miranda drag in *Three Men and a Little Lady*.

1990: David Duchovny puts his "panties on one leg at a time" as DEA Agent Dennis/Denise Bryson on David Lynch's edgy ABC TV series *Twin Peaks*.

1990: Eric Idle and Robbie Coltrane don habits in *Nuns on the Run*.

1991: The *Designing Women* try to convince a stubborn Suzanne Sugarbaker (Delta Burke) that a beautiful drag performer named Lolita LuPage (David

Shawn Michaels) is really a man. When he pulls off his wig, Suzanne says, "That doesn't mean diddly," and pulls off hers.

1991: Drag in zero gravity: The cult hit *Vegas in Space*—cowritten by and starring the inimitable Sidney- and San Francisco–based drag queen Doris Fish (Philip Mills)—is released.

1991: *The Golden Girls* spoofs Bull Durham and Blanche's softball-playing boyfriend (Tim Thomerson) ends up in a blue dress, pearls, and matching earrings.

1991: The Fleetwood Mac tribute party known as "Night of 1000 Stevies"—as in Nicks—makes its debut. Thousands of shawls later, the bleat goes on.

1991: Parisian designer Thierry Mugler sends John "Lypsinka" Epperson down the runway in his Spring 1992 fashion show and she looks féroce!

1992: Joel Vig establishes Sylvia St. Croix as a drag role in *Ruthless!*, an otherwise all-female musical sendup of *The Bad Seed* (and other camp classics) by Joel Paley and Marvin Laird, at the Off-Broadway Players Theatre.

1992: Martin Lawrence not only plays the title character on the Fox sitcom *Martin*, he also plays his own mustachioed mother Edna and—oh, my goodness!— the ghetto-fabulous salon owner Sheneneh Jenkins.

1992: Jaye Davidson plays Dil, a girl with something extra, in Neil Jordan's *The Crying Game*.

1992: Grunge icon Kurt Cobain and his Nirvana bandmates wreak havoc in borrowed dresses in the music video for "In Bloom" from the *Nevermind* album.

1993: Let's Have a Kiki Dee: Elton John and RuPaul release a dance version of "Don't Go Breakin' My Heart" that reaches number seven on the British charts.

1993: Miss Understood (Alex Heimberg) founds a drag queen booking agency called Screaming Queens, providing what the *New York Times* calls "adults-only clowns" for society parties.

1993: Lucky Cheng's, a restaurant with an all-drag wait staff, opens in the East Village and quickly attracts celebrated patrons including Prince Albert of Monaco.

1994: Thomas O'Neill's *Judy at the Stonewall Inn*, "a pep rally of a play," according to the *New York Times*, about a Garland impersonator, opens in New York.

1994: A sensation from Down Under, the Australian film *The Adventures of Priscilla, Queen of the Desert* proves there are few things more fetching than "a cock in a frock on a rock."

THE WORLD'S #1 VACATION FOR DRAG FANS

VALENTINA EUREKA

DRAG STARS AT SEA CRUISE

PRESENTED BY ALandCHUCK.travel

ALEXIS NINA & MORE

DRAG CON SPECIAL ONLY $49 TO BOOK AT BOOTH 204

EUROPE/RUSSIA SEP 9-16 2017
CUBA DEC 4TH-11TH 2017
AUSTRALIA MARCH 5TH-12TH 2018

SHOWS EVERY DAY! NIGHTLY PARTIES! VACATION WITH THE QUEENS!

$99 ULIMITED DRINK PACKAGE
FOR DRAG STARS AT SEA CUBA

BOOK ONLINE www.DragStarsAtSea.com or CALL 1-866-949-1429
AND RSVP FOR $99 DOWN AND ONLY $99 A MONTH PAYMENT PLAN

1994: At the rock 'n' roll dive bar Don Hill's in New York City, Misstress Formika (Michael Ortega) helps found SqueezeBox!, a weekly punk party that serves as the drag hothouse where *Hedwig and the Angry Inch* is born.

1994: Billie Ann Miller (Bill LaMonica) begins her reign as the Empress of Peace and Love at the Imperial Court of New York's *Night of a Thousand Gowns*.

1995: Bar d'O nightclub chanteuse Raven O. appears as a New York transvestite on a stateside-set episode of *Absolutely Fabulous* called "The End."

1995: Androgynous New York DJ Miss Guy forms the band Toilet Böys.

1995: Howard Stern becomes the Queen of All Media when he is photographed in drag for the cover

of his book *Miss America*.

1996: Dave Navarro walks the Anna Sui runway in a lace-trimmed teddy.

1996: Julian Fleisher publishes *The Drag Queens of New York: A Field Guide*.

1996: Flamboyant children can finally play with their own paper dolls when David Croland illustrates *Drag Dolls: 8 Cut-Out Drag Queens and Their Fabulous Over-the-Top Ensembles*.

1996: Pro-baller-turned-author Dennis Rodman puts on a wedding dress to prove he's *Bad as I Wanna Be*.

1997: New York's Film Society of Lincoln Center presents What a Drag!: A Cross-Dressing Series for Kids, a family-friendly film series curated by nine-year-old fourth-grader Victoria Kabek.

1997: New York City mayor Rudy Giuliani—known as "Rudia" in drag—plays an Italian grandmother on *Saturday Night Live*. It only got worse.

1997: Cherry Jubilee celebrates the best in New York drag with the first annual Glammy Awards hosted by Mona Foot at Barracuda. Rudia isn't even nominated.

1998: Country music superstar Garth Brooks is an "Old French Whore!" on *SNL*.

1998: The Fabulous Belle Aire (Scott Presley) begins cohosting Legendary Bingo charity benefits. Balls are called. Money is raised. "O-69!" gets laughs.

1999: Mabel Simmons, better known as Madea, makes her official debut on stage in Tyler Perry's *I Can Do Bad All By Myself*. In the decades that follow, Perry plays her in at least nine more theatrical shows, eleven movies, and on several TV series. *Entertainment Weekly* calls his drag alter ego "the profane, gun-toting granny you never had but (maybe) wish you did."

2000: Trey Parker and Matt Stone, nominated for the *South Park* movie, walk the red carpet at the Oscars dressed as Jennifer Lopez and Gwyneth Paltrow.

2000: Ving Rhames makes one really big drag queen in Showtime's *Holiday Heart*.

2000: Leslie Jordan is unforgettable as Brother Boy, an institutionalized Tammy Wynette impersonator, in Del Shore's beloved movie comedy *Sordid Lives*, a role he reprises in a 2008 TV series and a 2017 movie sequel.

2001: Charles Busch proves afternoons are a drag as modeling agency owner Peg Barlow on *One Life to Live*.

2001: Kathleen Turner plays Chandler's drag queen father, Charles Bing aka Helena Handbasket, on *Friends*.

2002: Girls! Girls! Girls! Paul Vogt serves Charlotte Rae realness as Mrs. Garrett on a *Facts of Life* episode of the NBC summer series *The Rerun Show*.

2003: Champagne for everyone! Matt Lucas and David Walliams star in *Little Britain* and introduce the world to such characters as Marjorie Dawes, Carol Beers, the unconvincing transvestites Florence and Emily, and Bubbles DeVere.

2003: Much to the right wing's dismay, Harvey Fierstein dresses as Mrs. Santa Claus and waves to delighted children during that most televised of American celebrations, the Macy's Thanksgiving Day Parade.

2004: Hollywood Square Bruce Vilanch replaces *Laverne & Shirley*'s Michael McKean as Edna Turnblad in *Hairspray* on Broadway. Comedian John Pinette and George Wendt, who played Norm Peterson on *Cheers*, follow.

2004: Gael García Bernal is just too damned beautiful in drag in the Pedro Almodovar drama *Bad Education*.

2004: The hotel room is a bit crowded, but that drag queen is going to be fierce if she ever gets dressed in George Michael's "Flawless (Go to the City)" video.

2005: The Outfest UCLA Legacy Project is founded to preserve LGBT films including the groundbreaking *Queens at Heart* (1967).

2005: Tobias (David Cross) disguises himself as a domestic named "Mrs. Featherbottom" to spend time with his daughter on *Arrested Development*.

2006: *Kiki & Herb: Alive on Broadway*—the musical brainchild of downtown darlings Justin Bond and Kenny Mellman—opens at the Helen Hayes Theatre and is nominated for a Tony Award for Best Special Theatrical Event.

2006: John Mahoney—Frasier's dad—plays a drag queen caring for his dying lover on the thirteenth season's episode of *ER* entitled "Somebody to Love." At the end of the show, he sings "You're Nobody Till Somebody Loves You."

2007: Future *Drag Race* contestants Willam and Chad Michaels guest-star on the "To Drag & to Hold" episode of the short-lived ABC series *Women's Murder Club* and make it clear that nothing can screw up a wedding like a dead drag queen.

2008: Gender-nonconforming short-order cook Lafayette Reynolds (Nelsan Ellis) has the most biting sense of humor in a town full of vampires on *True Blood*.

2008: Ron Davis and Stewart Halpern's documentary *Pageant* follows contestants vying for the title Miss Gay America. Tina Turner impersonator Larry "Hot Chocolate" Edwards, who won the crown in 1980, is a judge.

2008: The Big Bad Wolf finally self-identifies as a cross-dresser in *Shrek The Musical* on Broadway.

2009: Director Allan Neuwirth's documentary *What's the Name of the Dame?* explores the link between ABBA and drag. One word: Ponchos.

2009: BeBe Zahara Benet—a former male model from Cameroon named Nea Marshall Kudi Ngwa—is crowned America's Next Drag Superstar on the first season of *RuPaul's Drag Race*.

2010: New York photographer Terry Richardson shoots heartthrob James Franco in drag for the cover of the transversal style magazine *Candy*.

2010: *RuPaul's Drag U*, a spinoff series in which drag queens give cisgender women makeovers, premieres on Logo.

2010: Nothing says Christmas quite like Drag Queens on Ice. The annual event gets its start on the Safeway Holiday Ice Rink in San Francisco's Union Square.

2011: "Terrorist drag" queen Christeene (Paul Soileau) appears in Kyle Henry's outrageous, fluid-soaked tearoom comedy *Fourplay: Tampa*.

2011: Tom Tierney, paper-doll artist extraordinaire, publishes *Life's a Drag!*, featuring cut-out versions of Tootsie, Mrs. Doubtfire, Yentl, Madea, and more.

2012: Daniel Franzese, who was "almost too gay to function" in *Mean Girls*, is an Italian mom who says shit in *Shit Italian Moms Say*.

2012: Judy Garland and Bea Arthur tribute artists Peter Mac and D.J. Schaefer are the unlikeliest of "Bosom Buddies" when they celebrate what would have been the women's ninetieth birthdays together at the French Market in Los Angeles.

2013: In blond curls and scads of pink ruffles, the sweetly villainous Gru (Steve Carell) stands in for the "most magical fairy princess of all" in *Despicable Me 2*.

2013: Caftans, courageous! *The Million Mrs. Roper March* steps off at Southern Decadence in New Orleans, proving that *Three's Company*, but a million is fabulous . . . if a bit exaggerated.

2013: Norwegian art historian Henriette Dedichen juxtaposes Andy Warhol's paintings of actual female royalty and his Polaroids of drag queens in the book *Warhol's Queens*.

2013: *Drag Race* veterans Alaska Thunderfuck 5000, Willam, and Michelle Visage star in *The Rocky Horror Show* at San Antonio's Woodlawn Theatre.

2014: Kevin Spacey dresses as Julia Louis-Dreyfus—and vice versa—for (fraternal) twin covers of *Entertainment Weekly* spotlighting *House of Cards* and *Veep*.

2014: Filmmaker James Hosking pays tribute to the Tenderloin drag bar Aunt Charlie's Lounge in *Beautiful by Night*, a documentary short that finds favor on the LGBTQ film festival circuit.

2014: *Gay Pimp* and *Big Gay Sketch Show* alum Johnny McGovern launches the drag-tastic talk show *Hey Qween!* with Lady Red Couture as his Ed McMahon.

2015: A struggling Elvis impersonator (Dave Thomas Brown) becomes a successful heterosexual drag queen in Matthew Lopez's Off-Broadway comedy *The Legend of Georgia McBride*.

2015: Twenty years after directing Carol Channing in the 1995 Broadway revival of *Hello, Dolly!*, Tony-nominated actor Lee Roy Reams stars as the matchmaker herself at the Wick Theater in Boca Raton, Florida.

2015: Let's Make a Heel! Emmy-winning game show host Wayne Brady steps onto Broadway and into *Kinky Boots* as Lola.

2015: After almost 120 episodes of *Numb3rs*, David Krumholtz retires to Boca Raton a rich widow in *Gigi Does It*. The show, on IFC, lasts eight weeks.

2015: The man behind the curtain is a drag king when Queen Latifah plays the title character in *The Wiz Live!* on NBC.

2015: Miley Cyrus slays the MTV Video Music Awards with "Dooo It," joined by thirty gyrating *Drag Race* queens including a death-dropping Laganja Estranja.

2015: Drag star Babette Schwartz closes her eponymous gift emporium in San Diego's Hillcrest neighborhood and shoppers cry a glittered tear.

2015: Adele celebrates her twenty-seventh birthday dressed as George Michael.

2016: Artist Damien Frost publishes *Night Flowers: From Avant-Drag to Extreme Haute Couture*, an ode to what Boy George, in a foreword to the book, calls the "slack drag" of London's club scene.

2016: The Strokes release "Drag Queen," the first single and video from their EP *Future Present Past*.

2016: In a role that *Entertainment Weekly* called "the biggest challenge of his career," Willem Dafoe impersonates Marilyn Monroe, getting air blown up his skirt *Seven Year Itch*–style, in a Snickers ad shown during the Super Bowl.

2016: RuPaul becomes the host of *Skin Wars*, a body painting competition on GSN, and *Gay for Play*, a game show on Logo.

2016: Photographer Magnus Hastings asks *Why Drag?* in a coffee-table collection of portraits of some of the world's most beloved queens.

2016: Bob the Drag Queen (Christopher Caldwell) stars as Kitten Withawhip—alongside fellow *Drag Race* alums Tempest DuJour (Patrick Holt), Detox (Matthew Sanderson), and Latrice Royale (Timothy Wilcots)—in Assaad Yacoub's award-winning film comedy *Cherry Pop*.

2017: New York City's Anthology Film Archives programs The Cinema of Gender Transgression: Trans Film, a series that includes Frank Simon's pioneering 1968 documentary *The Queen*.

2017: Katy Perry sings "Swish Swish" backed by a draggle of queens, but a skinny boy in a backpack steals the show on *Saturday Night Live*.

2017: *Drag Race* runner-up Mimi Imfurst becomes the first American drag queen to perform in modern-day Cuba, lip-synching to Madonna's "Express Yourself."

2017: Pandora Boxx, Farrah Moan, and Manila Luzon impersonate three Real Housewives on Andy Cohen's *Watch What Happens Live*.

2017: New York City gets its own version of RuPaul's DragCon.

2017: *Susanne Bartsch: On To*p, a documentary by filmmakers Anthony Caronna and Alexander Smith about the New York nightlife legend, wins the John Schlesinger Award at the Provincetown International Film Festival.

2017: Drag Race favorites Trixie Mattel and Katya get their own TV program, *The Trixie & Katya Show*, on Viceland.

2018: Kentucky Fried Chicken casts Reba McEntire as Colonel Sanders in a series of commercials, making her the first woman to ever cross that dream off her bucket list.

2018: *Canada's a Drag*, a nine-part docuseries spotlighting north-of-the-border queens, premieres on CBC Arts.

TRAVEL THE WORLD AND VACATION WITH YOUR FAVORITE DRAG QUEENS FROM

RUPAUL'S DRAG RACE

AL and CHUCK.travel

DRAG STARS AT SEA CRUISE

CUBA EUROPE RUSSIA

WWW.DRAGSTARSATSEA.COM

2018: You better walk! RuPaul gets his own star on Hollywood Boulevard.

2018: *Drag Race* Season 10 in six words: "Miss Vanjie. Miss Vaanjie. Miss Vaaaanjie."

2018: When Young Sheldon (Iain Armitage) is cast as the title character in a gender-defying production of *Annie* and then experiences stage fright, his drama teacher Mr. Lundy (guest star Jason Alexander) goes on in drag instead.

2018: Comedian John Mulaney plays a vicious drag brunch waitress named Tawny Pockets on *Saturday Night Live*.

2018: New York club kid Giovanni Palandrani, better known as Aquaria, wins Season 10 of *RuPaul's Drag Race*.

2018: The category is . . . a hit. Ryan Murphy's *Pose* sheds glittering light on the drag balls of eighties Harlem with a cast led by Billy Porter and an electrifying bevy of trans actresses. A second season reportedly will lead up to the release of Madonna's "Vogue" single.

2018: Jamie Patterson's feature *Tucked*, about an 80-year-old drag queen (Derren Nesbitt), snatches major international awards at OutFest: The Los Angeles LGBTQ Film Festival.

2018: *Drag Race* alum Peppermint becomes the first trans performer to originate a lead role on Broadway when she stars in the Go-Go's musical *Head Over Heels*.

2018: They're shop boys by day, superhero drag queens by night when Netflix greenlights the animated series *Super Drags*.

2018: Jinkx Monsoon, Peaches Christ, Thirsty Burlington, Jimmy James, and Ryan Landry lead Drag Camp, a week of workshops and performance in Provincetown.

2018: Instagram sensation and *Buffy* alum Tom Lenk stars as the title character in Byron Lane's absurdist comedy *Tilda Swinton Answers an Ad on Craigslist* at the Edinburgh Fringe Festival, following sold-out runs in Los Angeles and New York.

2018: Vicky Vox is a mean, green drag mother from outer space as the man-eating plant Audrey II in a London revival of the musical *Little Shop of Horrors*.

2018: With a score by Tony Award-winning composer David Yazbek and *Crazy Ex-Girlfriend*'s Santino Fontana in the Dustin-Hoffman-in-drag role, a musical version of *Tootsie* gets a pre-Broadway try-out in Chicago, not Cleveland.

2018: London's Hayward Gallery mounts the exhibit *Drag: Self-portraits and Body Politics*. Drag queen docents give tours.

2018: A *New York Times* headline blares "WIG-STOCK RETURNS FROM THE DEAD" as Lady Bunny and Broadway's original Hedwig, Neil Patrick Harris, revive the greatest outdoor drag festival of them all.

2018: Sasha Velour, Jiggly Caliente, and Shea Coulee —not to mention the legendary Lypsinka—work the runway for Opening Ceremony and make the show the most buzzed-about, celebrity-packed presentation of New York Fashion Week for Spring 2019.

2018: *Drag Race* all-star Ginger Minj is *Truly Divine* in a live one-woman tribute to Baltimore's favorite plus-size thief and shit-kicker.

2018: "Drag Kids" become a phenomenon—fabulously so!—thanks to such pioneering, preteen queens as Desmond is Amazing, E! The Dragnificent!, and Lactatia. A *Teen Vogue* profile attracts attention. Instagram adores them. Their parents approve.

2018: Miss Fame, as Kurtis Dam-Mikkelsen is better known, introduces her own makeup line featuring $19 lipsticks in such provocative shades as "How's Your Head?," "Fame Whore," and "Dirty Couture."

2018: Alyssa Edwards, the "grand dame diva of the South" and alter ego of dance teacher Justin Lee Johnson, gets her own Netflix documentary series, *Dancing Queen*.

2018: Bradley Cooper's remake of *A Star is Born* features not only Lady Gaga, but also the stellar Shangela and Willam, who explained, "Gaga fucking loves drag queens!" We know! We know!

2019: Rizzoli publishes this book.

Photo Credits

Page 2: Photograph courtesy of United Artists via Photofest © United Artists

Page 5: Collection of the author

Page 8: Photograph courtesy of New Line Cinema via Photofest © New Line Cinema

Page 11: Photograph by Bruce Gilkas via Getty Images

Page 13: Photograph by Araya Diaz via Getty Images

Page 14: Photograph courtesy of Bettmann via Getty Images

Page 17: Photograph by Sheridan Libraries/Levy/Gado Archive via Getty Images

Page 18: Photograph by Kurt Hutton/Picture Post via Getty Images

Page 20: Photograph by Barry Fitzgerald

Page 23: Photograph by Walter McBride/Corbis via Getty Images

Page 25: Photograph courtesy of Frank Marino

Page 26: Photograph courtesy of Larry Edwards

Page 29: Photograph courtesy of Rick Skye

Page 31: Photograph by Nick San Pedro

Page 33: Photograph courtesy of Steven Brinberg

Page 35: Photograph by Greg Gorman, provided courtesy of l.a. Eyeworks © l.a. Eyeworks

Page 37: Original Polaroid by David Yarritu

Page 38: Photograph by Barry Fitzgerald

Page 39: Photograph by Barry Fitzgerald

Page 40: Photograph courtesy of Tommy Femia

Page 43: Photograph courtesy of Chuck Sweeney

Page 44: Photograph by ABC Photo Archives/ABC via Getty Images

Page 46: Photograph by ABC Photo Archives/ABC via Getty Images

Page 47: Photograph by Catherine McGann © Catherine McGann Photography

Page 49: Photograph by Dick Loek/*Toronto Star* via Getty Images

Page 50: Photograph courtesy of Photofest

Page 52: Photograph by G. Gershoff via Getty Images

Page 53: Photograph courtesy of Hulton Archive via Getty Images

Page 54: Photograph courtesy of Photofest

Page 56: Photograph courtesy of Photofest

Page 57: Photograph by Bruce Glikas/FilmMagic via Getty Images

Page 59: Photograph on left courtesy of CBS Photo Archive via Getty Images.
Photograph on right by Mike Coppola via Getty Images

Page 60: Photograph courtesy of Photofest

Page 63: Photograph courtesy of Photofest

Page 65: Illustration by Ken Fallin

Page 66: Photograph by Michael Wakefield

Page 67: Collection of the author

Page 69: Photograph by Ron Galella/Ron Galella Collection via Getty Images

Page 72: Photograph by Steven Menendez

Page 73: Illustration by Ken Fallin

Page 75: Photograph courtesy of Photofest

Page 76: Photograph by Jack Robinson/Condé Nast Collection via Getty Images

Page 78: Illustration by Ken Fallin

Page 79: Photograph by David Rogers

Page 80: Collection of the author

Page 81: Collection of the author

Page 82: Photograph courtesy of Columbia Pictures via Photofest © Columbia Pictures

Page 83: Photograph on left courtesy of Photofest
Photograph on right by Mario Tursi and provided courtesy of United Artists via Photofest © United Artists

Page 84: Photograph courtesy of Gramercy Pictures via Photofest © Gramercy Pictures

Page 85: Photograph at top courtesy of Archive Photos via Getty Images
Photograph at bottom left courtesy of Lionsgate via Photofest © Lionsgate
Photograph at bottom right by Bruce McBroom provided courtesy of Paramount Pictures via Photofest © Paramount Pictures

Photo Credits

Photo Credits

Roxy Tumbledryer ⚬ DeManda Refund ⚬ Kim Ch
Mackerel ⚬ Dani Kay ⚬ Rhea Listik ⚬ Maxine Pa
Alotta Boutte ⚬ Landa Lakes ⚬ Summer Clearan
Sheila Blige ⚬ Lois Carmen Denominator ⚬ Anita
Agnes of Gosh ⚬ Robin Banks ⚬ Carlotta Tendant
Rolds ⚬ Tara Fyde ⚬ Cherry Jubilee ⚬ Patti O'Furn
⚬ Ginger Vitis ⚬ Vodka Stinger ⚬ Scylla Kone ⚬ A
Unfaithful ⚬ Monet X Change ⚬ Vile Lynn ⚬ Lucy
Urethra Franklin ⚬ Windy Breeze ⚬ Anne Chilada
O'Gram ⚬ Sue Veneer ⚬ Gilda Wabbit ⚬ Freida Sla
⚬ Frans Gender ⚬ Electra Cute ⚬ Lucy Stoole ⚬ Gi
A. Girl ⚬ Annie Depressant ⚬ Lola Palooza ⚬ Ch
Q. ⚬ Afrodite ⚬ Karen from Finance ⚬ Patty Melt
⚬ Gin-ja Lox ⚬ Pollo Del Mar ⚬ Tara Dactyl ⚬ Jo
Cox ⚬ Blackie Onassis ⚬ Panda Dulce ⚬ Frieda L
⚬ Gia Maica ⚬ Just May ⚬ Pearl Harbor ⚬ Ivy Dri
⚬ Paige Turner ⚬ Juana Bang ⚬ Tulip Sonya Cox
⚬ Joan Jett Blakk ⚬ Amber Alert ⚬ Sue Casa ⚬ I
Courtney Act ⚬ Amanda Poupon ⚬ Rachel Tensio
Magnolia Blossum ⚬ Della Catessen ⚬ Anna Cond
Tration ⚬ Gusty Winds ⚬ Prairie Sky ⚬ Sarah Pr
Cee'Mour Cox ⚬ Mae Loda-Bride ⚬ Helena Handb
Ruby Rims ⚬ Gloria Swansong ⚬ Rosemary Chic
Kay ⚬ Penny Costal ⚬ Ethylina Canne ⚬ Mama L